Monument Wars

THE PUBLISHER GRATEFULLY ACKNOWLEDGES THE GENEROUS
SUPPORT OF THE RICHARD AND HARRIETT GOLD ENDOWMENT FUND IN ARTS AND
HUMANITIES OF THE UNIVERSITY OF CALIFORNIA PRESS FOUNDATION.

Monument Wars

WASHINGTON, D.C., THE NATIONAL MALL, AND THE
TRANSFORMATION OF THE MEMORIAL LANDSCAPE

KIRK SAVAGE

UNIVERSITY OF CALIFORNIA PRESS

BERKELEY LOS ANGELES LONDON

PUBLICATION OF THIS BOOK HAS BEEN AIDED BY A

WYETH FOUNDATION FOR AMERICAN ART PUBLICATION GRANT

OF THE COLLEGE ART ASSOCIATION.

University of California Press, one of the most distinguished university presses in the United States, enriches lives around the world by advancing scholarship in the humanities, social sciences, and natural sciences. Its activities are supported by the UC Press Foundation and by philanthropic contributions from individuals and institutions. For more information, visit www.ucpress.edu.

"Statues in the Park," from THE TROUBLE WITH POETRY AND OTHER POEMS, by Billy Collins, copyright © 2005 by Billy Collins. Used by permission of Random House, Inc.

University of California Press
Berkeley and Los Angeles, California

University of California Press, Ltd.
London, England

Library of Congress Cataloging-in-Publication Data

Savage, Kirk, 1958–
 Monument wars : Washington, D.C., the National Mall, and the transformation of the memorial landscape / Kirk Savage.
 p. cm.
 Includes bibliographical references and index.
 ISBN 978-0-520-27133-3 (pbk. : alk. paper)
 1. Mall, The (Washington, D.C.) 2. Monuments—Washington (D.C.) 3. Memorials—Washington (D.C.) 4. Memorialization—United States 5. Washington (D.C.)—Buildings, structures, etc. I. Title.

 F203.5.M2S38 2009
 725'.9409753—dc22 2008048364

Manufactured in the United States of America

18 17 16 15 14 13 12 11
10 9 8 7 6 5 4 3 2 1

The paper used in this publication meets the minimum requirements of ANSI/NISO Z39.48–1992 (R 1997) (*Permanence of Paper*).

To my whole family, including my daughter Eliza,
who wasn't here for the first book, and Bill Thomas, who left
us before I finished this one

And to all the people of this earth who may never have
a monument to call their own

Contents

Acknowledgments

This project has been a collective effort in many respects. Although it has required a great deal of new research, it is also a synthesis incorporating the work of many scholars who have come before me. Without their painstaking research on the history of Washington, D.C., this book would not have been possible. Even though my own interpretations have sometimes diverged from theirs, I have relied heavily on the scholarship of Kenneth Bowling, Wilhelmus Bryan, Howard Gillette, James Goode, Constance Green, C. M. Harris, Alan Lesoff, John Reps, and Pamela Scott, to name only a few.

My research has also benefited from the hard work of many crack research assistants at the University of Pittsburgh over the past five years. They include Brianne Cohen, Maria D'Annibale, April Eisman, Scott Hendrix, James Jewitt, Annie Kellogg-Krieg, Travis Nygard, Cindy Persinger, Miguel Rojas, and Don Simpson.

Several people have given their time generously, talking through thorny problems in my argument and reading the manuscript at various stages in the writing process: Terry Smith, Elizabeth Thomas, and the late Caroline Newman, who went out of her way to champion the project. I have also had the good fortune to enjoy the assistance and conversation of numerous other friends and colleagues, who lent a hand or made a point that stuck in my mind. These include Drew Armstrong, Lucy Barber, Wendy Bellion, Julian Bonder, Kathleen Christian, Josh Ellenbogen, Fred Evans, Veronica Gazdik, James Goode, Kai Gutschow, Patrick Hagopian, Bernie Herman, Kathy Linduff, Barbara McCloskey, Ikem Okoye, Peter Penczer, Susan Raposa, Stephen Savage, Dan Sherman, David Stone, Sara Thomas, Frank Toker, and Krzysztof Wodiczko. None of them, of course, bear any responsibility for my conclusions or for the errors I have undoubtedly made.

I am grateful for the extraordinarily strong support of the University of Pittsburgh's

Department of History of Art and Architecture, and of our dean, John Cooper, and senior associate dean, Jim Knapp. The university generously supplied me with a research grant from the Central Research Development Fund at an early stage of the project, as well as a publication grant from the Richard D. and Mary Jane Edwards Publications Fund at its end. As the chair of my department, I would not have made much progress on my research without the fine work of my administrative staff, Linda Hicks and Emily Lilly, and the unselfish aid of Kathy Linduff, who took over as acting chair during a medical leave.

At the University of California Press, I was very fortunate to have the unwavering support and editorial expertise of Stephanie Fay. A great production team, including Madeleine Adams, Eric Schmidt, Lia Tjandra, and Jacqueline Volin, took painstaking care of the project from beginning to end.

This book was conceived and written in between two major surgeries, which means that I owe some special debts, first to a group of brilliant, dedicated doctors who made sure I stuck around to finish the project. I especially want to thank my surgeon Kareem Abu-Elmagd, whose devotion to his craft and his patients is legendary. Most of all I want to thank my wife, Elizabeth Thomas, and my daughters Charlotte, Eliza, Rose, and Sara, who worried over me and cared for me and helped me appreciate what it means to be alive.

Introduction

"Since the invention of types [printing], monuments are good for nothing," North Carolina congressman Nathaniel Macon declared on the House floor in 1806. Working himself up to a fever pitch, he explained why he could not support a lavish memorial in the nation's capital even for the most deserving of men, George Washington. Words, not stones or statues, preserved the memory of great men, he said. A modern enlightened nation, with democratic institutions and a literate citizenry, had no use for such "pernicious acts of ostentation."[1] Some thirty years later, former president John Quincy Adams, pondering why Congress had still not managed to build a national monument to Washington, famously observed, "Democracy has no monuments. It strikes no medals; it bears the head of no man upon its coin; its very essence is iconoclastic." The new nation was so "swallowed up in the present" that it took no care of its heroic past.[2]

Even while Adams lamented this so-called iconoclasm, many—if not most—Americans were siding with Macon, holding the public monument in suspicion. Monuments, the skeptics thought, were mere gestures by a powerful few rather than spontaneous outpourings of popular feeling. True memory lay not in a heap of dead stones but in the hearts and minds of the people; no monument could substitute for living social memory, nourished by liberty and education. This resistance to monuments had deep roots, extending as far back in time as ancient Athens, where Pericles famously claimed that the most distinguished monument was "planted in the heart rather than graven on stone." In the United States, the iconoclastic sentiment had strong cultural support from a variety of sources: the Revolutionary critique of monarchy, the Puritan hostility toward graven images, and the Renaissance belief, seemingly verified by the ruins of antiquity, that words always outlived the grandest handiworks of sculpture and architecture.[3]

Although the American resistance to monuments did dissipate over time as all these older traditions waned, it lingered in a strong vein of populist thought. "Ah, not this marble, dead and cold," Walt Whitman wrote when the gigantic obelisk honoring George Washington was finally completed in the center of the nation's capital in 1885. Washington's "true monument," Whitman's poem argued, was not fixed in a single structure or icon but spread throughout the world, "Wherever Freedom [is] pois'd by Toleration, sway'd by Law."[4]

Yet by the time Whitman articulated this anticentrist, democratic ideal of a living memorial, public monuments had become commonplace and in their own way populist. No longer the prerogative of kings and great commanders, statue monuments had spread through cities and even small towns, honoring common soldiers, civil servants, and local politicians—or, as Thomas Carlyle remarked in England, just about "anybody much heard of in the newspapers, and never yet convicted of felony." The *Atlantic Monthly* in 1879 found "the people at large blazing lately with ardor, not yet spent, to cover the land with monuments, and set up statues to all their perishable celebrities."[5] Washington, D.C., took the lead among American cities, and in the sheer number of its monuments the nation's capital rivaled the major cities of Europe by the end of the nineteenth century (figure 1).[6] One reason for the monuments' spread is that public statues became much less expensive to produce over the course of the century. What had been a small-scale artisan activity grew more commercialized, with statues increasingly becoming "the products of the shop, not the studio," as the American Federation of the Arts asserted. This in turn provoked the ire of the art establishment, which by the end of the century was arguing that almost any alternative to the standard shaft or statue monument was preferable. "Why is there not one [society] for the suppression of the vice of monument building?" cried a letter to the *Washington Post* in 1901. In the early twentieth century, modernists got into the act and began to heap their own opprobrium on the phenomenon. Then, after World War I, proponents of the "living memorial" movement gathered steam and seemed poised to defeat the traditional columns and statue monuments once and for all.[7]

Still, the public monument rose up from the dead and continued to spread through the nation's capital and in towns and cities from coast to coast. Throughout the nation's history, monuments have been subject to nearly constant attack, yet they have managed to thrive in ways no one could have anticipated. The nation's memorial landscape has expanded relentlessly, reaching even outside the territorial borders of the United States, with major monuments on battlefields in Europe, North Africa, and Asia, and now into the solar system, with a monument on Mars to the fallen crew of

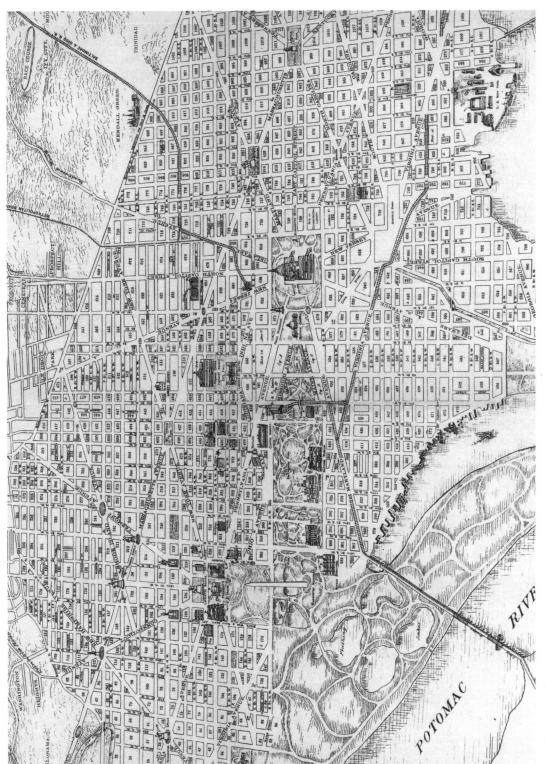

1 B.H. Warner & Co., *Bird's-Eye View of the City of Washington and Suburbs*, 1886, detail. The map shows the many public statues erected through the mid-1880s. (Library of Congress, Geography and Map Division.)

the space shuttle *Columbia*. In Washington, the monumental core of the nation, the National Mall has become more densely filled with memorials and visitors than ever. Although there has been much chest-beating about the monument glut, no proclamation or plan or law seems to be able to seal off the central space of the Mall from further monument building.

Given the longevity of the opposition in the United States to both the theory and the practice of the public monument, the wonder is that Washington has any monumental core at all, let alone the supremely powerful space that came to be organized around the National Mall in the early twentieth century. This book tells the story of how that monumental core emerged, and in the process probes the larger question of how this core has come to define the nation and to change the character of national experience.

In 1800, Nathaniel Macon argued for more "rational" ways to remember national heroes, by the simple act of reading history, for instance.[8] Macon was assuming that a democratic citizenry could operate as an enlightened public sphere, a widespread community of readers and talkers resembling the now classic model articulated by the political theorist Jürgen Habermas. Benedict Anderson, in an equally celebrated formulation, has characterized nations as "imagined communities" brought into being by the spread of the printed word.[9] Although an imagined community, unlike the classic public sphere, need not be governed by reason, neither model accounts for the peculiar power of national monuments. There is no doubt that the modern state has been built on the mass circulation of the written word. Public monuments, by contrast, offer an anachronistic experience: a face-to-face encounter in a specially valued place set aside for collective gathering. This is one reason why rationalists like Macon were so suspicious of them; they reeked of idolatry and superstitious ritual. But the public monument speaks to a deep need for attachment that can be met only in a real place, where the imagined community actually materializes and the existence of the nation is confirmed in a simple but powerful way. The experience is not exactly in the realm of imagination or reason, but grounded in the felt connection of individual to collective body.

In this way the monumental core in Washington functions somewhat like a pilgrimage site, where communities of believers actually come together in the act of occupying a holy site, seeing a relic, reenacting a sacred event.[10] The rhetoric of civil religion—pilgrimage, holy ground, sacred space—is often used to describe monumental Washington because it does seem to ring true. But we must not forget that

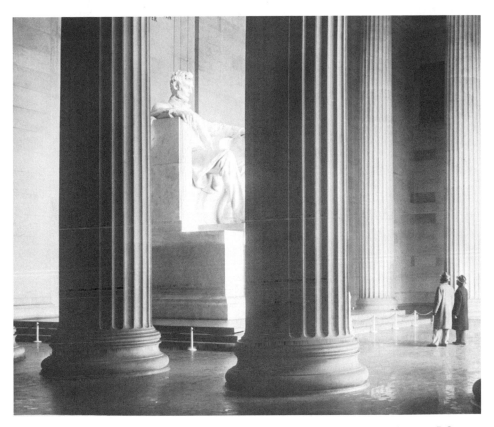

2 Henry Bacon, architect, and Daniel Chester French, sculptor, Lincoln Memorial, Washington, D.C., 1922. Photograph by Scurlock Studio, ca. 1940. (Scurlock Studio Records, Archives Center, National Museum of American History, Behring Center, Smithsonian Institution.)

in the disenchanted world of the modern secular nation, the monument is not, properly speaking, a sacred site. Typically it holds no relic or spiritual trace of a past presence. The site of the Lincoln Memorial, for instance, did not even exist in Lincoln's lifetime; it sits quite literally on mud dredged from the Potomac River bottom in the late nineteenth century by the Army Corps of Engineers. The memorial itself contains no actual relics of Lincoln. It is pure representation—a colossal marble statue and the text of two speeches carved on enormous panels, all housed in a neoclassical temple (figure 2). One of those speeches, the Gettysburg Address, had already been reproduced ad infinitum in newspapers and readers and textbooks long before the monument was built. The major Union veterans' organization had even sponsored a drive to put a bronze plaque carrying the full speech in schools and public places throughout the nation.[11]

Why make a pilgrimage to a site with no historical significance to read a text that

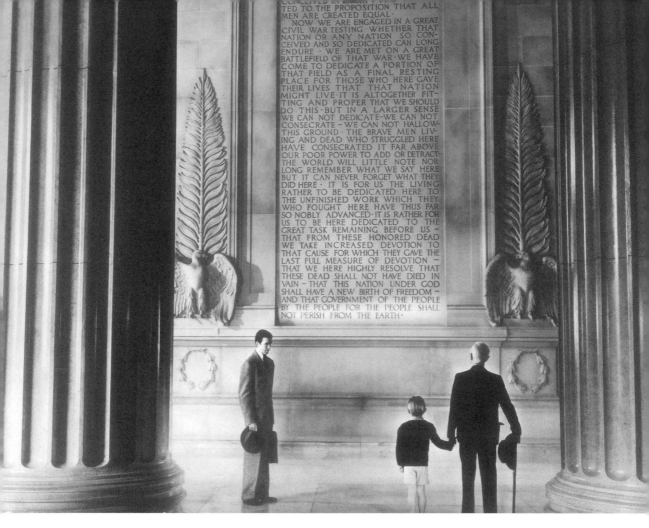

TED TO THE PROPOSITION THAT ALL
MEN ARE CREATED EQUAL·
· NOW WE ARE ENGAGED IN A GREAT
CIVIL WAR TESTING WHETHER THAT
NATION OR ANY NATION SO CON-
CEIVED AND SO DEDICATED CAN LONG
ENDURE · WE ARE MET ON A GREAT
BATTLEFIELD OF THAT WAR·WE HAVE
COME TO DEDICATE A PORTION OF
THAT FIELD AS A FINAL RESTING
PLACE FOR THOSE WHO HERE GAVE
THEIR LIVES THAT THAT NATION
MIGHT LIVE·IT IS ALTOGETHER FIT-
TING AND PROPER THAT WE SHOULD
DO THIS·BUT IN A LARGER SENSE
WE CAN NOT DEDICATE–WE CAN NOT
CONSECRATE – WE CAN NOT HALLOW–
THIS GROUND · THE BRAVE MEN LIV-
ING AND DEAD WHO STRUGGLED HERE
HAVE CONSECRATED IT FAR ABOVE
OUR POOR POWER TO ADD OR DETRACT·
THE WORLD WILL LITTLE NOTE NOR
LONG REMEMBER WHAT WE SAY HERE
BUT IT CAN NEVER FORGET WHAT THEY
DID HERE · IT IS FOR US THE LIVING
RATHER TO BE DEDICATED HERE TO
THE UNFINISHED WORK WHICH THEY
WHO FOUGHT HERE HAVE THUS FAR
SO NOBLY ADVANCED·IT IS RATHER FOR
US TO BE HERE DEDICATED TO THE
GREAT TASK REMAINING BEFORE US –
THAT FROM THESE HONORED DEAD
WE TAKE INCREASED DEVOTION TO
THAT CAUSE FOR WHICH THEY GAVE THE
LAST FULL MEASURE OF DEVOTION –
THAT WE HERE HIGHLY RESOLVE THAT
THESE DEAD SHALL NOT HAVE DIED IN
VAIN – THAT THIS NATION UNDER GOD
SHALL HAVE A NEW BIRTH OF FREEDOM –
AND THAT GOVERNMENT OF THE PEOPLE
BY THE PEOPLE FOR THE PEOPLE SHALL
NOT PERISH FROM THE EARTH·

3 Frank Capra, director, "Mr. Smith Goes to Washington," ©1939, renewed 1967 Columbia Pictures Industries, Inc. All Rights Reserved, Courtesy of Columbia Pictures. (Photograph: Margaret Herrick Library, Academy of Motion Picture Arts and Sciences.)

was already everywhere? The answer is simple: the monument manufactures its own aura. In the context of the Lincoln Memorial, the Gettysburg Address ceases to be a mere "mechanical reproduction" and becomes a treasure-piece by virtue of its hand carving in stone, at large scale, in a sequestered space, distinguished by lavish materials and aesthetic refinement. And the monument creates an actual, if temporary, community of readers, who must obey a particular decorum: they must stand at a certain distance to see the text panels in their entirety, which is not the way we ordinarily read—as photographers and filmmakers have observed to great effect (figure 3). Everything about the experience marks it as extraordinary and authoritative.[12]

If the nation is ordinarily experienced in a diffuse, ever-shifting circulation of words and images, national monuments acquire authority by affixing certain words and images to particular places meant to be distinctive and permanent. Thus, mon-

uments stand apart from everyday experience and seem to promise something eternal, akin to the sacred. Yet no matter how compelling they are, they can never fulfill that promise. People and history get in the way, and they force the commemorative landscape to change and adapt. For that we should be grateful: change keeps the monuments alive.

Yet change is not the message visitors to the National Mall come to get. More often they assume that it must be old and venerable, as if it always had been there, in more or less that form. The geometric order of the landscape and the "timeless" architecture of Egyptian, Greek, and Roman building types within it reinforce the impression of antiquity. No historic markers or plaques remind visitors of what once existed before this remarkable space took shape.

Up through the early twentieth century the Mall area looked nothing like how it does today. Even as late as the 1920s, when huge memorials to Ulysses Grant and Abraham Lincoln were finished at either end of the Mall's long east-west axis, the space in between still remained filled with flower gardens and old shade trees in curvilinear patterns, remnants of the nineteenth-century picturesque park that once meandered from the Washington Monument to the Capitol building (figure 4). On the edges of this park there was a little of everything: some working greenhouses, a few statues, a couple of ponds stocked with fish, several large blocks of antebellum row housing. Not until Franklin D. Roosevelt's administration in the mid-1930s did the federal government finally level the Mall, clear-cut the last of its old trees, lay down a road network, and establish the grand vista that tourists now take for granted. Even then the landscape continued to evolve incrementally over the course of the twentieth century. New museums and monuments emerged on the Mall's perimeter, roads were reconverted to pedestrian paths, and kiosks sprouted all over.

The most inescapable change of recent years came in 2004, when the World War II Memorial opened just west of the Washington Monument, the first new monument on the center line of the Mall's east-west axis since it had been cleared seventy years earlier. The memorial's location had touched off a bitter controversy that was settled only when Congress intervened to quash a citizens' lawsuit. The architecture critic Paul Goldberger dramatized the stakes of the battle by comparing the site to an ancient work of nature: the National Mall, he declared, was "a great public space, as essential a part of the American landscape as the Grand Canyon" (figure 5).[13] In reality, the cleared space of the Mall was not even as old as the veterans who assembled at the opening of the World War II Memorial, and the space had come into existence only after a deliberate war against the nineteenth-century land-

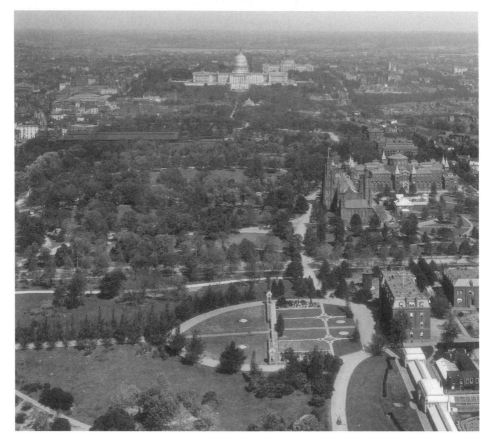

4 View from the Washington Monument looking toward the Capitol, ca. 1900. (Smithsonian Institution Archives [SIA], Record Unit 79, image no. MAH-24711.)

scape that required dredging, demolition, and clear-cutting. Yet in the critic's mind, and the minds of so many others coming to Washington, the Mall had become an "essential" landscape, seemingly as pure and unchanging as a million-year-old river gorge. How did this space come to be set apart from its own history? How has it become purified of the political traffic that dominates public life in the capital? The monumental core succeeds in making visitors feel removed from the lobbying and negotiating and money-raising that define contemporary democracy, even though these very practices helped get the monuments built in the first place. Instead the core re-creates what Lincoln once called the "mystic chords of memory," those psychic threads that bind a people to their nation despite the often disappointing twists and turns of actual history.

The monuments erected by a people, Carlyle argued in the mid-nineteenth century, reveal who the people really are. "Show me the man you honor," he wrote; "I

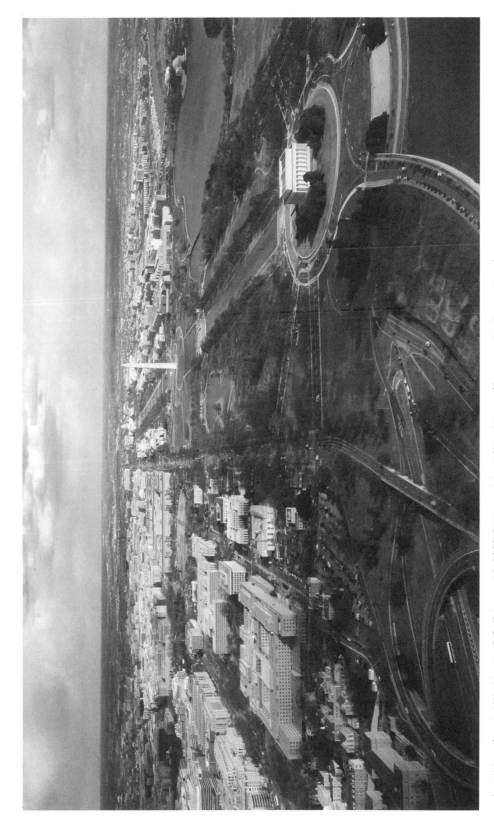

5 Aerial view of central Washington, D.C., February 19, 2008. Photograph by Jeffery J. Iovine. (Courtesy of Jeffery J. Iovine.)

know by that symptom, better than by any other, what kind of man you yourself are."[14] If the language of male honor sounds anachronistic, his gendering of the monumental landscape is not. A century and a half later, as the World War II Memorial confirms, the landscape is still dominated by statesmen and warriors, even if those warriors now tend to be common soldiers rather than great generals. Public monuments are an inherently conservative art form. They obey the logic of the last word, the logic of closure. Inscriptions are fixed forever; statues do not move and change. Traditionally, this means that monuments strip the hero or event of historical complexities and condense the subject's significance to a few patriotic lessons frozen for all time. Washington's monuments, in this conception, promise to immerse visitors in the "essential" America, the "soul of the nation."[15] Clustered together in one place, these monuments to heroes of all different time periods create a memorial landscape that evokes an abiding sense of national identity. Everywhere else politics and change rule the day, but in the midst of this heroic landscape the nation's high purpose seems to remain constant.

Investigating the history of this landscape cuts against its deepest grain. History is about change, contingency, fallibility. The most cherished axiom of the memorial landscape is its permanence, its eternity. That axiom shuts a lid on history. Just like the Grand Canyon, the "essential" America stays essential because it triumphs over historical change and human frailty. National "identity" somehow arises majestically from the machinations of the people who actually run the nation. The National Mall itself invokes the same logic. The urban planners who dramatically transformed and expanded the Mall in the early twentieth century always claimed that they were returning to the original plan of Pierre Charles L'Enfant drawn up at the behest of George Washington in 1791, as if their task were simply to restore the essence of the founders' original scheme. The planners' claim was profoundly misleading, as we shall see, but understandable: if the nation has a core identity that endures through trial and tribulation, so too must the place that best represents it.[16]

Reconstructing the history of this place, then, cannot help throwing a wrench in the works. To write a history of the memorial landscape is to subvert it, to watch it emerge from the fog of "identity" and into the sharper light of human affairs. Yet if historical inquiry tends to demolish the notion of an "essential America" somehow embalmed inside the nation's monuments, history by no means suggests that the monuments are irrelevant. The memorial landscape of Washington is the one place, above all, where people come to find the nation and to engage with it as citizens. "Whatever we are looking for," wrote Bruce Catton in 1959, "we come to Washington in millions to stand in silence and try to find it"—a sentiment that has now been per-

manently inscribed in Freedom Plaza on Pennsylvania Avenue.[17] True enough, except for the silence: the people who come searching for the elusive "whatever" are by no means voiceless. Throughout Washington's history they have managed to take what they found and reshape it into something new.

The history of commemoration is therefore a history of change and transformation. Grand plans are transformed into actual places, and those places are in turn transformed by the people who occupy and use them. The ground perpetually shifts as changes in the landscape and in the world around it open up new possibilities of engagement. Sometimes far-sighted designers—like the army engineer who finished the Washington Monument—anticipate these possibilities. But in many cases, once public monuments are built they leave the orbit of their planners and designers and acquire a life and a direction of their own, as the Lincoln Memorial has dramatically demonstrated over the past century. Although its designers downplayed Lincoln's role in the abolition of slavery, the memorial later became so inextricably linked to the black civil rights movement that, after the election of Barack Obama to the presidency, nearly every national media outlet went there to gauge Americans' reactions to the event.[18] Often unexpectedly, then, the monuments of the capital have galvanized the nation and created new and unexpected "chords of memory."

This is ultimately why a history of the memorial landscape is important. Washington's plans and monuments aspire to represent the essential America, but as they take shape on the ground, they become enmeshed in the complex realities of a living America. It is this interplay of aspiration and practice that makes the memorial landscape come alive, for in that interplay the landscape ceases to be a mere symbol of America and becomes an actor in the nation's drama. Not only do the monuments of Washington retell the story of the nation but in certain times and places they change national history itself.

The scholarly literature on Washington's monumental core is sharply divided. On the one hand, a large group of boosters has lavished praise on the twentieth-century Mall as an inspired work of civic art, a triumph of visionary government, and a model for other cities in the United States and the world. The reinvented Mall, John W. Reps wrote in the 1960s, was "a composition of civic design unmatched in American history and surpassed by few comparable efforts elsewhere in the world."[19] On the other hand, a long line of critics has lambasted this "composition" as a gaping void in the city's fabric, an elaborate set piece that ignores human scale and need. Beginning with Lewis Mumford, in 1924, some of these critics have read the Mall essentially as a betrayal of America's founding principles—an "imperial façade" to dignify the na-

tion's aggressive push toward global empire.[20] Despite their opposition, though, the two sides share some common prejudices. Both tend to assume that the nineteenth-century landscape—created in the long interval between L'Enfant's plan and its supposed restoration in the early twentieth century—was an ill-defined, unplanned jumble, hardly worthy of serious consideration. Through this common filter scholars of many different stripes have argued that the nineteenth-century Mall was an "incomprehensible forest of wiggly paths" (Kiley), that the capital had only "slight regard for the proper treatment of public boulevards and open spaces" (Reps), and that "by 1900 the city had slipped into incoherence and disorder" (Washburn). As a consequence, the nineteenth-century landscape of statue monuments, mostly erected outside today's monumental core, has received little serious attention even though it was more elaborate than any other in the Americas.[21] If by design the memorial landscape was already resistant to history, these prejudices have made the task of historical synthesis even more difficult to accomplish.

Despite these obstacles, we cannot ever hope to understand today's monuments unless we understand what came before them. This book will therefore push ahead with an admittedly quixotic project: fashioning a synthetic history of Washington's memorial landscape from its inception in L'Enfant's plan to its current form in the twenty-first century. The book proposes to read the landscape as a series of transformations wrought partly by aspiration and design and partly by the unpredictable effects of human use and practice. Along the way we will witness a sea change in how Americans have understood and interacted with public monuments. From objects of reverence and emulation—the archetypal hero on a pedestal—monuments became spaces of reflection and psychological engagement. But this broad shift was not planned in any sense. In fact the memorial landscape as a whole still remains fundamentally unplanned, despite the twentieth-century proliferation of regulatory agencies meant to take control of it. And almost no major plan or project in the history of Washington's monumental landscape has ever turned out the way its makers intended. Rather than viewing this history as a series of failures or disappointments, we should see these unintended changes and consequences as a measure of the continuing vitality of the landscape.

Shifting our lens accordingly allows us, for starters, to put the L'Enfant plan in a different perspective. One of the standard story lines, still repeated into the late twentieth century, was that L'Enfant and his grandiose Baroque plan both fell into obscurity after George Washington fired him in 1792, only to be resurrected in 1900 by the enlightened efforts of professional architects.[22] It is true that for decades the capital looked almost nothing like what L'Enfant had envisaged: the city developed slowly

and up through the mid-nineteenth century most of its streets and squares existed only on paper. Nowhere was the failure more conspicuous than in the plan's central axis, which L'Enfant had designated as a "grand avenue" leading from the Capitol building to an equestrian statue of George Washington. Published descriptions were enthusiastically calling it a "Mall" and "Pleasure Park" as early as the fall of 1791.[23] Yet by the 1840s it was neither avenue nor park but still unkempt scrubland, occasionally traversed by chained gangs of slaves being sold downriver—a palpable blot on the "empire of liberty" L'Enfant's plan was supposed to represent.[24]

In the second half of the nineteenth century, however, a massive campaign to develop the city's infrastructure combined with a new craze for public statues made the layout of the plan emerge in something like its intended glory. The ideas of L'Enfant and the founders were finally being realized "after a sleep of more than three quarters of a century," one guidebook announced in the 1870s. By the end of the century, the whole city had become an immense memorial landscape filled with trees and punctuated by monuments dispersed through its far-flung streets and squares, as L'Enfant himself had imagined (see figure 1) "Washington is a city of statues," the *Washington Post* bragged in 1891.[25] Reaching its apogee in the years just before and after 1900, this diverse landscape of trees, gardens, fountains, and monuments was the subject of much local and national pride. Even the Mall itself was developed into a nearly continuous public walk, though more a picturesque "pleasure park" than the formal avenue L'Enfant presumably had in mind, and with a gigantic obelisk monument to Washington in place of the equestrian statue. L'Enfant's plan was neither ignored nor forgotten: it had been compromised and altered in various ways, as most grand plans are, but still many observers in the late nineteenth century could argue plausibly that its legacy had made Washington the most impressive city in the nation. The narrative of neglect did not begin to take hold until a group of reformers under the leadership of the American Institute of Architects reclaimed L'Enfant's plan for themselves at the capital city's centennial in 1900. They managed to turn the designer into an unappreciated genius whose vision of the capital had been overwhelmed and lost amidst the philistine culture of the nineteenth century, a culture which in their view preferred soldier statues and specimen gardens to large-scale civic grandeur. The reformers sensed that this Victorian mentality was giving way to a renewed appreciation of civic form and the "City Beautiful."[26]

In one sense they were right. There was indeed a shift under way in the early twentieth century, yet it had little to do with rediscovering L'Enfant or reviving a long-lost Baroque aesthetic. The shift was not a return to mythical origins but rather a process of modernization—a shift from the nineteenth-century concept of *public grounds* to

the twentieth-century concept of *public space*. Writers on architecture and landscape from the mid-twentieth century onward take the notion of public space as a given, a fact of urban life. Goldberger's description of the Mall as a "great public space" uses now perfectly conventional language, but in the nineteenth century such language was rarely if ever heard. Visitors to the nineteenth-century Mall and the other land-scaped squares and parks of the capital went to explore or inspect the "public grounds," not to be in "public space." Behind the shift in vocabulary lurks a shift in sensibility.

For human beings the tension between ground and space has existed for millennia. To be human is to be shackled to the ground: the ground nourishes us in life and absorbs our remains in death. The ground is concrete, tangible, messy, diverse. Space is intangible, empty, abstract, pure. We can smell and see and hold the ground, but space eludes us. For this reason almost every culture has populated space with gods, inspiring human dreams of transcending the earth and achieving immortality. Ralph Waldo Emerson in the most celebrated passage of his essay "Nature" (1836) defined transcendental experience by the juxtaposition of ground and space: "Standing on the bare ground,—my head bathed by the blithe air, and uplifted into infinite space,—all mean egotism vanishes. I become a transparent eye-ball. I am nothing. I see all. The currents of the Universal Being circulate through me; I am part or particle of God."[27] Lifting off the ground, he loses his body; gaining space, he joins God.

Although landscape design from its earliest origins has always worked with these contradictory impulses—to be rooted in the earth, and to be free from its constraint—the modern shift from *ground* to *space* registers a new stance toward the world around us. Space is no longer mere emptiness or the enchanted realm of God but a medium that human beings now claim the power to control and manipulate. With the aid of human ingenuity, space can now flow, envelop, expand, or contract. Urban planning and design becomes an art of large-scale "space composition," of "Titanic space modeling," to use a phrase coined in 1935 by the brilliant urban design theorist and landscape architect Elbert Peets.[28] Space is disenchanted, taken away from the gods and made subject to modern systems of control and design. Yet it still manages to retain its ancient aura of transcendence. It acquires a new kind of agency, becoming invested with psychological purpose and power. Space envelops the body, lifts it, and *moves* it—toward exaltation or tension or even trauma. As Bruno Zevi declared in 1948, space becomes the "protagonist of architecture."[29]

With this powerful new conceptualization of space came an equally striking devaluation of the ground surface and the design traditions that had embraced it. In

particular the picturesque tradition, which had exalted the principle of variation in ground and surface effects, found itself relegated to the historical dustbin. To the new enthusiasts of space, the ground became little more than a platform for the display of spatial effects. The new imperative was to eliminate distracting details on the ground and open up the city fabric to sweeping expanses of space. This attitude hastened the impulse toward urban renewal, of which the twentieth-century Mall was an early example. Public grounds became a sentimental anachronism or, worse, a drag on progress.

In Washington the grounds of the nineteenth-century Mall had fostered strong local attachments to particular trees, flower gardens, and shady nooks. But for the twentieth-century planners these particularized local experiences fragmented the Mall and undercut its claim to represent the nation. The creators of the Senate Park Commission Plan of 1901—the opening salvo in the campaign to redevelop central Washington—made their intentions clear by declaring the new Mall a "system."[30] The word evoked modern rationality and organization, implicitly rebuking the sentimentalized landscape of the past. The "Mall system" described in the plan was much larger than the eighteenth-century pleasure walk contemplated by L'Enfant, and far more uniform than the patchwork grounds of the nineteenth century. Local diversity was suppressed in favor of national grandeur: this entailed the destruction not only of plants and trees but of whole neighborhoods, as we shall see. In the monumentalized Mall, the nation would free itself from the sentimental weight of local ties and emerge transcendent, glorified in and by this new, instantly recognized spatial unity (figures 6 and 7).

The heroic statues that dotted the public grounds and streets of nineteenth-century Washington, and many other cities, also fell victim to this shift in sensibility. The designers of the capital's new monumental core would have been happy to see most of the city's public statues sent to a scrap heap. Never mind that many local residents as well as visitors had formed attachments to quite a number of them over the years; the reformers saw the city's statues as mere ornaments scattered haphazardly across the ground of the city, without spatial coordination or impact and therefore without any lasting significance. The reformers were certainly right about the lack of "system": until 1910, no federal agency or board reviewed monument proposals. For the most part, public monuments were built not by the federal government but by relatively small, politically connected interest groups—veterans associations, ethnic organizations, party elites. These groups were much more interested in putting their own mark on a site than in creating a spatial ensemble.

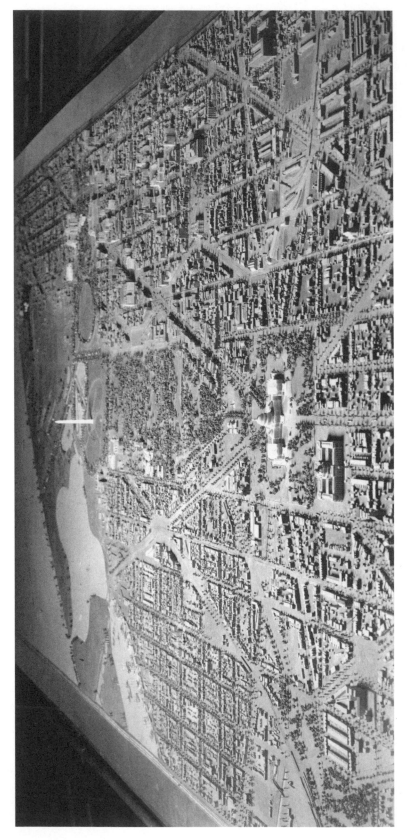

6 U.S. Congress, Senate Committee on the District of Columbia, *The Improvement of the Park System of the District of Columbia,* ill. no. 34, *Model of the Mall, Showing Present Conditions, Looking West,* 1902. (Courtesy of the U.S. Commission of Fine Arts.)

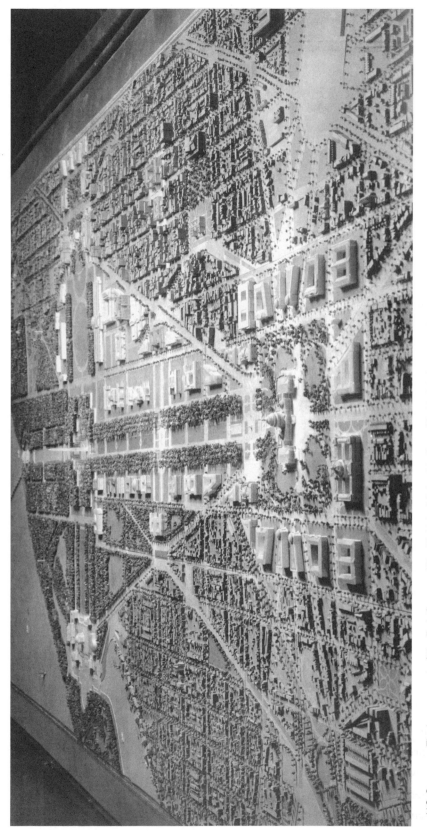

7 U.S. Congress, *The Improvement of the Park System of the District of Columbia*, ill. no. 35, *Model of the Mall, Showing Treatment Proposed, Looking West*, 1902. (Courtesy of the U.S. Commission of Fine Arts.)

Planners wanted desperately to create a new kind of monumentality, but they had to fight on two fronts simultaneously. On the one hand, they had to overcome considerable resistance from local Washingtonians who had become deeply attached to the nineteenth-century landscape and its comforts, beauties, and associations. Scholars have consistently underestimated the depth of local resistance and the difficulty the planners had in defeating it. On the other hand, the planners worked in a professional atmosphere increasingly hostile to the very idea of the public monument. Partly in response to Washington's new monumental core and its insistent neoclassicism, Mumford argued in 1937 that "the notion of a modern monument is a veritable contradiction in terms." The monument was a dead form, Mumford and many others believed; in its pursuit of timelessness, the public monument simply recycled clichés from the past.[31]

The men who reshaped monumental Washington were poised between what they considered the sentimental philistinism of the past and the radical modernism of the future. Although, for this reason, they are difficult to pigeonhole, many critics have put them in the antimodern camp anyway, largely because of their stylistic commitment to neoclassicism. Focusing on the retrograde style of the planners' "City Beautiful" is misleading because it overlooks the modernizing thrust of their drive to create a new spatial "system." The planners, however, did give their modernist critics plenty of ammunition. The Senate Park Commission Plan of 1901 proudly displayed the results of the planners' intensive study of historical precedent, their in-depth field work on the formal effects of André Le Nôtre's seventeenth-century palace gardens and Sixtus V's Rome. The plan's stunning illustrations conjuring up a vast, open, formal Mall are interleaved with photographs of the great baroque gardens of Europe. Despite the plan's ruthless assault on the capital's public grounds, the designers seemed to remain "garden-minded," as Peets charged.[32] Neither the plan's text nor the illustrations even hint at the new social and psychological potential of this vast public space—its ability to attract and engage masses of tourists and demonstrators. If the plan rejected the spatial incoherence of the public grounds, it seemed to embrace the social gentility of those grounds, in illustrations of decorous visitors and carriages scattered thinly across the landscape.

One of the most notorious of the plan's illustrations imagines a shepherd with his flock near the centerline of the Mall, a faux rusticity suggesting that the new monumental core might somehow seal itself off from modern urban clatter and re-create an idealized Arcadia (figure 8). The automobile and the railroad had no business in the planners' ideal Mall, and indeed one of their early successes was to remove a train station that had been located on the northern edge of the Mall. But if the plan tried

8 U.S. Congress, *The Improvement of the Park System of the District of Columbia,* ill. no. 59, *View of the Monument Seen from the Mall at Fourteenth Street, Looking West,* 1902. (Courtesy of the U.S. Commission of Fine Arts.)

to wrap itself in a romanticized past, its new spatial thrust unleashed the forces of modernity in ways the planners could hardly anticipate. By the time the Mall's space was finally cleared and leveled in the mid-1930s, the automobile had become unavoidable; it was one of the key forces behind the new century's assault on the ground plane. Instead of a pastoral retreat, the Mall would become for a time a gigantic traffic median, sandwiched between parallel roads laid close to the centerline. In 1900 planners were complaining about a train station on the edge of the space; three decades later they were filling the space promiscuously with automobiles.

If the new monumental core originally aspired toward Arcadia, it took off in an entirely different direction. While the early twentieth-century planners failed to anticipate the new technologies and social practices to which their monumental space would be subjected, neither did they envision the change in memorial experience that their spatial aesthetic set in motion. Their insistence that monuments work as spatial ensembles rather than independent objects led ultimately to a new psychology of memorial space. In the major new memorials to Grant and Lincoln, finished in 1922, a tragic mood for the first time crept into the capital's memorial landscape. Although both monuments adhered roughly to the spatial profile laid out for them in the 1901 plan, the monuments' designers went far beyond the plan's brief and

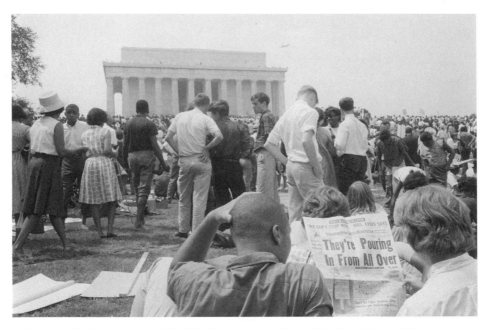

9 March on Washington, August 28, 1963. Photograph by Warren K. Leffler. (Library of Congress, Prints and Photographs Division.)

worked to intensify the spatial experience, immersing it in strife, suffering, and historical contradiction. By doing so they drew visitors into a psychologically complex encounter with their collective past. Not all subsequent monuments followed this example, but a new tendency did emerge, anticipating the more openly traumatic "victim" monuments that began to appear in the late twentieth century. In the process the great axis of the Mall transformed itself as well. Anchored by the Lincoln Memorial, the monumental core became the setting of some of the most important civic demonstrations in the nation's history (figure 9). Although it was conceived in 1901 as a majestic representation of national reunion and harmony, the Mall turned into a highly charged space of collective introspection, political strife, and yearning for change. Nothing like this was possible in the nineteenth-century memorial landscape, with its triumphant parade of national heroes marching through L'Enfant's streets and squares. And even the twentieth-century planners who made it possible would have been amazed, and quite likely dismayed, by the turn it took.

By the late twentieth century, the immense success of the Vietnam Veterans Memorial sealed the new fate of the public monument. Although Maya Lin's design almost literally turned the neoclassical memorial landscape upside down, her unorthodox solution confirmed and popularized the already emergent spatial turn in

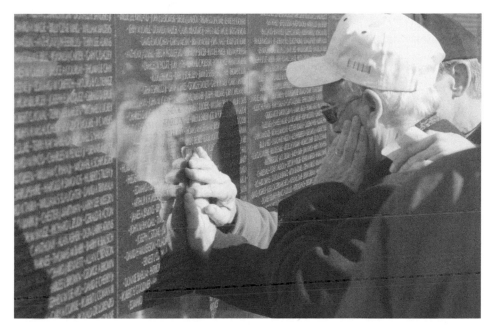

10 Maya Lin, Vietnam Veterans Memorial (detail), Washington, D.C., 1982. Photograph by Edward H. Pien, November 11, 2007. (Courtesy of Edward H. Pien.)

monumental design. In the wake of her success it could be taken for granted that "the space itself serves as the memorial," to quote from the description of the winning design for the Pentagon Memorial to victims of 9/11.[33] These words would have baffled most readers just a few decades earlier.

At the beginning of the twenty-first century, national memorials are now expected to be spaces of experience, journeys of emotional discovery, rather than exemplary objects to be imitated (figure 10). This reorientation has succeeded in reviving the public monument as an art form and rescuing it from the early death Mumford and others had confidently reported. But the consequences of this change are not well understood, and as a result the character and purpose of the public monument have become muddled. The traditional expectation of closure that comes with the monument's promise of permanence now coexists with a conflicting awareness that monuments must evolve as audiences and social practices change. Memorial spaces find themselves juggling the relatively new psychological demands of discovery and healing with traditional demands for patriotic or inspirational teaching. Even the disciplined minimalism of Lin's Vietnam Veterans Memorial, which put the burden of creating meaning on the visitor rather than the monument, has not entirely escaped these traditional demands, as we shall see. Because public monuments ultimately

do have to justify their own existence, they cannot entirely shed their didactic character. In one way or another, today's monuments must still offer up some self-explanation that allows us to understand why we placed them in public space and why we continue to care for and about them.

All this means that monuments will still be subject to dispute and change before and after they are built, and the landscape of national memory will never cease to evolve. As we chart the historical twists and turns of this landscape, we will come up against its limits as well as its possibilities. While sweeping transformations have indeed taken place, some aspects of the landscape have changed little. White men, of course, have long dominated the landscape, despite recent attempts at greater inclusion. War, which has also predominated from the beginning, stubbornly continues to do so. War's ideals of domination and destiny, still intertwined, underlie the greater part of the landscape. If people come to Washington, as Catton said, to find "whatever we are looking for," some will find much less to their liking than others do. Yet millions will continue to flock to the monumental core to renew the promise of the nation, as they did in record-breaking numbers for the inauguration of President Barack Obama. One of the hopes of this book is that readers may become empowered not just to "stand in silence" at Washington's shrines but to follow the example of citizens before them and shape a different future.

1

A Monument to a Deceased Project

When the French designer Pierre Charles L'Enfant arrived at the future site of the U.S. capital in the spring of 1791, he came "to change a wilderness into a city."[1] The site Congress had reluctantly authorized—after a series of contentious votes—was in the upper South, straddling the border between Virginia and Maryland. President George Washington, whose own plantation was nearby, chose the precise spot: the Potomac River at its "fall line." Here the upcountry hills abruptly met the tidewater plain and created an ecological platter of amazing richness. The woods teemed with game, the river with sturgeon, shellfish, and waterfowl. The flocks of ducks and geese were so immense that the sound of their wings as they took off was "like the rumble of thunder."[2] Washington imagined this dense habitat transformed into a great port, which would one day connect the western rivers to the eastern seaboard and become the commercial hub of North America. L'Enfant, tramping through the forest and the remnants of old tobacco plantations, imagined a sprawling empire of a city, filled with grand boulevards and monuments. For both men, the new capital was to be an enactment of the civilizing process, one that would tie the nation's internal factions together and extend its control outward over vast continental distances.[3]

The capital city that emerged in the early nineteenth century fell far short of their dreams. Soon after the capital moved from Philadelphia in 1800, Washington, D.C., became a locus of national contradictions. From the start, the city's claim to represent an "empire of liberty" clashed with its location in the very cradle of American slavery.[4] The only interstate commerce that flourished in the capital was the traffic in human chattel. Yet the economic engine of the slave trade—the spectacular expansion of the nation's territory—had little effect on the city's fortunes. Even as the nation pressed toward the Pacific coast, the federal government remained small and weak and the city grew slowly, its great streets and squares disappearing into dust.

Thomas Doughty's sketch of the city center, lithographed in 1832, gives some notion of the village character of what was supposed to be the "national metropolis" (figure 11). Charles Dickens, visiting from England in 1842, saw the city as a ruin in the making: "a monument to a deceased project, with not even a legible inscription to record its departed greatness."[5] A few decades after its inception, the capital was fast becoming a memorial to its own failure.

Occupation

The United States was a newfangled political experiment with old-fashioned territorial ambitions. Conventional wisdom dictated that a republic—a form of representative government whose power was vested in its citizens—worked only at a small scale, but President Washington and many others thought that their republic could defy precedent and conquer North America. For the American republic, occupying the continent was not simply a matter of taking control of the ground from Indians and European powers. Americans had to reconcile two competing impulses: imperial aggrandizement, which fed on expansion and change, and republican restraint, which rested on social stasis and thrift. Was the United States to be a classical republic of farmers—modest, frugal, self-restrained, and self-contained—or an empire with visions of eternal growth and progress? The act of occupation put this question to the test, becoming in the process both a military endeavor and a task of the imagination. L'Enfant's 1791 map of the new capital brought these two dimensions of occupation together in brilliant fashion. His plan of Washington was at once a street system meant to establish possession of the city and a cognitive map for the new national empire (figure 12). In his vision, public monuments would play a key role in fueling the city's development and justifying the nation's expansion.

L'Enfant himself was a multidimensional talent—an artist who had studied at the French Academy, an architect, a mapmaker, and a military man who had served in the Revolutionary Army's corps of engineers. A few years before Washington tapped him for the capital job, L'Enfant had proposed a national Corps of Engineers that would be responsible for military fortifications as well as public works. City planning did not yet exist as an independent discipline, so L'Enfant's route into it was not that unusual. In the European tradition, military engineers had played a key role in the design of cities because defense concerns were critical in shaping city form. Although L'Enfant himself told Washington, "the sciences of Military and Civil architecture

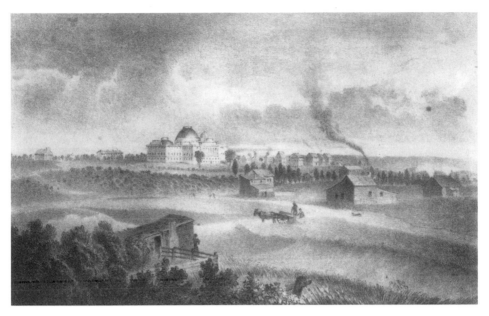

11 Thomas Doughty, *The Capitol, Washington, D.C., West Front from the City Hall*, lithograph, 1832. (Library of Congress, Prints and Photographs Division.)

are so connected as to render an Engineer equally serviceable in time of Peace as in war," the military aspect of his thinking has received relatively little attention from scholars who have exhaustively studied his methods and precedents.[6]

L'Enfant's plan created two street systems, one superimposed on the other. The first was the rectangular grid plan beloved by Thomas Jefferson and many others. The second was a scattering of coordinates—in the form of squares and circles— from which great avenues radiated in diagonals, cutting through the gridded streets at odd angles. Most of these coordinates were located on high ground and were to hold a symbolically important building or commemorative monument. The two most important were the Congress's House, located on the biggest hill near the Potomac River, and the President's House, located on another rise about a mile away; the great diagonal boulevard Pennsylvania Avenue connected the two. But there were many other symbolic coordinates dispersed throughout L'Enfant's city plan, some devoted to federal institutions and others to the fifteen individual states that comprised the Union at that time. The states, L'Enfant thought, would get into the act by sponsoring monuments to their own heroes. Each one of these monumental coordinates occupied a square or circle from which avenues radiated to other squares and distant points of the city.

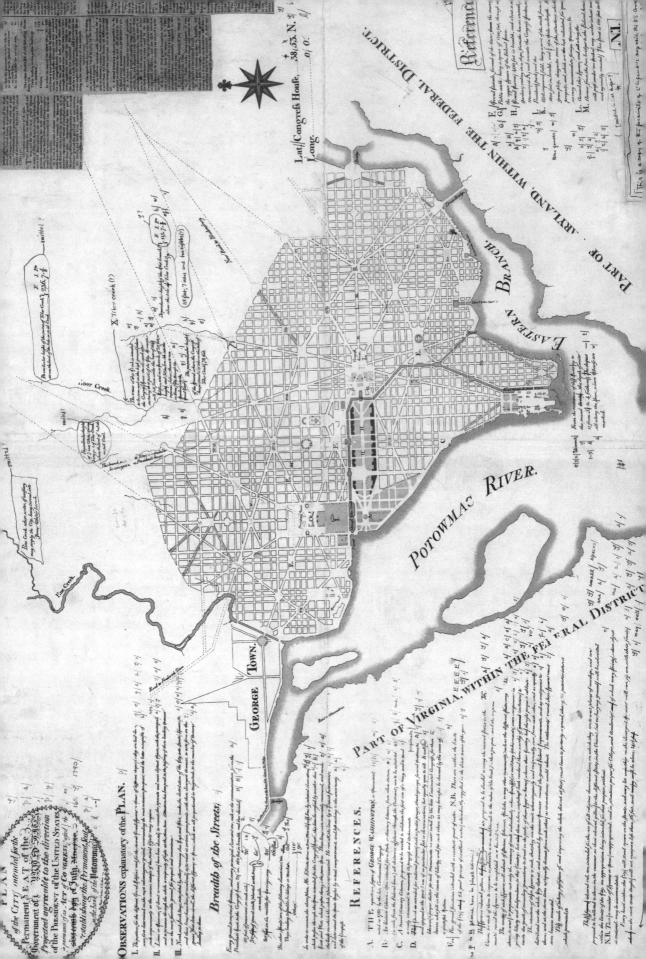

Scholars have long studied L'Enfant's aesthetic debt to French models of urban and garden design, especially the axial planning of Paris in the mid-eighteenth century and the radial vistas of French palace towns, royal gardens, and hunting grounds.[7] But from the mid-nineteenth to the early twentieth century, it was even more commonplace to note that L'Enfant had devised his plan to make the city easier to defend against internal insurrections. As a Parisian, the thinking went, L'Enfant knew about popular uprisings and understood how violent resistance flourished in densely packed neighborhoods that could be barricaded against the royal army. Thus his plan was seen as a counterinsurgency tactic in the context of urban rebellion. The wide diagonal boulevards that cut through the denser grid were supposed to open up these local pockets to surveillance and long-distance weapons. Along these great streets artillery could be moved into place to command the entire city. Some Americans even argued that L'Enfant was the precursor of Baron Georges Haussmann, Napoleon III's urban planner, who blasted huge boulevards through the old working-class quarters of Paris after the Revolution of 1848.[8]

Few recent scholars have repeated this line of argument. For one thing, L'Enfant never wrote explicitly about urban insurrection. That is hardly surprising: the prospect of civilian rebellion was unlikely to enter into his promotional discourse. Yet military language did creep into L'Enfant's official plan. The "observations" appended to his map explained that the various coordinates were all on "advantageous ground, commanding the most extensive prospects," and that "lines or avenues of direct communication have been devised to connect the separate and most distant with the principal and to preserve through the whole a reciprocity of sight at the same time." Although the passage is shot through with military concepts of command, communication, and surveillance, scholars have read these terms to refer to an aesthetic ideal of open vistas or to a political ideal of democratic interconnectedness.[9]

The other objection to the nineteenth-century argument is that it credits L'Enfant with impossible foresight. The urban insurrections in Paris of 1830 and 1848 obviously colored the thinking of nineteenth-century observers, but L'Enfant's plan predated these by decades. While the Parisian tradition of rebellion by barricade did stretch back to 1588, the practice disappeared in the eighteenth century until its revival in 1795, four years after L'Enfant created his scheme. Nevertheless, the point cannot easily be dismissed. The whole European tradition of cutting straight streets

◀ **12** Pierre Charles L'Enfant, *Plan of the City Intended for the Permanent Seat of the Government of [the] United States*, 1791, facsimile produced by U.S. Coast and Geodetic Survey, 1887, annotated 1931. (Library of Congress, Geography and Map Division.)

through dense urban areas, as Spiro Kostof has observed, had roots in military prepa-
ration against internal insurrection. Radial street planning probably originated as a
military tactic, gaining new urgency with the beginning of the French Revolution in
1789, as the specter of mob action loomed in many minds.[10] Even before the Revo-
lution, Jefferson's experience of Paris had left him with a sour view of life in the me-
tropolis: "The mobs of great cities add just so much to the support of pure govern-
ment, as sores to the strength of the human body."[11]

Even if urban warfare was not uppermost in L'Enfant's mind, his plan of Wash-
ington is a nearly perfect diagram of the military principles of territorial occupation.
Occupation is always a question of controlling a large area of ground with limited
resources; there are never enough soldiers to put everywhere. The classic solution
to that problem is to establish control over various key points, usually on high ground,
dispersed across the surface, and to create clear lines of communication between
those points. By defending the lines and the points, the occupier controls the infill
areas and dominates the whole territory. L'Enfant conceived of his planning task in
similar terms, as a way to enable the city to "extend over a large surface of ground."
The squares and circles formed the points, the boulevards the lines connecting them,
and the grid the infill area. Without the principal points and the avenues between
them, the grid would be lost and aimless and actually impede the city's expansion.
By dispersing the points over every quadrant and widening the connecting boule-
vards to 160 feet, L'Enfant made the system transparent at a mere glance at the map.
He summarized his scheme as a "mode of taking possession of and improving the
whole district."[12]

By planning to install "statues, columns, and obelisks" at many of these coordi-
nates, L'Enfant also created a system of landmarks that made the abstract relations
of the map readable on the ground in a concrete way.[13] The typical L'Enfant boule-
vard did not set up a closed vista terminating in a large structure, or an open vista
leading to infinity. Instead his radial boulevards would lead from one relatively slen-
der vertical landmark to another. In a street 160 feet wide, the monument would di-
rect the vista but not interrupt it, always luring the eye and the feet (or carriage) from
one landmark to the next. As they were erected, the monuments would enable people
on the ground to measure the extension of the boulevards and the spread of the city.

The dispersal of squares and circles around and beyond the federal precinct also
extended the symbolic system outward, creating a vast multiplicity of centers that echoed
the nation's imperial project. The monuments that were to fill these centers would
occupy—literally and figuratively—the high ground of national self-representation.
Some were designated specifically to represent federal power. In a square one mile

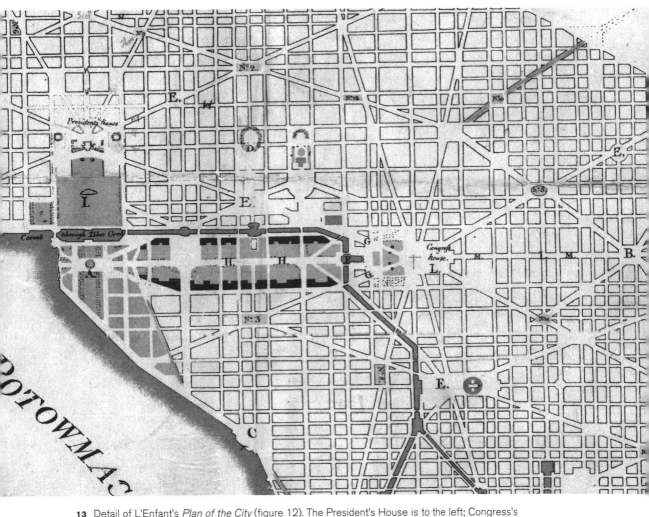

13 Detail of L'Enfant's *Plan of the City* (figure 12). The President's House is to the left; Congress's House is at the center right. (Library of Congress, Geography and Map Division.)

east of the Capitol, an "itinerary column" (point B) would establish the national station from which every point in the expanding nation would be measured (figure 13). On the Eighth Street axis were monuments to the nation's military prowess and valor. Where Eighth Street terminated at the Potomac River, a column celebrating the navy would "stand a ready monument to consecrate its progress and achievements" (point C); this was a time when naval forces held the balance of power in Europe. On the northern segment of Eighth Street L'Enfant located a "national church," clearly modeled on the Pantheon in Paris, which would house monuments to national heroes, including soldiers who gave their lives in the Revolutionary War (point D). This was one of the few points in the center of the city that was so important that its structure closed a vista.

In the fifteen far-flung squares representing the various states, L'Enfant intended the states themselves to erect monuments to homegrown Revolutionary war heroes and to others "whose usefulness hath rendered them worthy of imitation."[14] Like the federal military monuments, these too would serve to justify the nation's possession of the continent. They represented national expansion not as the brute imposition of authority but as the providential spread of moral exemplars, waiting to be imitated. The dispersal of monuments to great men and martyrs over the full extent of the city would represent territorial occupation as a civilizing process, both physical and moral.

The plan's symbolic mode of possession also had a pragmatic rationale. Each coordinate in L'Enfant's scheme was to be a hub of new development. The monuments marking each coordinate would give them prestige and help attract real estate buyers and developers. L'Enfant was familiar with French examples such as the royal square, built around a statue of the monarch, meant to stimulate the speculative development of luxury housing surrounding it.[15] In the real estate language of today, monuments were high-profile "amenities." For L'Enfant it was important to scatter them widely to encourage development across a large extent of the city. Real estate calculations like these actually shaped planning decisions from the start. Lacking a commitment from the federal government to fund the city's development, President Washington needed to finance its public works from the proceeds of land sales. Jefferson's alternative vision of an intimate town with its major government branches clustered close together in a simple grid plan was just too modest; Washington needed a spectacular infusion of private investment capital.[16] L'Enfant's genius lay in his ability to wrap the many elements of this project into one seamless package. The military premises of the map did not negate its aesthetic, political, ceremonial, and economic aspects; all of these went hand in hand.

The Enlightened Center

While L'Enfant was eager to disperse monuments and hubs across the city, he also planned for a strong federal center—the ultimate source of power from which the satellite centers radiated and spread the nation's reach. But even in this federal precinct L'Enfant designed a multiplicity of centers each with different functions, a conception much different from the unified monumental core that was completed in the twentieth century, supposedly to restore L'Enfant's scheme. It is often observed that he balanced federal representation between the "President's House" and "Congress's

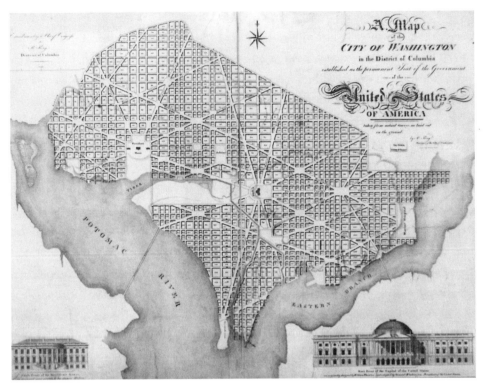

14 Robert King, *Map of the City of Washington*, 1818. (Library of Congress, Geography and Map Division.)

House," both of which were great hubs of radiating avenues (see figure 13). (The Supreme Court was a poor cousin at this time and did not appear in the officially published description of the plan, though L'Enfant had earlier discussed a site for it.)[17] More specifically, however, L'Enfant's plan actually included three designated center points, all on the east-west axis, each with a different reference. Congress's House—the Capitol building—was the central reference point for the city's map, at the exact center of the capital's four quadrants. From there the sequence of numbered and lettered streets in the grid originated. Point B, a mile due east of the Capitol building, was to be the itinerary column marking the nation's meridian, the designated reference point from which all other points on the continent's surface would be measured. Point A, a mile west of the Capitol, was the apex—in mathematical terms, the orthocenter—of a right triangle whose two other points were the President's House and the Capitol.

Nowhere were L'Enfant's elegantly interlocking metaphors more evident than at point A, reserved for the most important monument of all—an equestrian statue of George Washington as military commander of the Revolutionary Army. Point A

marked the precise spot where the east-west axis from the Congress's House met the north-south axis from the President's House. Unlike other points on L'Enfant's map, most of which followed local topography, this one was purely a geometric fancy. The point fell on the south bank of Tiber Creek—today an underground sewer—near where it emptied into the Potomac (figure 14); the spot was probably under water for at least some period of the year. To put a major monument there L'Enfant planned to alter the natural hydrology by redirecting the creek into a canal. There were several compelling reasons for taking all this trouble. Aesthetically, the monument would culminate two vistas, one from the President's House and the other from Congress's House, the latter a long, wide "avenue" to the river that was already being dubbed by others a "mall" (H in figure 13).[18] Ceremonially and politically, the statue focused the gaze of the executive and the legislature on the example of the founding father. Positioned cardinally, the image would be a moral compass for the nation's leaders. Like an ancient cult figure, it would guarantee that astronomical, mathematical, and political orders were all in alignment.

The focus of all this visual attention was a *military* image of command. Washington would appear not as citizen-president but as army commander, riding a horse, wearing a laurel wreath, and holding a truncheon, the ancient Roman symbol of command; on the pedestal would be bas-reliefs illustrating the victories he had commanded in person. This was the statue approved (but never funded) by the Continental Congress in 1783, and L'Enfant simply summoned the perfect site for it. He knew the type well, because it was the same one chosen for kings in France, and, like those royal equestrians, was to be erected in the leader's own lifetime. The difference was that Washington had voluntarily relinquished his military command, but the man himself was still president of the country at the time L'Enfant concocted the scheme. Located at the very heart of the capital, point A would constantly remind everyone in the federal center that Washington was the moral force behind the civilizing scheme that spread out and occupied the city, and by extension, the empire.[19]

Thus the Mall was born, conceived as a clearing that would create a formal vista between the Capitol building and the nation's most important hero monument. At the time L'Enfant developed the idea, an oak forest covered the land between these two points. His avenue would be not only an aesthetic exercise but also a literal imposition of power, as in the so-called grand manner of European landscape design, which L'Enfant knew well.[20] In that tradition, great axial avenues typically were cut through royal forests or through the dense winding streets of medieval quarters. The formal vista created by this act of destruction embodied power in two distinct senses.

One was the brute physical force to clear a level pathway through the fabric of nature or of other people's lives. The other, a consequence of the first, was the command of extensive sight lines, the ability to see through the metaphorical thicket of daily life to more important, more symbolic objects. The first was the simple power of conquest, the second, the enlightenment that supposedly springs from conquest and in turn justifies it. In L'Enfant's Mall, the two kinds of power were both meant to be visible, so intertwined as to be indistinguishable.

The Stakes of Commemoration

L'Enfant's spectacular plan ran into difficulties on the ground right away. First, L'Enfant was fired by President Washington for insubordination. Then the real estate bubble Washington needed to make the plan work never materialized. This meant there was little money for even basic improvements to the city's infrastructure, let alone for public monuments. As Andrew Ellicott, L'Enfant's successor, complained shortly after the Frenchman's dismissal, the plan simply had too many avenues and too many public squares.[21] When Congress arrived at the new capital in 1800, and for years thereafter, L'Enfant's ceremonial Pennsylvania Avenue remained at times impassable by carriage or foot. For decades, the great squares and circles of the plan lay empty, the city becoming a mixture of "perplexing dust and triangles," as one girl wrote to her friend in sophisticated Philadelphia. Washington had "more the appearance of several distinct villages than a city," according to a correspondent in 1842.[22] Livestock roamed and foraged in the streets. The Mall was undeveloped "waste ground," a largely unregulated zone where people dumped trash and tended their own vegetable gardens; the journalist George Alfred Townsend later claimed, rather luridly, that it was "patrolled by outlaws and outcasts."[23]

In this climate there was little chance that L'Enfant's "statues, columns, and obelisks" could be erected. His memorial landscape was nowhere to be seen. Point B never came into prominence as L'Enfant had envisaged; Jefferson set the meridian line through point A instead, and later in the century the meridian moved again, to the Naval Observatory.[24] Where the itinerary column was meant to be, the square remained undeveloped until after the Civil War. The costly equestrian statue meant for point A never materialized. A successor project, radically different in scale and type, did eventually emerge in the Washington Monument, but it took decades to complete and was located slightly off point A, on higher ground. Not until the twentieth

century would the "mighty obelisk that never came to [L'Enfant's] dreams" become the undisputed center of a new monumental core.[25] For most of the nineteenth century, point A was merely a scraggly spot on a riverbank. A simple stone marked the spot, erected there by Jefferson to establish the new meridian line. For decades this modest stone, used to moor boats in Tiber Creek, stood silently mocking the grandiose ambitions of L'Enfant's scheme.[26]

In the first half of the nineteenth century, while the capital seemed to languish, the United States was fast taking possession of its continental empire. Grabbing new territory proved to be far easier for the new republic than coming to grips with the consequences of its own enlargement. As the nation expanded from a cluster of states along the Atlantic coast to a behemoth that reached across the continent, its appetite for land created political and cultural problems of self-definition that could not be avoided in the fishbowl that was Washington. There the young nation's internal contradictions were put on display.

Nowhere were these contradictions more magnified than in the project for a national monument to George Washington. Deciding on a fitting monument to the republic's founding figure engaged the deepest questions about what kind of republic he had founded. As we shall see, commemoration is almost always more about the present than about the past. "The act of remembering," Andreas Huyssen observes, "is always in and of the present." Or, as the historian Michael Kammen has famously remarked, "Societies in fact reconstruct their pasts rather than faithfully record them, and they do so with the needs of contemporary culture clearly in mind—manipulating the past in order to mold the present."[27] But in the case of Washington's monument, this familiar process proved almost impossibly difficult. The story of the monument project spans nearly the entire nineteenth century and the first half of this book, an unparalleled example of a cultural and cognitive site where people could pour out their hopes and fears and discover disagreements they might not even have known they had.

The first idea for the monument, the equestrian statue, was originally approved by the Continental Congress, flush with its victory over Britain in the Revolutionary War. When L'Enfant later proposed to situate the statue at point A, Washington himself must have blessed the idea, because the two of them seem to have worked closely on all aspects of the city plan. Nothing more monarchical could have been imagined. Although in the 1790s, when Washington was serving as president, this monarchical image should have been a major provocation, there was never any serious opposition to the idea even from quarters where one might have expected outrage.

Republican revolutionaries had systematically torn images of King George III off public buildings and had toppled and destroyed his equestrian statue in New York City, the only equestrian statue erected in the territory of the future United States during the eighteenth century. When the firebrand Thomas Paine later proposed a "coronation" of the Constitution, the rite—featuring a crown above the law above a Bible—would show that the new republic was a government of laws, not kings. Not even the crown would survive the ceremony, though, for it was to be smashed to bits and distributed to the people, "whose right it is." American republicanism was deeply affected not only by the Enlightenment appeal to reason, but by the Protestant tradition that elevated the biblical word to supreme importance. In this tradition, the word gave the individual direct access to divine (or human) law, while images came from intermediaries, who used them as counterfeits to augment their own power and block access to the truth. The republicans' distrust of political imagery thus verged on outright iconoclasm.[28]

Republicans objected to images of George Washington on coinage, and public celebrations of his birthday, and the lavish scale of the "President's House" as planned by L'Enfant. Yet they did not dare attack the idea of the equestrian statue. Jefferson, the intellectual and political leader of the republican faction, actually tried on several occasions to secure a European sculptor who could carry out the commission. If L'Enfant's proposed placement of the statue at the key point A gave Jefferson pause, he never said so openly, and indeed he pressed the commissioners of the federal district to consider financing the statue by lot sales in the capital. Ironically, the only criticism, muted as it was, came from a leader of the opposing faction, the Federalists. The Federalists were proponents of a more vigorous centralized authority. Worried that the national union of independent states was headed toward disintegration, these men believed that only a strong executive and symbolic head could help hold the republic together. Federalist John Jay, the secretary of foreign affairs, supported the equestrian project, but he reported to Congress in 1785 that the monument would be less costly and more "laconic" if the bas-reliefs on the pedestal glorifying the general's victories in battle were replaced with the simple image of a book inscribed "Life of Washington." Below the book would appear the inscription "Stranger read it. Citizens imitate his example." Jay's proposal was an interesting early example of the effort to balance imperial imagery of aggrandizement with a "laconic" message of republican restraint. His notion of Washington as a book, a virtual Bible—a life so exemplary that it explained itself and needed no pictures to glorify it—shows just how widely iconoclastic republicanism infused the culture of the period. But the fact

remains that Jay's proposal left intact the idea of the statue itself, in all its monarchical glory.[29]

As the statue proposal languished for want of funds, the focus shifted to a different commemorative issue: the question of where to inter Washington's body. By 1793 Washington himself had approved a plan for the Capitol building by William Thornton that included a ground-floor tomb for his own remains. The crypt would occupy the exact center of the capital, where the city's four quadrants met, and in the rotunda above it Thornton indicated a new location for the equestrian statue.[30] The implications of this plan were far reaching, no longer simply about Washington's image but about his actual body and how it could be put to the service of the nation. Pantheons holding tombs of national heroes were not a new idea. By this date they were emerging as a full-fledged type in sacred structures, such as Westminster Abbey and Saint Paul's Cathedral in London and the Église Sainte-Geneviève in Paris, renamed the Pantheon.[31] As we have seen, L'Enfant proposed a "national church" along these same lines. But the Capitol project took the idea to a new level. Envisioning Washington's tomb in "Congress's House" made the hero's body not merely the nation's cultural patrimony but also a talisman of republican governance. The double monument of equestrian statue and tomb would have cemented the importance of the Capitol building as the unrivaled symbolic center of the nation.

Washington, who was a Federalist in spirit, could not openly advocate the tomb idea because he would appear to be sanctifying himself, like the pharaohs of old. Accordingly, his will specified burial at Mount Vernon, his family home. Similarly, Jefferson could not openly attack the idea for fear that he would appear ungrateful to the nation's founding father. Neither could show his hand publicly. As the scholar C. M. Harris has argued, however, they each found proxies in their architects. Thornton, the architect of record for the Capitol, answered to Washington and developed the tomb concept, while the superintendent of construction, Étienne Hallet, answered to Jefferson and sabotaged it. Eventually Hallet was fired for his role in this little drama, but the issue did not disappear.[32] In fact, the tomb question rose to the top of the national agenda when Washington died unexpectedly in December 1799, shortly before Congress was to move to the new capital.

Played out against the backdrop of an escalating battle between the Federalists and the Republicans, the debate in 1800–1801 about how to commemorate Washington represented the high-water mark of republican iconoclasm and a stunning rebuke to the hero worship embedded in L'Enfant's plan. The divisions between the Federalists and the Republicans deepened during the presidential electoral crisis of 1800,

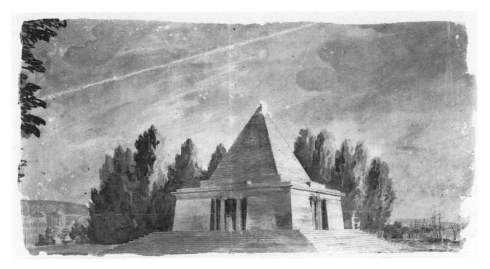

15 Benjamin Latrobe, perspective drawing for Washington mausoleum, 1800. (Library of Congress, Prints and Photographs Division.)

the most bitterly contested presidential election before the Bush-Gore contest of 2000; several of the most vocal participants in the dispute over the monument were also actively working behind the scenes for and against the election of Jefferson. Because Congress had finally moved to the capital city in the fall of 1800, the increasingly ac- rimonious debate took place within the very building where Washington was sup- posed to be laid to rest.[33]

After Congress had initially agreed to ask Martha Washington's consent to move her husband's remains to the capital, the Federalists sparked the first controversy by enlarging the proposed burial scheme from a relatively modest tomb inside the Capi- tol building to a much grander freestanding mausoleum outdoors, which would have become even taller and more imposing than the Capitol itself. In the spring of 1800 they unveiled a proposal by the architect Benjamin Latrobe for a hundred-foot-tall stronghold with a square interior chamber containing "a plain Sarcophagus" and "a statue of the General." Latrobe's ink-and-watercolor perspective drawing shows a finely stepped pyramid atop a square base, with the entrances framed by Doric columns and the whole elevated on a podium of thirteen steps (figure 15). Subsequent eleva- tion and section drawings developed a clerestory lighting scheme above the square base and exterior terraces at the clerestory level reached by winding stairs. Latrobe's proposal was a study in mixed metaphors. The ancient Egyptian motifs—the py- ramidal top, the projecting cornice, and the battered walls of the base—all evoked the eternal presence of divine kingship, while the Doric columns were a standard

symbol of republican simplicity and restraint. By combining them, Latrobe worked to fashion a visual language for a conceptual oxymoron: a grandiose republican monumentality. Surviving documents indicate that Latrobe had a specific site in mind on the bank of Potomac, not point A but a higher spot upstream, where the Naval Observatory would later be located. In the perspective drawing, a riverside scene occupies the right middle ground, and a public building in the far distance resembles the projected design of the Capitol with its dome. (The actual Capitol building at this time was still unfinished and much more modest.) A screen of trees isolates the monument and incorporates the structure into a sylvan setting, remote from the world of government affairs suggested by the background. Visitors to the monument would be able to see the monumental city in the distance but would feel removed from it.[34]

After Latrobe submitted this initial proposal, the well-known British architect George Dance refined and enlarged the scheme, dispensing with the Doric columns but retaining the statue of the hero in the interior space (figure 16). Dance's purer pyramid form emphasized the building type's core significance, its declaration of everlasting stability, which in this case referred not just to the immortality of its occupant but also to the permanence of the nation that he represented. The height of Dance's monument—150 feet—would have made it by far the most imposing structure in the city, significantly taller than the Capitol building of that time. Though Dance's drawings did not suggest a site for his project, its scale demanded the sort of independent, open site Latrobe had in mind.[35]

For the Federalists, then, the monument was not merely a sign or set of motifs; it was an extraordinary place in its own right, deliberately set apart from daily life to create a special impact on its beholders. With its impervious walls, unusual geometry, indirect light, and huge scale, all in a quasi-natural setting, the monument would "impress a sublime awe in all who behold it."[36] The more awe-inspiring the hero's monument, the Federalists argued, the more forcefully it would teach the citizenry to emulate his virtues and love his country. But even if it failed to pacify the population, the pyramid would remain an eternal stronghold, an insurance policy for the federal government. The monument would never be toppled, as George III's statue once was. Ironically, given the Federalists' antipathy toward France after 1789, their idea had much in common with the latest French Revolutionary models of commemoration, especially Charles de Wailly's proposal of 1797 to transform the Église Sainte-Geneviève into a pyramidal pantheon.[37] The problem of the monument in both cases was similar: how to replace devotion to the monarch with devotion to the nation. The likelihood that the Federalists were considering an independent site on the

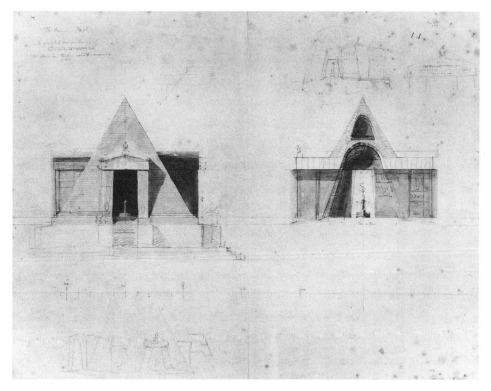

16 George Dance, elevation and section of proposed Washington mausoleum, 1800. (By courtesy of the Trustees of Sir John Soane's Museum.)

riverbank rather than on the Capitol grounds suggests that they were trying to counterbalance the authority of the legislature with a separate, quasi-sacred site for the executive, whose mystical presence would personify the nation. Washington's body would not be appropriated by a democratic assembly but would stand, metaphorically, on its own.

The enlargement of the project into a huge mausoleum independent of the Capitol polarized the debate and drove the Republicans to articulate a far more sweeping iconoclasm than they had dared to articulate before. While the equestrian image had retained some connection to Washington's biography—he was, after all, a military commander, though not a Roman general with a truncheon—the pyramid removed the man from history altogether and apotheosized him in a cult setting. The Federalist proposal recruited Washington for the larger purpose of inflating central authority, so magnifying the image of the federal state that it virtually crushed the individual republican citizen into insignificance. The Republicans had to strike back. Genuine national memory, they claimed over and again, belonged in

people's hearts, not in piles of stone. The fiery Republican Nathaniel Macon argued on the House floor in December 1800 that print in the modern era had made monuments redundant. History books were a more "rational" way of spreading Washington's memory. If the nation really wanted to teach Washington's example, Macon concluded, it would be more "honorable" to take the money budgeted for the monument and spend it instead educating the poor how to read.[38] As we have seen, Macon was arguing for a "public sphere" in Habermas's sense, a sphere of rational discussion among the people independent of state authority. In this sphere the word would reign triumphant, uncontaminated by official images meant to "impress" themselves on susceptible minds.[39]

The most extraordinary extension of this reasoning came from congressman John Nicholas of Virginia, a close ally of Thomas Jefferson. Nicholas asked rhetorically, "Was the memory of that great man [Washington] to be perpetuated by a heap of large, inanimate objects?" The answer seemed obvious. As Nathaniel Hawthorne would later remark after a visit to Westminster Abbey in London, "The fame of the buried person does not make the marble live,—the marble keeps merely a cold and sad memory of a man who would else be forgotten." Masonry, no matter how impressive, could not keep Washington alive in collective memory; only the people themselves could accomplish that. Nicholas therefore suggested a monument that "had never before been done." Over Washington's tomb in the Capitol he proposed installing "A plain tablet, on which every man could write what his heart dictated. This, and this only, was the basis of his fame. It was not to be blazoned by figures or representations of any other sort. It consisted in the undecaying recollection of his virtues. It must live in the national feeling."[40]

Here was the ultimate iconoclastic monument, with no images whatsoever. But its iconoclasm went beyond mere "plainness," beyond even Jay's "laconic" book. Nicholas's tablet would have no message of any kind; the audience itself would generate the content. His idea thus struck down the whole didactic premise of the hero monument, which was to provide moral exemplars for imitation. His proposal, moreover, rejected the premise of permanency, the idea that the monument could hold memory forever, long after actual social memory had died away. Nicholas proposed instead an "animate" monument, one that lived only as long as Washington's memory "lives in the national feeling." The enlightened iconoclasm of Nicholas and Macon and other Republicans stemmed from the belief that an intelligent citizenry—generally envisioned as an agrarian population of independent landowners—no longer needed images to prop up its patriotism the way illiterate masses or decadent aris-

tocrats had once needed imagery to spur their religious devotion. A free and rational people could write its own monuments in its own words.

This rhetoric has resonated ever since. The Republicans' argument anticipated by several decades Victor Hugo's famous declaration, in his novel *Notre-Dame de Paris* (1831), that the invention of printing would kill architecture. "The book of stone," he wrote, unwittingly echoing Nicholas, "was going to make way for the book of paper." Hugo argued that "in the era of architecture"—from the ancient pyramid builders to the medieval cathedral masons—mankind's "thought made itself a mountain and took powerful hold of a century and a place. Now [in the era of the printing press] thought turns into a flock of birds, scatters to the four winds, and occupies at once every point in air and space." It was precisely this faith in the modern circulation of thought and memory, rather than their deposit in some fixed sacred place, that brought the Republicans to such an ardent defense of iconoclasm.[41] Nicholas's proposal to replace the architectural monument with a people's book entailed a total break with the past, with the old era of pyramids and cathedrals. That is why his idea had the prescience to foreshadow the "living memorial" movement of the early twentieth century and the "countermonument" phenomenon of the late twentieth century. In all of these movements the main desire was to tap an authentically modern popular memory. Along with this desire came a suspicion that traditional monuments, in their very fixity, must impose a false, obsolete collective memory—a devotional façade behind which people might actually be apathetic or ignorant or even hostile. As we shall see, this suspicion never really died, even as public monuments became more accepted.

The votes in Congress on the mausoleum project strictly followed party lines, the Federalists in favor and the Republicans opposed. The day before Jefferson was inaugurated as president, ending the prolonged electoral crisis, the Senate refused to concur with the House's version of the mausoleum bill and the matter died. Jefferson's role in this remains mysterious: his voluminous letters reveal nothing except for one sly reference to the mausoleum when the electoral crisis was at its peak. On New Year's Day, 1801, he speculated that the ongoing mausoleum debate would help distract Congress from the crisis, which was fine with him; he did not want Congress meddling in the election.[42] A decade later, pinning the blame for the mausoleum's downfall on the "Jeffersonians," several Federalist newspapers claimed that Jefferson and his allies could accept the equestrian statue of Washington only because it was a military image; but their pride would not allow a monument that would make Washington the first statesman of the land. It is doubtful, though, that Jefferson or

his allies saw the debate merely as an electoral sideshow or as a personal competition with Washington. The way to commemorate the Revolution, they repeatedly suggested, was not by constructing tombs or pyramids but by living according to its principles. "A just and solid republican government maintained here," Jefferson wrote shortly after he assumed the presidency, "will be a standing monument & example." In a similar vein, others later argued that the capital city itself was Washington's monument—in the words of the *Washington City Weekly Gazette*, "a living, intelligent, monument of glory," which, unlike a "useless pyramid," would "freshen with the current of time." Iconoclasts continued to worry, though, that the city's grandiose public architecture might send the wrong message. As *Poulson's American Daily* argued in 1811, the expanding Capitol building was "proportioned rather to the extent of our territory than to the quantum of our population—to the pretensions of Royalty than to the profession of Republicanism."[43]

Slavery, Progress, and the Monumental Capital

If both the republic and the capital were living memorials, as the Republicans hoped, they were living with a contradiction in their midst. The presence of slavery in the very heart of the nation had mocked Republican rhetoric from the start. Despite all their populist talk, Macon, Nicholas, and many other critics of Federalist aggrandizement were themselves unapologetic slaveholders. Owning slaves constituted the ultimate aggrandizement of personal power, without any checks or balances—despotism in its purest form. Americans found innumerable ways to misrepresent or mystify the power relations of slavery, however, and to bring it in line with classical republicanism, which had also coexisted with slavery.

Washington, too, was a slave-owner, along with many of the Federalists who supported him. When the controversy over his tomb first erupted, advocates and opponents of slavery were not yet divided along partisan or regional lines. New England merchants were deeply involved in the Atlantic slave trade, and slavery was still legal in many Northern states. But in the early nineteenth century the geography of slavery changed substantially. Slavery was abolished or drastically curtailed in the Northern states, while the cotton gin fueled the expansion of large-scale plantation slavery south to the Gulf of Mexico and west to Texas. The expansion of plantation slavery made America look less and less like Jefferson's ideal republic of small independent farmers. As the nation spread westward, the key question facing the re-

public was whether newly acquired territory would be turned over to the planter-slavers or occupied by a free citizenry. On this question of occupation hinged not only the political balance of North and South, but also the future definition of the nation.

The same question reshaped the debate over Washington's monument as well. As the issue of his tomb resurfaced repeatedly over the first third of the nineteenth century, there were still Northerners and Southerners in Congress on both sides of the debate, but the balance was tipping. Increasingly, Northerners led the effort for the federal tomb and Southerners led the opposition.[44] Southerners rehearsed the same old antimonument rhetoric, but that rhetoric now seemed to mask a different agenda. For example, Nathaniel Macon's speech in 1800 eloquently attacking the whole idea of monuments continued to endure in national memory and was still quoted in newspapers as late as 1821. Yet in the late 1810s, this slaveholder from North Carolina helped his home state procure an elaborate monument to Washington for the State House in Raleigh, perhaps the most ambitious sculptural monument erected in the United States to that date—a seated figure in Roman military garb designed by the most famous sculptor in Europe, Antonio Canova. This was an amazing act of self-promotion for North Carolina, aggrandizing the local planter elite who claimed Washington as one of their own, though in typical "republican" fashion the monument misrepresented the plantation's social order by depicting Washington, in a subsidiary image, as a modest farmer outside a rude cabin.[45]

Iconoclasm, it seems, could easily be discarded if the right opportunity arose. The real issue for a firebrand like Macon was no longer whether to build a monument but where to build it. A national monument to Washington in the capital had the distinct potential to strengthen the federal government's stature at the expense of the states, an outcome that was increasingly problematic for Southern planters who based their right to own slaves on state sovereignty.

At the same time, the institution of slavery began to insinuate itself into the landscape of the capital in various ways. When Washington had occupied the office of president in Philadelphia in the 1790s, he kept his own house slaves in the executive residence amid the two hundred or so slaves who still remained in the city after Pennsylvania's Gradual Abolition Act of 1780.[46] In the District of Columbia, slavery and the slave trade remained fully legal, so one would expect slavery to have had a much greater impact on the image of the city. Yet the daily life of slavery in the capital was largely hidden in back alleys and yards not visible from the street, and its coercive apparatus—jails, auction houses, chain gangs—was deliberately kept remote from the official city. This began to change in the 1820s and 1830s as the city became

an important regional market in the expanding interstate slave trade, and as aboli-
tionists began to draw attention to the anomaly of human traffic in the capital of a
supposedly free republic. With plantation slavery extending into new states and ter-
ritories, slaves from Maryland and Virginia were funneled through markets in the
capital to meet the ever-increasing demand for fresh slave labor in the growing re-
gions farther south and southwest. Even free blacks were ensnared in this traffic, vic-
tims of nefarious dealers who confiscated their identity papers and sold them off to
cover the "costs" of their bogus imprisonment. Seventh Street, in the heart of the
city, became the local hub of this miserable traffic. There slave pens sat right on the
edge of the Mall, and slave coffles—groups of slaves chained together—shuffled across
the Mall's "waste" on their way to loading docks on the river. What L'Enfant had imag-
ined as a glorious avenue leading to the equestrian image of Washington was now a
scrubland pockmarked by the visible traces of the slave trade. The symbolic posses-
sion of the continent, built into L'Enfant's plan, looked increasingly like the pos-
session of human chattel. Standing at the Seventh Street crossing of the Mall near a
well-known slave pen and gazing east at the domed Capitol on the hill, one could vis-
ibly connect the private commerce in human flesh to the political bargaining in Con-
gress that sustained the trade. Abolitionists used illustrated broadsides to juxtapose
the monumental pretensions of the Capitol with the miserable reality of the traffic
in slaves, undertaken in plain sight (figure 17).[47]

At this same time, a quasi memorial to Congress's bargain with slavery emerged
in the very center of the Mall near the Capitol. Completely unrecognized in histories
of the city, this intervention in the landscape marked the outcome of the first of the
grand bargains struck by Congress to solve the problems created by slavery's expan-
sion into new territories. The Compromise of 1820, or Missouri Compromise, ad-
mitted Maine as a free state and Missouri as a slave state, and prohibited slavery in
the Louisiana Purchase everywhere north of the 36° 30' parallel, excepting Missouri.
The memorial came in the form of two street names created after some Congres-
sional wheeling and dealing to raise money for public works. Congress had author-
ized the city to sell off some of the public land at the east end of the Mall and create
several large new residential blocks. The deal created two new diagonal avenues within
the Mall, each one an inner spoke that shrank the boundaries of the Mall between
Third and Sixth Streets (figure 18). (These diagonal streets and the resulting blocks
of mostly residential buildings were all razed in the early 1930s. The sites are now
occupied by the National Gallery of Art and the National Museum of the American
Indian.) In the 1820s the city council named the new avenues after the two new states
that had been admitted to the Union by the 1820 Compromise: Missouri, the slave

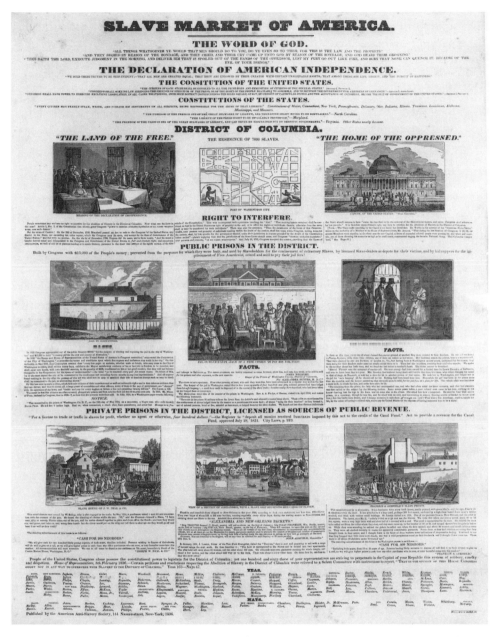

17 American Anti-Slavery Society, "Slave Market of America," letterpress with wood engravings, 1836. (Library of Congress, Prints and Photographs Division.)

state, and Maine, the free state. For reasons unknown, the northern street was named Missouri and the southern street Maine. For more than a hundred years, this pair of radiating avenues framing the east entrance to the Mall marked the ultimately futile effort to contain the political crisis wrought by slavery.[48]

While the Capitol building served as the setting for a whole series of compromises

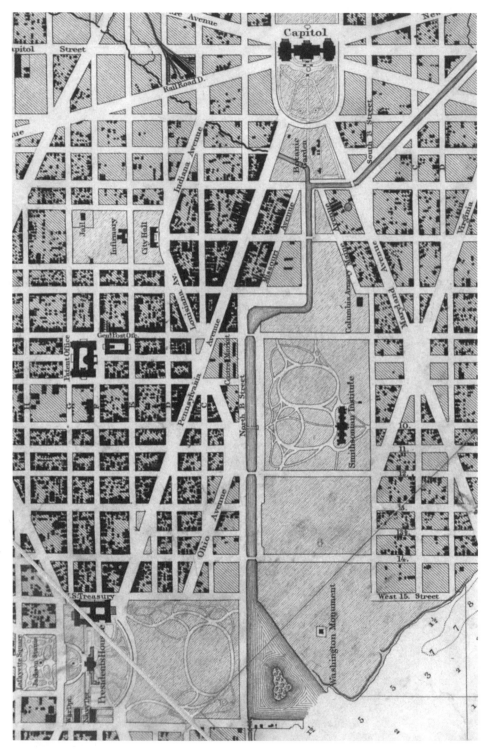

18 A. Boschke, *Topographical Map of the District of Columbia*, 1861, detail. (Library of Congress, Geography and Map Division.)

and deals on slavery up until the Civil War, the intensifying sectional crisis made compromise on Washington's tomb impossible. If we think of the dispute over Washington's body as a proxy for the sectional conflict over slavery, it is ironic that the battle lines in the "symbolic" dispute would be even more sharply drawn than the battle lines in the "real" dispute, where actual lives were at stake. Commemorative projects are polarizing because they claim to be about essential truths, which by definition admit no compromise, whereas the normal business of politics involves bending principles and negotiating details. The object of the tomb was the "true" Washington rather than the historically nuanced, politically calculating individual. Already abstracted from history, the "true" Washington became molded by events taking place well after his death. As slavery expanded relentlessly westward, the republic he knew ceased to exist and fractured into two sections with fundamentally different definitions of freedom. The true Washington could not sit in both camps simultaneously. He had to take a side—in a dispute he never encountered or foresaw. This is why, even though Washington's grave at Mount Vernon was only a few miles downriver from the capital, the symbolic distance might as well have been an ocean.

The issue came to a point in 1832, the centennial of Washington's birth, which demanded a national reckoning of some kind. As one congressman from Georgia summed up the majority mood of the Southern delegation, the proper solution was not to transfer Washington's body to the halls of Congress but to transfer his "spirit"—whatever that might be.[49] Washington's heir categorically refused to move his remains from Mount Vernon, even after Congress mustered enough Northern votes to overcome the Southern opposition and make the request in early 1832. From this point onward the focus shifted to a project for a colossal statue to be installed in the Capitol Rotunda, above the crypt where the tomb had been intended to go. The statue project passed with less opposition from the Southern delegation, though Northern congressmen were far more enthusiastic in their support.[50] It was a watershed moment: the first commemorative statue ordered by the federal government that actually came to completion.

Horatio Greenough's soon-to-be-infamous statue of a seminude Washington, seated rigidly on a huge throne in the posture of Jupiter, has gone down in the annals of American art history as the most reviled public statue ever erected (figure 19). Installed in 1841, it lasted less than two years in the Rotunda before being banished to a makeshift location on the Capitol grounds. Despite learned defenses by well-known intellectuals such as Edward Everett of Massachusetts, the statue ended up accomplishing almost nothing in the continuing quest to build a national monument

19 Horatio Greenough, *George Washington*, Washington, D.C., 1841. Photograph ca. 1900. (Library of Congress, Prints and Photographs Division.)

to Washington. "It is a ridiculous affair, and instead of demanding admiration, excites only laughter," one correspondent observed in 1844. Later in the century it was tolerated, almost affectionately, as "that marble absurdity called Greenough's Washington." Yet Greenough's work cannot be so easily dismissed: despite its misfires, it was the earliest statue monument to deal with the complex question of national expansion. The work aimed to build a bridge between Washington's classical republican character and the modern nation that had already replaced the world from which he came. Greenough intended his statue to reveal Washington's true mission on the world historical stage.[51]

For the central figure of Washington, Greenough turned the ancient pose of Jupiter, which was all about the display of power, into a classic republican gesture of "self-abnegation." With one hand pointing to heaven, the other returning a sheathed sword, Washington voluntarily relinquishes his military power so that a republic of free, self-governing citizens can live and flourish under Providence. This central narrative of self-restraint and power in check was then counterbalanced by its opposite, an epic tale of national expansion, revealed in the subsidiary sculpture on Washington's throne. On the sides of the throne were two relief panels, one showing Apollo driv-

ing his chariot and the other representing the infant Hercules battling with a snake while his half brother Iphiclus shrinks in fear. Apollo was an allegory of enlightenment, spread by the United States under Washington's example; according to Greenough's own description, Hercules stood for a courageous North America and Iphiclus a cowardly South America. On the back of the throne were two small figures, one a downcast American Indian contemplating the vanishing of his race. The other was originally to have been the figure of a "negro." In contrast to the Indian supposedly vanishing from the New World, the black figure was taking his place as plantation slavery spread across the continent, the engine of U.S. expansion into the Louisiana Purchase and the Mexican territories. Greenough's "negro" would have connected Washington to slavery, something no monument had ever done or would ever do. But the figure would also have connected Washington to a particular vision of national expansion guided by slavery, a vision that Washington himself did not share. Washington had belonged to a generation, before the invention of the cotton gin, that thought that slavery—like the Indian—was vanishing. In Greenough's scheme, however, the "negro" would make Washington appear to be the founder of a nation whose destiny was both to civilize and enslave the New World. The melancholy Indian and the cowardly South American are left behind to vanish or languish as the forces of Anglo American civilization sweep across the continent in a historical movement that Greenough may have thought of as "progress" but today could just as easily be characterized as "ethnic cleansing." Greenough's friends, notably the soon-to-be-famous abolitionist Charles Sumner, convinced Greenough to remove the negro figure. He replaced it with the much safer choice of Columbus, thereby making Washington the bridge between white discovery of the New World and Anglo American domination of it.[52]

Greenough was representing in allegorical form the idea of "manifest destiny," years before the term was first coined, in 1845. The notion was emerging in the 1830s to describe the world historical mission of the United States, a mission steeped in assumptions of national and racial superiority.[53] Politically, "manifest destiny" was associated closely with the Democratic Party, which had coalesced in the 1820s to support the presidential candidacy of General Andrew Jackson, an expansionist who became famous (or infamous) for his expulsion of Indian tribes from the southeastern United States. In 1846, barely five years after Greenough's statue arrived in the Capitol, one of Jackson's successors, President James K. Polk, decided to invade Mexico to fulfill the nation's historical mission. By early 1848, Mexico had ceded almost half its territory to the United States, from Texas to California. In the process, huge new tracts of land became available for cotton cultivation, further intensifying

the crisis over the expansion of slavery. Washington's nation now stretched from the Atlantic to the Pacific, bringing to completion the very narrative Greenough's monument had foretold and setting in motion the historical forces that would lead to the Civil War. Poor Greenough received no credit for anticipating the nation's destiny because his neoclassical figure seemed so rooted in a distant, easily ridiculed past.

The Failure of the Capitol

By the early 1840s the Capitol building and its grounds seemed to be one of the few bright spots in an otherwise straggling capital city. It was the largest and grandest public building in the United States, beautifully situated on a hilltop overlooking the rivers and landscape around it. After being burned by the British in the War of 1812, the building and its collections had seen a period of steady growth, prompted by the nation's expansion and the corresponding increase in size of the Congress. The list of commemorative undertakings at the Capitol became far more ambitious than anything attempted elsewhere in the country. In the Rotunda an ongoing series of oil paintings and sculptural reliefs commemorated the Revolutionary War and the earlier history of white settlement. On the west front outside stood the capital's first free-standing public monument, the Tripoli Memorial, privately financed and erected there in 1831; it was a wedding cake assemblage of allegorical figures commemorating a half dozen naval officers who had died in 1802 in a trade war with North African Muslim potentates (figure 20). (The monument was removed to Annapolis in 1860.)[54] On the east front, Greenough's *Washington* took up position in 1843 after its brief stay in the Rotunda, followed by Luigi Persico's sculptural group of *Columbus's Discovery of America* in 1844 and Greenough's pioneer-themed *Rescue* in 1851. Aside from the bronze statue of Jefferson installed on the president's lawn in 1847, no comparable commemorative sculpture existed elsewhere in the city in the first half of the century.

Though unrivalled as the commemorative center for the capital and the nation, the Capitol complex had some serious problems. The failure of Greenough's *Washington* was symptomatic of a much larger failure of artistic imagination and of public reception. The Capitol dodged all representation of the slave system that helped fuel national expansion. While Indians were emblazoned on the building, inside and out, slavery was absent from view but a source of tension within the decorative program.[55] What was on view increasingly became a target for criticism coming from all directions.

20 Giovanni C. Micali, sculptor, Tripoli Memorial, 1808. Installed in the Capitol grounds 1831, relocated to Annapolis, Md., 1860. Photograph late 1850s. (Historical Society of Washington, D.C.)

The building and its monuments were not protected from ordinary life and its profane tendencies. Boys played on the statues outside. Hawkers sold oranges and root beer in the hallways inside. "Idlers" lounged in the Rotunda and made jokes about the patriotic art on display. Well before Greenough's *Washington* and Persico's *Columbus* appeared, one congressman complained of the "reckless levity that is witnessed everyday at the pictures" in the Rotunda; in his view, this was a reason against placing any monument to Washington in the space.[56] The Capitol's artistic repository fell prey not only to popular irreverence but to elitist criticism as well. Even guidebooks could be unsparing in their criticism of particular works. Hawthorne in the early 1860s wanted "to banish those stiff and respectable productions" in the Rotunda, but other critics were even more blunt. As late as 1875, the *New York Times* wrote that "the Capitol is a sort of museum of failures in painting and sculpture . . . a huge

national joke. It has exercised the powers of ridicule of great and small wits ever since Persico's theatrical base-ball player, otherwise 'Columbus,' was set up to adorn the great central portico."[57]

The examples most frequently ridiculed were the allegorical or "ideal" works, in which human figures stood for abstract ideas not in a realistic narrative but in a rhetorical argument. In Europe such works were standard fare in the public landscape. In the United States the audience had some notion of the allegorical game but typically refused to play it. Although the works had some eloquent defenders, more often than not they became the butt of deliberate misreadings: Washington with his loincloth slipping down was waiting for his clothes; Columbus with his globe held up was bowling ninepins. Misreading the monuments not only produced a laugh but also mocked the pretensions of officialdom.[58]

Despite its grandeur, then, the Capitol building often failed to inspire the reverence expected in a great commemorative center. Nor had it found a convincing way to connect the nation's republican origins with its expansionist tendencies built on slavery. The commemorative program was micromanaged by a legislature and bureaucracy that were also split on sectional lines. No wonder point A, still undeveloped a mile away in a virtual no-man's-land, would continue to beckon to the imagination of later generations as it had to L'Enfant's decades earlier.

The Beginning of the Monumental Core

In the late 1840s the contrast between the nation—a muscular republic triumphantly spanning the continent—and its capital, paralyzed by the growing conflict over slavery, could not have been greater. But in reality these were two faces of the same coin. Although the social and political contradictions of the nation might be resolved temporarily by balancing new territory between slave and free labor, those same contradictions in the concentrated landscape of the capital city became all too noticeable. Where L'Enfant had used the power of sight as a governing principle of his plan— the legislative and executive branches were supposed to survey each other and the monumental example of George Washington—the growing political crisis now made sight problematic. Beginning in the 1830s, abolitionists had turned the power of sight against official stagecraft; in broadsides and speeches they focused attention on the disparity between the capital's monumental ambitions and the sordid reality of slavery in its midst. Proslavery apologists did their best to suppress references to

slavery in the public record and in the Capitol complex, and they simply refused to see the traces of slavery that could not be hidden from view. *Willful blindness* was the term used to describe the phenomenon by the *National Era*, an antislavery newspaper that opened in the city in 1848. To counter that blindness, the paper told exactly where to cross the Mall to find the most notorious slave pen right on the edge of L'Enfant's public ground. Ironically, it was near the Smithsonian, the new national scientific institute under construction at that moment in the western end of the Mall, not far from the creek and marshland surrounding L'Enfant's point A.[59]

Out in that unlikely wilderness, another project for a national monument to Washington got under way, this one the most ambitious and problematic of all. Whereas Greenough's statue was financed by the federal government, this undertaking was sponsored by a private association led by a handful of prominent Washington residents. They envisaged a monument that would not only dwarf Greenough's statue but become the tallest structure in the world. Their Washington National Monument was meant to be the ultimate act of monumental aggrandizement, outshining the Capitol and dashing the building's claim to the commemorative center.

The design by the longtime federal architect Robert Mills, adopted in 1845, combined an obelisk reaching six hundred feet high with an immense Doric-colonnaded "pantheon" at the base, surmounted by a colossal sculptural group of Washington driving an imperial chariot (figure 21). The design did everything humanly possible to steal the Capitol's thunder. The pantheon would hold battle paintings and statues of Revolutionary heroes, thereby rivaling the Capitol Rotunda. The project included an observatory at the top of the obelisk (reached by a "railway" whose mechanism went unexplained) and a subterranean gallery in the pantheon that could hold Washington's remains if his heirs ever allowed the removal of his body in the future. The Mills design combined many of the elements of Charles de Wailly's 1797 proposal for the Pantheon in Paris, which also had a crypt below and a viewing platform above, but the Washington project would overtop it by hundreds of feet. The price tag of $1.2 million was to be paid entirely by voluntary donations of the American people.[60]

Mills's elaborate design was certainly an affront to republican restraint, and its eclectic mixture of Greek, Roman, and Egyptian elements carried contradictory messages. The portico featured the republican symbolism of Doric columns, as in Latrobe's pyramid design, yet they were coupled with the imperial Roman motif of the chariot, which suggested conquest and expansionism. Far from accidental, these inconsistencies were fundamental to the nation's own problem of self-definition as it

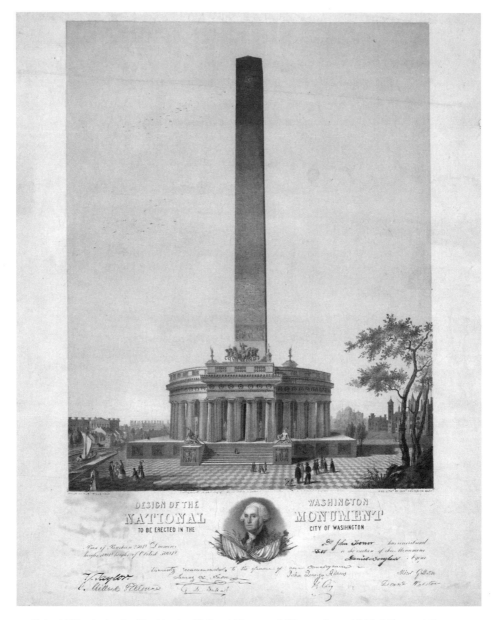

21 Robert Mills, design for Washington National Monument, lithograph, ca. 1846. (Library of Congress, Prints and Photographs Division.)

tried to reconcile territorial expansion and large-scale slavery with the more modest vision of a stable republican order of independent farmers.

The scale and ambition of this immense commemorative project gave artists a reason to imagine the Mall anew, from the vantage of the river on the west rather than the Capitol on the east. The earliest such vista to include the monument was probably an 1847 lithograph after Joseph Goldsborough Bruff's *Elements of National Thrift*

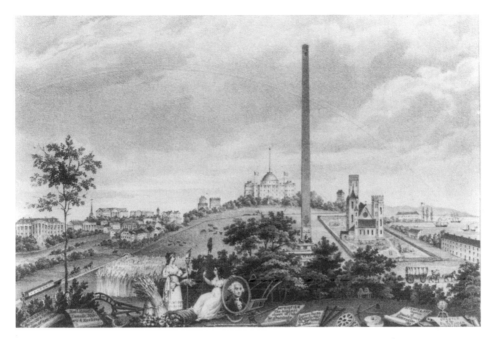

22 J. Goldsborough Bruff, *Elements of National Thrift and Empire*, lithograph, 1847. (Library of Congress, Prints and Photographs Division.)

and Empire (figure 22). Unlike Latrobe's drawing of 1800, which sequestered the mausoleum in its own sylvan setting, Bruff's fanciful view integrated the monument into a new civic scheme. His image used a lot of topographical rearrangement and wishful thinking to visualize a true central core for the capital, organized around the Washington Monument, the Smithsonian, and the Capitol. Together the three structures (two of which existed only on paper) represented the pillars of a successful society—patriotic memory, scientific and artistic advancement, and good government. Here for the first time the center of the capital was imagined as a national core symbolic of ideal institutions and values for society. Of course it was an image in which the reality of slave traffic in and near the Mall had to be erased.

Bruff's image shows that the managers of the monument society had set in motion a powerful fantasy—a new way to project the nation's image from an alternative center. To make the fantasy come true, the managers of the society had to overcome understandable opposition from Congress, which was highly reluctant to bestow its approval on a privately funded association with little accountability for how it raised and spent its money. The managers used subscription agents, paid on commission, to fan out across the country gathering donations; it was impossible to know how much they pocketed for themselves. By 1848, after several years of fundraising, the society had $87,000 on hand, enough to persuade Congress finally to

donate the public reservation that included L'Enfant's point A.[61] President Polk, fresh from his epochal victory over Mexico, formally deeded to the society the site at the west end of the Mall. But point A proved untenable. Mills and the monument managers sited the foundation on higher ground about four hundred feet away, shifting the monument off both of L'Enfant's axes and creating headaches for planners ever since. The managers also scaled down the project to the obelisk only, leaving the question of the pantheon to a future date.[62] Even so the monument, if finished, would still be the most commanding structure in the capital, the ultimate landmark, visible for miles around.

On July 4, 1848, the ceremonial laying of the cornerstone took place before a crowd of many thousands that included the president and vice-president of the United States, congressmen, representatives of Indian tribal nations, and other dignitaries. Such ceremonies were important occasions, carefully planned especially when the monument depended on voluntary contributions, for here the nation gathered ritualistically to launch the monument's construction and confirm its importance. Hand-sewn state flags from as far away as Texas were brought by special delegations. Elaborate letters of invitation went out across the country; replies of equal gravity came back and were duly archived for publication.[63]

Perhaps the most important element in the ritual was the choice of orator for the occasion, who had to be someone who could overcome his sectional or partisan affiliation and speak as a unifier. This was no easy task in 1848, following a war that had divided the country along party lines (the Whigs generally opposed, the Democrats in support). Even more alarming, the vast increase in national territory owing to the war had reignited the debate over the expansion of slavery, which threatened to make the growing divide between North and South even more intractable. These divisions particularly troubled the local sponsors of the monument, who were deeply invested in the capital city; they knew that Washington could survive and grow only if sectional conflict was overcome and the national Union cemented.

The monument society eventually settled on the Speaker of the House, Robert Winthrop of Massachusetts, a well-known orator and a Whig. Winthrop had argued against the extension of slavery into the Southwest, famously declaring in a speech of 1845 that he was "uncompromisingly opposed . . . to adding another inch of slave-holding territory to this nation." At the same time, he resisted abolitionism and tried to steer a middle ground on the war with Mexico. In the climate of 1848 that made him a compromiser, the sort of politician who could speak across the growing rifts of party and section.[64]

Winthrop's speech was remarkable for what it did not say. He said nothing about manifest destiny or the recent war with Mexico. He talked a great deal about current events, but all in Europe—the latest revolution in France and the reformist stance of the Vatican. These great liberation movements, he argued, owed their origins to the example of the United States and George Washington. Although he spoke eloquently of the Declaration of Independence and its premise of equality among all men, Winthrop said nothing about Washington's slaves or the institution of slavery. In this forum, Winthrop the compromiser was not about to solve that contradiction, which had haunted the republic from its inception.

Yet at the end of his speech he could not help circling back to the great national crisis spawned by slavery's expansion. "The extension of our boundaries and the multiplication of our territories are producing, directly and indirectly . . . so many marked and mourned centrifugal tendencies," he lamented. In the figure of Washington he hoped the Republic could find "the all-sufficient centripetal power" that would hold the Union of states together. "Let the column which we are about to construct be at once a pledge and an emblem of perpetual union!"[65]

In coining the term *all-sufficient centripetal power*, Winthrop had put his finger on the most powerful recurring dream for the capital, beginning with the Federalists' idea of raising a pyramid monument and continuing with the efforts of future generations to carve out a monumental core from L'Enfant's original Mall. Winthrop seemed to believe, with the Federalists, that a pile of masonry could somehow unify a nation, as if this gigantic obelisk—associated with the sun in ancient Egyptian culture—could be the central star that would hold its satellites in orbit. But as he moved toward the speech's climax, he changed his tack and veered back toward republican iconoclasm. The work of memory must not stop with this monument, he argued. "Think not to transfer to a tablet or a column the tribute which is due from yourselves. Just honor to Washington can only be rendered by observing his precepts and imitating his example. . . . This wide-spread Republic is the true monument to Washington."[66] In the end this blueblood Whig, descendant of the great Massachusetts Federalist tradition, echoed the rhetoric of the Republican slave-owner Thomas Jefferson. No obelisk, Winthrop understood, could save the Union. Only its people could, through their living commitment.

Three years later, a quiet image of "Washington's monument," dated "16 Nov. 1851" and drawn by Seth Eastman, suggests the mixed outcome of Winthrop's exhortation (figure 23). While Eastman's drawing echoes Bruff's print by compressing the three great national structures—the monument, the Smithsonian, and the Capitol—

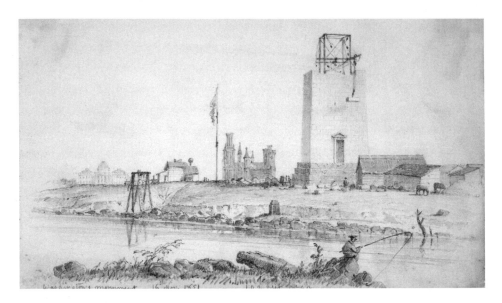

23 Seth Eastman, *Washington's Monument, Under Construction*, November 16, 1851, graphite on laid paper, 12.2 x 19.8 cm, Museum of Fine Arts, Boston, gift of Maxim Karolik for the M. and M. Karolik Collection of American Watercolors and Drawings, 1800–1875, 54.1721. (Photograph © 2009, Museum of Fine Arts, Boston.)

into one frame, the bird's eye vantage of Bruff's view here comes down to earth. In the foreground a seated fisherman with his line in Tiber Creek sets the slow pace of the scene. In the middle ground the flag is still, work on the monument proceeding sluggishly amid a ragtag scene of sheds, people, and animals below. Ironically this stump, a little over a hundred feet high, would remain essentially unchanged for three decades. The monument had not even reached a third of its projected height when the Civil War broke out thirteen years after Winthrop's oration. During the war years, and long afterward, the unfinished stump stood out, visible from all directions, as an emblem of a broken nation, scorning Winthrop's "all-sufficient centripetal power."

Just visible in Eastman's drawing, on the opposite bank of the creek, is Jefferson's old meridian stone, planted at L'Enfant's original point A. This unassuming stone, apparently forgotten in its swampy surroundings, is the perfect representation of Dickens's "monument to a deceased project." Hints and premonitions of failure seem to permeate the image, as if registering the nation's inability to overcome its internal contradictions. Yet such interpretive hindsight hides as much as it reveals. The real work of occupation, like the work around the monument grounds, in fact continued. Even in the 1850s the nation and the city pushed forward to fill their territory. With that push a distinctive memorial landscape would eventually begin to take shape in the national capital.

2

Covering Ground

When Dickens surveyed Washington, D.C., in 1842 from the height of the Capitol, the view did not cohere into the sort of urban unity he had expected from such a magisterial prospect. The city was unreadable. He saw only gaps, incompletions, absences: "Spacious avenues, that begin in nothing and lead nowhere; streets, mile-long, that only want houses, roads, and inhabitants; public buildings that need but a public to be complete; and ornaments of great thoroughfares which only lack great thoroughfares to ornament."[1] Within a few decades, however, his description was obsolete. New development spread through the empty streets of the city, and the dusty squares and triangles of L'Enfant's plan began to fill with statues of heroes as well as flowers and trees. A unified urban layout emerged and became readable, both from afar and up close.

The Compromise of 1850 abolished the slave trade in Washington and thereby removed from the capital the most egregious signs of the nation's internal division. Although the compromise only temporarily stalled the national crisis over slavery's expansion, the capital did finally begin to prosper and to reflect the swelling size and power of the nation. In the 1860s the Civil War put enormous strain on the city and changed its social fabric forever, but the war also accelerated the process of urban expansion that had begun in the previous decade, as refugees, soldiers, journalists, civil servants, and lobbyists flooded into the city.

Before 1850 the city had only a small cluster of monuments on the Capitol grounds, which were relentlessly ridiculed, and a single statue (of Jefferson) on the White House lawn. In the second half of the nineteenth century, statue monuments proliferated throughout the capital, creating a dispersed memorial landscape of great men on pedestals. Some two dozen in all spread across L'Enfant's map, much as he had hoped except that they were concentrated mainly in the northwest quadrant, where the

affluent were settling. By 1875, the journalist George Alfred Townsend could remark that the brand new equestrian statue of General Scott (commander in the Mexican-American War) added "another proof to the sagacity of Major L'Enfant, who has dotted the town with sites and spaces purposely left for statuary."[2] Meanwhile, the city managers had embarked on a massive campaign of infrastructure improvements and tree planting unrivalled in any other U.S. city. Sewers put creeks underground; streets were graded, paved, and planted with trees, and public statues erected—all making it possible for L'Enfant's paper layout to become visible at last. Townsend wrote that "the whole surface of the city came to light like some tracery in invisible ink when held to the fire."[3] By the end of the nineteenth century, trees, statues, and streets had come together as civilized partners, transforming the image of the city in the process (figures 24 and 25). With its heroic monuments and gracious parks spread out in residential squares and circles, the capital finally seemed to overcome the disjointed picture that Dickens had observed a half century earlier.

Today this late nineteenth-century city is almost impossible to imagine. The monumental core we now identify with the capital did not yet exist. Visitors saw few obvious signs of Winthrop's "centripetal power," even after the long-delayed completion of the Washington Monument in 1885. The Mall was a polyglot place, a series of leisure zones offering meandering walks amid well-tended groves and gardens fringed by working operations such as railroad stations, greenhouses, arboretums, and even brothels. Visitors to the capital did not gravitate to one central space but spread out across the city to see the widely scattered high points of the memorial landscape. Most of the individual monuments (and a few of the gardens) still survive today, but the collective impression they once made has been shattered. That sense of a profusion of edifying and delightful grounds, so celebrated by late nineteenth-century visitors, fell victim to the urban transformations of the twentieth century, especially the massive clearing of the Mall, which took place in stages from 1904 to 1935.

Photographs and prints can document some of the losses, but the problem for us is more fundamental. A photograph can show certain objective facts about a place but cannot tell us how it felt to those who once lived or walked there. We have lost the frameworks of experience that nineteenth-century men and women brought to this city. One way to unlock this earlier mode of landscape experience is to look closely at the terms people once used to describe it. One of the most common terms in the nineteenth century was the word *grounds.* The term lingers on in contemporary manifestations such as *groundskeepers,* but for the most part it has been replaced by the notion of "space," which registers a different way of approaching and understanding

24 (top) Joseph Pennell, *Thomas Circle*, in "The New Washington," *Century Magazine*, March 1884, 650. The statue shown is of the Union Army general George H. Thomas. (Hillman Library, University of Pittsburgh.)

25 (bottom) Dupont Circle, ca. 1910. (Library of Congress, Prints and Photographs Division.)

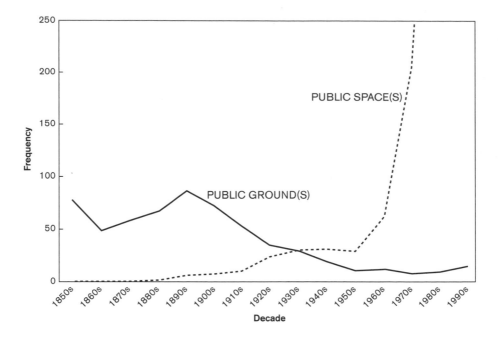

26 Frequency of the phrases *public ground(s)* and *public space(s)* in the *New York Times*, 1851–2000.

the landscape. While "public grounds" have become a genteel anachronism, "public space" is now a ubiquitous object of attention—a fact easily demonstrated by examining how frequently the two terms have appeared in the news media over the past 150 years or so (figure 26). The "spatial turn" in our own thinking has become so ingrained that it takes real effort to understand the earlier period on its own terms. This is precisely why the term *public grounds* is valuable to us now. In the nineteenth-century capital, the ground mattered in a particularly significant way.

Space, Ground, and Violence

To understand this, there is no better place to start than the work of Andrew Jackson Downing, the famed horticulturalist and landscape designer who played a key role in the development of the nineteenth-century Mall. Downing was brought to Washington in 1850 by some prominent local citizens in league with the new president, Millard Fillmore, who had helped negotiate the recent compromise on slavery. Eager to capitalize on the nascent spirit of unity, Fillmore asked Downing to create a worthy landscape setting for the President's House as well as for the Washington Monument and the Smithsonian Institution, both under construction on land to the south-

southeast. Downing responded in 1851 with a proposal for "laying out the public grounds at Washington" that encompassed virtually all the public land reserved by L'Enfant in the federal center. Downing intended to transform the entire Mall into a "national park," a "public museum of living trees and shrubs" (figure 27).[4]

Downing's explanation of the plan used the term *grounds* fourteen times, *ground* five times, and *surface* twice; the word *space* appears only once. This text, like any of his other essays, reveals how much a sensitivity to the ground—the terrestrial surface—drove his thinking, rather than a sensitivity to space in our sense. Downing described a forest as "a wooded surface," for example, not a space occupied by trees. He devoted a whole essay to "the beautiful in ground" but almost never used the word *space*. When he did, the word emerged in the text as a neutral category of measurement: the spatial question was simply whether there was enough of it to create the landscape he wanted. Ground and surface, by contrast, were aesthetic categories with real substance. They had a positive character, springing from their climate, vegetation, soils, slopes, and undulations. Downing especially prized "diversity of surface," which allowed for a succession of distinct landscape "scenes"—artistic, romantic, wild. A good part of the landscaper's job, in his view, was to shape scenes that flowed organically from the ground's intrinsic character.[5]

Downing, in other words, seems not to have conceived of landscape as space. Accustomed as we now are to spatial thinking, this statement at first seems absurd. How can any landscape not be a space? We are taught in geometry class that we live in a three-dimensional world; space is given to us naturally, or so we think. For Kant, space was a mental framework that existed before perception itself. Its very invisibility, and impalpability, lets us believe that space is universal, a core constituent of reality (or of the mind) shared by everyone in all times and places. Not all agree, however. The great psychologist of perception James J. Gibson (whose theory of perception was tied to surface rather than space) has argued that the third dimension is a mathematical concept, not a perceptual given, and that "space is a myth, a ghost, a fiction for geometers." Closer to art history, James Elkins declares that "the concept of space is not a given: it exists in history . . . [and] remains inextricably entangled, therefore, in currently viable Western concepts of art and experience."[6] The surprise is that we do not have to go very far back in time to realize that space and ground are both historical categories, constituents of their cultural milieu.

Space in Downing's day was an abstraction, defined essentially as emptiness: the unfilled area or gap between two solid objects or the open expanse between geographical or astronomical markers. Space had no intrinsic character.[7] The term *public space* was uncommon in the nineteenth century, and when it did appear in lawsuits

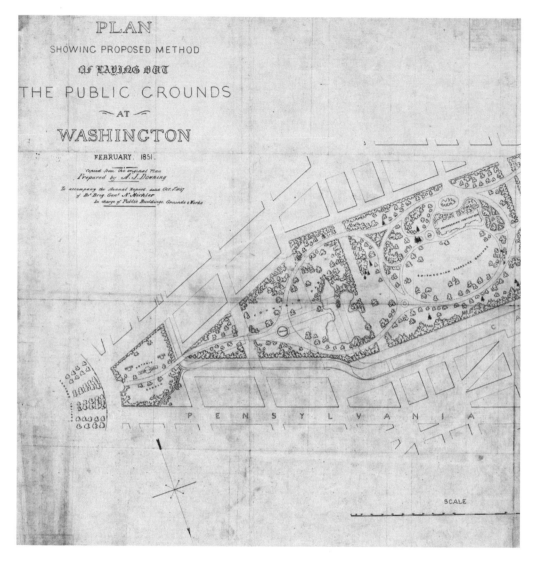

27 Andrew Jackson Downing, "Plan Showing Proposed Method of Laying Out Public Grounds at Washington," 1851, copy by Nathaniel Michler, 1867. (National Archives and Records Administration, Cartographic Branch, Record Group 77.)

or real estate descriptions it was usually as a means of designating open areas without clear identity or purpose. For example, a Washington ordinance of 1870 replaced the designation "the public space at the intersection of Massachusetts and Maryland avenues" with "the more distinctive proper name" of Stanton Place.[8] On the other hand, ground was never abstract or without character. It has always been beneath our feet, the touchstone of our daily experience. In an 1837 description of St. Augustine, Florida, a rare instance of *public space* shifts immediately to *public ground*: in the center of the town "is a public space, of about four acres, called Plaza de la Constitución.

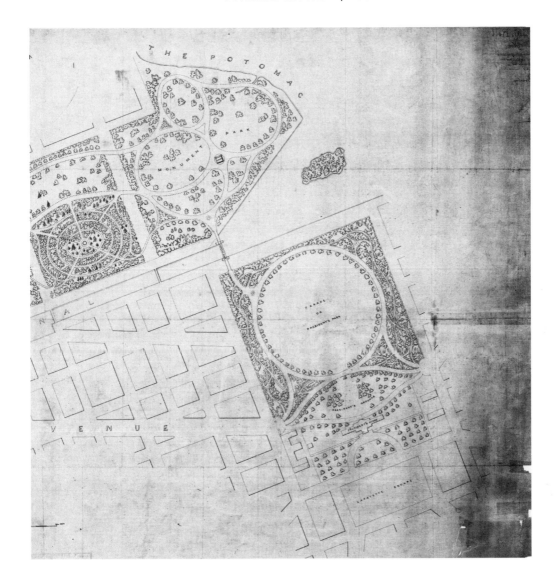

In the midst of this public ground is a small monument." The abstraction of four acres of space becomes ground on which a monument can be planted.[9]

For Downing, the landscape at its most fundamental level *was* the ground, the soil and topography that could be seen, felt, smelled, trampled, planted. This is not to suggest that Downing and others kept their noses stuck in the dirt—they also delighted in vistas and prospects, in the open air. Downing designed landscapes to move people in and out of clearings, from immersion and seclusion to openness and distance. The experience involved the whole human body in motion: walking, riding,

rambling, exploring, paying attention to particulars. The body in the landscape, therefore, was not a purely visual experience but also kinetic and multisensory, involving tactile sensation, scents, temperature, moisture, breeze. This is still true, of course, but since the nineteenth century the technologies of transportation and climate control have radically diminished our intimacy with the terrestrial environment. The nineteenth-century experience is impossible to recover from photographs: the camera was a fixed eye, not a body in motion, and its lens did not register gravity, much less the sensations arising from our attachment to the ground. In a sense, the camera had already overcome the ground and achieved transcendence.

Like space, the notion of ground has a history, as human beings have reshaped the ground over time and changed their relationship with it. The term *public grounds* was commonplace in the nineteenth century, but it had certain associations, especially of class. Grounds were distinct from open land or commons or farm fields. From Shakespeare's time, the term meant "enclosed land surrounding or attached to" a building, "serving chiefly for ornament or recreation."[10] Grounds were thus a by-product of enclosure, a complex social process with a long history in Britain. Enclosure was the legal and political mechanism by which large landowners restricted vast tracts of common land previously open to anyone and any use. Even when public, grounds were the result of barrier and artifice—accessible only under certain conditions and for certain leisure pursuits.

Before Downing arrived, the public grounds of central Washington were unworthy of the name because, as the author Joseph B. Varnum Jr. observed in 1848, they were simply "a large tract of waste ground . . . a mere cow-pasture." Varnum claimed that "it is not generally known, even to the members of Congress, that this is the national mall."[11] The land had been an oak forest until the trees were cut down in the late 1810s. By the time Downing proposed his national park, the clearing process had turned the Mall and much of the rest of the city into an eroded scrubland. Pigs and cows roamed the streets of the capital and chewed away most of the new saplings that might have regenerated the urban forest.[12]

For Downing, this disaster was not only environmental but moral as well. He could make sense of tree clearing only as a destructive fever, akin to war, that "warped and smothered" our better feelings. "Thus old soldiers sweep away ranks of men with as little compunction as the mower swings his harmless scythe in a meadow," he wrote in 1847, "and settlers, pioneers, and squatters, girdle and make a *clearing*, in a centennial forest, perhaps one of the grandest that ever God planted, with no more remorse than we have in brushing away dusty cobwebs." He wrote these words in the immediate aftermath of the Mexican-American War, which promised another mas-

28 Thomas Crawford, sculptor, *Progress of Civilization*, pediment on Senate wing, U.S. Capitol, 1855–1863. (Photograph by the author, 2008)

sive expansion of territory for national development. In a half-hearted nod to the prevailing belief in national destiny, Downing conceded that war and deforestation were necessary evils, "probably both wise means of progress," but his point was that both the physical and moral destruction had to be redressed and repaired.[13]

Monumental Washington, even in its embryonic form, trumpeted the ideal of progress, without reservation. Greenough's memorial to Washington and the Washington National Monument project did so even before the rhetoric of progress reached a fever pitch in a massive sculptural pediment over the porch of the new Senate wing, begun in the mid-1850s. Thomas Crawford's huge multifigured composition, *Progress of Civilization*, drew Downing's parallel between war and deforestation, but without his remorse (figure 28). Crawford paired the figure of a tree-cutting pioneer with that of a soldier drawing his sword, the two flanking a central allegory of America. The pioneer's drawn ax promises to finish off the tree and, by extension, the Indian family to the right. Both the forest and its aboriginal inhabitants in this image are destined for extinction, to be replaced by the civilizing forces of commerce, industry, and agriculture represented in the left half of the pediment.[14]

Although most white Americans wanted to believe this rhetoric of progress, many, like Downing, could not help feeling some lingering moral doubts, at least about the trees. This helped fuel the popularity of George Pope Morris's poem and song "Woodman Spare That Tree," first published in the 1830s but famous for almost a century.

In the poem a venerable oak tree, threatened by the ax, becomes an indispensable repository of family memory. "My mother kissed me here; / My father pressed my hand— / Forgive this foolish tear, / But let that old oak stand." The memories yield sentiment that may be "foolish" and unproductive, especially in comparison with the goal-directed vigor of the woodsman. But that sentiment is, at the same time, a cry for human connection and continuity in a world dedicated almost solely to material progress, with its constant drive to destroy the old and remake anew. By rooting the family's past in quasi-sacred ground, the tree preserves memory and quite literally takes a stand against progress. (With "earth-bound ties," the oak towers "to the skies.") Downing thought the song should be "re-echoed by all the agricultural and horticultural societies in the land."[15]

In essays published over decades in the *Horticulturalist*, Downing criticized both country and city for their wanton destruction of nature. He mocked settlers who destroyed beautiful woods around their houses only to plant "a straight line of paltry saplings before their doors." For Downing, returning to the military metaphor, it was like exchanging a yeomanry, "as honest and free as the soil they sprung from," for a file of "sentinels or *gens-d'armes*, that watch over one's outgoings and incomings."[16] Downing's objection to the straight line was no mere aesthetic prejudice but was deeply rooted in his moral understanding of the landscape. In his late essay "The Beautiful in Ground" (1852), which was heavily indebted to English picturesque tradition, Downing argued that nature itself tended toward curved lines. Nature softened and wore away level surfaces and straight lines or hid those that could not be softened beneath a variety of vegetation. The straight or level line, by contrast, was the result of destructive violence, either that of a cataclysmic natural event or, more often, the violent subjugation of nature by man. Such ideas lasted long after Downing's death. The philosopher George Santayana, writing at the end of the nineteenth century, used recent German research on the physiology of the eye to argue that it was physically uncomfortable for the eye to follow a straight line: "There is violence in keeping to it, and the effect is forced." Curving lines produced "a more natural and rhythmical set of movements in the optic muscles."[17]

The "violence" of straight lines could be interesting as an expression of power, Downing argued, but for that very reason they pandered to the popular thirst for conquest. Since most men, he thought, valued power over beauty, landscapers almost always wanted to level the natural variations in the ground's surface. "To subjugate or level, is the whole aim of man's ambition"—an impulse intrinsic to urbanization in general, and to formal monumental landscapes in particular.[18] To "rule" a landscape—note the double meaning, mathematical and political—the most basic step

was to convert a natural surface into a plane surface. Whatever precise form L'Enfant had in mind for his grand avenue on the Mall, it was to be straight, level, and clear. Dominated as we are now by spatial thinking, we interpret such gestures as attempts to command space rather than ground. That interpretation is misleading.

Although Downing's plan for the Mall has its place in landscape history as the first comprehensive layout of a major urban park in the United States, preceding the design of New York's Central Park by seven years, his proposal needs also to be understood as an intervention in Washington's emerging monumental landscape. Downing's Mall was a place of moral repair for a nation and a city devoted to the relentless pursuit of "progress." His "museum of trees" would restore the human connection with nature broken by the national quest to subjugate land and resources.

Even though his plan included some architectural features, such as a grand entrance in the form of an elaborate triumphal arch (and in a later essay he suggested statues too),[19] the layout of the park was defined almost entirely by its tree plantings and by the drives and footpaths that moved around and through them. Downing ignored L'Enfant's broad avenue concept and filled the east-west vista to the Washington Monument with irregular patterns of trees clustered along winding drives.[20] Rather than create one large-scale spatial arrangement, like that of the Mall today, the design established a sequence of six park scenes distinct in character and plantings. The movement from one to the next was to be a process of revelation, each scene emerging in full force only as one stepped into or out of it. Moving from the "Evergreen Garden," tightly planted in concentric ovals with more than a hundred species of foreign and native evergreens, the visitor emerged into the more open "Monument Park," planted entirely with American trees of large growth, arranged to permit a series of "fine vistas of the Potomac river." Inside the Evergreen Garden the Washington Monument and the river would be essentially hidden, revealed dramatically only when the visitor stepped out across Fourteenth Street. Throughout the Mall area, Downing paired dense, secluded groves with sparse, airy groves, thereby moving the visitor from dark to light, closed to open, and back again. In so doing he was developing the themes of "closure and openness, restriction and release" that were fundamental to naturalistic garden design in Europe.[21] The ensemble formed a continuous L-shaped park from the President's House to the Capitol, but the landscape within shifted continually as visitors wound through it on curving paths and drives. Thus "the straight lines and broad Avenues" of the city's street system, which called for an entirely different experience based on clear and reciprocal sight, "would be pleasantly relieved and contrasted."[22]

As Raymond Williams once pointed out, the original picturesque parks devel-

oped on British estates in the late eighteenth century depended for their effect on the straight roads and hedges that enclosed and organized the agricultural fields outside the park gates. The irregular pleasure grounds and the regularized landscape of production were part of the same system.[23] The same may be said of Downing's picturesque park and the grid surrounding it: both were in effect products of enclosure. The city demanded the park, and each had its own standards of behavior. Dell Upton has argued that urban parks in this period emerged as "the genteel alternative to the streets." With streets overrun by the working class and saturated with tobacco spit and other signs of aggressive masculinity, parks offered a refuge where the gentry could stroll in peace and display their good manners.[24]

Downing and other picturesque practitioners of the nineteenth century have thus received a good bit of criticism from recent scholars for their class bias. This is hardly surprising, given Downing's argument that "every laborer is a possible gentleman," made in defense of public libraries, picture galleries, and parks.[25] The statement implied that the public park existed merely to train the working class in the decorum of their betters, as if the laborer had no legitimate values and pursuits of his own. Though certainly anchored in his own class circumstances, Downing's thinking went beyond this simple idea of elevating the common man. His landscape rested on a much more sweeping moral critique that ultimately transcended class concerns. Insofar as his design challenged the military regimentation of the landscape and the idea of violent conquest that lurked not too far behind the straight lines and formal vistas, his proposal was essentially antimonumental. In contrast to the efficiency and aggression of the urban/military order, Downing's design promised a deliberately different experience of time and place—meandering, variegated, revelatory. The Downing plan was a blueprint for rescuing the city—and the nation—from their own worst impulses.

Downing's project faltered early. He died in a steamship accident in 1852 and could not lend his considerable prestige to the funding requests needed to keep the work going. The most notable success was the Smithsonian grounds, which were planted roughly in accord with his wishes and became an especially popular resort for visitors. Ironically, the first finished monument in the Mall was located there: an urn dedicated to Downing in 1856, designed by his architect partner Calvert Vaux, decorated with encircling vines and set on a pedestal with inscriptions from his essays. Other areas of the Mall, planted later, followed Downing's recommendations less consistently.[26]

Nevertheless, the basic thrust of his plan endured even if the details did not. From this point on, the focus was trees. Over several decades the Mall was reforested, with

groves of shade trees and other specimens stretching from the monument grounds to the foot of the Capitol. The idea of distinct park "scenes" survived, largely because of the fragmented administrative structure of the Mall. The L-shaped reservation was carved into discrete units run by separate federal agencies and congressional committees, each with its own horticultural specialists and constituencies. The 1886 map of B. H. Warner & Co. (see figure 1) designated no less than seven different parks between the Washington Monument and the Capitol: Monument Park, Agricultural Park, Smithsonian Park, Armory Park, Sixth Street Park, Third Street Park, and the Botanic Garden. The great landscape architect Frederick Law Olmsted complained in the 1870s that all these different parks were "managed in an absurd and wasteful way under advice and control of nearly a dozen independent Committees of Congress, assisted by nearly as many heads of bureaus and other officials, architects, surveyors and gardeners."[27] But on the ground, several devoted British-born nurserymen managed to bring some order out of the administrative chaos. William Saunders of the Agriculture Department and William R. Smith of the Botanic Garden became powerhouses in their own right, running their areas as virtual fiefdoms for decades. Saunders supervised a sprawling empire of greenhouses and demonstration gardens, both formal and informal, just to the west of the Smithsonian, while Smith jealously guarded the specimen gardens at the east end of the Mall, just below the Capitol building. Smith actually lived on the site, restricted visitors' hours, and kept a wall around the Botanic Garden even after Congress ordered him to remove it. Despite their fierce territoriality, these nurserymen collectively helped make Washington a recognized center of urban arboriculture. The park system of the capital, wrote the *New York Times* in a 1900 obituary for Saunders, "is to the visitor and dweller in Washington a perpetual pride and delight, and to the student of gardening and tree culture an object lesson that has made an impression not confined to the United States."[28]

The Monument in the Park

The one mystery in Downing's plan was the role of the gigantic national monument to George Washington in its midst. Recent research has turned up evidence that Downing disliked Mills's design and sketched ideas to improve it.[29] Nevertheless, Downing highlighted it in his Monument Park and seemed to reinforce its grand national ambitions by surrounding it with tall American trees. But we are still left wondering how the monument and the park would have harmonized in practice, because the two were actually working in opposite directions. The monument aimed to

become the ultimate national symbol, a magnetic force that would attract the attention of everyone in the capital city. All the achievements and aspirations of the country were to be concentrated in this single shaft, taller than anything in the city and the whole world. No matter how much Downing tried to confine the monument's impact to its immediate surroundings, a conspicuous central icon simply did not mesh with his decentered, meandering grounds. Downing wanted his park to draw attention to a thousand different particulars, not just to one big symbol. Metaphorically, the monument's dominating scale spoke of power and subjugation, whereas Downing's grounds were meant to bring out man's "better feelings" and nurture a new moral equilibrium in harmony with nature.

When Downing drew up his plan in early 1851, the monumental shaft was barely one-quarter complete, and construction was already slowing down significantly. The monument's fate in the 1850s offered a cautionary tale for all who hoped to create a symbolic center in the national consciousness. Initially the monument's board of managers had naively anticipated a massive outpouring of popular support, and had even made a decision to *limit* the size of contributions to one dollar per person. They soon abandoned this dream and by 1855 were lobbying Congress for a bailout, an all-too-familiar pattern in the nineteenth century.[30] Shortly thereafter the story took an unexpected turn: the managers were ousted in a hostile takeover of the Monument Society by a secretive political party called the Know-Nothings. The Know-Nothings (who got their name from their secrecy, not their lack of education) were a national party of "native-born" Americans organized around opposition to immigration and Catholicism. They had taken control of Washington's city government in 1854 and had already caused a stir when they stole from the monument's grounds a block of stone that had been donated by the pope.[31]

The so-called nativists were drawn to the monument because no national symbol could rival it in scale or impact. A national monument built by popular subscription was supposed to channel the voice of "the people." The nativists staked a claim to that voice, though not everyone accepted it; the question of who are the American people has always been a political and cultural issue, not a demographic one. Slaves were not considered legitimate members of the nation, no matter how many generations they had been on the continent, and immigrants from Catholic regions of Europe were suspect as well. In the nativist's view, true Americans were like Washington himself: white, Protestant, of Revolutionary stock. The Know-Nothings wanted the monument to showcase the power and reach of their movement, so they restricted contributions to their own "brethren." Since they claimed to be the true Americans, the monument they built would issue from "the true American heart." When com-

plete it would vindicate their idea that "Americans must and shall govern America."[32]

How could a physical monument ever claim legitimately to represent something as intangible as "the true American heart"? The proof was in the popular subscription. If enough people supported it and the monument got built, it fulfilled its own prophecies. Only then, as Joseph Varnum had earlier argued, did it represent a genuine "popular enthusiasm" rather than a mere deference to authority.[33] In this respect the original Washington National Monument Society had failed conclusively. But the Know-Nothings ended up faring no better. Their national political base quickly dwindled in the late 1850s as the increasingly violent struggle over slavery pushed the nativist agenda to the sidelines. The monument's prospects sank with the party's. No one knows how much money they raised (or stole), but after three years they surrendered the monument and handed over to the original managers a grand total of $285.09 in funds.[34] The Know-Nothings learned what their predecessors already knew, that it was immensely difficult to create a mass movement to build a national monument.

The popular magazine *Leslie's Illustrated* tried to blame the failure on the project itself rather than the miserliness of the American people. "There was nothing in the original conception of this monument that elicited the sympathies of the nation," the magazine declared in 1857, "or in any way appealed to its well-known patriotic impulses." For the *Philadelphia Inquirer*, the problem was that the campaign had been too much in local hands, "a District of Columbia affair rather than one which was truly national." Whatever the cause of the failure, the Washington National Monument as a voluntary undertaking was now dead. Silence reigned at the site, *Leslie's* reported, except when broken by "derisive laughter."[35]

The Spread of Monumental History

In the mid-nineteenth century, Americans seemed unable or unwilling to concentrate national memory in one gigantic icon or central precinct. The Washington Monument languished as an eyesore at one end of the Mall while the Capitol building at the other end inspired a self-perpetuating record of parody. It is natural enough that some observers would generalize from the failures of central Washington and assume, with John Quincy Adams, that "democracy has no monuments." But when Adams made his famous observation in 1831, a shift in consciousness was already under way. By midcentury, commentators were increasingly calling for the avenues' open spaces to be "properly closed and adorned with statues to our Presidents, States-

men, and distinguished benefactors." Unlike the iconoclasts who had dismissed monuments as ostentatious and inert, these new enthusiasts argued that monuments worked through "the moral power of example."[36] Ironically, one of those enthusiasts, Joseph Varnum, turns out to have been the son of one of the Jeffersonian Republicans in Congress who had voted against the Washington mausoleum in 1800. Varnum knew very well the arguments his father's party had made against public monuments, and he systematically shredded them. To the old claim that literacy made monuments useless, he responded that few people studied history books and even fewer remembered what they read. "Upon such persons," he concluded, "objects presented to the senses make the greatest impression." He thus rehearsed the sensationalist psychology that the Federalists and French revolutionaries alike had used to justify political image making.[37]

The successes of local monument campaigns in many other U.S. cities—by 1830 there were at least four major statues of Washington in marble from Raleigh, North Carolina, to Boston, Massachusetts—helped pave the way for public monuments to make their mark on the nation's capital. Most of the monuments erected in Washington in the nineteenth century, and well into the twentieth, were in effect localized, the product of specialized constituencies rather than mass national campaigns or federally sponsored programs. Political elites, veterans groups, ethnic organizations, and other civic and private associations used some combination of political connections and popular support to sponsor most of the monuments built in the capital. "Whoever squeals the loudest gets a monument," a planning official complained as late as 1960.[38] As dire as the situation appeared then, it was even more true in the nineteenth century: public monuments emerged one by one, without any controlling plan or regulatory authority. The Tripoli Memorial came from a small group of naval officers, the Downing urn from the American Pomological Society, and so on. Although voluntary monument associations were able to create a dispersed memorial landscape, they could not create a monumental "core" for the nation. Instead of concentrating national memory in one structure or precinct, the statues and other sculptural objects of the nineteenth century created a patchwork quilt of commemorative sites across the city—as we shall see, a "cognitive map" in which the citizen could wander.

The first major success came in 1853 with the placement of an equestrian monument to Andrew Jackson in Lafayette Square (figure 29). It was the first equestrian statue in the nation's history and also the first finished monument in the capital city located in a residential district rather than the grounds of a federal building. Lafayette Square was a fashionable area in the city's growing northwest quadrant. It was the

29 Casimir Bohn, *Mills' Colossal Equestrian Statue of General Andrew Jackson*, lithograph, ca. 1853. (Library of Congress, Prints and Photographs Division.)

first of L'Enfant's squares to be landscaped and planted with trees, initially in preparation for the Marquis de Lafayette's visit in 1824. And it had the advantage of being located on the principal north-south axis of L'Enfant's plan, directly across from the President's House.[39]

The monument was financed by a small group of prominent local Democrats, the Jackson Monument Association, and completed with the support of a Democratic administration. Jackson, the Democratic president from 1829 to 1837, had been swept into power by a new politics of universal white male suffrage. A war hero and populist, he also engineered the brutal removal of eastern Indian tribes to the arid West. Fittingly, the sponsors chose an untrained sculptor, a former house plasterer by the name of Clark Mills, whose self-made career echoed Jackson's own. Mills rejected the "ideal" sculptural language of Greenough and the Capitol building and instead lifted his design from a popular print showing General Jackson on a rearing horse tipping his cap to his troops. Translating the image into the medium of bronze was no mean trick: Mills had to overcome the technical challenge of balancing the horse on its two hind legs. When he did so, he instantly became a popular hero. "The Washington people are in ecstasies," the *New York Times* reported. At the monument's unveiling Stephen Douglas, the dominant Democratic politician of the 1850s, lauded Mills as a "natural genius" worthy of the man his statue honored.[40]

Mills's statue had its critics, however. Over time the Jackson monument became,

in professional art circles, a benchmark of popular tastelessness. For professional critics and artists it was a low-culture horror that brought to mind the circus, popular theater, and children's toys. But Congress, controlled by the Democrats, loved it and rewarded Mills with an astonishing bonus of twenty thousand dollars (almost twice his original fee) and with a new commission for an equestrian statue of Washington, which Mills completed in 1860.[41]

Though crudely executed, the Jackson statue was the model of the commemorative landscape to come. It was the first in a long line of portrait statues of military heroes, many of them equestrians. Decades later, visitors to the capital could easily observe that there were almost no statues of scientists or men of peace—much less figures of women!—to offset what one critic in 1900 called "this sculptured militarism." Collectively, the city streets of Washington were becoming an outdoor version of indoor military pantheons such as St. Paul's Cathedral in London, though without the planning and coherence that European states brought to such commemorative projects.[42] Most of the capital's military figures were unabashedly commanding. While Greenough depicted Washington *resigning* his military command, Mills had Jackson reveling in it. Mills's insistence on fidelity to contemporary appearances, and his rejection of ideal conventions, would also become standard, even though allegorical sculpture never quite died out. Even more important, though, was the statue's location in a residential square. Mills's second monument, the equestrian Washington, followed the example of the Jackson statue and ended up in a residential circle several blocks away, not on the Mall as L'Enfant had envisioned. Over the next several decades, well over two-thirds of the city's freestanding monuments went up in the northwest quadrant, scattered in the squares, circles, and odd-shaped reservations left by L'Enfant's plan. They tended to go where the city's affluent were heading, and thus public statues became part of the infrastructure of new real estate development. By 1891, the total numbers were impressive enough that the *Post* could call Washington a "city of statues."[43]

As it turns out, the development of this commemorative landscape was only temporarily interrupted by the cataclysm of the Civil War. The antebellum monuments that sounded the same refrain uttered on the pedestal of the Jackson monument—"Our Federal Union / It Must Be Preserved"—failed to temper the long national dispute over slavery, which finally split the federal Union after Abraham Lincoln's election in 1860. During wartime, soldiers and escaping slaves poured into the city center with their supplies and animals, providing ample opportunity for ironic juxtapositions with the unfinished Washington Monument (figure 30). Though at times it

30 *Beef Depot Monument*, in *Frank Leslie's Illustrated Newspaper*, February 1, 1862, 173. (Library of Congress, Prints and Photographs Division.)

seemed the capital might not survive, work continued on the Capitol dome and on Crawford's pediment celebrating the progress of civilization in a united white nation. Within a few years, the Union victory along with the martyrdom of Lincoln helped to restart the commemorative engine and accelerate the spread of statues that had begun in the 1850s.

In 1866, when the Senate debated a statue of Lincoln for the rotunda of the Capitol, the famous antislavery senator from Massachusetts, Charles Sumner, still believed this statue was likely to be the only one of Lincoln in the capital city. "Repetition or reduplication would be out of place," Sumner intoned.[44] Stuck in an earlier model, he could not imagine that within ten years the capital would have three statues of Lincoln, in three different parts of the city (and all this decades before the Lincoln Memorial appeared on the Mall). As the capital's statues spread, they changed the image of the city and the experience of it on the ground. Public monuments literally renamed and reshaped the city's squares and circles, and provided a new set of mental markers by which visitors and residents navigated the capital.

Statue monuments were proliferating across the United States and indeed Europe and its colonies, part of a broad "secularization" of the public monument. Hero monuments had once been reserved for royalty and great noblemen, men who ruled by virtue of their predetermined place in a divinely ordained social order. By 1851, Thomas Carlyle in England was complaining that any newspaper celebrity "never yet convicted of felony" could get a statue. Carlyle believed that statues should be for "sacred men," but even he conceded that they could become "sacred" by example rather than by birth.[45]

In Washington, while there were occasional statues of a now forgotten judge or scientist, most of the new monuments honored wartime commanders, whether presidents or soldiers. Typically the monuments made no attempt to represent the historical forces or ideologies that had motivated these men and driven the nation in its military campaigns against Mexico, Indian tribes, and Confederate rebels. The statues simply glorified the individual leaders as exemplars of the nation's continuing greatness. The two monuments to the Mexican-American War army commander Winfield Scott, for example, were single portrait statues that declared simply "Scott." If we scan the memorial landscape of Washington, we see very little direct imagery of conquest. Aside from Crawford's pediment *Progress of Civilization*, there are no monuments to the many Indian wars fought before and after the establishment of the nation, or to the defeat of Mexico in 1848 and the acquisition of its immense western territories, or to the defeat of Spain in 1898 and the subsequent expansion of the nation to the Pacific. The collective enterprise of the nation disappeared from the equation. Instead monuments seized on individual representatives and their glorious personal qualities, such as discipline, command, foresight. Such monuments, as Nietzsche once argued, created an eternally present parade of heroes, torn from the very historical dynamics that made them what they were. In "monumental history," as Nietzsche called it, "the great moments in the struggles of individuals form links in one single chain," creating "a mountain range of humankind through the millennia." Precisely because monumental history ignored the underlying geology from which the peaks emerged, the peaks of achievement remained "still alive, bright, and great."[46]

There is no better example than the Freedmen's Memorial to Abraham Lincoln, erected in 1876 in Lincoln Square (figure 31). This sculptural group—Lincoln standing with outstretched hand above a crouching slave whose chains have just been broken—condenses the complex and problematic history of emancipation into a single triumphant act by one great man. The monument aimed to bring the whole phenomenon of black slavery, which had bedeviled and scarred the capital city since

31 Thomas Ball, Freedmen's Memorial to Abraham Lincoln, Washington, D.C., 1876. Photograph by L.C. Handy, ca. 1903. (American Sculpture Photograph Study Collection, Smithsonian American Art Museum, 30000113.)

its founding, to a happy conclusion that would confirm, once again, the moral greatness of the nation.

The Freedmen's Memorial was the first public monument in the United States financed by the donations of African Americans, most of them Union soldiers. The monument asserted their right as citizens to enter the public sphere and the commemorative landscape, although that entry was framed in a language of gratitude that white society could accept. Not surprisingly, the money and the design were controlled not by the donors themselves but by the well-connected white officers of

a charitable organization involved in freedmen's relief. Their connections got the monument a prominent site, in one of L'Enfant's original centers on the east-west axis with the Capitol. This was the square he had marked B, originally reserved for the itinerary column. The rationale for the monument's site, as far as we can tell, was simply to "get the best place in the Public Grounds in Washington." No one would have even considered the Mall, which had only the unfinished Washington obelisk and the modest urn in honor of Downing. The square, named for Lincoln in 1867, sat in the mid-1870s at the edge of a budding residential district extending from Capitol Hill.[47] Like the statues in northwest Washington, the Freedmen's Memorial took its place as both a national monument directly tied to federal power and a spur for local real estate development.

As if to cement the monument's connection with the nation, the sculpture faced the Capitol building one mile away, precisely on axis. A line drawn due west from the center of the monument would have bisected Greenough's Washington outside the Capitol entrance before cutting through the center of the Capitol Rotunda. If the monument was placed with geometric precision, the grounds surrounding it were laid out with a conscious asymmetry, in the picturesque fashion of Downing (figure 32). The monument itself was slightly west of the square's center, the true center having already been taken for a memorial tree to the abolitionist congressman Thaddeus Stevens.[48] Although the curving walks and scattered trees did not appear to block the view from the monument down East Capitol Street, they did interrupt the straight axis. The axial orientation of the Freedmen's Memorial within a counteraxial landscape was common in late nineteenth-century Washington; Jackson's statue in Lafayette Square was another prominent example. Axial positioning connected the monument to the larger national scheme, while the picturesque layout enclosed the monument in a local sphere with its own distinct character and pleasures.

As for the sculptural design itself, it presented problems not usually encountered in a heroic monument. As a "gift" of the freedmen, the monument could hardly avoid the conundrum of representing slavery, a subject at once so mortifying and so divisive that it had been virtually impossible to portray in American sculpture. As the *New York Times* declared bluntly, "a bronze group to perpetuate the memory of the institution of slavery is repugnant to many."[49] And this bronze group was a *national* monument located in public grounds meant to be peaceful and morally elevating.

The solution, wrought by the sculptor Thomas Ball, steered clear of the depths of slavery's crime and its historical trauma. Aside from the slave's shackles and a whipping post tucked discreetly behind him, around which a rose now twined, the

32 U.S. Army Corps of Engineers, Office of Public Buildings and Grounds, *Lincoln Park*, site and tree map prepared by George H. Brown, landscape gardener, 1905. The Freedmen's Memorial is the small square shown at center left. (Congressional Serial Set vol. 4948, 59th Cong, 1st sess., H. Doc. 2, pt. 7.)

composition made no direct reference to the institution's cruelty. Ball's group re-
duced the slave to a foil, so that Lincoln's moral majesty could shine forth with ab-
solute clarity. It thus recycled the popular abolitionist imagery of prewar years that
had depicted the slave kneeling and in chains, a passive creature awaiting a savior.
With Lincoln as savior, Ball's composition transformed history into parable. Lincoln
holds the Emancipation Proclamation in one hand and flourishes the other over the
slave, as if in blessing. The man's chains have magically broken, and he looks up
with the first dawning awareness of freedom. He may be about to rise, as many as-
sumed, but he is not in the act of rising or pushing off the ground. It is Lincoln who
acts, the slave who reacts. The pairing of the two called on the ancient associations
of ground and space: when juxtaposed to the slave hunched miserably over the earth,
Lincoln's otherwise ordinary stance assumed an air of godlike agency.

An earlier monument to Lincoln in Philadelphia, by the sculptor Randolph
Rogers, had Lincoln seated, holding a pen, in the process of composing the procla-
mation. This was the formula for a great man of letters rather than a man of action.
Ball wanted to create a hero in action. The problem was that signing a document was
hardly a forceful act, and anyone who had lived through the war knew that Lincoln's
proclamation had had no immediate authority. The proclamation declared slaves
in *Confederate* hands free, but left slaves in Union territory alone, paradoxically
asserting agency where it had no force and withdrawing it where it could have been
exerted. This is not to deny the importance and even audacity of Lincoln's procla-
mation, which changed the terms of the war decisively, but merely to underline the
difficulty of fitting his act to the tidy image Ball wanted to project. In fact Lincoln's
proclamation made no sense when divorced from the actual historical events of the
war, particularly the phenomenon of Southern slaves escaping to Union forts, which
had been happening since the early days of the war. The proclamation intended to
hasten a process the slaves themselves had already begun and to prevent federal in-
terference, as Lincoln said, "in any efforts they may make for their actual freedom."[50]

As Lincoln's own proclamation thus recognized, emancipation involved a part-
nership between slaves acting in resistance to oppression and Union authorities en-
couraging and helping them. Ball's monument, however, polarized the two. All the
heroism had to be concentrated in Lincoln the savior, leaving the black slave at best
an inchoate person, an empty vessel. Lincoln's "act" of emancipation had to be in-
flated to miraculous proportions, the slave's own ability to act reduced to near noth-
ingness. The white sponsors of the monument were uncomfortable enough with this
black-and-white dichotomy to try to correct it, but their efforts only underscored the

absurdity of Ball's parable. They made Ball model the black figure's face after a real slave named Archer Alexander, who had escaped dramatically from his master and assorted bounty hunters. But Alexander, it turns out, had escaped in Missouri, a Union slave state exempted by the Emancipation Proclamation. Lincoln's act had not helped him one bit.[51]

By the time the monument was erected, in 1876, its imagery was even more out of step with historical reality. In contrast to Ball's crouching slave, actual emancipated slaves had been serving for years in the Union army and in political office. Increasingly, their hard-won gains were leading to a violent backlash by white supremacists. Hopes for true emancipation were already dwindling when Ball's sculptural group was unveiled to great fanfare in front of one of the most impressive racially mixed gatherings in nineteenth-century America.[52] Less than a year after the monument was dedicated, the new president removed the last occupying federal troops from the South. Reconstruction and its ambitious agenda for black civil rights were all but dead, replaced by a long era of segregation that marked life in Washington, D.C., as well. Yet the monument's simple parable of white moral triumph would endure and take on a life of its own, historically preposterous though it was. The slave would always be "about to rise," and Lincoln would remain the slave's "emancipator," the nation's great agent of moral progress. The monument's old-fashioned abolitionist image of black passivity and white paternalism seemed to gain new value during the segregation era in justifying, or at least explaining, the indefinite postponement of black civil rights. The monument had no trouble blending into its pretty park setting, and tourists regularly made the rounds there without registering shock, guilt, or moral discomfort. Ball's composition became iconic, copied in a public monument in Boston, shown in the final moments of Thomas Edison's 1902 film version of *Uncle Tom's Cabin*, and reproduced on a twentieth-century postage stamp commemorating abolition.[53]

While the heroic landscape of nineteenth century Washington followed the general pattern of the Freedmen's Memorial, occasionally a more nuanced representation of moral leadership would appear. One example is John Quincy Adams Ward's equestrian statue of the Union general George H. Thomas, erected in 1879 in a complex intersection in the city's northwest quadrant (see figure 24). Thomas was a Virginian who had stayed loyal to the United States after his home state seceded and who later helped win several key battles in Tennessee. Ward's composition contained nothing overtly warlike, no drawn weapons or overheated gestures; its narrative was a study in understatement (figure 33). The sponsors of the monument—veterans of the Army of the Cumberland, which Thomas had commanded—clearly wanted to

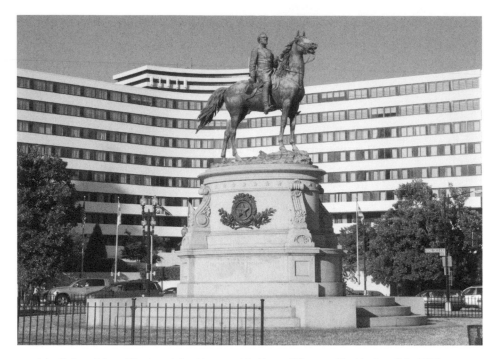

33 John Quincy Adams Ward, sculptor, Monument to General Thomas, Washington, D.C., 1879. (Photograph by the author, 2008.)

erect a statue that would not solicit the sort of criticism directed at Mills's equestrian statue of Jackson. They chose a highly skilled artist and wrote a contract specifying that at least three of the horse's feet must remain on the ground. The sponsors were trying to avoid the "stagey, theatrical animal that poses and postures in so many of the public squares of the United States."[54]

In equestrian statuary, the rider's relationship to the horse is the key metaphor; the way the rider guides his mount reveals how he commands himself and his men. Instead of a glorious moment, Ward strove to create a more "natural" narrative that would show the commander's steady underlying qualities—a pregnant pause amidst the din of battle. One was supposed to see that the horse had just reached a slight ridge, and that his rider was pulling back on the reins to stop and observe the battle developing somewhere in the distance. The stallion, leaning slightly forward, "snuffed the battle from afar," his excitement showing in his "dilated nostrils, erect ears, tense muscles, and waving, bushy tail."[55] The commander remained quiet and unmoved, straight-backed, a model of disciplined concentration. Art critics loved such moments of "repose," which allowed visitors strolling in the grassy park to appreciate the work at a slow viewing pace. The statue became one of Washington's best-known monu-

ments, routinely featured in articles on the capital and praised as one of the finest equestrian statues in the country.[56]

The Commemorative Map

The Thomas equestrian was located at the convergence of four streets—M, Fourteenth, Massachusetts, and Vermont, the last a radial avenue from the President's House. Marked "No. 9" on L'Enfant's map, it was one of the original fifteen "squares" reserved for development by individual states. That scheme died with L'Enfant. Not until the late 1860s was the intersection landscaped as a circle; by then the surrounding residential area was becoming a fashionable location "in the most attractive part of the city," as the *New York Times* observed, but still the circle had no focal point or commemorative identity. The installation of the Thomas statue instantly defined it as a place within the capital's emerging commemorative map. The monument was the sixth equestrian statue erected in Washington, all but one of them located in intersections in the surrounding northwest neighborhood and each marking a hero of a major U.S. war. The equestrian statues of Jackson (War of 1812), Scott (Mexican-American War), and McPherson (Civil War) were within a few blocks of Thomas, while Mills's statue of Washington (Revolutionary War) was a bit farther away. With the installation of the Thomas statue, the site was rechristened Thomas Circle, just as the statues of Washington, Scott, McPherson, Farragut, Dupont, and others renamed their sites. The monument enhanced the circle's prestige by giving it a commemorative identity in this rapidly emerging landscape. Thirty feet high, the statue on its pedestal was in keeping with the scale of its grounds and the well-appointed houses around the circle (which then looked nothing like today's circle, with its gigantic hotels and office structures).[57] Like the nearby equestrians, the Thomas statue served at once as a national monument honoring a war hero and a real estate amenity for an affluent urban setting. The Thomas monument was thus the creation of national and local forces that fueled the city's expansion, connecting new neighborhoods symbolically to the federal center, as L'Enfant had planned.

We cannot be sure why the Thomas statue ended up in its particular intersection. Monument proposals then were not subject to regulatory review, and locations were decided away from the public eye, usually in consultation with the Secretary of War and the Army Corps under his jurisdiction. As one critic later complained, the subject matter and location of public monuments "have been entirely left to chance."[58]

This was not entirely true, however. Although the distribution of monuments in the nineteenth-century capital may seem to be scattershot, two monumental axes of particular importance did emerge, aligned with L'Enfant's original cardinal axes (see figure 1). One was East Capitol Street, on the east-west axis of the Capitol building, and the other was Sixteenth Street, on the north-south axis of the President's House. The two axes crossed at L'Enfant's point A on the Mall, but in the nineteenth century the memorial energies worked outward and away from that center.

East Capitol Street, as we have seen, had Greenough's Washington at one end and Ball's Lincoln at the other. West of the Capitol building, on the same axis, these same two presidents would later get the much grander monuments that would establish the new monumental Mall of the twentieth century. But before then the line east of the Capitol, away from the Mall, was the one that mattered. The Sixteenth Street axis, located in the fast-growing northwest, saw more memorial action. Two monuments were located precisely on axis, the Jackson and Scott equestrians (1853 and 1874). By 1900, several other statues had been grouped around these two in their respective grounds, Lafayette Square and Scott Circle. In Scott Circle, for example, monuments to the great orator Daniel Webster and to the German homeopathic doctor Samuel Hahnemann (both 1900) created a short cross-axis with Scott in the center. Two other major monuments, to the Civil War heroes McPherson (1876) and Farragut (1881), were located in squares symmetrically balancing Sixteenth Street at the cross-axis of I Street. At the cross-axis of P Street, two more monuments to Civil War commanders were later added in eponymous circles on either side of Sixteenth: Dupont (1884), originally a standing statue of the naval officer (the fountain seen today replaced the original statue in 1921), and Logan (1901), an equestrian statue.

By the late nineteenth century, Washington boasted a profusion of newly ornamented grounds such as Lincoln Square, Thomas Circle, and Dupont Circle. Statue monuments played an important role in this development. As objects isolated on pedestals, statues occupied a special place amid the flower beds, trees, and curving paths, a place befitting their status as morally elevating examples for the national citizenry. They redefined and sometimes renamed their local grounds (for example, Iowa Circle became Logan Circle when the equestrian statue was installed there in 1901). In the process, statues created a commemorative network that spread out and superimposed itself on L'Enfant's street layout. Statue monuments were at once high points in their own local settings and nodes in a broader, if still loosely knit, landscape of national memory.

Guidebooks to the capital suggested that the best way to see and understand this landscape was to wander, preferably in "a carriage or a hansom with an intelligent

driver." There were no real shortcuts. An 1892 guide offered the following itinerary: a ride up Pennsylvania Avenue and side streets in the general direction of the White House and Lafayette Square; continuing through the "fashionable west end" to Dupont Circle; then returning via Massachusetts Avenue and Seventh Street to the Mall to see the Smithsonian and Washington Monument among other sights; finally, up to the grounds of the Capitol "and then down East Capitol Street as far as Lincoln Square, returning by way of North Carolina and Pennsylvania Avenues."[59] Repeatedly radiating from the center and back again, logging between five and ten miles of travel, the visitor would learn quickly enough that there was no simple and direct way of navigating the city's high points. Seeing the city's most important statues required a commitment to wander from one square or circle to the next, as if exploring the rooms of a large, well-appointed house. And just as ancient orators made a mental map of a house and its objects to memorize their speeches, visitors to the capital could make a commemorative map of the city to remember their visit and connect it to the nation's story of moral progress.[60]

Trees

The experience of this memorial landscape was shaped profoundly by the development of Washington's urban forest. The twentieth-century devastation wreaked on that urban forest makes it almost impossible to imagine the importance of trees to the nineteenth-century capital. Trees conspicuously identified the city with beauty and sentiment rather than commerce. Although that identification was misleading at best, it had a powerful hold on visitors and residents, who perceived—and misperceived—the city's diversity through a dense screen of trees.

In the early 1870s the city embarked on a massive campaign of tree cultivation, which in many ways became the envy of the nation. Tree planting was part of a huge program to improve the city's infrastructure, implemented largely by the Army Corps of Engineers. More than seventy thousand trees, planted over several years, shaded most of urban Washington. Where earlier tree-planting efforts had been ineffectual, the new campaign was implemented by experienced horticulturalists who took great pains to nurture new plantings. By the mid-1880s, *Century* magazine was reporting that "in this matter of trees, Washington is unrivalled among all the cities of the world." Trees, like statues, became inseparable from the capital's self-image. "Who in Washington is not a tree lover?" asked one writer in 1898.[61]

As Washington's trees matured in the last two decades of the century, many

observers marveled at how they had transformed the city. From the height of the Capitol, where Dickens had seen a scrubland of rude buildings and unformed streets, the city now looked carpeted in green, as if it had been "swallowed up by forest." "All but the tallest buildings and spires are obscured" by "a mass of luxuriant foliage."[62] The tree canopy could beautify the postcard views of the capital's monuments and at the same time cloak the alleys and the brothels and much of the rest of the city's working-class underbelly in a glorious haze of greenery. "I found beautiful lawns, magnificent buildings, splendid trees and foliage," one tourist wrote in 1884, "all just like fairyland."[63] Visiting from Europe in 1905, Henry James wrote that "one lost one's way in the great green vistas of the avenues quite as one might have lost it in a 'sylvan solitude.'" In full leaf, "the national capital is charming in proportion as you don't see it."[64] This covering of green, projecting an image of unity and harmony, masked a far more complicated urban plot.

Trees were also, as Downing knew well, repositories of sentiment. Like statues, they served as markers of memory and place, sometimes even functioning explicitly as living memorials. Across many different cultures and eras, trees have spawned repeated myths about shelter, danger, heroism, and freedom.[65] The connection between tree and memory had a powerful hold in the nineteenth century. Unlike a "pile of stone," a tree was an organism, a living connection to a remote past or to a particular person who may have planted it or used its shelter at some important historical moment. Downing wrote, "if we have neither old castles nor old associations, we have at least, here and there, old trees that can teach us lessons of antiquity, not less instructive and poetical than the ruins of a past age."[66] Sometimes old trees were lone survivors of the primeval forest and therefore summoned up the lost world of America before the white man; sometimes they marked specific events in the nation's past. Although much of this had little basis in historical fact, ancient trees wove a spell that seemed to guarantee the authenticity of the stories attached to them.

Long before the twentieth-century movement to erect "living memorials," it was already customary to designate old trees as memorials or plant new trees for commemorative purposes. They were often called "living memorials" or "living monuments," terms in circulation in the early nineteenth century, as in the case of George Washington, whose nation and city were themselves proposed as living monuments to his greatness. The tradition of "memorial trees" stretched back to the Revolutionary period and perhaps to the earliest European settlements in North America.[67] These living memorials no doubt had special resonance in the United States, with its history of political iconoclasm and suspicion of public monuments. Trees had much of

the formal power of columns, obelisks, or pyramids, without the didacticism; they did not tell the public what it was supposed to think or admire. And they required no special power or connections to create: anyone could plant a tree.

No ancient trees had survived in Washington, but by the late nineteenth century there was a growing collection of newer trees hallowed by the men who had planted them or saved them from the ax. The Capitol grounds had its own Washington elm, supposedly planted by the founding father himself. But probably the most famous tree in the capital in the late nineteenth century was the Sumner tree, also on the Capitol grounds, named after the Massachusetts senator responsible for saving it (temporarily) in 1874. The tree had apparently been planted from a sapling brought from Scotland by the naval commander William Bainbridge after the War of 1812, and it stood on the east grounds, facing the porch of the Senate wing and its marble tree-cutter in the *Progress of Civilization* pediment. Sumner intervened to preserve the tree from a massive regrading project, and a few weeks later he died. The tree thus became a public memorial, and the Capitol's nurserymen made heroic efforts over the next decade to save it in accordance with his "dying wish." Without Sumner alive to contradict them, increasingly elaborate stories began to circulate about the tree and his special connection to it.[68]

Unlike traditional monuments, which fixed their meaning in permanent inscriptions and images, trees changed with the seasons, growing and aging, and as they did their meanings visibly changed. Celebrated trees accumulated new stories, legends, and memories over time. In this way memorial trees were like John Nicholas's tablet for Washington—a blank slate on which memory could be written and rewritten, as long as the hero remained alive in cultural tradition. As time passed, the Sumner tree combined the national memory of a great politician with domestic memories of his everyday humanity into an ever more compelling package. Even after the tree finally died in the late 1880s, part of its stump was put on display in the Capitol building.[69] At the request of former congressman John Bingham—famous for writing the due process clause of the Constitution's Fourteenth Amendment—a new tree of the same species was planted in the Botanic Garden and came to be known as the Bingham-Sumner tree. Press reports drew attention to the tradition into the twentieth century.[70] Sumner had no statue anywhere in the capital (aside from a bust portrait the Senate acquired in 1894), but in the long aftermath of the Civil War and Reconstruction these arboreal artifacts evoked his name and fame.

The memorial tree phenomenon in Washington expanded in the second half of the nineteenth century as political figures began to plant their own memorial trees,

particularly in the President's Park, the Capitol grounds, and the Botanic Garden. By the end of the century, lists of these trees were in circulation. An interesting pendent to the Sumner tree was an overcup oak, native to Kentucky, planted in the Botanic Garden during the Civil War by the Kentucky senator John J. Crittenden. A Cotton Whig from a border state with divided loyalties, Crittenden had sons fighting on opposite sides of the war even though he himself remained a loyal Union man to the end. He is most famous for the effort he made on the eve of the war to forge a peaceful compromise, which was narrowly rejected after vigorous opposition from antislavery men such as Bingham and Sumner. For this reason, Crittenden's memorial tree came to be known as the "peace tree," a designation vigorously promoted by the superintendent of the Botanic Garden, William Smith.[71] The emergence of this new meaning no doubt correlated with the eclipse of Radical Reconstructionists like Sumner and the nation's increasing emphasis on reconciling North and South. In its incarnation as peace memorial, the Crittenden oak would come to play a significant oppositional role in the early twentieth-century conflict over the clearing of the Mall.

Picturesque Ground

Although memorial trees represented a "living" alternative to the statue monument, there was seldom any conflict between the two in nineteenth-century Washington. Lincoln Square, for example, had its statue of emancipation as well as a memorial tree to Thaddeus Stevens. Trees and statues mingled comfortably in the ever more articulated grounds of the capital. By the late nineteenth century, both the Washington press and the national press were hailing the tree-planting and statue-building campaigns as a national success story. Visitors "will be surprised and delighted," the New Hampshire *Herald of Gospel Liberty* reported in 1887, "with the broad asphalt avenues, lined with shade trees, forming miles of green vistas, and with the statues and fountains and parks and flowers that they will see at every turn." All this activity helped to define the once dusty expanses of L'Enfant's scheme. Street trees accentuated the lines of communication between the squares and circles, which in turn took shape as gardens punctuated by statuary. "Every view along the avenues ends in a cloud of foliage, with an equestrian statue in the heart of it," *Harper's Monthly* reported in 1895.[72]

Trees and monuments help explain why Washington emerged in the nineteenth century as the most important tourist city in the United States. Washington had always been set apart from every other major American city, since it developed as a repre-

sentational city rather than a commercial or industrial center. Once its physical charms suited its representational status, the tourist phenomenon accelerated. By the 1880s, "the embowering shades of Washington" had surpassed Niagara Falls as the destination of choice for newlyweds. Railroads and travel agents competed to offer cheap three-day "personally conducted" trips to and around the capital. Although the package tour and its naive tourists became fodder for humorists, there was little doubt that the expansion of tourism cemented the city's identity as a national showcase of natural beauty, commemorative art, and public collections.[73]

All of this happened in the absence of a formal monumental core, a "centripetal" space that condensed and concentrated the nation's experience. There was no "federal bond," Olmsted argued in 1874, and the planners of the early twentieth century echoed his complaint.[74] Washington's urban landscape had developed into an unplanned scattering of "sights" and locally agreeable environments. Public buildings and monuments were spread across the city, not quite as haphazardly as the planners claimed but hardly according to a centralized scheme. Although the systematic tree planting campaigns of the late nineteenth century added a connecting tissue to the scattered city, even that ordering effect reversed itself over time. As the shade trees grew larger, their green canopy began to disrupt the vistas and axial relations of L'Enfant's plan. Once the trees fully matured, they could even come to be seen in conflict with statue monuments that required space for visibility.[75]

Nowhere was the tree canopy more striking—or, the planners thought, more disruptive—than on the Mall itself, where the old "waste" ground took shape as an urban forest by the late 1870s. Downing's scheme was partially realized in the extended Smithsonian grounds stretching from Third to Twelfth Streets, where more than three thousand trees were growing by 1886.[76] Other departments, such as Agriculture to the west and the Botanic Garden to the east, were busy with their own tree-planting and horticultural programs. Increasingly, the Mall inspired sylvan views, whether from the camera or from the trained hand of the artist. A photograph of a deer in the dappled shade of the Smithsonian's woods seems to transport the viewer to a country estate (figure 34). Andre Castaigne's tonal illustration of 1894, *A Corner of the Agricultural Grounds*, is an elusive study of positive and negative shapes that suggests the shimmering heat and light of a summer meadow fringed by forest, even though the actual grounds of the Agriculture Department were much more formal in character (figure 35). Not a hint of the outlying city, or of the monumental capital, intrudes in these rustic images.

By the 1880s most of the fences and walls that had once separated the Mall's various parcels had come down, and carriages could drive nearly the length of the park

34 Deer on the Mall, ca. 1890. (Smithsonian Institution Archives [SIA], Record Unit 95, image no. 2002–10690.)

along winding, tree-lined drives. (The major obstacles were the B&P railroad tracks, which crossed the Mall along Sixth Street, and a brick wall and fence around the Botanic Garden at the foot of the Mall, both of which survived into the early twentieth century.) Although the Mall's reputation as a resort for hoodlums continued into the late 1870s, increased maintenance and policing helped make the grounds a more comfortable precinct for polite society. *Harper's Monthly* announced in 1881 that the Mall was now a "noble pleasure-ground," having "almost taken shape as the continuous public park it is intended to be." Some observers saw this result as an appropriate fulfillment of L'Enfant's original vision, even though the park's varied design did not adhere to his plan for a broad avenue down the Mall.[77]

By the end of the century the spreading urban forest effectively integrated the Mall with the surrounding city. On the ground, street trees extended from the grid into the Mall and connected the street layout to the park's picturesque drives. From a height such as the Capitol, the viewer could see the tree canopy spread across the grid and over the Mall, a green blanket unifying city and park. From above and below, Downing's division between the two was no longer absolute now that what James called "the great park-aspect" colored the whole of the capital, streets and grounds

35 Andre Castaigne, *A Corner of the Agricultural Grounds*, in "Washington as a Spectacle," *Century Magazine*, August 1894, 495. (Hillman Library, University of Pittsburgh.)

alike. As late as 1915, *National Geographic* declared that there was no need to bring the country into the city, as Downing had once argued, because "a mighty forest is growing in the midst of metropolitan life." Well before the Mall's central axes even existed, the capital was already "a city of vistas" framed by its celebrated street trees (figure 36).[78]

Olmsted's Critique

Frederick Law Olmsted, who witnessed this transformation during his tenure as landscape designer for the Capitol grounds in the 1870s and 1880s, had mixed feelings about it. He dismissed as misguided the enormous expenditure of time and money required to develop the city's ornamental garden landscape, with its tidy flower beds, costly monuments, and individually marked trees such as the Sumner tree. "At our national capital," he wrote in 1886, "while we are every year adding to its outfit new decorations in marble and bronze, formal plantations, specimen trees, and floral and bushy millinery, we leave the charmingly wooded glen of Rock Creek in private hands,

36 "A City of Vistas," photograph by Albert G. Robinson in *National Geographic Magazine*, March 1915, 224.

subject any day to be laid waste." Rock Creek, as Henry Adams would later recall, "was as wild as the Rocky Mountains," yet the government seemed to have more interest in nurturing a sick memorial tree than protecting a healthy forest.[79]

Olmsted rehearsed Ruskin's argument that modern sensibilities were supposed to value "all that in natural scenery which is indefinite, blending, and evasive," a good description of the sort of pictorial effect toward which Castaigne aimed in his view of the Agriculture grounds. Modern civilization, according to Ruskin, was no longer so easily impressed by formally organized landscapes that showed off the power of

human manipulation. The modern sensibility was less moved by artificial waterways than by rivers and oceans; less moved by single trees that stood out in the open than by trees merged "in groups and masses, as in natural woodsides." Yet, unaccountably, Washington had neglected these natural resources, focusing far too much attention instead on ornamental fashions and individual "specimen" planting. Olmsted, in his own plan for the Capitol grounds, had worked hard against these tendencies by clustering trees in groups designed to "obscure" their individual qualities.[80]

In his essay of 1882 quaintly titled "Index to Trees about the Capitol, with Advice to Visitors Interested in Them," one of the most interesting documents ever written on the landscape of Washington, Olmsted took the Mall area to task for its uncoordinated design and inadequate resources. A Downing disciple, Olmsted lamented that the Smithsonian grounds had not been given the reverent attention they deserved as the only public work of the late master. He was gratified that Downing had a monument there, one of the few nonmilitary monuments in the capital: "Nowhere will a monument be found commemorating a riper fruit of the Republic, more honorable aspirations, or devotion to a higher standard of patriotic duty." But the grounds themselves had not lived up to Downing's standard. Parts had become "stuffy and crowded," or "run down and poverty-stricken." Downing's larger plan for the Mall had been mostly ignored, and the park lapsed into separate parcels that were "unfortunately divided and fragmentary, and, each by itself, incomprehensive and incomplete."[81]

Despite his disappointment with the park's evolution and management, however, Olmsted saw great potential in the urban forest that was beginning to coalesce on the Mall. Trees, for Olmsted, supported a web of material effects and moral meanings that were vital to the landscape experience. Like Downing, Olmsted believed in the health and sanitation benefits of trees; he even proposed planting a belt of trees southwest of the Capitol building to block the "poisonous" air floating there from the river lowlands that was thought to carry disease.[82] But the effect on mental health was equally important to him. In his essay "Public Parks and the Enlargement of Towns," written before his involvement in Washington began, he had argued that town dwellers needed places where they could enjoy "the greatest possible contrast with the straining and confining conditions of the town, those conditions which compel us to walk circumspectly, watchfully, jealously, which compel us to look closely upon others without sympathy." The health benefits of the park depended on the ground and the trees, "those variations of the surface which, next to the woods, are the most important features of the design." Maps were too abstract to represent these potent surfaces, the "beautiful meadows, over which clusters of sheltering trees cast

broad shadows, and upon which are seen scattered dainty cows and flocks of black-faced sheep, while men, women, and children are seen sitting here and there forming groups in the shade, or moving in and out among the woody points and bays." Olmsted was describing a total environment meant to restore human sympathy—a multidimensional experience anchored, like the trees, in the material conditions of the ground.[83]

In the second half of the nineteenth century the Mall's urban forest served most of the real and allegorical functions Downing and Olmsted had assigned to it. For Olmsted the potential of this forest revealed itself best from a distance, specifically, from the very grounds he was redesigning. From the magnificent hilltop Capitol building, the forested Mall stretched to the Potomac River (figure 37). Viewed from this vantage point, the Mall's long history of ecological damage and bureaucratic fragmentation hardly seemed to matter. The various defects of design and coordination practically disappeared, and the whole merged into a single sylvan view "almost approaching grandeur."[84] To capitalize on the spectacle, Olmsted designed an enormous stone terrace on the west front of the Capitol and rearranged the tree plantings on the west grounds to clear the view toward the wooded Mall and block the sight of the urban development on the Mall's fringes. Both the opening and the closing of sight were equally important.

Today, government office buildings and sleek museums ring the Mall. In Olmsted's time, the Mall and its edges were a far more motley and diverse mix of commerce, housing, recreation, botany, art, and vice. The Centre Market, the largest food and grocery market in the city, was still thriving on the northern edge of the Mall (on the site now occupied by the National Archives). Nearby, at Sixth Street, was the B&P railroad station, whose sheds and tracks actually extended into the Mall. The Agriculture Department operated greenhouses on the south side of the Mall, and northwest of the Washington Monument the Fish Commission stocked ponds, popular with ice skaters in the winter. At Seventeenth Street, just inside the Mall, stood an old lock house built for the canal (still there today) that was abandoned at midcentury and occupied for generations by "colored squatters."[85]

Much closer to the Capitol were the two neighborhoods that had grown up around Missouri and Maine Avenues, on land formerly belonging to the Mall reservation. Densely developed, they had an intricate system of back alley housing that some thought was a breeding ground for crime and disease. In fact, scholars usually describe the whole area between Pennsylvania Avenue and the Mall (before it was leveled in the twentieth century for government buildings) as a "notorious" slum known as "Murder Bay," a term that actually goes back to Reconstruction and was a code

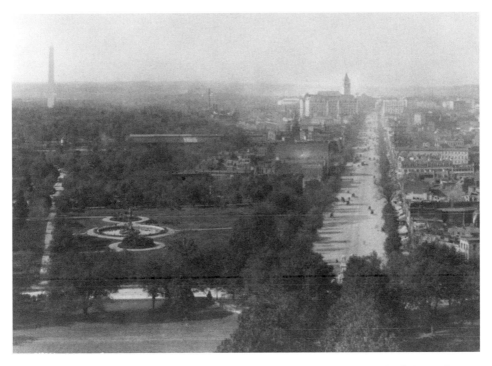

37 View of Washington from the Capitol, 1901. Photograph by Detroit Photograph Co. (Library of Congress, Prints and Photographs Division.)

phrase for the presence of contrabands, or former slaves. In genteel circles the area was known as "the disreputable quarter of the city" in the late nineteenth and early twentieth centuries.[86] Photographs, newspaper articles, directories, and census records reveal a more multidimensional reality. According to the census of 1900, residents were most likely to be single, white, male, and working-class, but still they were relatively diverse in race and status. Along Missouri Avenue, directly facing the Mall, were well-maintained brick houses (figure 38). A great flood in 1881 carried off "valuable carpets, pianos and other furniture"—hardly the possessions of slum dwellers. At the same time, the radical leader of the Labor League lived on the same street. In the early twentieth century the north edge of the neighborhood near Pennsylvania Avenue became part of the city's first Chinatown.[87] Across the Mall, the Maine Avenue neighborhood was more isolated, in a part of the city then known as "the island." Excavations in the 1990s revealed that on the current site of the National Museum of the American Indian an upscale brothel once thrived, managed by one of the richest businesswomen in the city, who probably catered to a Capitol building clientele. But the neighborhood as a whole was poorer than its counterpart on Missouri Avenue and more heavily African American (37 percent in 1900).[88]

This is not what Olmsted wanted visitors to the Capitol to see. On the west side

38 Corner of Third Street (right) and Missouri Avenue (present site of National Gallery East Wing), ca. 1930. (Historical Society of Washington, D.C.)

of the building he planted trees to "obscure the nearer part of the city" and focus the outlook instead on the woods of the Mall. He was using trees, as Downing had proposed, to conceal what he considered the city's defects. This was consistent with his approach to upholding public decorum in the grounds by means of design features to hide or prevent the ungenteel behavior that often took place in city streets. Against a backdrop of complaints about disorders and depredations on the Capitol grounds, he argued in 1880 that ordinary park seats were inappropriate "for reasons of taste and propriety, as well as the disorder and misuse to which they would lead." Instead he made special resting places hidden outside the main sight lines, "with all practical precautions against abuse." Two years later Congress went far beyond these measures by enacting a whole series of behavioral regulations—which prohibited loud talking, climbing on statuary, commerce, and political assembly, among other things—in its infamous "Act to Regulate the Use of the Capitol Grounds." This law survived for nearly a century before being struck down by the Supreme Court in 1972.[89]

Olmsted wanted people on the terrace of the Capitol to see an idealized sylvan core, free of the urban complexity that characterized the city itself. It was not the view we see today, with the central axis cleared of trees and defined by monuments to Washington and Lincoln. That view was not yet even in the imagination. Here is Olmsted's extraordinary description of the view from the Capitol in his 1882 re-

port: "An outlook is obtained between the northern and the southern divisions of the city in which a slope of unbroken turf, seen over a strongly-defined and darkly-shadowed architectural base, will be the foreground [the Capitol grounds]; a wooded plain, extending a mile beyond the front of the slope, the middle distance [the Mall]; and the partly-overgrown, partly-cultivated hills beyond the depression of the Potomac, the background [Virginia]; the latter so far removed that in summer conditions of light and atmosphere it is often blue, misty, and ethereal. Because, perhaps, of the influence of the cool waters of the river passing between the dry hills from north to south across this field of vision, sunset effects are often to be enjoyed from the west face of the Capitol of a rare loveliness."[90] For Olmsted it was not a spectacle of great buildings and monuments, artifacts of human construction. It was Ruskinian scenery, "indefinite, blending, and evasive." Like most picturesque descriptions, this one evoked a journey through a succession of grounds—turf, wooded plain, hills—and called for a viewer who could bring them into a pictorial unity. As Olmsted described it, the unity was that of a picture—made of soil, trees, and air rather than pigment and canvas. It had a recognizable structure from mid-nineteenth-century landscape painting, with a cleared foreground, a wooded middle ground, and an atmospheric background.

The Absent Shaft

There was only one problem with Olmsted's scheme: he could not screen out the Washington Monument. Although the monument had fit uncomfortably into Downing's plan, Downing at least acknowledged it. Olmsted's description avoids the monument altogether, as if it had disappeared from the view. Yet when he wrote his report, construction of the monument had resumed and it was rising rapidly. Under the direction of the Army engineer Col. Thomas Lincoln Casey, the shaft had reached over half its final height of 555 feet and already towered over the trees and gardens below (figure 39). Far from being indefinite, blending, or evasive, it was glaring white, hard-edged, and conspicuous. The journalist Grace Greenwood had predicted a few years earlier that the monument "would be a tiresome, obtrusive, unpleasant object in the landscape. In harmony with nothing in heaven or earth, it would be . . . four hundred and fifty feet of white unmitigated glare."[91] There it was in the middle of the sylvan view Olmsted described, the shaft introducing an entirely new sense of scale to the scene. He must have suspected that this enormous obelisk—designed to be the

39 The uncompleted Washington Monument, seen from the roof of the main building of the Department of Agriculture, ca. 1882. (National Archives, Record Group 54.)

tallest structure on the planet—would become the focal point of any view from the west front of the Capitol. Instead of following the subtle gradations of distance Olmsted saw—from turf to woods to misty hills, under a low horizon line—the eye would now leap across the Mall to the obelisk and measure the whole landscape against its towering height. While Olmsted modeled his beautiful vista on a nineteenth-century landscape painting, the Washington Monument belonged to a different universe. Unlike the typical "landmark," it drew the eye up and away from the picturesque beauties of the land's surface. Moreover, the shaft lured not only the gaze but the body of the viewer to its summit: by 1882 visitors to the monument were taking the construction elevator up to a dizzying height of more than three hundred feet, and trying there to make sense of a disconnection from the ground they had never experienced before.[92] The view from the top was not just higher than the prospect from the

Capitol building but qualitatively different. The Capitol prospect was anchored to the topography of L'Enfant's city; the view from the monument left it behind as the shaft catapulted viewers into a sphere far above.

A new spatial experience of the capital was being born. Olmsted could not yet grasp it, or perhaps he simply suppressed it as alien and unwelcome. Col. Casey's modern engineering marvel in progress spelled the beginning of the end of the sylvan ecology that the great horticulturalists had tried to nurture in the center ground of the nation.

3

The Mechanic Monster

How did the Washington Monument *happen*? It is one of the great mysteries in the history of American architecture—how such a triumph of modern abstraction would emerge in the midst of a picturesque park, at a time when most people thought of monuments as elaborate artistic combinations of figural sculptures and great words. The Washington Monument has no images, ornament, or words anywhere on its exterior, except for the tiny inscriptions crediting the builders on the nine-inch-tall aluminum apex, 555 feet above the ground, where only the birds, or gods, can read them.[1]

Few people at the time would have predicted this outcome. After the federal government took over the long-dormant project in the mid-1870s, dozens of ideas and detailed designs were proposed, everything from a triumphal arch to a neo-Aztec tower to a pedestal for Bartholdi's Statue of Liberty (the very one that ended up in New York's harbor). The original obelisk had almost no advocates, now that it was seen as an embarrassing hand-me-down from an earlier era. But it did have the unwavering support of a most crucial actor in the process, the visionary engineer in charge of construction, Col. Thomas Lincoln Casey of the Army Corps of Engineers.

Most histories attribute the design of the monument to Robert Mills, the early nineteenth-century federal architect who drew up the initial scheme for the Washington National Monument Society in the 1840s. As we have seen, Mills had envisioned a five-hundred-foot obelisk as the centerpiece of an amazingly complex confabulation of architectural and sculptural elements, including a huge circular colonnade, freestanding sculpture inside and out (most conspicuously a giant statue of Washington driving a horse-drawn chariot), and a variety of relief sculptures, inscriptions, and ornament on the shaft itself. By the time construction got started, in 1848, only the idea of the obelisk had survived, along with some residual ornament from the previous

scheme. This pared-down project became the unfinished eyesore that stood virtually unchanged through the Know-Nothing fiasco, the Civil War, and Reconstruction. When Casey was put in charge of construction in 1878, he rethought every detail of the surviving structure. Working outside the public eye, and sometimes in conflict with his own bosses, he carried the obelisk steadily upward but changed the height, proportions, and profile of Mills's shaft and did away with all traces of sculpture and text on the outside. He even removed the little scraps of ornament over the doorways that had been completed to Mills's specifications, to make the exterior surface uncompromisingly abstract. Inside the shaft, hidden from view, Casey made equally momentous innovations. He equipped the monument with the most advanced technology ever installed in a tower: a steam-powered elevator lit by electric lights. By the time he had brought the monument to completion, most observers seemed to agree with *Harper's Weekly* that "no one can examine this remarkable column without feeling that a new advance has been made in architecture."[2] It is hardly surprising that in the inscription on the apex Casey ignored the earlier designer and listed himself instead as "chief engineer and architect."[3]

Casey's engineering marvel frustrates classification. Dressed up in the most traditional of forms, and built without iron or steel structural reinforcement, the obelisk seemed the culmination of the Federalists' original dream of a sublime pile of stones recalling ancient models of commemorating rulers. (The monument is in fact taller than the Egyptian pyramids and still the tallest unreinforced masonry structure in the world.)[4] Yet the shaft was also a turning point, a skyscraper monument to engineering skill and industrial power that deliberately refused to be readable as art. It was radically out of scale with the picturesque landscape below it, and aesthetically jarring with its abstract planar surfaces, its sharp lines cutting like a dagger into the sky. Flaunting its difference from the capital's genteel environment of parks and statuary, the Washington Monument demanded of its visitors an entirely new experience and changed forever what could be imagined for the Mall's future (figure 40).

The Question of the Monument

Obelisks were a familiar monumental form in the nineteenth century, in the city and country alike. The most immediate design precedent for Casey—and one he studied carefully—was the 221-foot-tall Bunker Hill monument, erected outside Boston in 1826–43 to commemorate the first major battle of the Revolution. Obelisks like this were, first and foremost, place markers. They might mark boundaries, as when the

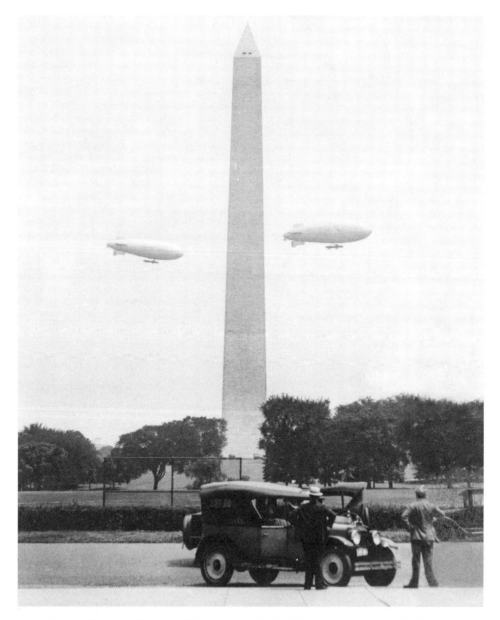

40 "U.S. Army Blimps, the T.C. 5 and T.C. 9 from Langley Field, Va., Passing Over the Washington Monument during a Practice Flight," ca. 1925. Photograph by National Photo Co. (Library of Congress, Prints and Photographs Division.)

federal government in the early 1850s erected a string of small obelisks from Texas to California to claim the new territory won from Mexico. More often they marked the site of a death or a dead body, as in a cemetery or on a battlefield. The Bunker Hill monument was the best-known example, but it had many companions. On a field in Wyoming, Pennsylvania, an obelisk funded by public subscription was

41 *Wyoming Monument*, in *National Magazine*, September 1858, 250. (Hillman Library, University of Pittsburgh.)

erected in the 1830s to mark the death of American soldiers in a Revolutionary bat-tle at the site; the shaft, inscribed with the men's names on the exterior, housed a vault with their remains inside (figure 41). Sometimes the practice extended outside the cemetery or battlefield. When New Yorkers decided to build a monument in the 1850s to the Mexican-American War hero James Worth, they erected an obelisk right

in the heart of town, at Broadway and Fifth Avenue, and moved his body to that spot, thus creating a public cemetery of one.[5]

The age-old Egyptian prototypes had a supernatural quality, because they were monoliths cut from a single block of stone; the nineteenth-century versions sometimes retained that magic by virtue of the sacred ground they honored. In effect they hallowed the ground beneath them by extending its presence upward into the sky, where it would be visible from a much greater distance. The Bunker Hill obelisk marked the spot where supposedly the first blood was shed in defense of American liberty. Thus, even though the monument is unadorned, it is not really abstract: it gains meaning by a mystical relationship to the ground below.

The Washington Monument, however, does not sit on ground sanctified by the blood or bodies of patriotic heroes. The spot does not even have any special historical connection to George Washington's life or death; he is buried a few miles away at his home in Mt. Vernon. The site is simply a point on a map, near but not exactly at L'Enfant's point A. Compared with Bunker Hill, the Washington Monument is more fundamentally abstract, since the ground it marks is empty of significance. Even the scale of the obelisk—more than double the height of Bunker Hill's—disconnects it from the ground beneath. The earthly foundation seems to pale into insignificance below the soaring reach of the shaft.

In form, the Washington Monument should mark a place when in fact it marks a person, a hero who is situated in a broad national consciousness rather than the particular spot of ground occupied by the monument. One of the great achievements of the nineteenth century—or one of its greatest follies, depending on your point of view—was to make hero monuments commonplace. As they proliferated, they gave the abstract idea of national consciousness, or national "memory," a concrete public form. Monuments to individuals took center stage because national history, as we have seen, was understood less as a process and more as a chronicle of great men doing great things. Men made "history" since they had the authority and the resources to achieve in a conspicuous public way. Military achievement, the ultimate masculine pursuit, ranked especially high in this scheme of things. Public monuments brought these men and their stories into privileged public locations, above all through the medium of portrait sculpture, the public statue. The monuments were unabashedly didactic, condensing the moral lesson of the hero in the form of his body and a few accompanying words.

As early as 1800, long before public monuments became a familiar sight in American towns and cities, iconoclasts worried out loud that if a national monument to

Washington were erected, "every pretender to greatness will aim at the same distinction."[6] The prophecy turned out more true than anyone could have imagined. While public monuments proliferated throughout the capital and the country, the republican suspicion of monuments lingered in ridicule and rhetorical jabs. A highly conspicuous project such as the Washington Monument was particularly vulnerable. When construction of the monument stalled in the 1850s, *Leslie's Illustrated* did not lament it because "the greatest monument to his memory is the union and prosperity of these States." As late as the mid-1870s, editorial opinion clamored for the monument's removal. "It is one of the blankest, ugliest, and most unmeaning piles that encumber the surface of the globe," *Harper's New Monthly* declared, "a memorial of public indifference not to the great Father of his Country, but to this form of remembrance." The *New York Tribune* called for the nation to abandon the monument and "give its energies instead to cleaning out morally and physically the city likewise named after the Father of His Country."[7] Even as statues spread across the capital, supposedly inspiring imitation and reverence, the question remained whether public monuments helped sustain a genuine collective memory, or were simply useless and dead, as the Republicans had originally maintained.

A Modern Monument

Congress finally decided to take control of the Washington Monument in the centennial year, 1876. Until the mid-1870s, that body had been divided over the necessity and wisdom of supporting such projects in the capital city. Democrats saw them as Republican schemes to glorify a strong centralized national authority that was dedicated, among other things, to black civil rights. Some Democrats professed to hate the very word *nation*. But as the Republicans in the 1870s backed away from the civil rights agenda of Reconstruction, Democrats could soften their stance. They were also cheered by the abolition of the District of Columbia's territorial government in 1874; its boss, Alexander Shepherd, had been a Reconstruction Republican with a strong local base of African American support. The new form of government, by appointed commission, disenfranchised district residents for a century. But it gave local white elites some authority and thereby created a governing structure more in line with the image of the nation that white Democrats, and ultimately white Republicans too, preferred.[8]

The commission form of government gave the Army Corps of Engineers even more authority over the development of the capital. It was not surprising, then, that the

Joint Commission set up by Congress to oversee the Washington Monument's completion named Col. Casey to take charge of construction. Today the idea of choosing a military engineer to build a monument would seem odd, to say the least. But since 1867, responsibility for the public buildings and grounds in the capital had shifted from the Interior Department to the War Department. (The Interior Department would regain responsibility in the 1930s.)[9] The shift had a certain logic: the Army Corps of Engineers brought nonpartisan professionalism and necessary expertise, adapted from its experience in building military fortifications and directing civilian infrastructure projects. Casey himself had worked during the Civil War building coastal forts and defenses.

In 1877, Casey was made chief of the Office of Public Buildings and Grounds for the District of Columbia. His duties ran the gamut from horticulture to major construction. On any given day he might be arranging the delivery of flowers to a congressman (from greenhouses on the Mall) or supervising the completion of the immense State, War, and Navy Building (now called the Old Executive Office Building). It was a very public job, involving large sums of money. Casey's immediate predecessor in the office, Major Orville Babcock, was notorious for financial corruption even though he accomplished a great deal; it is likely that Casey was chosen in part to reestablish the Army Corps' good name.[10] Casey appeared frequently in the newspapers, but he worked hard, for the most part successfully, to keep his reputation intact.

When the problem of the Washington Monument was dumped in his lap in the spring of 1878, he was in no mood to deal with it. There had already been numerous arguments and counterarguments about the strength of the foundation and the need to redesign the shaft. "It is a matter I care very little about," he wrote his father in March, "as the whole structure seems to be the football of quacks."[11] Casey was a consummate professional, who liked to solve problems dispassionately; he seems to have had little temper for the political gamesmanship that had long plagued the monument campaign.

An interesting insight into his self-image comes from the many letters he wrote to his father about his son Linck, who was then at West Point struggling to reach the top of his class. Casey had graduated first in his class in 1852, and he expected Linck to do the same. Casey's letters from this time are filled with charts showing the precise scores and standing of his son and the other top five or six classmates. Both Casey and his son believed that there was some kind of political influence against him at the school. "I think our tribe have always suffered more mentally from a sense of injustice than from any other cause," Casey told his father. "But there is lots of it in this world."[12]

[H.Mis. Doc. 7, 2 ses., 45 Cong.] *PLAN.*

42 Thomas L. Casey, *Plan for Strenthening [sic] the Foundation of the Washington Monument*, 1878. (Congressional Serial Set, vol. 1861, 45th Cong., 3rd sess., H. Misc. Doc. 7.)

Casey fell victim to that same sense of injustice several times during the many years required to finish the Washington Monument. When he finally sat down to the seemingly thankless task of rebuilding the shaft, he was both inspired by the challenge and filled with self-doubt. First, there were serious questions about the workability of the existing foundation. The unfinished monument was situated on a riverbank, near the intersection of the Potomac River and the old Tiber Creek (before it and the Washington Canal were covered in the early 1870s). Even though the Washington National Monument Society had located the shaft more than a hundred yards from L'Enfant's easily flooded point A, the foundation did not rest on bedrock and the stability of the soil there was uncertain. "I wouldn't build a house there," one con-

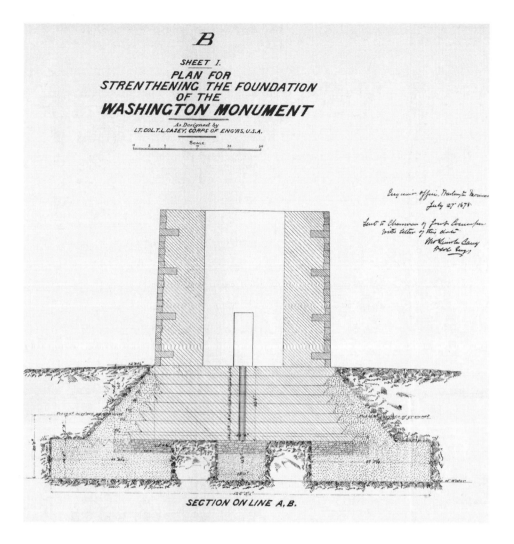

gressman said.[13] Moreover, the foundation seemed too small to carry the weight of the shaft as planned. Casey's first job was to calculate what size foundation would be necessary and then figure out how to build it. After three weeks of "figuring and cyphering" until his head "ached as if it would split," he came up with a plan to build a much deeper and wider foundation. The idea was fairly simple from the standpoint of structural engineering; the problem was the execution. Workmen would have to tunnel under the existing foundation, lay a new foundation underneath it, and then attach the new foundation to the old with a series of buttresses (figure 42). To find the right labor force, Casey recruited workmen from as far away as mines in Nevada.[14]

In the final analysis, the whole project was a calculated risk. No one, not even Casey,

could know for sure how the new foundation would behave. He ordered the work done, and then crossed his fingers as he started to build the shaft upward. "I have great faith to believe that the structure will stand on what has been prepared, but perhaps it may fail after all," he confessed to his father in the summer of 1880. "I hope and pray daily that it may succeed," he wrote the following year, as the shaft reached a height of two hundred feet.[15]

The difficulties of the foundation, as great as they were, paled in comparison with the political infighting Casey encountered almost immediately. The Washington Monument was the largest and most conspicuous public monument under way in the United States. No wonder so many people wanted a piece of the action—not just artists and architects who coveted the work and the exposure but also politicians who had their own vision as well as a sense of entitlement in spending the taxpayers' money.

When Casey complained that the monument was "the football of quacks," his remark was no doubt colored by the long and troubled history of the enterprise. But he also had more immediate problems on his hands, the most serious of them a continuing battle over who really had control of the monument's design. Nominally the five members of the Joint Commission did, and Casey answered to them. But the Washington National Monument Society retained an official advisory role and Congress held the purse strings. At key junctures Casey found himself caught between the Joint Commission, which itself had internal difficulties, and the two other bodies, whose ideas were often at odds with the commission's. With great finesse, he learned how to sidestep these conflicts and advance his own aesthetic vision, all the while denying that he had any design authority.

The conflicts that erupted in the late 1870s were very different from those that marked the monument campaign earlier in the century. Twice before, deep ideological divisions in the nation had intruded into the monument campaign, during the electoral crisis of 1800–1801 and the nativist movement of the 1850s. In both cases, George Washington—the man and the monument—became a battleground for competing visions of the American people and the American nation. But by the 1870s, Washington as symbol had lost much of his urgency. This is not to suggest that the nation was more unified. White supremacy in the South had been violently reestablished in the wake of the Civil War, and in the North the rise of monopoly capitalism was giving birth to the labor movement. Even though Washington himself was both a slave-owner and a capitalist, his mythic status made him increasingly remote from these struggles in the present. Washington's heroic persona became so abstract that he no longer seemed to matter, not even in his own monument. He

dropped out of the debate, only to reappear, trivialized, in perfunctory appeals for a "fitting" or "worthy" memorial.[16]

Here we can see the beginning of the process that ultimately led to Casey's embrace of abstraction: no one could articulate any content for the monument other than banalities. Although monuments were supposed to be powerful tools to instruct, or to inspire imitation, the didactic function of this project had already been superseded by a veritable onslaught of Washington monuments, images, memorabilia, and books. But even if the monument had little left to say, it still had a purpose, distinct from that of any other monument or relic. Politicians and critics alike agreed that, like it or not, it put a face on the nation. In its forlorn state of incompletion, the monument had been projecting a most unflattering portrait. The task ahead, as the critic Henry Van Brunt argued, was to transform the unfinished stump into a "modern symbol of national unity and greatness."[17] The key word here is *modern*. The monument was to be a fitting symbol of the *modern* nation and its newfound unity and greatness (even though, as we have seen, this unity was in reality compromised). The monument was not about the world of George Washington and his thirteen colonies; it was about a new nation that had split apart violently, reunified forcibly, and now stood poised to become an international power on the world stage.

What did matter, then, was the monument's form, its scale, its physical impact. These were the issues that erupted in conflict in the late 1870s. What would the monument look like, and would it do justice to the new self-image the nation's elites were trying to promote? Now began a protracted style war, a din and clatter on the margins of Casey's world that ultimately distracted his adversaries and left them unable to stop the engineer from adhering to a radically different vision.

Overwhelmingly, educated opinion of the 1870s rejected the obelisk as wrong, no matter how big it became. James Jackson Jarves, the art critic for the *New York Times*, was more charitable than most commentators when he found a "certain instructive propriety" in the obelisk, because it "fittingly symbolized the loftiness of the people's faith in themselves." Even so, the shaft was "destitute of aesthetic interest." For most other art critics, the mere idea of finishing the obelisk was horrifying. Even in Congress a steady stream of vitriol poured forth when the subject of the shaft arose: it was "a mere unshapely mass," with nothing but "its massiveness and its height to commend it." Only the "common mind," argued the *American Architect and Building News*, would be impressed by the obelisk's "plainness and height." Cultivated minds wanted more than just a "*big thing*"; they demanded, according to Henry Van Brunt, "elegant reserve and studious refinement."[18]

The antiobelisk rhetoric shows just how completely the nation's cultural elite had forgotten its republican roots. In the Jeffersonian period, the metaphorical sense of cultivation was still close to its literal basis in farming. Plainness was a virtue, a sign of republican simplicity and uncorrupted rational thinking. Even the Federalists had proposed a starkly simplified form for Washington's tomb. Not quite a century later, in a transformed political landscape and a vastly expanded consumer culture, cultivation was now synonymous with "refinement." Plainness was equated with backwardness and vulgarity; refinement was elevating, precisely what separated true art from shoddy consumerism. The Jeffersonian republicans' earlier faith in knowledge and reason had given way to a more agonized view of modern culture, strained by the explosive growth of industrial capitalism. Critics of the obelisk often called it a "chimney," as if the ultimate insult were to compare it to a common utilitarian form defined merely by its function rather than by the subtlety of its composition and ornamentation.[19] The monument had to be "refined" to represent the nation's advancing civilization, its triumph over the crass utilitarianism of modern life. This attitude was not a critique of progress or a sermon on the benefits of nature, in the mold of Downing, but a frankly elitist effort on the part of high culture to monopolize the public sphere for its own privileged cultural representation.

Although the critics were virtually united in demanding refinement, that demand failed to answer the problem posed by the monument. Before a form could be refined, it had to be imagined. The *American Architect and Building News* imagined something like Trajan's column in Rome, densely decorated with a continuous spiral of relief sculpture. If the shaft were thus "crowded with evidence of human thought, skill, and love," then "it would be a work of art, a true monument." Anyone with cultural pretensions agreed that public monuments had to include sculptural imagery of some sort. William Dean Howells wrote in 1866 that whatever architectural form monuments might take, they should always include "some significant piece of statuary."[20] Sculpture gave monuments meaning by translating their historical subjects into the language of human form. Only the most modest public monuments included no sculpture, and even these had inscriptions. It was practically inconceivable that a major monument would have not a single word or image on it. This is another reason why so many critics of the obelisk derided it as "a blank and meaningless pile."[21] But in a project of the scale and importance of the Washington Monument, there were no ready formulas for making it "meaningful," or representative of the nation. Trajan's column may have represented ancient Rome, but it was unclear whether it or any other European prototype could represent America.

In the late 1870s, responding to what some critics were calling an "emergency," artists and architects of all stripes submitted a dizzying array of proposals to finish the monument. This odd collection of unbuilt monuments constitutes one of the most striking episodes in the history of the nation's architectural imagination. The whole problem of a "national style," which plagued artists and critics in the late nineteenth century, was here compressed into one great public work.[22] Permanent and unchanging, the monument could not merely capture a fleeting characteristic of American life but had to embody something of its eternal essence.

Few of the commentators who kept track of the project could offer real guidance. James Jackson Jarves thought that a truly original American style was still a long way off, and in the meantime he could only recommend avoiding mistakes in taste. One of the few critics who applied himself systematically to the problem was Henry Van Brunt, who grounded his observations in a theory explaining why making monuments had become so complicated in modern societies. In earlier times, he wrote, each society had its own distinctive and powerful forms of memorial expression; monuments spoke "not only of the monarch or hero commemorated, but of the people who would honor him and the times in which he lived." Without any conscious design, monuments represented their people's distinct values and aspirations. But in "modern times, the visible memorial has in great part lost this expressive power; for architectural utterance has been distracted by archaeology, it has lost the divine virtue of simplicity, and is oppressed by the accumulation of knowledge; so that, by reason of the very completeness of its appreciation of the monumental expressions of antiquity, architecture cannot speak without a consciousness of itself."[23] Van Brunt yearned for the "simplicity" of a premodern past but conceded that modern architects in their self-consciousness could not recapture it. Thus architects had become in a sense ventriloquists, trying to speak modern thoughts through the styles of the past.

Van Brunt's analysis of the situation is typical of a much larger anxiety about the problem of art in modernity. Nietzsche had come to similar conclusions in ruminating on the role of history in modern life and art. In a celebrated essay of the early 1870s, he wrote: "We moderns have nothing that we have drawn from ourselves alone; we become something worthy of attention . . . only by stuffing and overstuffing ourselves with alien times, customs, arts, philosophies, religions, and knowledge." Creating an authentic national culture, what Nietzsche called "true cultivation," required the "destruction of modern cultivatedness."[24] Walt Whitman's call for a "poet of the modern" in *Democratic Vistas* (1871) also seethed with disdain for the false refinement of "dandies and ennuyees, dapper little gentlemen from abroad, who flood us

with their thin sentiment of parlors, parasols, piano-songs, tinkling rhymes." When Henry Bellows surveyed the state of American culture in an essay of 1876, he thought that a "truly American literature and art" were still decades away, and when they materialized they would come from the West, "the Valley of the Mississippi." In the meantime, the role of the East would be "mainly of a critical, regulative, restrictive, or polishing kind," rather than a generative force.[25]

The proposals for finishing the Washington Monument utterly confirmed the critics' pessimism, for they were almost all deliberate revivals of one historic form or another—Italian Romanesque campaniles, English Gothic towers, even Aztec temples. The most popular of these redesign schemes was a proposal by the expatriate sculptor William Wetmore Story, based loosely on late Gothic Italian bell-towers (figure 43). Story was unapologetic about its Italian pedigree. Like Jarves, he argued that there was no such thing as an American architecture, and since designers had to borrow forms anyway, they were better off borrowing from the heritage of the Italian republics, because these had more in common with the American political system than did aboriginal Mexico. Story and his supporters liked to present him as an artist who had found in Italy and its classical culture a refuge from modern society; the *New York Times* claimed that his life "arises like a beacon of light from the formless mass of triviality and money-grabbing, which constitute the joys of the modern world."[26]

But Van Brunt did not want to turn his back on the modern world. He was one of the very few critics who thought a solution might actually emerge from popular, low-culture traditions of design. For him, the inexpensive local soldier monuments that began to appear in the late 1860s, with their realistic soldier statues atop elaborately cut shafts, had "the elements of a true indigenous art" that came directly out of the untrained efforts of cemetery stone-cutters. But their problem was that they were "ungrammatical" and vulgar. The Washington Monument posed a similar dilemma: at one extreme was the obelisk, a "brute mass," while at the other was the Story design, "effeminate and dainty." A middle ground was needed, a way to temper brute energy (coded masculine) with grace and refinement (coded feminine). Van Brunt's reliance on gendered metaphors shows how architecture, for him, was caught up in a larger cultural crisis, in which male practitioners struggled against the fear of dependence and emasculation. The problem, however, was that Van Brunt was trying to square the circle. He wanted a learned vernacular, a style at once unselfconsciously modern and consciously tasteful, potent and refined. The only proposal that he found promising was almost laughably inadequate to his task: a huge pile "correctly set forth in the style of the modern French Renaissance [i.e., Beaux-Arts]"

43 William Wetmore Story, design for completion of the Washington Monument, ca. 1878, in *American Art Review* 1 (1880): 60. (Frick Fine Arts Library, University of Pittsburgh.)

44 Arthur Mathews, attributed, design for completion of the Washington Monument, ca. 1879, in *American Art Review* 1 (1880): 64. (Frick Fine Arts Library, University of Pittsburgh.)

yet presenting "strong points of affinity with some of the better Hindu pagodas" (figure 44).[27] This was modern? This was American?

Van Brunt was searching for something that Lewis Mumford would later deem impossible: a modern monument. Van Brunt wanted a form that would capture something authentically American yet satisfy the monument's inherently conservative demand for permanence and tradition. This was the very contradiction that would continue to ensnare monumental design in Washington well into the twentieth century. Critics such as Mumford were quick to point out, for example, that the neoclassical trappings of the Lincoln Memorial (1922) had nothing to do with "the homespun and humorous and humane America that he wished to preserve."[28] A new monumental language was needed, but the nature of the medium seemed to prohibit innovation.

The Technocratic View

The solution to the challenge posed by the unfinished Washington Monument did not come from the professions of architecture and sculpture, which were vying furiously with each other for the commission. They represented the traditional artistic realm of monumental design, which proved irrelevant to the outcome. The solution came instead from the belly of the modern beast itself—the technocratic bureaucracy of the Army Corps of Engineers. Casey solved the style problem by sidestepping it almost entirely. Rather than try to produce a representative style, he proposed a new way of thinking about the monument.

Casey succeeded where others had failed because he rejected the terms of the debate. He almost always discussed the monument project as a technical problem, not an aesthetic issue, and he protested that he had no design authority. "I cannot decide upon anything whatever for the Monument," he wrote the sculptor Larkin Mead in 1882, in his typical no-nonsense prose.[29] He and the Joint Commission clung to the official line that they had to build an obelisk because the act of Congress authorizing the work mandated the "continuation" of the monument. In other words, he was there only to help carry out the law. This was a transparent fiction. After all, as some critics pointed out, the original Mills design had included all sorts of other elements that were no longer being "continued," so why not make more changes? Casey himself was busy considering a host of design changes, concerning the proportions, surface treatment, and crown of the obelisk, though little of this thinking came

out in public and few people understood where he was heading. His plans emerged little by little, mostly in obscure technical reports or in internal correspondence.

The archives make it clear, however, that from the very beginning his vision had three key components. First, it was to be a "plain obelisk," a form "admitting no ornamentation." Second, it was to be an observatory. Mills's original scheme had included this idea in embryonic form, but Casey developed it much more elaborately; in 1878 he planned to crown the shaft with an iron and glass top. Third, it was to be a technological marvel. The Joint Commission had directed him to design for 525 feet, and he decided to make the most of it by including the highest passenger elevator as well, lit within by electric lights. "525 feet is higher than any structure yet erected by the hand of man," he wrote his father in 1878, "and such a height is hardly appreciated by even intelligent persons."[30] What to high-culture critics of his day was mere bigness, to Casey was a triumph of modern science. He had in mind an entirely new kind of monument inconceivable to those critics: a modern electrified skyscraper doubling as the most ancient of memorial forms.

To get there, he had to outmaneuver a formidable opposition. The opponents of the obelisk were far more numerous and vocal than its supporters. Even on the Joint Commission, the opposition had a major voice. The chair of the commission, William W. Corcoran, perhaps the most important art patron in Washington, hated the obelisk and was part of the chorus calling it a "chimney." He and Casey fought bitterly in the first couple of years. Corcoran was outnumbered on the Joint Commission, for the rest of the commissioners—including President Rutherford Hayes—were pragmatists who just wanted to finish the monument as soon as possible. But since Corcoran was a rich man and also an officer of the Washington National Monument Society, his opinions had to be treated with respect. Corcoran and many others in the society championed the Story proposal, and for a while, in 1878–79, that idea seemed close to getting congressional approval. The critics of the obelisk, however, soon sabotaged one another. Story's design came under attack in the art press. Meanwhile, other sculptors and architects were busy pressing their own claims to their particular congressional patrons. (Today it is hard to imagine any member of Congress even knowing a sculptor, much less championing his or her work. But in the nineteenth century it was understood that some members favored particular artists and worked to get them commissions.) After more than a year of this confusion, Corcoran noted disgustedly, the members of Congress became so "wearied with the numerous plans and suggestions of interested parties here" that they finally passed an appropriation to build the obelisk.[31]

Throughout this controversy Casey worked quietly on the foundation and let the critics argue with one another. From time to time he stirred the pot by letting sympathetic reporters know that there were enough plans and counterplans "to load a frigate," and if the society or the commission or Congress tried to sort through them all, the monument would never get built. One particularly sympathetic newspaper, the *Washington Gazette*, reported in March 1880 that the old "fossils" on the board of the Washington National Monument Society "have been so badgered by the contesting artists and have had such tremendous doses of high art forcibly rammed into their craniums that they are all in a daze and have been entirely unable to agree upon any of the designs presented." This was a favorite theme of the *Gazette*—the ineffectual, fossilized monument board versus Casey the expert modern engineer—except that here the paper also tarred "high art" itself with the associations of antiquarianism and incompetence. "Give Casey the money," the paper declared in 1878, "and tell him to go ahead, oh! ye legislators."[32]

Congress gave Casey the money reluctantly, in dribs and drabs. In 1879, when the clamor for Story's redesign was at its peak, the appropriation for finishing Casey's new foundation passed the Senate by only one vote. The following year, Congress appropriated $150,000 "for continuing the work on the Washington Monument," but it is not at all clear that Congress knew which design it was funding. In a classic bureaucratic tactic, the appropriation was buried among countless other line items in the Sundry Civil Appropriations Bill, an all-purpose funding bill, and thus afforded little opportunity for public debate. One of the few recorded comments came from Senator Justin Morrill, a vehement critic of the obelisk, who remarked, "I confess that I don't know what the design is."[33] The sculptor Larkin Mead later claimed that Congress thought it was appropriating money for his version of the obelisk, ornamented with sculptural reliefs showing important events in Washington's career. This sculptural version was one of the plans apparently approved by the Washington National Monument Society, and a sketch of it was on display in Congress in 1880 when the appropriation bill passed. Certainly, Corcoran, Morrill, and others all assumed that they would have a say in "finishing" the shaft with appropriate sculpture. But Casey had other ideas.[34]

The issue of decorating the shaft finally came to a head in 1882, when Corcoran pressed the joint commission to take action on Mead's proposed bas-reliefs. Having given up on Story's more radical proposal, Corcoran could settle for the obelisk as long as it had some sort of sculptural program. Mead was the major contender for the job: he had lobbied assiduously for years, using every trick in the book, to gen-

erate publicity for his ideas. Jarves had written in the *New York Times* that the Mead reliefs would "humanize the shaft" and "bring its meaning, apart from its abstract symbolism, more to the level of the ideas and sentiments of our civilization." Mead's sculpture would make the obelisk conform better to the standard didactic model of the public monument.[35]

Casey decisively rejected that model. All his drawings and descriptions of the obelisk from 1878 on show no sculpture or ornamentation whatsoever. Because the joint commission was nominally in charge, however, it had to make a decision on the sculpture question. The commission took one look and ducked, arguing that it had no authority to approve any decorative schemes. Congress was supposedly in charge of "design," while the commission was the mere builder. So the commission in March 1882 instead directed Casey to produce a sketch of a terrace below the monument that would include Mead's reliefs. When Casey responded a month later, he finally revealed the full scope of his vision. He asserted frankly that the obelisk was a form "admitting no ornamentation," and even went a step further. He recommended closing Mills's two entrance doors at the base of the monument and filling them with marble to match the bond of the outer walls. The doors, he argued, "detract from the character of an obelisk and lessen the impressiveness of the structure." To make them unnecessary he proposed an underground entrance through the terrace; the terrace would also hide the machinery needed for the passenger elevator and lights inside the obelisk. He wanted the illusion of an absolutely inviolate form, perfectly smooth and unbroken.[36]

On the question of how to decorate the terrace, Casey actually ignored the commission's instructions. Instead of producing a sketch that included Mead's reliefs, he recommended that Congress appoint a separate commission of eminent architects and sculptors to design a sculptural program for the terrace. This was most likely another ruse on Casey's part. Although his official letter to Corcoran conceded that the terrace "would seem . . . to be a work capable of extensive and splendid ornamentation," his private view was almost certainly the opposite. On this issue Casey usually did not let himself be quoted, but his subordinates, named or unnamed, casually dismissed the idea of any sculpture on the base. They scoffed at all the allegorical schemes—"the models of statues of peace and war, independence, progress, enlightenment and all that sort of thing"—which had come pouring into their office from sculptors and designers. "Severity" was the engineers' aesthetic credo. The *New York Sun* reported that Captain Davis (Casey's right-hand man) "wants his severe shaft to rise severely from the ground." "The plain, severe style of the monument," an

unnamed assistant was quoted as saying in another paper, "will rather discountenance any attempt at fancy work around its base."[37] *Fancy work* was a term usually referring to women's handcrafted projects at home, so its use here makes the very idea of sculptural decoration seem effeminate and out of place.

The engineers' rhetoric of severity and plainness seems to bring us full circle, back to the ethic of the Jeffersonian republicans. Both put their faith in reason; both dismissed the didactic claims of political imagery. But in fact, the politics of plainness had changed so drastically that Casey's appropriation of the term would probably have made the early republicans explode. Think of scale: Casey wanted the biggest building in the world; the Jeffersonians were constantly trying to shrink the monument and its cost. For them, plainness and grandiosity were fundamentally incompatible; they wanted a simple monument, to echo the simplicity of their republican system. Moreover, in their thinking, simplicity would bring the monument closer to the people. Casey had no such populist urges. For him, plainness was the right choice because it was the simplest technical solution and it cut a clean straight path through all the "quackery" of art criticism and legislative favoritism. To achieve his goal he had to establish a disciplined bureaucratic design process effectively hidden from public scrutiny. This strategy would have appalled men like John Nicholas (the author of the "plain tablet" proposal), who in another context argued that the people "should possess the purest information, as to not only the acts, but the motives of the public agents."[38]

In the end Casey got everything he wanted. The joint commission dutifully adopted his plan and sent his recommendation for a special terrace commission to Congress, which, as Casey must have anticipated, failed to act on it. As usual, too many cooks spoiled the broth: the schemes for the terrace were "about as numerous as the stones that have been placed in the shaft," Casey's unnamed assistant explained. The aging sculptor Clark Mills had confidently predicted to Mead that there would be "work for us all," but in the end there was work for no one.[39] In December 1884, with the obelisk virtually complete, Casey put forward a proposal for a simple earth terrace, and the joint commission adopted it on the grounds that it was less expensive. They also seemed to be thinking about how to coordinate the monument with the picturesque park that then surrounded it. Casey confessed to a reporter that "a pretty irregular slope, leading gradually up to the monument, would be much more effective" than an ornamented terrace. All hopes for a sculptural program promptly disappeared.[40]

Casey was not exactly alone in his effort to keep the obelisk "pure and simple."[41]

He had help from a prominent antiquarian, George Perkins Marsh, who schooled him in the minutiae of the obelisk form. Marsh argued that the Washington obelisk should resemble a monolith and have no openings. He taught Casey the true proportions of an Egyptian obelisk and thereby helped him redesign the top of the shaft from the relatively squat apex of Mills's design to a steeply pointed pyramidion. In Mills's working drawings of 1848, the height of the pyramidion had been considerably less than the width of its base; Casey reversed these proportions, elongating the pyramidion's sides and bringing them to an acute angle high above their base. The sharpening of the pyramidion created a true pinnacle for the shaft, with a soaring energy and a geometric purity (figures 45 and 46).[42]

Although Marsh played an important role in the monument's design, Casey himself was no antiquarian. Without any qualms he was building a modern tower. He took what he could from Marsh and rejected the rest. Marsh had nothing against sculptural reliefs on the shaft itself because true Egyptian obelisks had hieroglyphic inscriptions, including pictures. Casey's total prohibition of ornament had no justification in the ancient tradition. His observatory idea was equally wrong from Marsh's point of view. "There will no doubt be people who will be foolish enough to insist on a peep-hole somewhere," Marsh wrote; to lessen the harm, Marsh suggested that any "peep-hole" should be fitted with a matching marble shutter to be imperceptible from below.[43] Casey did change the plan for the top of the obelisk from his original iron-and-glass observatory to a pure marble pyramidion but retained the observatory function by cutting a total of eight "peep-holes" in the pyramidion, two in each face. Following Marsh's suggestion, Casey fitted each of them with marble shutters that, when closed, made the openings invisible. The marble shutters, now gone, were once a source of fascination to visitors (figure 47).[44]

Casey's adjustments thus created the illusion of a smooth, unbroken masonry surface, as if the tower were a huge stone crystal that had been cut and polished to perfection. Once he embraced this vision, he never deviated from it, finding alternative solutions whenever his first ideas turned out to be impracticable. For structural reasons he had to abandon the idea of an underground entrance, but he maintained the effect of unbroken masonry at the bottom of the shaft by eliminating one of the two entrances and outfitting the remaining one with a marble door, which, like the shutters, matched the masonry bond of the walls. To complete the effect, he stripped off the original ornament above the door, a survival from Mills's design.[45]

Inside the monument, however, was an utterly different aesthetic. Its interior walls were studded with all kinds of decorated and inscribed stone blocks, donated since

45 Robert Mills, architect, *Details of the Washington National Monument*, 1848. (Courtesy of Historic New England.)

the 1850s by states, cities, and various local associations. A staircase winding up the tower, lit by electric lights, allowed viewers to see this Babel-like interior, so at odds with the perfect uniformity and blankness of the exterior. This motley collection of stones seemed to represent the nation in its wonderful diversity, building the "imagined community" of the whole country into the belly of this single monument. By the time the monument opened, however, many of the stones were already relics of

46 Thomas Lincoln Casey, *Washington Monument: Plan and Sections Showing Progress of the Work*, 1884. (Congressional Serial Set, vol. 2310, 48th Cong., 2nd sess., H. Misc. Doc. 8.)

47 *In the Top of the Washington Monument, Harper's New Monthly,* April 1895, 663. (Hillman Library, University of Pittsburgh.)

a bygone era, "like so many Rip Van Winkles waking from their long sleep in blissful unconsciousness of the changes wrought by the passing years on the surface of things about them."[46] Reversing the nation-building process, relic hunters soon began to vandalize the stones to take fragments back home with them as souvenirs. All those artifacts fabricated locally and assembled laboriously in this one central shrine were slowly disassembled and dispersed by tourists taking back a small piece of the nation. The problem became so embarrassing that less than five years after the shaft opened to the public the monument commission considered closing down the monument altogether.[47]

This would also, however, have closed off the most celebrated feature of the interior, the passenger elevator, which lifted visitors to what was then the highest viewing platform in the world—a small space inside the pyramidion more than five hundred feet off the ground. The experience had quickly become a major tourist draw. *Harper's Weekly* boasted about the technological marvel by reviving the comparison once made between the obelisk and Trajan's column: this time the column came out a loser because it lacked an elevator. Whereas the visitor to Trajan's column had to ascend "by a weary flight of steps," in Washington's monument "the visitor will be seized upon by the genius of steam and raised in a comfortable elevator almost to

the copper [*sic*] apex at its top."[48] There visitors could stick their heads out the openings and look down from a staggering height on the capital city and the surrounding countryside. It is safe to assume that as they beheld an urban view unprecedented in human history, George Washington was not uppermost in their minds. "The shaft may commemorate the virtues of Washington," one newspaper wryly observed, "but it will certainly please the sight-seeing appetite of the American people."[49]

The view from the zenith was perhaps the most astonishing of all the monument's triumphs. Beginning in 1882, when it was not yet four hundred feet high, newspapers from around the country began to describe the "journey cloudward" and to clutch at metaphors for what they saw and felt.[50] Part of the drama was the elevator ride itself, a completely novel experience at the time. For ten full minutes—seven by 1893—the rider could neither see the outside world nor measure the progress of the climb by the usual bodily references of stairs and steps. It was "like going through a tunnel toward heaven," with "the sensations of curiosity, awe, fear, and surprise rapidly succeeding each other."[51] This was completely different from a gradual ascent on one's own power, with periodic glimpses of the world below. Even balloonists, who were beginning to reach fantastic heights, were able to watch the ground drop beneath them. Nothing in the elevator's strange ride prepared the visitor for the unprecedented situation at the top. Over and over, observers struggled to explain how they felt to find themselves so far removed from the ground that the ordinary benchmarks of human existence no longer seemed to apply. The view "gave the city the appearance of a child's play house," the *Washington Republic* wrote. To a reporter from Chicago, the street cars and wagons were so far below that they looked like "bugs." Even the Capitol dome, formerly the highest peak in the capital, now "looked squatty" far below (see figure 4). With the ground and the trees flattened out beneath them, visitors saw a region below that was "less like a landscape than a map" or a "checkerboard."[52] They found themselves in a new abstract realm, where even topographical cues no longer seemed to apply.

Olmsted's hilltop view from the west face of the Capitol, which until then had been the grandest prospect of the city, was now superseded by an experience that was both more intense and utterly incomparable. "Our accomplished builder has made an excursion into the regions of the air quite unparalleled," *Harper's Weekly* wrote in 1884. "Why should we not have houses as tall? Why abandon the upper regions of the air and cling so closely to the tainted earth?"[53] The "tainted earth" was another reminder of our deep-seated ambivalence toward the ground—the ground that feeds us is also our prison, the material realm that swallows our wastes and then swallows us when we die. The challenge issued by *Harper's* indicates that a new

realization was dawning: architecture might overcome the ground and conquer space. Balloonists had already begun to explore these "upper regions" and produce aerial photographs. As early as 1863, Oliver Wendell Holmes saw one of Boston taken from a balloon at twelve hundred feet, and felt it "a relief to soar away" from his own version of the tainted earth, the horrific battlefields littered with corpses that he had been studying in photographs from Antietam.[54] Technological ingenuity seemed to promise a spatial transcendence that only the gods of old had experienced. For the writer in *Harper's* the monument pointed to a future where people would not just soar into space but live there, free of the constraints that had bogged down human beings from the beginning of time. Long before Le Corbusier experienced the "bird's-eye view" from an aircraft and concluded that the cities of old were "finished," the Washington Monument was inspiring a new spatial ideal that would eventually be embraced by twentieth-century modernists like him and, in their own fashion, by the planners of Washington.[55]

Within five years of the monument's completion, the Eiffel Tower was built of wrought iron, with a viewing platform more than nine hundred feet high, far surpassing that of the Washington Monument and causing its short-lived achievement to be all but forgotten. The French have long made the "bird's-eye view" their own, producing some of the most memorable descriptions of it. The list includes not only Le Corbusier's musings in *Aircraft* but also Victor Hugo's famous chapter imagining the view in 1482 from the tower of Notre Dame (226 feet), Roland Barthes' analysis of the viewing experience of and from the Eiffel Tower (906 feet), and Michel de Certeau's account of his experience atop the World Trade Center (1,377 feet). De Certeau, ironically, comes closest to the early nineteenth-century American Ralph Waldo Emerson, who had his own transcendental experience of height without ever having to leave the ground. Just by standing erect, "uplifted into infinite space," Emerson became "a transparent eye-ball": "I am nothing. I see all. The currents of the Universal Being circulate through me; I am part or particle of God." For De Certeau, a century and a half later and a quarter mile higher, a modernist skyscraper enables the viewer "to be a solar Eye, looking down like a god. . . . The fiction of knowledge is related to this lust to be a viewpoint and nothing more." Somewhere between these two points, Emerson's transcendental vision upward and de Certeau's "voyeuristic" gaze downward, the Washington Monument was a critical—and mostly unacknowledged—step in the development of a modern spatial sensibility. Decades before photographers turned their cameras downward from New York City skyscrapers, tourists and professionals were doing so from the monument's eight openings, experiencing "the regions of the air" as only a few intrepid balloonists had been able to do.[56]

The Skyscraper in the Trees

When the obelisk reached its final height in December 1884, the *New York Times* fittingly called the result "undesigned." Casey must have had a good laugh, because this was the very strategy he and the joint commission had used all along. His art was the absence of art, or at least the absence of what most people thought art was. Even some of the monument's strongest supporters conceded that it did not represent the "advanced art" of the time. "The structure would make no appeal to a close and critical inspection as a mere work of art," the aged Robert Winthrop wrote in a letter to Congress that helped tip the political balance in favor of the obelisk. Instead, it would "add a unique feature to the surrounding landscape" and "attract the admiring gaze of the most distant observers." If art was a matter for close visual analysis, for connoisseurs who pored over minute details of execution, this monument worked at an entirely different scale. It imposed its magnificent bulk over a vast landscape, a landscape much bigger—physically and symbolically—than the park that surrounded it.[57]

Without question, the Washington Monument succeeded in remolding the landscape of the capital. It gave the city a whole new focal point, entirely different from point A as L'Enfant had imagined it in the eighteenth century. L'Enfant had envisaged a heroic portrait statue, a human image that would gradually come into focus as it was approached on two axes, from the Capitol and the President's House. Casey engineered a blank skyscraper that dominated the city around it. The shaft, far taller than anything in the local topography, created its own vistas, no matter what stood in the way.[58] Viewed from the Capitol, the White House, or the Smithsonian, the shaft seemed to float on a forested base, a needle in the sky against which all local distances would now have to be measured (figure 48).

Ironically, Casey's finished form seemed almost the logical extension of the old Federalist project. It was a leaner, simpler version of the original pyramid, inflated to such extravagant scale that it could not fail to inspire awe in even the most jaded observer. It was put together the old-fashioned way, just as the pyramid would have been, by stonemasons piling one block on another, without the benefit of iron or steel reinforcement; a single African American craftsman mixed all the mortar on Casey's watch.[59] Yet the shaft's uncompromising flatness and abstraction, its sharp-edged affront to the soft sylvan surroundings, struck a wholly new chord. Robert Mills's first design, for all its excess, would have fit more comfortably into Downing's original park. The Mills design had had variety in its profile and projections,

48 View from the Smithsonian building (under repair) looking toward the Washington Monument, 1930. (Smithsonian Institution Archives [SIA], Record Unit 285, image no. MAH-15103B.)

and architectural and sculptural accoutrements to give it scale. Casey's "huge white, staring monument," as one unsympathetic viewer described it, was the aesthetic opposite of the picturesque landscape that had evolved since Downing's plan.[60] The engineer deliberately stripped the shaft of anything that might give it human scale, or harmonize it with the curving paths and irregular tree plantings of the Mall's park. Its straight edges, sharp angles, and clean planes stood out with stark clarity from the sylvan surround.

Moreover, the visitor's experience in the gardens and winding drives surround-

ing the shaft was radically different from that of the monument itself. The elevator ride and thrilling view seemed to belong to the world of popular amusement rather than the genteel world of the public grounds. No didactic program in the monument counterbalanced the new technology of sightseeing the structure offered. The monument made no pretense of fostering moral regeneration but delivered, simply and effectively, a new perspective on the visitor's world.

Boosterism prevailed in the early reactions to the finished monument, but in a few instances one can see signs of a struggle to incorporate this strange new object into the landscape of the capital and the nation. The journalist Kate Foote, writing in December 1884, reported two divergent reactions she overheard on the west steps of the Capitol, representing the main divisions she expected would intensify over time. One side was repelled by the monument's utilitarian, engineered form. The other saw a beauty in the shaft and even accommodated it to the picturesque aesthetic. The two reactions are worth examining in detail.

Foote's more appreciative informant was immediately struck by the interplay of the object and the atmosphere around it. "How the morning light will play around its top," she reportedly murmured, "and the clear falling light of noonday will soften its gray-white sides; and at sunset how the clouds, rosy and golden, will bring out its perfect proportions!"[61] From a distance the pure surfaces of the shaft seemed to register the shifting light and atmosphere of the surrounding environment, which in turn modulated and naturalized the form's insistent regularity. Olmsted's account of the view from the same spot had ignored the monument altogether, instead describing the atmospheric effects of the luminescent river and ethereal hills in the distance; now it seemed as if the shaft had collected and focused all those atmospheric effects into its own immediate orbit.

Soon enough, atmospheric descriptions of the monument became a minor theme of Washington travel writing. An 1894 magazine article, "Washington as a Spectacle," by Marion Crawford (son of the sculptor Thomas Crawford) included stunning tonalist illustrations by Andre Castaigne of the monument wrapped in clouds and mist and extravagant descriptions of the obelisk seen at twilight and dawn, when the "lonely shaft" looked as if it "had stabbed night in the sky and drawn the sweet blood of daylight upon its point." The concluding note of his article was a poignant meditation on the view of the monument from Arlington cemetery, where the obelisk evoked a giant sundial, telling "in shadow-time for us, the living, the hours of the dead men's endless day." Shaft, sunlight, and sacrifice were all brought together in one great national view (figure 49).[62]

Writing at nearly the same time, the well-known nature and travel writer Ernest In-

49 Andre Castaigne, *A Quiet Evening—From the Virginia Shores*, in "Washington as a Spectacle," *Century Magazine*, August 1894, 493. (Hillman Library, University of Pittsburgh.)

gersoll gave perhaps the most sensitive account of the monument's visual impact in a *Rand McNally* guide to Washington, observing how "with every varying mood of the changing air and sky, or time of day, it assumes some new phase of interest to the eye"—sometimes "hard, sharp-edged, cold, near at hand," then withdrawing into the distance, its form softening and seeming "to tremble in a lambent envelope of azure ether," and finally swimming in a golden mist at sunset.[63] Ingersoll went on to tell his readers how to integrate the monument into a picturesque view, as if he were coaching amateur photographers. "The most picturesque view of it, doubtless, is that from the east [i.e., the Capitol side], where you may 'compose' it in the distance of a picture, for which the trees and shrubbery, winding roads and Norman towers, of the Smithsonian park form the most artistic of foregrounds." In Ingersoll's hands, the jarring contrast between the formal geometry of the shaft and the informal artfulness of the ground became a picturesque virtue. The cover of his guidebook featured a beautiful example of this picturesque contrast. A flat graphic composition, the image took advantage of the sharp simplicity of Casey's form to make the vertical line of the obelisk's corner bisect the large red W of the book's title in one strong red, white, and blue statement (figure 50). But as a naturalistic image the vertical format displayed a full range of light effects, from the watery foreground below to the atmospheric background above. Against a blue-and-white twilight sky, the shaft rose from a base of trees in simplified shapes, whose white outlines drifted downward into twisting currents and pools of reflected light on a pond at the bottom of the image (one of the fish ponds that still ex-

RAND McNALLY & CO.S HANDY GUIDE TO THE CITY OF WASHINGTON

PRICE 25 CTS

RAND. McNALLY & CO PUBLISHERS CHICAGO & NEW YORK

50 *Rand, McNally & Co.'s Handy Guide to the City of Washington*, front cover, 1893.

51 "The Washington Monument on an Autumn Morning," photograph by E.L. Crandall in *National Geographic Magazine*, March 1915, 233.

isted on the Mall at the time). Similar views of the monument rising from the trees (and the water) proved extremely popular (figure 51). Even after the vista from the Capitol was cleared in the 1930s, photographers continued to shoot the monument from oblique angles to create the same picturesque contrasts. Such views far outnumbered strict axial views of the shaft in the cleared Mall.[64]

If such was the picturesque appropriation of the engineer's shaft, the contrary view

reported by Foote in her December 1884 piece would have none of it. Despite all the design changes Casey made to the original shaft, to Foote's other informant it was still a "factory chimney." "It looks as if some manufacturing company, bloated to an unhealthy size by a government devoted to protection, had come here to the head-center and gratefully raised a higher chimney than any on the surface of the globe." For this observer, the monument brought to mind an unholy alliance between the federal government and industrial capitalism. The outlandish scale of the shaft, with its arrogant ambition to be the tallest in the world, made it the perfect symbol for a government that no longer served the interests of ordinary people but catered to the ever more concentrated wealth of large industrial corporations. Two years later, the highly influential art critic Clarence Cook also called it an "exaggerated factory-chimney" and took it to task for the absence of anything on its surface that could give it a recognizable scale. "It does not look its height because its uninterrupted lines give no means for calculation. The eye goes with one sweep from base to summit." Other observers would celebrate that same sweeping movement up into space, but for Cook it made the monument inarticulate, unable to address the citizen and the nation in any meaningful way. It was, he concluded, a "mere mechanic monster, where we had a right to hope for a work of art."[65] No doubt this mechanic monstrousness sprang not only from its incalculable height but also from the industrial apparatus that powered its interior, which for Cook must have seemed to overthrow art and consume the nation's citizens all at once.

The Blank Shaft

Casey's obelisk was a "mighty sign," the orator John Daniel declared at the monument's dedication in 1885. But a sign of what? At the most basic level, the monument seemed to be a sign of the nation's new power and unity. A monument that had stood unfinished for decades, a symbol of national failure, was now the tallest structure in the world. Its successful completion, despite so many pessimistic prognostications, was a ready-made metaphor for the reunification of the country after the Civil War. And its dedication became one of the first major post–Civil War rituals of "national reconciliation"; the choice of Daniel, a former Confederate, as the orator for the occasion was deliberate. The ceremony took place shortly after the inauguration of the first Democratic president since the Civil War, Grover Cleveland, a coincidence that one Massachusetts politician seized on to declare that the nation's "long night of disunion ends in the resplendent day of political peace and amity

throughout the land."[66] In reality, all the rituals and self-congratulations masked the federal government's systematic retreat from its initial postwar commitment to civil rights for freed slaves. By the time Casey had begun work on the obelisk, the nation had effectively given up its effort to protect minority rights and correct the lasting injustices of slavery. The "peace and amity" supposedly projected by the monument were purchased only with the acceptance of white supremacy and its violent social order, which lasted for a century.

This is not a public monument that could ever have a simple message of unity. More than any other monument before or since, it was a project built on ambiguity. On the one hand, the monument exemplified how modern democracy wins the admiration of its citizens. The shaft's technological ingenuity, scale, and strength were the very qualities America projected as an international power. (Let us not forget that this was a monument designed by a West Point officer and built under the jurisdiction of the War Department.) By drawing visitors inside its "monstrous" mechanism and lifting them up into space, the monument enabled people to experience its power as an extension of their own. On the other hand, the monument's blankness made its power ultimately unfathomable and raised the specter of "big government" that has frightened Americans since the days of the Jeffersonian Republicans. As much as this monument seemed to belong to its citizens and to give them a sense of heroic command, its own authority was as invisible and unknowable as the real workings of power in Washington were to those on the outside. The whole symbolic charge of the original monument—that it would be built by the voluntary contributions of the American people—proved a chimera, and the monument was rescued, as free enterprise so often is, only by a big government bailout. The shaft's empty exterior and its unreadable tribute to the builders on the apex perfectly expressed the hidden bureaucratic process by which the monument was finally made. This was indeed a "modern monument" that had nothing to do with George Washington and his agrarian world. It was a monument to technocratic wisdom and bureaucratic efficiency, seemingly accessible to a democratic people yet remote from their experience and understanding.

When the monument was finally dedicated on the 153rd anniversary of Washington's birth, the old-fashioned republican rhetoric about living memory surfaced once again. The poet John Greenleaf Whittier wrote that the "imposing" shaft was "but an inadequate outward representation of that mightier monument, unseen and immeasurable, builded of the living stones of a nation's love and gratitude, the hearts of forty millions of people."[67] Walt Whitman went beyond Whittier's polite rhetoric and pub-

lished his defiant poem, "Washington's Monument, February, 1885," a protest descended from the great early national tradition of republican iconoclasm. He dismissed the monument in the poem's very first line ("not this marble dead and cold"). Washington's memory was not fixed in a single object, no matter how big that object was, but spread everywhere, "far from the base and shaft expanding." The poem spun around the continents, to Europe, Africa, Asia, "Wherever sails a ship, or house is built on land, or day or night / Through teeming cities' streets, indoors or out, factories or farms." Moving through this seemingly inexhaustible list, the poet finally concluded, "Wherever Freedom, pois'd by toleration, sway'd by law / Stands or is rising thy true monument."[68] The message was remarkably similar to that of Nicholas, Jefferson, and even Winthrop at the laying of the cornerstone in 1848: Washington mattered only if his memory lived to inspire others to build a free society. (Never mind the slavery business: as usual this inconvenient truth was ignored.) The physical monument was a false idol, sequestered from the world; the real monument merged with life itself.

Whitman's republican critique had a ring of truth. Many public monuments do become lifeless, even in a national capital, as we shall see. But not the Washington Monument. Casey's obelisk took on a life of its own. Its mysterious combination of huge scale and empty content exerted a powerful hold on almost everyone in its orbit. The clash of opinions that Kate Foote had predicted would only harden over the years disappeared soon enough. Voices of dissatisfaction were drowned out by declarations of astonishment and pride. Although a few critics such as Cook continued to demur, the newspapers went out of their way to sing its praises. *Leslie's Illustrated* was typical: in the 1850s the paper had dismissed the design as an uninspired copy of Bunker Hill, but in late 1884 the paper's writers were calling Casey the "brainiest engineer" in the Corps and praising him for finishing the monument "in a manner that will awaken the admiration and wonder of all beholders."[69] Even erudite critics such as Henry Van Brunt admitted that a "vast amount of thought and skill" had gone into its completion. Within several years, the *New York Times* architecture critic Montgomery Schuyler declared that even though the design had been "opposed by almost the united art community of the country," there were "very few sensitive artists now who imagine that anything more effective than this tall crystalline, far gleaming obelisk could take its place."[70]

Still, the Washington Monument remained an enigma, waiting to be "finished." Many people imagined additions to it that would give it the didactic certainty that monuments were supposed to supply. Even Daniel at the monument's dedication speculated that bas-reliefs and "figures of Justice and Patriotism, of Peace, Liberty,

52 Thomas Nast, *From the Monument*, in Will Carleton, *City Ballads* (New York, 1886), 149.

and Union" might one day be added. According to Schuyler, the sculptor Augustus Saint-Gaudens proposed that a text such as Washington's Farewell Address should be inscribed directly on the shaft.[71] Contemporary illustrations of the new monument sometimes did the job themselves. In *City Ballads* of 1886, the famous illustrator Thomas Nast inscribes the monument's blank exterior with "U.S." at the top and a long list of states below; at its base are a framed portrait of Washington, an allegorical figure pulling back a flag, a smoking urn, and a quotation (figure 52). For many

53 Advertisement for Heurich's Beers, *Washington Star*, January 11, 1908, 9. (Reprinted with permission of the D.C. Public Library, © Washington Post.)

years a Washington brewery advertised its lager with a line drawing of the monument inscribed with the words Purity's Monument—associating the monument's high technology with the "scientific and medical experts" who recommended beer drinking (figure 53).[72] These were all imaginary acts of completion, wrestling with or capitalizing on the monument's mystifying blankness. The real completion of the monument would come when the landscape around it was cleared and transformed, creating a new, more abstract space that would remold the nation's center in the monument's image.

4

Inventing Public Space

Evening on the Mall, Washington. I walk on the grass, on axis. Flocks of swift starlings sweep toward the [Federal] Triangle and the city. Soon the lights will come on at the Capitol. I turn to look at the soaring [Washington] Monument and then back at the dome of the Capitol, rising above broad horizontals. Reciprocal forms, would that be the word? I walk, thinking inevitably of Versailles and St. Peter's and then of the things I am to write here. . . . Here is the Mall, surely tonight the most beautiful place man has yet made in America. At last the Monument does not stand beyond a woods from the Capitol; with the flow of space between them, they now join in formal relation.[1]

Here, in the midst of the Great Depression, came the epiphany for which the great landscape critic Elbert Peets had waited so long. After the Senate Park Commission first envisioned the Mall as a "flow of space" in its plan of 1901 for *The Improvement of the Park System of the District of Columbia*, its advocates had to spend decades working tirelessly against congressional resistance and local opposition before that space could finally take shape. To create this monumental core required acts of conquest and destruction far more sweeping than any L'Enfant had contemplated: the clearing and leveling of acres of trees and gardens, extensive demolition of housing, massive construction on landfill, and miles of new roads.

The key to this vast project was the Washington Monument. The plan of 1901 left little doubt that its "chimney" days were long past: "Taken by itself, the Washington Monument stands not only as one of the most stupendous works of man, but also as one of the most beautiful of human creations. Indeed, it is at once so great and so simple that it seems to be almost a work of nature. Dominating the entire District of Columbia, it has taken its place with the Capitol and the White House as one of the three foremost national structures."[2] The "mechanic monster" had now become a metaphor for nature, so powerful that the actual living things

on the ground around it—the trees and gardens and fish ponds—could be sacrificed to enhance its aura.

Here was a complete turnabout from Olmsted's vision for the Mall in 1882. Where he ignored the monument, the plan of 1901 embraced it; where he tried to construct a view as if it were not there, the plan's central spaces were organized around it. The change was all the more surprising because Olmsted's son Rick was one of the four commissioners who developed this radical new vision. As late as 1900, when he first publicly outlined his thoughts on the redesign of the Mall, he called the obelisk an "eccentricity," noble in its design but located off axis, without evident connection to the city around it. He still believed then that some of the Mall's picturesque grounds were worth preserving, even though he advocated clearing a formal axis in the center.[3] But when the plan was unveiled less than two years later, in a spectacular set of models and renderings, the "eccentricity" was the only feature of the existing Mall left standing. Everything else had disappeared: not just the Smithsonian grounds but the building too, along with every other remnant of the nineteenth-century landscape. In their place were long, straight corridors of grass and water framed by uniform alleys of elm trees, the basis of the twentieth-century Mall (figure 54).

For almost twenty years, photographers and guidebook writers had been trying to integrate the pristine monument with the picturesque landscape around it. The commissioners believed the time had come to choose between the two. In their plan of 1901, the decision was crystal clear. The Washington Monument was now the fixed, unchanging point around which they wove their dreams of a new monumental core. That decision made their plan veer away from L'Enfant's original scheme, despite all their claims to be restoring it. L'Enfant himself would never have dreamed of a blank obelisk 555 feet high: it obliterated the human scale and focus of his main vista.[4] The genius of the Park Commission designers lay in their realization that the very "eccentricity" of the monument—its abstraction and lack of scale and connection—gave it the power to shape a new autonomous space. Over and over, the illustrations in the 1901 plan feature the monument, the needle around which space flows (figures 55 and 56). Low horizon lines emphasize its presence and compress the ground plane beneath it. Nothing on the monument's blank surface compels us to stop and "read" it. The obelisk's sharp lines keep the eye in movement, at once lifting our gaze up off the ground and speeding vision longitudinally across vast distances. The monument draws us into and through space, subordinating the ground to a new compositional logic.

Not until the Mall was actually cleared in the mid-1930s could Elbert Peets finally

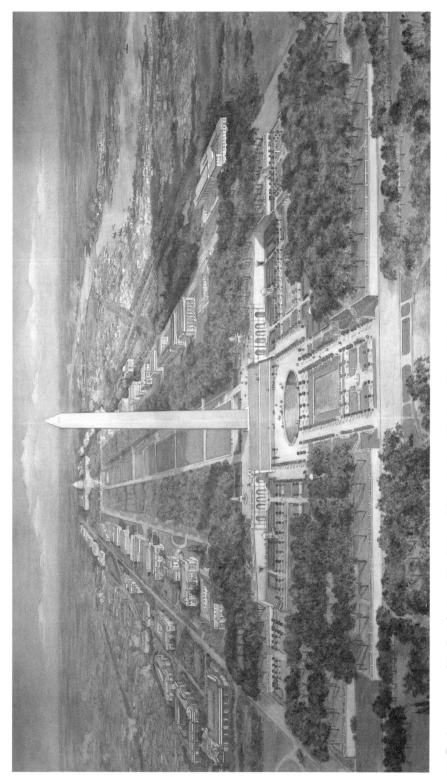

54 *The Improvement of the Park System of the District of Columbia,* ill. no. 58, *General View of the Monument Garden and Mall, Looking toward the Capitol,* 1902. (Courtesy of the U.S. Commission of Fine Arts.)

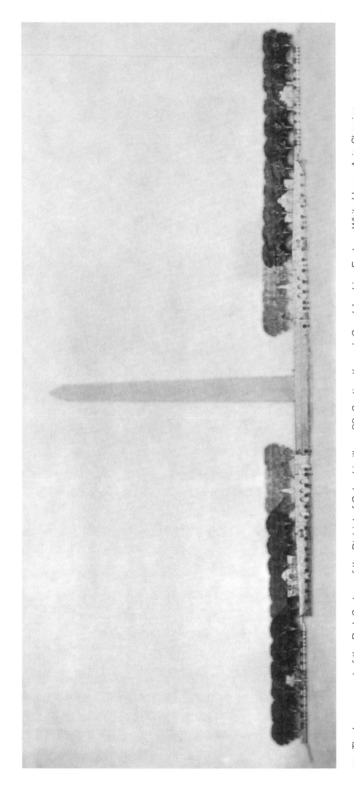

55 *The Improvement of the Park System of the District of Columbia, ill. no. 29, Section through Canal, Looking East, on White House Axis, Showing Proposed Treatment of Approaches and Terraces, Forming a Setting for the Monument. (Courtesy of the U.S. Commission of Fine Arts.)*

56 *The Improvement of the Park System of the District of Columbia,* ill. no. 47, *View of the Terrace and Monument Garden, Looking East.* (Courtesy of the U.S. Commission of Fine Arts.)

experience its flow, in the twilight of a summer evening. The planners had succeeded in replacing the public grounds of the nineteenth century with a new public space, designed to surround the Washington Monument and, in effect, live up to it. Theirs was a sweeping urban renewal project that eradicated the social and biological diversity of the nineteenth-century Mall, years before Robert Moses and others engaged in similar renewal schemes in New York and other American cities. If the plan was "imperial" or "statist," as some have claimed, it staged power differently from L'Enfant's scheme of territorial occupation, personified in the Roman commander image of Washington, at point A. Taking its cue from the blank shaft of the Washington Monument, the Park Commission plan staged power more abstractly, in a compelling spatial order. With a Union Square at one end of the Mall and a Lincoln Memorial at the other, framing the obelisk in the center, the plan enshrined a national narrative of reunification the authors no doubt believed would be universal and timeless. The new spatial order unified the geographic center of the capital and promised to overcome the fragmentation of both landscape and nation.

The achievement of this new order marked a decisive step in the modern "spatial turn" that so profoundly changed urbanism in the twentieth century. It was in space—with its qualities of abstraction, uniformity, and transcendence—that the twentieth-century planners believed the nation's true greatness could finally become apparent. The newly organized space of the monumental core provided a transcendental experience of the federal nation-state, a way to understand its spread and its authority not as brute physical power but as the work of an irresistible and beautiful system. The implementation of the plan, however, depended on real physical power, mobilizing the resources and energy of the national government to reshape facts and lives on the ground in a decisive, even pitiless, way.[5]

The War against Disorder

The story of the Mall's transformation has been told many times. Usually it begins in 1893 with the spectacularly successful World's Columbian Exposition in Chicago, the so-called White City, a temporary monument to American progress made to commemorate the four hundredth anniversary of Columbus's landing in the New World. The fair's stunning Court of Honor made the ideal of a City Beautiful come alive for millions of Americans. This ephemeral vision of a monumental civic center, constructed on undeveloped parkland, relied on formal axial planning organized by canals, sculptural focal points, and highly coordinated neoclassical architecture. When Sen-

ator James McMillan, in league with the American Institute of Architects, hatched the idea of a new plan for Washington, he reassembled the celebrated design team responsible for the Chicago fair: the architects Daniel Burnham and Charles McKim, the sculptor Augustus Saint-Gaudens, and, in place of the landscape architect Frederick Law Olmsted, his son Rick Jr. They were a cosmopolitan group, from Chicago, New York, and Boston, comfortable in the elite Republican circles that provided not only their art patronage but also the political momentum for the urban reform movement of the early twentieth century.[6]

In Chicago these men had worked with a relatively blank slate, an "unimproved" wetland where they could do just about anything. The Mall in Washington in the early twentieth century was hardly a blank slate, although some scholars have suggested that it was. According to one of the standard monographs on the Mall, "the land areas essential for [the plan's] ultimate realization still lay almost untouched."[7] This statement is hard to understand except as yet another instance of "willful blindness." The supposedly "untouched" land areas held the Botanic Garden and its structures; the Smithsonian Institution and Agriculture Department, along with their extensive grounds and greenhouses; ponds belonging to the U.S. Fish Commission; thousands of trees that had been carefully nurtured for decades; and, according to the 1900 census, homes for more than fifteen hundred people.[8]

Although the cosmopolitan men of the Senate Park Commission knew all this, they too minimized the destruction inherent in the plan. Their report made no effort to tabulate the homes that would be lost or the mature trees that would have to be sacrificed to create the grand spaces revealed in the plan. The report focused instead on the problem of the railroad station encroaching on the Mall at Sixth Street, as if this were the only serious obstacle standing in the way of a monumental core. From a business standpoint, it *was* the only problem. The resolution of this difficulty, the report declared, "removed the one great obstacle to the preparation of adequate plans for the improvement of the city." Only later, in congressional hearings on the plan, would Burnham concede that no grand improvement in Washington was possible "without destruction." For support he pointed approvingly to the example of Haussmann's redevelopment of Paris, which had "destroyed entire neighborhoods."[9] On the Mall similarly drastic action was required: everything *except* the Washington Monument would have to be destroyed to make way for the Park Commission's scheme of improvement.

The Mall was meant to be understood instantly as a national Court of Honor, a transcendent space unique in the capital and even in the country. The heart of the 1901 design was L'Enfant's east-west axis, adjusted a few degrees southward to align

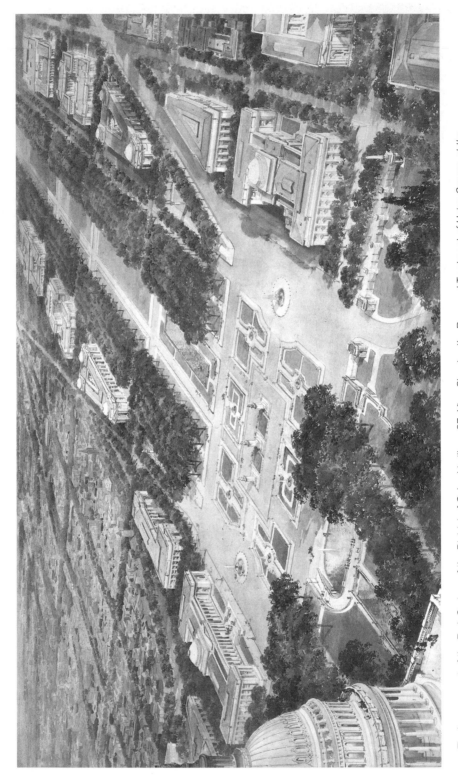

57 *The Improvement of the Park System of the District of Columbia,* ill. no. 37, *View Showing the Proposed Treatment of Union Square, at the Head of the Mall.* (Courtesy of the U.S. Commission of Fine Arts.)

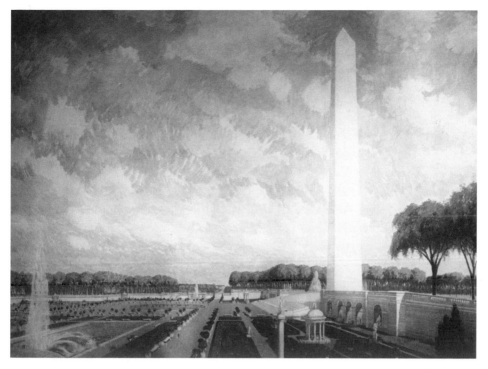

58 *The Improvement of the Park System of the District of Columbia,* ill. no. 47, *View in Monument Garden, Main Axis, Showing Proposed Treatment of Approaches and Terraces, Forming a Setting for the Washington Monument.* (Courtesy of the U.S. Commission of Fine Arts.)

it with the Washington Monument. On this axis the plan envisaged one continuous corridor of space, to replace the mixture of gardens and woods that currently intercepted both the eye and the body. First, at the foot of the Capitol, where the Botanic Garden had been located since 1850, would be a vast paved plaza called "Union Square," modeled on the Place de la Concorde in Paris, with equestrian statues of Grant and two of his subordinate generals on high pedestals in the center (figure 57). Then came the *tapis vert*, a wide carpet of grass extending nearly to the Washington Monument, flanked on either side by bosks of elm trees in four straight rows; beyond the trees would arise the "white palaces," as Burnham imagined them (see figure 54).[10] This composition, the heart of the Mall, would replace the extensive grounds, greenhouses, and tree collections of the Smithsonian and the Agriculture Department. The monument itself stood on a kind of shelf, below which a sunken "Monument garden" spread out to either side to reestablish the north-south axis originating from the White House (figures 54 and 58). This garden was essentially a huge spatial void floating above a shallow formally patterned landscape of urns, fountains,

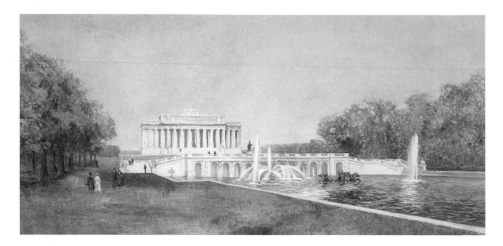

59 *The Improvement of the Park System of the District of Columbia*, ill. no. 49, *View Showing the Proposed Development of the Lincoln Memorial Site, Seen from the Canal.* (Courtesy of the U.S. Commission of Fine Arts.)

small temples, and elegant topiary. Finally, on the landfill west of the monument garden, a rectangular pool of water lined with more elm trees led to a large horizontal Lincoln memorial culminating the vista (figure 59).

The cross-axis from the White House was also to be formalized, with straight alleys of trees on the east and west edges of the axis originating from two possible monument sites immediately southeast and southwest of the White House grounds (figure 60). (The Sherman Memorial, in 1903, and a World War I Memorial, in 1924, would later occupy these two sites.) The centerline of the axis would cross the sunken Washington Monument garden and culminate in a large memorial in the Tidal Basin whose subject was left open. (It would eventually become the Jefferson Memorial.) The north-south cross-axis and the longer east-west axis together created the armature of a large, kite-shaped monumental core, deliberately carved out of the preexisting city. Within that core the designers envisaged only monuments, official buildings, and formal open spaces.

The plan was indisputably "big," and spared nothing to make the landscape unified and transcendent. In place of the Botanic Garden's idiosyncratic mix of greenhouses, gardens, and memorial trees, the plan proposed a monumental expanse without a single flower or tree. In place of the hundreds of varieties of trees and shrubs and the many flower gardens that spread out around the Smithsonian and the Agriculture Department, the plan unabashedly touted monoculture: one kind of ground cover (grass) and one species of tree (elm). No halfway measures were permitted.

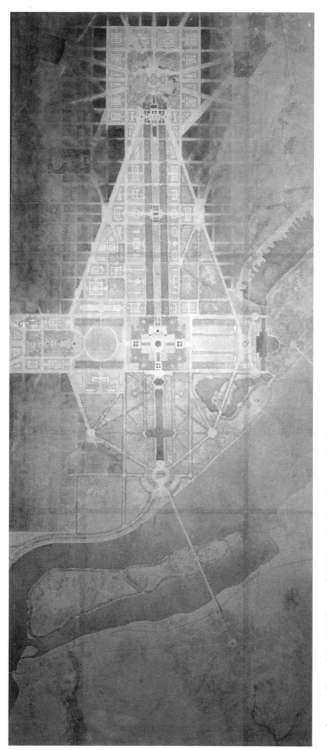

60 *General Plan of the Mall System* (1901), in *National Geographic Magazine*, March 1915, 2".

As the planner Charles Eliot II later explained, the 1901 plan belonged to the early days of the City Beautiful movement, when progressive reformers "went to war against disordered cities."[11] Listening to their talk of war and destruction, one cannot help thinking of the rhetoric of Downing, who wanted to make the landscape a moral compensation for these evils. The reformers of the early twentieth century were cut from a different cloth. They belonged to a world organized by monopoly capitalism, where expertise and efficiency were the watchwords. It was perfectly natural for Burnham to compare urban design to modern methods of military conquest and industrial production; he declared proudly that planning was "an element as vital in successful art as in a campaign industrial or military."[12]

The irony here is that Washington was already one of the most technocratically run cities in the nation. Since 1874, when home rule was abolished, the city had been ruled top-down by a federally appointed commission that included an expert from the Army Corps of Engineers. For the most part the local business elite approved of the arrangement, confident that "Washington is one of the best governed cities in the world."[13] Washington's problem, as far as the cosmopolitan designers were concerned, was not outright urban disorder but something more subtle: the capital had failed to become "a work of civic art." The city's managers had done an admirable job modernizing its infrastructure and planting trees but had failed to think comprehensively about the evolution of the city as a national capital.[14] Its development suffered from a lack of integration, of "system." Public monuments of dubious distinction were scattered willy-nilly around the city, and what should have been the nation's monumental core had been carved up into a series of heterogeneous landscapes and functions. On the outskirts of the city where large parks should have been, there were effectively none; and where there was a large park, in the federal center, its uncoordinated design failed to create a true symbolic core. As Olmsted had remarked thirty years earlier, "The capital of the Union manifests nothing so much as disunity."[15]

In the reformers' eyes, nineteenth-century Washington was hopelessly obsolete, littered with dead monuments and botanical clutter: it failed to commemorate meaningfully, failed to signify nationally. As we have seen, their view was hardly the majority view of Washington. Residents and visitors alike were proud of the city's extensive collection of outdoor statuary and seduced by the leafy beauty that gave the capital an overall impression of unity. Like most visitors, Henry James was struck by the "great park-aspect" of the city, but he echoed the reformers when describing what he called "monumental" or "imperial" Washington: it was a "clustered, yet at the same time oddly scattered, city," yielding "a general impression of somewhat vague, empty,

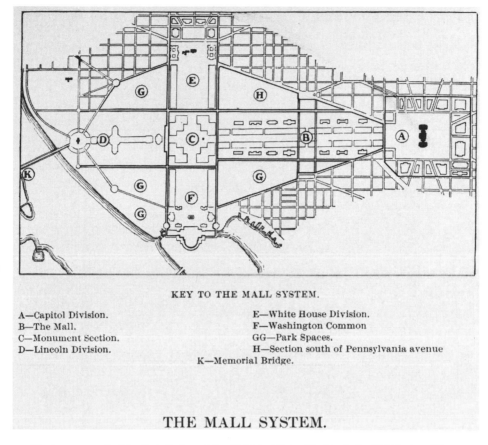

KEY TO THE MALL SYSTEM.

A—Capitol Division.	E—White House Division.
B—The Mall.	F—Washington Common
C—Monument Section.	GG—Park Spaces.
D—Lincoln Division.	H—Section south of Pennsylvania avenue
	K—Memorial Bridge.

THE MALL SYSTEM.

61 *The Improvement of the Park System of the District of Columbia, Key to the Mall System,* 35.
(Congressional Serial Set, vol. 4258, 57th Cong., 1st sess., 1902, S. Rep. 166.)

sketchy, fundamentals."[16] This was a legacy of L'Enfant's own principle of dispersed centers, which the monument builders of the nineteenth century had embraced wholeheartedly. But the men of the Senate Park Commission were more or less horrified at how this dispersed monumental landscape had evolved. They wanted a monumental center that was both concentrated and coherent, a well-regulated ensemble of memorials, museums, and other public buildings. Nothing else would provide the "simplicity with dignity" the federal government deserved.[17]

The Park Commission thus took extraordinary pains to create a compelling symbolic core. Like the Court of Honor at the Chicago fair, this was the linchpin of their whole plan. The commissioners devised many other innovative schemes that extended far beyond the Mall—involving recreation, transportation, hydrology, and woodlands preservation—but their "comprehensive plan" stood or fell on what they called the "Mall system," the reconfiguration of the city's monumental center (figure 61). This

62 Eugene Savage, *Charles Moore*, oil, 1935. (Courtesy of the U.S. Commission of Fine Arts.)

is readily apparent in Eugene Savage's flamboyant portrait of Charles Moore, the secretary of the Park Commission, painted in 1935 just as the Mall was finally being completed; looking like a lord before his dominion, Moore poses against a dramatic backdrop of the Mall's east-west axis, his life achievement (figure 62). Paradoxically, the commissioners' determination to create a strong monumental core also established, by default, a periphery; the hierarchical relation between them marginalized much of their own plan and thwarted the very integration they sought. This core-periphery dynamic has shaped—and limited—the understanding of Washington ever since.[18]

The idea of a monumental core was not exactly new. Bruff, in his 1847 illustra-

tion, had begun to imagine the Mall as a distinct center defined by the key structures on its edges (see figure 22). An eccentric inventor in 1874 wrote to the congressional delegate for the District with an idea, inspired by the Ming tombs in China, for a monumental boulevard lined with statuary, which he thought could be obtained by gathering together all the existing statues from their squares and circles and relocating them to the new boulevard.[19] In 1900, the capital's centennial had produced a number of new schemes on paper for boulevards down the Mall lined with public buildings. But for the Senate Park Commissioners it was essential to show that L'Enfant himself, in his original plan, had already imagined a unified center. Then they could claim to be rescuing L'Enfant's plan from the destructive hand of the nineteenth century.

As the commission report described the original design process for the capital in 1791, "The first consideration in its planning was the location of public buildings and the grounds relating to them." This was a thoroughly conventional way of defining the relationship between architecture and grounds: buildings come first, then the land attached to them. But a few pages later the report shifted into a different gear when it described what had happened in the nineteenth century: "The great space known as the Mall, which was intended to form a unified connection between the Capitol and the White House, and to furnish sites for a certain class of public buildings, has been diverted from its original purpose and cut into fragments, each portion receiving a separate and individual informal treatment, thus invading what was a single composition."[20] By grouping the assemblage of grounds into a "great space" the text was making an important move. The term *great space* now referred not only to the size of the land area, as it would have for Downing, but also to a more significant qualitative dimension. Space itself now had an integrative power, knitting together various spots and structures into a compelling whole.

The commission report repeatedly oscillated between grounds and space. That oscillation is symptomatic of the commissioners' own stance, one foot in the past and the other in the future. But when they sharpened their disagreements with the recent past, they moved more clearly in a spatial direction. Without question they believed that the nineteenth-century landscapers were not planners. The landscapers had failed to see that their little bits of ground, attached to this or that building, were part of a much more important space. It was the planners' job to unclutter the space and give it a new power—the power to subordinate grounds and buildings alike to a higher-order unity. To use a military metaphor, space was the commander, and the buildings and grounds the foot soldiers.

The Power of Space

Whether L'Enfant himself understood his project in these terms is highly debatable. It can easily be argued that the primary purpose of L'Enfant's L-shaped reservation was not to create a "unified connection" between the two federal houses—that job belonged to Pennsylvania Avenue—but to make room for "public walks," as he sometimes called them, leading to the equestrian statue at point A. The park he seemed to have in mind was not especially unified, at least by the standards of the Senate Park Commission designers. On L'Enfant's map the axis from the President's house had a much less formal character than the "grand avenue" on the Capitol axis. But even that east-west axis was probably not intended to be as uniform as the twentieth-century planners wanted it to be. Certainly the grand avenue in the center of the Mall had to be straight and clear, but it was to be "bordered with gardens ending in a slope from the houses on each side." It is quite possible that L'Enfant expected these gardens to be varied, even picturesque. Picturesque gardening had been coming into fashion in France since the mid-eighteenth century, and when L'Enfant referred to "walks artfully managed" and "trees artfully planted" in the vicinity of the equestrian statue he probably did not have straight and level lines in view.[21] Moreover, L'Enfant's schemes for building on the Mall were probably very different from those the Park Commission attributed to him. Burnham claimed that the original Mall plan called for "a line of white palaces, one on each side of the Avenue," an arrangement suspiciously like the Court of Honor in Chicago.[22] L'Enfant did imagine early in the process that the Mall could accommodate "play houses, rooms of assembly, academies," but by the time the plan was published he was referring to houses for foreign ministers, with gardens sloping down toward the Mall. In any event, however L'Enfant's thoughts evolved, the Park Commission's plan to make the Mall a concentrated precinct of museums, memorials, and technical-scientific buildings was its own vision, inspired by the new needs of the modern capital.[23]

The designers studied the L'Enfant documents as carefully as anyone, but they had a powerful incentive to shape all his ideas into forerunners of their own spatial "systems." The commission and its supporters were conscious of the need to legitimate their work by making it appear to revive the founders' vision for the capital.[24] They minimized their differences with L'Enfant and exaggerated similarities. This much is clear. The more difficult, and more interesting, question for us is whether L'Enfant himself envisaged the Mall as a "great space" that commanded the build-

ings and grounds in its orbit. Fundamentally, the question is whether it was even possible, in L'Enfant's time, to think of space in this way.

It has become routine to use spatial terminology to describe grand urban schemes from Sixtus V's Rome in the late sixteenth century to the Mall in the twentieth century. According to Spiro Kostof, one of the very best historians of urban form, L'Enfant and his predecessors were pioneers in a new art of "structuring space." The vision for Rome of Sixtus V seems particularly apt for monumental Washington: both opened up vistas marked by obelisks. In Rome these were actual Egyptian obelisks, monoliths about one-tenth the height of Casey's skyscraper. Kostof argues that they functioned as "space markers," to "fix the space" of an urban square.[25] The verb *fix* here means *fasten* rather than *repair*, and it functions metaphorically, since space cannot possibly be fastened. Before the turn to spatial terminology, the more straightforward term was *landmark*, an object literally fastened to a spot on the land. The obelisks in Rome marked the ground in front of an important church so that pilgrims walking through the city could reach their church by keeping the right obelisk in view; they functioned as navigational signposts, dividing long thoroughfares into segments and leading visitors from one segment to the next. If the landmark fixed anything, it fixed the viewer's eye on a spot in the distance. Similarly, the "statues, columns, and obelisks" in L'Enfant's plan were supposed to function as signposts marking midpoints or terminal points on avenues that stretched for miles. This system organized the capital's many distances both perceptually and cognitively: perceptually because the landmarks spread visual cues over what otherwise would be an unreadable sprawl; cognitively because the statues and shafts attached a unique commemorative significance to each local center they marked. By organizing the surface of the city into a meaningful pattern, the monuments enabled the eye, mind, and body together to experience a sense of command over the territory.

If we equate this command of territory with a command of space, as architectural scholars are now accustomed to do, we miss the key shift in sensibility that is the crux of the twentieth-century plan for Washington. That shift began in the late nineteenth and early twentieth centuries, coinciding with modern technologies that increasingly freed the human body from the ground. Skyscrapers such as the Washington Monument, equipped with new mechanisms of transport, began to make the traditional frameworks of terrestrial experience obsolete. In its breathtaking scale, the Washington Monument carried the eye up and away from the ground and the horizon and freed the body to flow imaginatively in space. The notion of a "space marker," to take Kostof's example, is much more appropriate to Casey's obelisk than to those of Sixtus V or L'Enfant.

The shift in sensibility is dramatic if we compare the Washington Monument to L'Enfant's scheme for point A. L'Enfant had positioned an equestrian statue monument near what was then the bank of the Potomac River; Washington's image, viewed from the walks leading up to it, would be framed by the wooded hills of northern Virginia in the distance. L'Enfant even talked about *lowering* point A, despite its swampy site, to make sure that the statue would not "intercept" this vista to the river.[26] Clear vistas to the south and west would create a strong visual link between Washington's statue, the river, and the open continent waiting to be occupied and put to use.[27] From the vantage of the Mall, man and nature would fit seamlessly together in a grand horizontal vision of expansion and progress. Casey's immense abstract obelisk blew this horizontal sequence to smithereens. The monument's sheer size, along with the absence of any decorative or figural detail to link it to its surroundings, overwhelmed the horizon line and "intercepted" the view in front. The modern-day obelisk produced a dramatic vertical expansion of the Mall every bit as important as the horizontal expansion created by the landfill in the Potomac River.

The Washington Monument complicated the Mall's relationship to L'Enfant's original plan and to the whole European tradition of grand manner planning, which the Park Commission invoked repeatedly to justify its work. Photographs of historical precedents from royal or aristocratic gardens and European capitals fill page after page of the commission's report. None of these gradual vistas to infinity, however, even when filled with decorative urns, fountains, or statues, included any object remotely like the Washington Monument in size or power. The "eccentricity" of Casey's obelisk, as Rick Olmsted had called it, shattered the very precedents invoked to redesign the landscape around it.

We think of vistas as naturally eye-catching delights, but axial perspectives into the distance are a peculiar, highly artificial, phenomenon. Keeping the viewer inside such a vista, subject to its power, is a difficult and, one might argue, unnatural preoccupation. The great garden designers of the seventeenth century, such as Le Nôtre, created strong axes in their landscapes but allowed diversions and incidents on the edges that sidetracked the visitor's attention.[28] These gave the vista a sense of scale and humanized it, enabling the visitor on the ground to explore and take some measure of personal control. The sloping side gardens L'Enfant himself planned next to his central avenue suggest that he took a similar approach to the art of the vista.

Philosophers from Spinoza to Walter Benjamin have long made a distinction between the distant, composed view of an urban landscape and the tactile or "haptic" experience of it up close. As Benjamin asserted in the early twentieth century in a much-quoted passage, "As soon as we begin to find our bearings, the landscape van-

ishes at a stroke like the façade of a house as we enter it."[29] Once we learn to navigate a landscape, in other words, we start to operate at a micro rather than a macro scale, heeding necessary bits and pieces of it at ground level and losing the extraordinary visual "composition" we get from afar. The Park Commission plan for the Mall can be seen as a systematic effort to prevent this perceptual shift from happening—to prevent the synthetic view from being swallowed by the "tactile" fragments. In a sense, the Mall axis keeps us from "finding our bearings," or more precisely, deprives us of all bearings but one: the Washington Monument.

To accomplish this, the Park Commission designers had to neutralize the Mall's variegated ground and replace most of it with simple planar surfaces—grass bounded by straight edges, or sheets of water confined in geometric pools. Sidetracking incidents were progressively eliminated. Lining the Mall's void with identical elm trees in a perfectly regular sequence, the design kept both eye and body focused on the channel of space that flowed toward and around the shaft in the center. As Peets wrote in 1922, when implementation of the plan was still far from complete, the longitudinal flow down the axis was all important and "every lateral pull upon the attention will diminish the essential value of the Mall." Thus the edges of the axis had to be kept perfectly uniform with every device of design: "uniform terraces and fences, hedges, and clipped trees—everything that will tighten the bounding walls of the avenue, define its channel, and facilitate its flow."[30]

In the plan of 1901 it was not enough to clear space in the center of the Mall; its external boundaries also had to be redefined and "tightened." The nineteenth-century Mall had a shifting array of ambiguous edges, making it impossible to draw a sharp line separating the city outside from the Mall inside. Residential blocks, a railroad station, greenhouses, occasional houses, baseball diamonds, and other features brought a whole range of urban activities inside the confines of the original Mall. The Park Commission plan rectified this situation by eliminating what were now seen as nonconforming structures and uses, and establishing a symmetrical composition of tree alleys and public buildings that effectively walled off the Mall from the urban areas to the north and south (figures 7, 54, and 60). By establishing a much more absolute boundary, the plan transformed the Mall into a homogeneous totality, a world unto itself.[31]

The uniformity of the enclosed Mall made the world outside it irrelevant and kept the viewer within subject to its unitary space. The various local landmarks of the nineteenth-century Mall—the giant mulberry tree near Tenth Street, or the lily pond near the Agriculture Building—were replaced with uniform plantings designed *not* to arrest attention, not to be place markers. If the mulberry tree told you that you had

reached Tenth Street, the elm trees told you nothing except to keep moving toward the obelisk ahead. The Mall's axis thus became a nonplace, where customary local bearings no longer applied. The Washington Monument loomed as the sole orienting feature, but severed from a normal landscape context its scale became unreadable. Its exaggerated size and the uniformity of its framing vista collapsed distance and made the shaft seem closer than it really was, thereby tempting the viewer onward toward a goal strangely out of reach.[32]

The Mall was transformed into a space where routine habits of perception had to be transcended. In the peculiar logic of the vista, a rigorous spatial discipline took hold of the viewer and did not let go. Peets called the effect a "flow of space." The expression is so commonplace now that we barely notice it, but it marks an important transfer of meaning. Space is not a medium like water or vapor. Space cannot literally flow, just as it cannot be fixed or fastened. Peets was taking the body's kinetic sensation (for example, the feeling of being propelled forward toward the obelisk) and attributing it to a power of space itself. This transference of human sensations to spatial powers is one of the distinctive intellectual moves of the twentieth century. In the creation of Washington's monumental core, that transference underlay the triumph of the nation. Space itself now became the "system" that reformed the Mall's tactile "disorder" and immersed the citizen viewer in an irresistible force.

The Spatial-Historical System

When the Park Commission plan was officially unveiled at the Corcoran Gallery of Art in January 1902, its vision of the Mall was so seductive that for a time it appeared to banish all doubt. The elaborate models, with an implied vantage point of two thousand feet above the ground (see figure 7), and the watercolor renderings, which collapsed vistas into breathtaking compositions, guided viewers to see the landscape as a planned ensemble in space. The scheme wowed President Teddy Roosevelt, most of the nation's architecture critics, and the local and national press. Even the *Washington Star*, which had lambasted earlier avenue schemes bent on destroying the Mall's trees and gardens, was temporarily enchanted, though it would later change its mind. A few dissident voices could be heard in letters to the editor, insisting, for example, that the Mall should "follow the lead of nature as fully and completely as possible." But for years they were ignored.[33]

The designers knew the adulation would not last. The visual experience of inspect-

ing models and renderings in an art gallery could be exhilarating, but there was still a real landscape on the ground with a long history of "tactile" associations for generations of residents and visitors. Rick Olmsted, writing an internal memo twenty-five years later, made clear just how well the commissioners understood this from the start. Much of the existing Mall, he conceded, had become "locally agreeable" as the trees and gardens had matured. The solution that he and McKim had devised in 1901 was not to sweep the nineteenth-century landscape clean all at once but to replace it piecemeal over a period of years: remove obstructive trees gradually to open up the vista; plant the formal rows section by section. Even after some of this work had been accomplished, Olmsted still believed the surviving remnants of the grounds of the Smithsonian and the Agriculture Department were "jealously cherished," and opposition to their destruction was "even today confidently to be expected."[34]

Locally agreeable facts on the ground—an old tree, a cherished garden, a house, a streetscape—are precisely what anchor people to places. For residents of Washington and longtime visitors, such "tactile" spots did not fragment the landscape or hinder more coordinated systems. Quite the opposite: the locally agreeable landscape knit human lives into recognizable patterns. In the minds of the park commissioners, however, these local attachments were mere clutter that undercut the idea of the national. The nation would have to make itself present, to find a space for itself, by replacing local attachments with an instantly grasped spatial unity, or what Burnham called "a great architectural picture."[35]

It was crucial not only to clear vistas and make spatial flows but to give this new picture an aura of national unity. For this the designers turned to memorials, to saturate the space with national significance. In 1901, when the designers were at work, the Mall already had five monuments, one of which was the obelisk. Each of the other four, raised separately by its own constituency, were related to specific public buildings or their grounds. The American Pomological Society's urn in honor of Downing graced the Smithsonian grounds; Congress's statue of Joseph Henry stood outside the entrance to the Smithsonian, where Henry himself had been the first director; the American Surgical Association's statue of the Philadelphia surgeon Samuel Gross (figure 63), now remembered chiefly because of Thomas Eakins's famous painting *The Gross Clinic*, stood near the Army Medical Museum (now the site of the Hirshhorn Museum); and the American Photographer's Association's nearby monument to the French inventor of photography, Louis Daguerre, marked the site of the nation's photographic collection in the National Museum (now called the Arts and Industries Building). (All four monuments were eventually moved, the latter two off the Mall.)[36] Connected only to their particular sites, they had no association

63 Alexander Stirling Calder, Monument to Samuel D. Gross, Washington, D.C., 1897, relocated to Philadelphia, 1970. (Library of Congress, Prints and Photographs Division.)

with one another; they were even more localized than the statues outside the Mall. Even if Olmsted were right that no monument was more patriotic than the Downing urn, most Americans would not rank high the hero of the national fruit-growers association. With the exception of the obelisk, the monuments inside the nineteenth-century Mall commemorated marginal figures in the nation's history, whereas the statues that defined the squares and circles of the outer city honored presidents and military commanders.

The park commissioners were determined to reverse this arrangement. Monuments to surgeons or horticulturalists or French inventors had no right to occupy the capital's most potent central space. Only the most important national figures, and the most important monuments, belonged there. Rather than perpetuate the fragmentation of the public into multiple constituencies (photographers, surgeons, pomologists), the monuments should draw Americans together into "one people, with common purposes and aims, common ideals, and a common destiny."[37] Above all, to unify the space around a common national theme, the monuments needed to relate logically to one another. Otherwise they would continue to create disparate pockets of merely local interest.

By the time the commissioners set to work on the Mall, the Civil War had come to permeate national culture: it was the defining event of the modern nation, in effect a second founding. More than a third of the statue monuments erected in Washington in the second half of the nineteenth century commemorated Civil War heroes. But not a single one of these stood inside the Mall.[38] While the statues outside the Mall reinforced the theme simply by adding individual heroes to an ever-growing parade of Union leaders, the commissioners saw the Mall as an opportunity to condense the theme into a more definitive, final form. With the Washington Monument in the center, representing in abstract form the birth of the nation, the outer poles of their composition could be devoted to the solemn story of the nation's rebirth: what Lincoln at Gettysburg called "a new birth of freedom."

Two national figures loomed large in the commissioners' minds: Lincoln, who had established the birth-rebirth narrative in the Gettysburg Address, and Grant, who had redefined warfare to make that narrative victorious. Both were Republican demigods—obvious figures to choose, given the Republican allegiances of the commission and its supporters. Lincoln had died a martyr, but Grant had lived on and become president for two terms, presiding over most of the period known as Reconstruction, when the federal government tried, but failed, to establish equal rights for the millions of former slaves in the South. This part of the story was inconvenient, to say the least. For the monumental core, the national narrative had to culminate decisively, not linger inconclusively. The story needed to be kept simple and abstract, like Lincoln's address.

Grant had no monument yet in Washington, though a competition was under way; Lincoln already had two outdoor statues, including the so-called Emancipation Monument, but neither one came close to meeting the commissioners' standards. To create a "Mall system," the memorials could not be mere statues inserted some-

where in the public grounds. They had to look completely integral with the space, as if they had always been there or always meant to be there. They had to surround and embrace the Washington Monument without competing with it. At first the designers experimented with making each memorial the terminal point of a separate axis, the Grant Memorial at the west end of the Capitol axis and the Lincoln Memorial at the south end of the White House axis. Eventually, though, they decided to leave an unspecified memorial structure in the latter location and to put both Civil War monuments on the principal east-west axis. Lincoln's monument would terminate the axis, in the landfill of Potomac Park, and Grant's would originate it, at the bottom of the hill below the Capitol building, in the new Union Square.[39]

Both monuments would need to be immense to hold their own at either end of an axis nearly two miles long. As a terminus, the projected Lincoln Memorial was essentially a classical billboard: Charles McKim envisaged the structure as a double colonnade supporting an attic story that would carry a giant inscription from the Gettysburg Address, the whole elevated on a high plinth (see figure 59). Below and in front of the building stood a much smaller portrait statue of Lincoln, duly subordinated to the architectural and literary climax up above. In contrast to the Freedmen's Memorial, Lincoln here would no longer appear as a liberator of slaves; his achievement would be generalized in the more abstract rhetoric of "a new birth of freedom." On the other end of the Mall, the statues of Grant and his generals, set on pedestals high above the enormous expanse of Union Square, said nothing about the legacy of the war they helped to win. They simply commanded the vista and set the space in motion; Lincoln's words terminated it. Together the two monuments reframed the Civil War as a story of national salvation, rather than liberation.

In one stroke the Union monuments defined the limits of the expanded Mall and reorganized its content. If Washington's obelisk gave birth to the space, the two monuments at either end would complete it. The Mall thus became the spatial equivalent of the nation's history, condensed to a simple sequence of birth-rebirth, founding-restoration. Just as the war had established once and for all the principle that the nation was unitary and indivisible, the monuments established the principle that the Mall was a single system, speaking in one universal voice. In this spatial-historical system, the nation finally established at least the appearance of undisputed dominion. The abstract power of the nation-state found its supreme expression in the command of space, which bound three great national monuments together into one conspicuous center. Space thus created a new kind of enlightenment, revealing the nation as a mysterious organizing force, rivaling nature itself.

The Segregated Center

While racial injustice persisted unabated, and social and economic conflicts inten-
sified, the monocultural system of the Park Commission's Mall would push all that
aside to the margins, just as it pushed aside the trees and gardens, the statues and
houses that would have disturbed its all-encompassing, self-enclosed spatial unity.
Their Mall was a white space, undisturbed by minority voices. All the grand talk of a
"common people" with a "common destiny" papered over key absences, without which
the illusion of universality would have been shattered. The commissioners' Civil War
theme simply ignored those stories that did not fit the unifying narrative of national
rebirth. The defeat of Reconstruction, the triumph of white supremacy, the daily strug-
gles of African Americans to survive and prosper in a segregated world all found no
place in the National Mall.[40]

The dreams of the Park Commission set in motion a process that displaced not
only inconvenient histories but actual people, in the interest of ridding the Mall of
what Burnham called "the ugly, the unsightly and even the commonplace."[41] The
demolition of lower-class residential areas to make room for nationally significant
space was happening at the same time in Europe, especially in Fascist Rome.[42] Here,
on the Mall, this new spatial sorting was unprecedented. Among the most "unsightly"
features on the Mall were the two residential areas along Missouri Avenue and Maine
Avenue, relics of the 1820 compromise on slavery. According to the census of 1900,
the two areas combined were home to 1,550 people, though they lost about a quarter
of their population in the next twenty years as the federal government planned for
their demise. They brought the messy realities of American urban life right inside
the original boundaries of L'Enfant's Mall, and in so doing contaminated the tran-
scendent space that Burnham and his fellow designers intended to create.[43] The areas'
internal alleys, especially on the Maine Avenue side, had become one of the primary
exhibits in a budding reform campaign to eliminate urban "filth" and substandard
housing. Prostitution had long thrived there, but the area exhibited a resilience that
received much less attention. For example, the former bordello on the current site
of the National Museum of the American Indian had by 1901 been converted into
the Miner Institution for the Education of Colored Youth, one of the many institu-
tions of black uplift in Washington struggling with the challenges of an increasingly
segregated environment.[44] The Missouri Avenue side was more white and more pros-
perous, though still very diverse by Washington standards (see figure 38). Neverthe-

less, scholars, without any in-depth study of the area, have characterized it with the very words—*filth, crime, slum*—often used to rationalize demolition and displacement.[45]

Typical of the "planning" of that era, no provision was made for the displaced residents of these two areas. Even though at least one local housing organization did ask the Park Commission designers to give "special consideration" to conditions in the poorer neighborhoods, there was no mechanism in the planning process to recognize, much less address, these human needs on the ground.[46] The residents themselves had no say in the plans affecting them, and no one bothered to ask their opinion. When the legal process of property condemnation began, officials could argue at least that they were compensating property owners for their losses and giving them a head start for the future, but renters made up more than 80 percent of the population there and they received no help whatsoever. Indeed, planners such as Rick Olmsted consistently showed more concern for displaced trees than for residents; a number of old trees that stood in the way of the vista were carefully transplanted at considerable cost.[47]

The residents of these two areas experienced a double erasure, first of their neighborhoods and then of their history. Historical amnesia was not an accidental by-product of the monumental core. The process of forgetting what was once there became integral to its very creation, because unlike most other places this one was supposed to look eternal, as if it were the one and only landscape that deserved to exist there. The work of historical recovery began with the superb research of archaeologists in the late 1990s, who studied the site of the National Museum of the American Indian on the Maine Avenue side. But nothing remotely comparable has ever been undertaken for the Missouri Avenue blocks, which were eventually razed in the 1930s to become the site of the National Gallery of Art. These blocks had a more conspicuous and spectacular history, beginning as a fashionable residential area in the 1830s and ending in the summer of 1932, when a "Bonus Army" of impoverished World War I veterans from around the country took over the area in a campaign to pressure Congress into speeding up promised bonus payments to them. Coming in the midst of the Great Depression, the Bonus Army protest added a tragic coda to the story of a neighborhood already eviscerated by redevelopment plans. Veterans and their families squatted in and around abandoned buildings there, which had been condemned by the federal government in anticipation of their demolition (figure 64). Several weeks later, the protesters' refusal to leave these encampments triggered a heavy-handed response from federal troops, who cleared the area with tear gas and bayonets and then proceeded to burn the rest of the veterans' camps throughout the city.[48]

64 A World War I veteran and his family in the Bonus Army camp near Pennsylvania Avenue, July 1932. (Library of Congress, Prints and Photographs Division, NYWT&S Collection, LC-USZ62–115568.)

The Bonus Army's occupation was one of the last political obstacles to clearing the Mall; ironically, once the vista was swept clean, a new era of social protests would take its place.

The actions of the Bonus Army were the opposite of what the Park Commission designers had had in mind for the Mall system. Their report made no mention of gathering places for public assembly or political expression. These activities were already prohibited by law on the Capitol grounds, and the dense development of gardens and forests on the Mall proper in the nineteenth century certainly did not encourage such behavior. The Park Commission plan recommended an array of new athletic facilities in the Tidal Basin area just south of the kite-shaped perimeter of the monumental core, but within the monumental axes themselves the commissioners imagined visitors engaged in gentle contemplation. The illustrations in the plan's report mostly show a sprinkling of visitors in elegant attire strolling on foot or riding in carriages (see figures 8 and 59). Even though the space they occupied was radically new, they were expected to follow the same genteel decorum practiced in

the old public grounds. Just as Olmsted and Downing had sought to screen out the jarring aspects of modern urban life, the Park Commission designers wanted to create a landscape segregated from the profane world around it.

Despite his great enthusiasm for the Mall vista once it was finally cleared, the landscape architect Elbert Peets was one of the first to object to the plan's isolation of the Mall. Peets characterized the park commissioners as nineteenth-century "garden-minded" designers who did not understand how cities work. L'Enfant, Peets thought, had intended the Mall not as a refuge from the city but as a fashionable urban avenue, "alive with citizens and guests of the city."[49] Peets was especially irritated that grass filled the center of the best urban axis in America, leaving the pedestrians on the walks to either side with an oblique view. For him there was no more telling illustration of the commissioners' antiurban outlook than the watercolor rendering in the plan marked number 59: a view toward the Washington Monument showing a shepherd, his crook balanced on his shoulder, strolling alongside a flock of sheep on the centerline grass in the main axis (see figure 8). There was actually a basis for this in nineteenth-century park practice. Sheep were used in places such as Olmsted's Prospect Park, in Brooklyn, to keep the grass under control and to foster the illusion of the countryside.[50] In view number 59, the gigantic shaft in the background punctured that illusion from the start. Its hard, straight, soaring lines were utterly out of scale and character with the rustic Arcadia evoked by the flock. No single illustration in the plan better expressed the contradiction between space and ground, the spatial flow toward the monument colliding with the slow-moving mass of sheep, literally feeding off the ground as they amble over it.

The designers understood the monumental core as exceptional, set apart— "forever free from proximity to the turmoil of ordinary affairs," as the architect Henry Bacon would later say of the setting for his Lincoln Memorial.[51] (Bacon extracted the famous phrase "forever free" from Lincoln's Emancipation Proclamation and gave it an entirely different resonance.) Even though Downing and Olmsted would have said much the same thing, the grounds they made were rooted in traditional place-making. Their trees and gardens interconnected with a network of similar grounds throughout the city, even if the design of the grounds did not always match the masters' principles. The space invented by the Park Commission commissioners made a more deliberate, radical break with ordinary experience. The monumental core was, as we have seen, a nonplace, where the normal logic of scale and navigability we expect in human places would no longer apply. It was designed to be timeless, segregated from the "discordant" and changing "secular" world around it (again, Bacon's words). The formal Arcadia of view number 59, with its strangely juxtaposed sheep

and obelisk, signaled the authors' basic intention to create a nonplace where time stood still and eternal truths could emerge.

For millennia, sacred centers have been designed on these same principles of segregation and eternal fixity. In the traditional scheme, the segregation of the center rests on social exclusion and hierarchy. The closer one gets to the center, the nearer one approaches to the divine; access becomes increasingly privileged.[52] In Washington, democracy demanded that the monumental core be open to all. But, as we have seen, this universalism had its own limits and exclusions.

Parking

In practical terms, the newly distinct monumental core created what Lewis Mumford in 1961 called "at best a fire barrier, which keeps segregated and apart areas that should in fact be more closely joined."[53] Although the Park Commission's Mall was a greenbelt, it actually split the city in two by cutting a huge gash through the urban forest that had come to blanket the capital in the nineteenth century. The east-west axis of the Mall had always threatened to split the northern and southern halves of the city, but when the Mall was reforested in the second half of the nineteenth century it reunited the city under one great arboreal canopy. As late as 1926, when the Mall's forest was threatened but hanging on, an article in the *Post* could still declare, "Were it possible to make the buildings vanish as if my magic, the groves and gardens would for the most part present a better unity."[54] By clearing a wide corridor of space through the city's forest, the twentieth-century Mall disrupted that sylvan image of unity and severed the historic connections between the grounds of the Mall and the grounds of the rest of the city. The plan's systematic tightening of the edges of the space into absolute boundaries further separated the Mall from the city around it. This was a deeply ironic result, for although the Park Commission designers had railed against the fragmentation and disorder of the nineteenth-century capital, they ended up destroying the one great unifying effect the city had so proudly cultivated.

Inevitably, the dream world of the Park Commission's Mall could never be sealed off entirely, even if the plan had been carried out to the letter. The "turmoil of ordinary affairs" was bound to creep in. On the Mall this happened even as the plan was being implemented. The first great challenge, which the commissioners had not anticipated at all, was the automobile. Had the commissioners drawn up their plan just a few years later, they could not have ignored automobile traffic, which was rapidly becoming a major problem for the city. L'Enfant's straight, wide streets, expressly

designed for wheeled vehicles, made driving in the capital easier than in most other American cities. But that salubriousness led quickly to traffic and parking difficulties, especially in the city center. By the time the final planning for the Mall clearing resumed in earnest in the late 1920s, the needs of automobile drivers had become a paramount concern of planners.[55]

Perhaps the most telling indication of this shift was the transformation of the word *parking*. In the nineteenth century, *to park* meant to plant a tree or spread a patch of turf or flowers—to create a little patch of parkland. In Washington, the Parking Commission was a group of respected horticulturalists who supervised street-tree planting. On the city's wide streets, *parking places* typically referred to strips of grass, flowers, or trees planted alongside the pavement, or in the larger squares or circles. These strips of parking not only cooled the streets but made them more manageable by reducing their great width and the amount of paving they required. By the turn of the century, such parking areas were sometimes used to hold horse-drawn carriages on special occasions; these were temporary intrusions that did not threaten the parkland itself.[56] When automobiles started to overrun cities in the early twentieth century, parking areas were given over to car storage and the word began to refer to the cars themselves rather than the trees and grass they were replacing. The new meaning of the word intertwined with the old in strange ways. In 1924, for example, the park in front of Centre Market, "one of the few spots of green along Pennsylvania Avenue," was converted into a "parking space" for cars over the opposition of the city's "superintendent of trees and parkings," who lamented that "the oil and gasoline from the parked automobiles will quickly kill whatever trees are left standing."[57] In early 1927, the District commissioners, acting on citizen complaints, appointed a committee to try to stop "the practice of parking automobiles on the grass-sown parkings between sidewalks and curbs."[58] At the same time, however, city officials were also beginning to cut down street trees throughout downtown Washington and widen pavements to make more room for automobile traffic and parking (in the new sense). Literally and metaphorically, the new parking conquered the old.

Against this backdrop, the Mall was finally cleared, not for the pedestrians, shepherds, and occasional carriages that the Park Commission designers had imagined, but for automobile roadways that would relieve downtown congestion. The so-called Federal Triangle—the huge area south of Pennsylvania Avenue and north of the Mall that had been known derogatorily as "Murder Bay"—had been purchased for a new complex of government office buildings, and planners estimated that one-third of the office workers would commute by car, greatly exacerbating traffic problems and increasing the need for (car) parking. In addition, tourists were now coming to

65 Clearing and grading operations around the Joseph Henry statue on the Smithsonian grounds, 1934. (Smithsonian Institution Archives [SIA], Record Unit 95, image no. 2002–12164.)

central Washington by car and their numbers would only increase as new museums and monuments were built. The Mall's parkland offered an obvious solution. Planners could at once create the vista called for in the Park Commission plan and meet the new automobile demands of the twentieth century.

Hence a plan was developed in 1927 to extend additional north-south streets through the Mall and to build four new east-west roadways on the Mall itself, the two central ones starting at Union Square, flowing around the Washington Monument, and continuing to the Lincoln Memorial. These two center streets were to be two-lane "highways" (one lane for one-way traffic and the other lane for parking), with the Mall's cleared lawn in between.[59] Several years later, as the plan was executed under Franklin Roosevelt's administration, the roadways west of the monument dropped out of the project but the four parallel streets east of the monument were built, requiring acres of ground to be leveled and hundreds of old trees to be removed (figures 65 and 66). When Elbert Peets shortly thereafter walked on the grass in the center of the axis and waxed enthusiastic about its "flow of space," he was actually walking

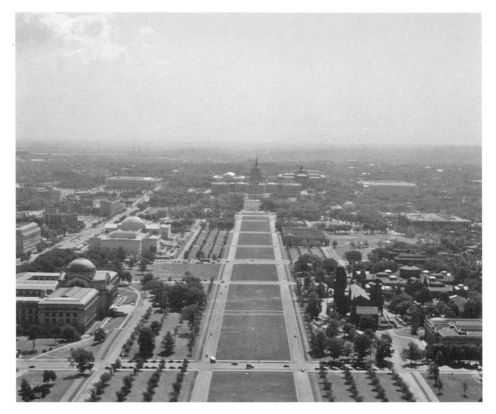

66 View from the Washington Monument looking toward the Capitol, ca. 1940. (Visual Resources Collection of the History of Art and Architecture Department, University of Pittsburgh.)

on a median strip between two roadways. A plan in the 1940s to put an expressway down the center of the Mall never came to pass, even though it was different only in degree from the road system that already existed. Automobiles dominated the center of the Mall for about forty years, until the two inner roadways were converted to gravel paths for pedestrians in the mid-1970s.[60]

What Mumford called a "fire barrier" in 1961 thus also served as a glorified traffic median. Peets hated the roads and wondered how anyone could appreciate the vista when peeking at it through the little windows of a "turtle-shaped" car.[61] His solution was to get rid of the roads and the grass and to pave the centerline of the axis for pedestrians only, so that people could experience its full effect in the open air. But this was not at all what the planners had in mind. William Partridge, the consulting architect for the National Capital Park and Planning Commission who had also worked on the 1901 plan, confidently pronounced in 1939 that "on the ground the great majority of visitors will view the Mall from automobiles."[62] From this point of view, the

automobile—let's imagine a convertible with its top down—might be seen as the perfect way to experience the peculiar placelessness of the Mall. In a car the absence of local variety on the ground no longer mattered because the car sped past these details anyway. From a vehicle gliding effortlessly just above the ground, the great shaft of the Washington Monument was no longer such a strange, immeasurable object. The speed and orientation of the automobile matched the size and uniformity of the perspective, and for a few transcendent moments the whole landscape could come together with a new clarity. The triumph of the automobile on the Mall completed the annihilation of the original ground and demonstrated that space now belonged most fully to those who could move through it unencumbered by traditional human constraints. For those poor folks still left on foot, the Mall had become, by contrast, "a vacant uninviting plain." As the *Washington Star* reported in 1964, in a nearly perfect description of the spatial logic of the vista, "It is so empty of life and movement that it seems like a picture instead of a place."[63]

The Monument in the Garden

The reconstruction of the Mall was especially remarkable given that Congress never adopted the Senate Park Commission plan. For years the various federal departments with jurisdiction over the Mall actively resented the planners' interference.[64] Although it is easy to blame resistance to the plan on turf rivalries, there was in fact a long, bitter history of grassroots opposition to the destruction Burnham so nonchalantly advocated. The secondary literature on the Mall has all but ignored this history, even though Olmsted and McKim themselves fully anticipated it.

The opposition to the plan had nothing to do with the displacement of people who lived in the residential blocks formerly within the Mall. They were not powerful enough to advocate for themselves, and no one seems to have advocated for them. The opponents cared instead about the park, and especially the trees. For a half century that park had been maturing; nothing on its scale existed in the capital. It took some time for many of the locals to grasp the full impact of the Park Commission's plan, but once they did they reacted as any group might to the threatened destruction of a cherished landscape.

This story has never been properly told because Charles Moore, the American Institute of Architects, and the rest of the commission's well-placed allies in the municipal art movement did such a brilliant job creating a flood of favorable national publicity for the plan, which made public opinion seem unanimous in its favor. News-

papers and magazines all over the country repeated the same talking points, often in exactly the same language. For a while only an occasional dissenting voice could be heard. The Cleveland-based *Ohio Farmer* complained that a "powerful lobby" had been "pushing its scheme before Congress, and its side of the question into most of the literary, news and political papers and magazines."[65]

The first public fracas came in 1904, sparked initially by a dispute over the replacement of the Agriculture Department building and grounds. Agriculture was a major player on the Mall at that time: the department managed an arboretum there that was apparently the second most comprehensive in the country.[66] The grounds, including greenhouses, stretched all the way from the south edge to the north edge of the Mall. Secretary James Wilson flatly opposed the Park Commission plan, undoubtedly because it would destroy the arboretum his former superintendent, William Saunders, had developed over decades. One of his officials testified before Congress that if the people of Washington could vote on it they would be unanimous in supporting the existing park.[67] We could dismiss this opinion as self-interested were it not for the anguished response once the first significant work of tree removal began. This happened in the summer of 1904, when construction began on a new national museum in the Smithsonian grounds (now the Natural History Museum). Behind the scenes McKim was closely involved in the siting and design of the project, while Congress appears to have been kept in the dark.[68] Some of the most beloved trees in the city, in the thick of the Mall's oldest woods, were cut down to clear the way for the new building. A despairing article in the *Post*—a paper not usually given to these sentiments—reported that old-time workers and residents in the area, who had watched the trees grow up, were in mourning. Under the headline "Axman Invades the Mall," the article divulged that "even the men armed with axes who did the work said they hadn't the heart to see the old trees go." Only partway through the job, the site was already "a picture of desolation" and hundreds more trees were still slated for the ax.[69]

This article, for all its drama, was a marginal note in a newspaper whose editorial page consistently supported the Park Commission plan. The fact that the most important voice quoted in the news report was that of an elderly African American man, not the sort of observer usually given serious attention in the *Post*, indicates that the story belonged to the realm of sentiment rather than serious politics. But this dynamic changed in the fall of 1907, when the next encroachment came, this time in the form of a war memorial.

The controversy erupted when construction began for a huge equestrian monument to Ulysses S. Grant on the grounds of the Botanic Garden at the east end of

67 Edward Casey, architect, and Henry Shrady, sculptor, plaster model of the Grant Memorial, 1902. (Courtesy of the U.S. Commission of Fine Arts.)

the Mall. The memorial was a revised version of the Park Commission's Union Square concept. The new design, by the architect Edward Casey and sculptor Henry Shrady, was actually much more innovative, replacing the two subsidiary equestrian statues with large combat groups of common soldiers spread out on an immense horizontal platform—the most ambitious sculptural program ever attempted in a Civil War monument (figure 67). But in keeping with the original Union Square plan, the new design was to occupy the center of the Botanic Garden grounds, a site occupied by many fine old trees, including a memorial tree especially cherished by the garden's superintendent, William Smith: the Crittenden oak, also known as the "peace tree" (figure 68).[70] Crittenden, it will be remembered, was the Kentucky senator who had made a last-ditch effort at compromise to head off the Civil War. Superintendent Smith did not fail to broadcast the irony of the situation—that a combat memorial would displace flowers and trees, including one that was a memorial

68 "Will Be Missed from the Botanic Garden," *Washington Star*, October 6, 1907, 2. (Reprinted with permission of the D.C. Public Library, © Washington Post.)

to a "peacemaker." In the great American antimonumental tradition, many congressmen and local civic groups and residents leapt to the defense of the trees, especially Crittenden's. "That tree," one congressman later argued, "will be a better monument to the cause for which Grant fought than the memorial it is proposed to erect." There was bound to be protest, the *Post* argued, "when a government board proposes to substitute a pantalooned statue for the living sculpture of God."[71] The

Post was absolutely right: conflicts about monuments displacing trees continued well into the twentieth century. But Smith understood that the issue was not only about one or two trees, or even the Botanic Garden itself. The Grant monument, he argued, was merely the "entering wedge" in a much larger campaign aimed at "the destruction of the Mall."[72]

Arriving at the same conclusion, the *Star* stoked the Grant Memorial controversy to a boiling point, and, riding a wave of popular outrage, the *Post* soon joined its rival and temporarily reversed its earlier editorial policy of unwavering support for the commission. The *Star* cited a long list of like-minded citizens from the community and systematically dismantled the Park Commission's plan—its undemocratic implementation, its false invocation of L'Enfant, and its real impact on the existing landscape. But the *Star* and the *Post* reserved their harshest criticism for the plan's "vandalism" of the Mall's parkland, the replacement of forested ground by empty, unshaded expanses of grass or pavement created in the service of what the *Star* called "the sham grand vista." Once they began to disenthrall themselves from the plan's spatial ideal and realize what was about to happen at ground level, their collective blood pressure rose quickly. The park commissioners, the *Star* claimed, wanted "all variety eliminated." Their "straight-jacketed" aesthetic found perfect expression in the "tub trees" clipped into identical cubes, famously mocked in a front-page cartoon that lampooned a parade of architects and planners (figure 69). Critics even took swipes at Le Nôtre, Versailles, and the French Baroque gardening tradition that so enchanted the commissioners. Beyond the aesthetic problem of uniformity, though, the critics pointed to the sheer physical discomfort the plan was sure to inflict. The proposed Union Square would replace the Botanic Garden with "a broad expanse of stone and asphalt broiling and baking during the summer, and a wintry waste, swept by freezing blasts, during the winter months." The Mall itself would become a "track of desolation as bare and as hot as the Desert of Sahara."[73] The designers' argument that fountains would solve the problem carried little weight.

The opponents refused to cede the "City Beautiful" to the Park Commission plan. Washington was already a "City Beautiful," one congressman argued, and the Botanic Garden was a big part of it.[74] The *Star* even claimed that the Mall's trees were "far more perfect and infinitely more precious as features of the city's attractions than any architectural works of which man's genius is capable." Drawing attention especially to the memorial trees, the paper tried to justify the park's preservation not only as a pleasant resort for visitors, but also as a functioning memorial landscape in its own right.[75]

The controversy over the Grant Memorial was, finally, about the whole future of

69 *Group of Le Notre–McKim Tree-Butchers and Nature Butchers, Washington Star,* January 14, 1908, 1. (Library of Congress, Prints and Photographs Division.)

the Park Commission's incipient monumental core. The memorial itself was a turning point because it was the first test of a sweeping plan to change how the city's entire memorial landscape was understood and used. The Grant Memorial Commission argued that the Botanic Garden site was the only one in the whole capital appropriate for the monument. Since L'Enfant had set aside so many possible memorial sites to choose from in the city's street layout, this argument was almost un-

precedented. The *Post* reacted incredulously. "There are dozens of places where statues might be placed," the paper editorialized, adding a dig: "The more they are screened by something beautiful like a tree, the better for the public and the sculptor."[76] The head of the Sixteenth Street improvement association was clamoring at that moment to locate the Grant Memorial on Meridian Hill, on the outer end of the Sixteenth Street axis. She could not understand why the sponsors would choose to situate the monument on some of the lowest ground in the city when more impressive sites were available on higher ground. After all, important monuments were supposed to be elevated, on "natural pedestals," an idea reminiscent of Carlyle's hero "set high."[77] But none of these conventional factors entered into the sponsors' decision: they insisted on the Botanic Garden site to advance the larger project of a unitary national space in the city's center.

The opposition was only beginning to grasp that the traditional parade of statues marching over the high points of L'Enfant's map was falling out of favor. A new commemorative hierarchy was emerging, in which a segregated center would become far more important than the surrounding residential streets and squares that had previously supplied the premier sites for new monuments. Those areas were now peripheral in every sense. No longer would there be unlimited room for monuments in the capital, because the only room that would really matter would be in the centrally planned core.

An architect who wrote the *Star* to defend the memorial site and Park Commission plan accused its critics of having "their noses so close to the ground that their horizon is a circle not more than three feet in diameter." These ground-huggers he contrasted with the park commissioners "who are broad-minded enough to see the grand future of this city, and to plan for it."[78] To care about the ground was a form of myopia; real vision, liberating vision, focused on space in all its breadth and grandeur. The way to enlightenment now meant shifting into a new spatial register and forgetting about the living ground.

The architect's view prevailed in the end, even though the monument project drew negative publicity nationwide and encountered substantial opposition in Congress. The opponents were outmaneuvered by a presidential administration under Teddy Roosevelt that strongly favored the Senate Park Commission plan.[79] Secretary of War William Howard Taft, who was in charge of the capital's public grounds, admitted "stepping on dangerous ground in mentioning that Senate plan," but he reminded everyone that the plan would require removing many more trees than just these few in the Botanic Garden. "To say that you cannot move a tree is to say that you cannot advance," he argued.[80] Although the only recorded vote on the matter in Congress

repudiated Taft's position and supported leaving the Botanic Garden alone, this majority could not muster the two-thirds necessary to bring their bill out of committee.[81]

Construction of the monument resumed and a sentimental coda to the story unfolded. According to newspaper reports, Superintendent Smith became a recluse in his private lodge on the site because he could no longer step outside "without the hateful memorial greeting his eye." By then in his mideighties, he "grew to dislike even his beloved garden" and chose to bury himself in his collection of Robert Burns books and memorabilia.[82] (Yet another eccentricity of the early twentieth-century Mall was that its Botanic Garden, because of Smith, was home to the second largest collection of Burnsiana in the world.) The Crittenden tree was transplanted to another spot in the garden, and Smith predicted that he would live to see its funeral. But the tree managed to outlive him by at least two decades. As late as 1928, the story of the tree was still told in the *New York Times*, with ever more fanciful elaborations; now it was said to be a descendant of the Charter Oak in Hartford![83] Though records are spotty, the Crittenden tree probably succumbed in the early 1930s, when the Botanic Garden was finally leveled as the 1901 plan had originally proposed; a new garden was created just south of the main axis.[84]

"The Rape of the Mall"

After the Grant Memorial fight nearly sank the Park Commission plan, the administration of President Taft in 1910 convinced Congress to establish an advisory Commission of Fine Arts (CFA), which he then packed with supporters of the 1901 plan in an effort to secure its full implementation. Taft and the other proponents dared not bring the plan itself to a vote in Congress, where it would have gone down to certain defeat. Instead they worked patiently through the authority of the executive branch. The CFA quickly won a great victory when it succeeded, in 1911, in winning approval for the plan's designated site for a Lincoln memorial on the landfill extension of the Capitol–Washington Monument axis. In a repetition of the Grant Memorial dispute, the plan's advocates had to beat back "peripheral" sites on the nineteenth-century model, notably, once again, Meridian Hill.[85] Securing the terminal site on the plan's east-west axis guaranteed the future of the monumental core, even though the Grant and Lincoln memorials would not be finished until 1922 and the land in between would not be cleared and regularized until the 1930s.

The CFA also had to contend with opposition from within the design profession to the neoclassical vocabulary of the plan and its monuments. This criticism began

to crystallize during the design process for the Lincoln Memorial after 1911. A nascent modernist movement saw the great structures of the 1901 plan as the last gasp of a dying style, a style particularly inappropriate, some critics argued, for the homely, unpretentious Lincoln.[86] Although this modernist assault was a real problem for the plan's advocates, who valued their good standing in the profession, the modernist/classicist dichotomy is reductive and misleading. The advocates of the 1901 plan rightly viewed themselves as modernizers in their desire to sweep away the Victorian architecture and landscape of Washington and replace it with a new "system." Classicism for them was a way to achieve systematic uniformity, in a language still considered, in the Eurocentric tradition, "timeless." They could not conceive of monumentality in any other way, because a modernist monumentality, as Mumford would later argue, was an oxymoron.

In practical terms, the modernists did not pose a serious problem because they had no real constituency in the U.S. Congress. For the keepers of the 1901 flame, the crunch was always Congressional appropriations. The various schemes in the plan, including both the Grant and the Lincoln memorials, were federally funded projects, so the most pressing task for each was to build a Congressional coalition to fund it. In most cases, architectural style was not at issue. The CFA had its hands full, for example, simply trying to clear away the Botanic Garden and its Victorian greenhouses, because even after construction of the Grant Memorial began congressmen were still introducing bills "to preserve here at the foot of the Capitol this little flower garden . . . a source of great instruction and profit and pleasure to the school children and people and laboring men of Washington."[87]

The CFA received a big boost when Congress established a second commission, the National Capital Park and Planning Commission (NCPPC), in 1926. Like the CFA, the NCPPC retained strong ties to the original Senate Park Commission. The intervention of the NCPPC was crucial in persuading Congress in the late 1920s to move the Botanic Garden off the Mall and to condemn the blocks adjacent to Missouri and Maine avenues—both prerequisites of the 1901 plan. But the NCPPC's mandate also forced it to deal more minutely with practical issues such as traffic and housing; in fact, the NCPPC replaced the former Highway Commission.[88] The final clearing of the Mall vista, as we have seen, came about in the context of the NCPPC's planning for automobile traffic and parking in the city center. By the time the necessary funds were appropriated for the Mall's "highway" project, in the first year of Franklin D. Roosevelt's administration, the Mall had experienced further encroachments by temporary office buildings and a power plant. But even with the park compromised by

three decades' worth of building projects, many Washingtonians still rallied to its defense one last time.

When protests in December 1934 temporarily halted the road/vista project and forced the secretary of the interior to reassess it, impassioned letters to the editor, particularly from women, poured in to the papers, in contrast to the strictly male voices represented during the earlier Botanic Garden controversy. The writers were aghast that trees would be sacrificed for the needs of automobiles: "Are there not hundreds of thousands of miles of raw highway all over this barren land through which cars can rush four abreast without destroying the very heart of our city's quiet shaded charm?" one woman asked. "Since it takes 50 years to make a tree and 5 minutes to make a car," Theresa Russell wrote, "they will never solve the 'parking problem' by any such methods as these." A male protester declared that "as a poor substitute for the trees they would give us a straight highway along which the myriads of automobiles, rapidly going nowhere at all, could save the time for which their drivers have no valid use whatsoever."[89] Several writers were aggrieved that government officials dismissed their objections as mere sentiment. Katherine Rowland, who worked in an office building near the Mall, wrote about a particular old oak tree where she used to keep a bowl of water for the birds and the squirrels. "One day a few weeks ago a group of men came up to 'my' tree, kicked away the bird bath, and proceeded to hack down the great, beautiful oak. . . . Perhaps sentiment does lie back of people's grief for fallen trees, but can we afford to let go of our sentiment?"[90] The passage contrasts aggression, marked as male, with sentiment, marked as female. This particular sentiment we would now call a place-based memory, an intensely felt, intensely local connection to a familiar spot that is part of the fabric of real human existence. For Rowland and many of the other writers, trees represented shade, comfort, companionship—all elements of the therapeutic sympathy that the elder Olmsted had imagined would infuse his park landscapes.

Their protests were soon brushed aside and the project continued. After nearly a year of tree cutting on the Mall, an article in the *Post*—a longtime backer of the 1901 plan and a booster of just about any project that could be characterized as "progress"— reported that many were calling the project "the rape of the Mall." The writer in this case was incensed by the destruction of a memorial elm, clearly identified by a plaque explaining that it had been planted forty years earlier by the founder of Arbor Day, the day set aside every year for planting trees and replenishing forests. Here was the perfect illustration, exquisite in its irony, of the "official vandalism" to which the planners had sunk. The article cast its net wide, openly mocking the "master minds" of the NCPPC and their "efforts to beautify the beautiful and improve on perfection along

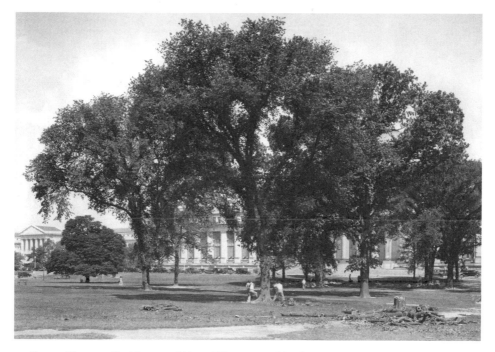

70 Tree-cutting near the Museum of Natural History, ca. 1934. (Historical Society of Washington, D.C.)

Washington's Mall."[91] The backdrop for this tirade was years of frustration with a program of modernization happening all across the city. Letters from the 1920s and 1930s are full of protests against the new orthodoxies of urban planning and landscape architecture, and their ongoing efforts to widen streets for automobiles, cut down street trees, uproot flower gardens in parks, pour concrete, and straighten once meandering paths. "Washington is no longer Washington," one longtime resident complained in 1933. "Trees, houses, streets and landmarks have been ruthlessly destroyed since 1915."[92]

There are few photographs of the tree destruction on the Mall, but a rare example probably from the summer of 1934 evokes the lingering value of the wooded park even as it was being dismantled (figure 70). The image shows a team of laborers, armed with a long saw, cutting down a tree in the vicinity of the Natural History Museum, while in the background others relax on felled trees or work quietly in the shade. A quasi-pastoral view, disturbed only by the tree stumps and the saw, this stretch of landscape would soon become the traffic median of the new Mall.

The supporters of the cleared Mall worked with amazing speed to erase recent memories of the park. A *Post* article from October 1936, under the headline "Work on Million-Dollar Mall Is Now 90 Percent Completed," declared that "not so many years ago, the Mall was a barren, unkempt commons, much of it a stagnant morass"

What 46 Years of Progress Did for the Mall!

Ruhland Lists Gain in Deadly Diseases in '35

Dangerous Communicable Ailments on Upswing, Board Is Told.

There were increases in the number of cases of many of the more dangerous communicable diseases for the calendar year 1935, Health Officer George C. Ruhland reported yesterday to the District Commissioners.

Epidemic cerebrospinal meningitis led, with a jump from 14 cases and six deaths in 1934 to 252 cases and 93 deaths last year. Dr. Ruhland pointed out that the increase had been general over the country.

A great increase was also noted in the number of cases of anterior poliomyelitis. In 1935 there were 85 cases and 10 deaths, with a mortality rate of 11.8 per cent, as compared with 1934, when there were 10 cases reported and a mortality rate of 30 per cent.

Diphtheria cases numbered 913 and 29 deaths as against 539 cases and 16 deaths in 1934. The health officer cited statistics to support a statement that immunization of children of pre-school age will do much to reduce the prevalence of this disease.

There was a marked drop in the cases of measles and whooping cough. The number of the former was 1,006, with no deaths, in 1935, as compared with 6,436 and 46 deaths in 1934. This slump was responsible for the total number of communicable diseases last year being below the preceding year.

Whooping Cough Less.

Only 183 cases of whooping cough were reported. This was the lowest number since 1931. There were but 3 deaths, while in 1934 the cases numbered 1,013 and the deaths 39.

Influenza cases numbered 153, as against 75 in 1934.

Pneumonia made a slight gain, with 1,353 cases and a case rate of 264.3 per 100,000 population.

"The high case rate attributable to pneumonia may serve to emphasize the fact that the disease is extremely prevalent," Dr. Ruhland said, "and it is also well known that the mortality is high, ranging from 25 to 60 per cent.

"It is believed that greater attention should be paid to the early laboratory diagnosis of pneumonia and the administration of serum to those types which are known to respond favorably to serum therapy. This cannot be done, however, until adequate personnel is made available for the laboratory to care for the increased demands incident to an adequate laboratory early diagnosis program."

Rocky Mountain spotted fever, which first was recognized in the District in 1930, has produced 39 cases and 13 deaths since that date, of which 8 cases and 3 deaths occurred last year.

No Smallpox Cases.

No cases of smallpox have been reported in Washington since 1932, the report pointed out, adding: The low incidence of smallpox is no doubt directly due to vaccination of a considerable portion of the population against the disease."

"Tuberculosis still ranks high among the communicable diseases in the District," Dr. Ruhland said. "During 1935 there were 1,366 cases reported, with a case rate of 266.8 per 100,000 population, the highest of any year since 1931."

Seventy-two cases of typhoid fever, with 13 deaths, were recorded last year, as compared with 37 cases and seven deaths in 1934.

Venereal diseases totaled 8,378 as against 7,946 in the preceding year and were classified as follows: Syphilis, 4,973; gonorrhea, 3,333; chancroid, 72.

Heart disease, with 1,978 deaths, led in the causes of death, with cancer, pneumonia and tuberculosis running.

Here's a

Mrs. W. H. Gannaway
the John Burroughs
inches wide. It is the
Wa

Jacobs St
Budget Bu
Of U.S. to

Donovan Submits
From 15 Agenc
Fiscal Surve

Reports from 15 muni cies as to the burden the Federal Governmen budgets were submitted by Maj. Daniel J. Don trict auditor, to J. L. rector of the President's tions study, as the adv mittee had its second m

Deductions of the heads were carefully gi it was indicated that v ception they found ther tures are substantially cause the city is the National Government.

The advisory committe held in the Commerce Bank Building, was clo public, but Jacobs said progress has been ma analysis of a mass of st formation.

He said the committe cided to hear delegatio civic and trade organ connection with their October 23-24.

Advance Memora

Jacobs said all or wishing to be heard sho memoranda in advance the advisory committee them and be prepared t tions. These memorand should be submitted not October 12.

Organizations which for a hearing are the Cit Committee on National tion, the Federation of C sociations, the Washingto late Board and the

role Is Near
r Countess,
led in Fraud

Must Find Self Home
and Means of Support, However.

dom shortly awaits the aged rippled Countess Grace de t, in jail three years for deug a 62-year-old school misMiss Louise Maret, of $5,000, learned yesterday at the Disarole Board. All she needs pe possible death in prison nd a home.

countess has been using every neans to regain her freedom the three years since she onvicted with George A. y of tricking the elderly proprietor out of $3,000 "hush

trick, evidence showed at al, consisted of Gormley's Miss Maret to a deserted vhere he switched off the n his car. They were shortly hed by a bogus policeman hreatened to arrest them. y said he could buy off the iam.

Maret, proprietor of the able Maret School for Girls, than jeopardize the future establishment, managed to lightly more than $3,000, she gave to Gormley. The und the countess guilty of acy in the plot. She was ed to an indeterminate term two to four years. Gorma straight eight-year sen n preference to a four to ar indeterminate sentence he was eligible for parole arlier date under the former. countess shortly appealed to eral court at Norfolk, conher indeterminate sentence gal on the ground that the ninate sentence law was not hen she was sentenced. The pheld her and she was rehere for resentencing December 19, 1935.

Joseph W. Cox, of the Supreme Court, December 20, led she would have to serve ncurrent terms of 15 months er two years already spent She became eligible for after serving one-third of m.

g served nine months, she ble for release from prison, role Board announced yesafter hearing her application day. oard indicated that as soon tisfactory parole plan can

Work on Million-Dollar Mall Now Is 90 Per Cent Completed

WPA Funds Make Possible Idea Conceived 143 Years Ago by Maj. L'Enfant, Who Laid Out Plans for City.

The million-dollar Mall is 90 per cent completed, National Capital Parks officials reported yesterday to Arno B. Cammerer, director of the National Parks Service.

Conceived 145 years ago by Maj. L'Enfant, who laid out the Federal City, the mile-long park connecting the Capitol with Washington Monument and Lincoln Memorial probably would still be in an early stage of development but for the allocation of PWA funds to finish the project.

To date $1,050,923.03 has been expended by the Public Works Administration in developing the Mall and its eastern extremity, Union Square. Miscellaneous planting, demolition of temporary buildings "E" and "F" and certain smaller structures, drainage work and in-

morial oak, which the former Chief Executive planted when he was chairman of the Library Committee; the "Oak of Confucius," grown from an acorn taken from the Oriental philosopher's grave; the O. R. Singleton memorial tree, only specimen of its kind in the park system, and the giant Zelkova, a Chinese tree which has a 100-foot spread at the crown.

In the upper picture the Mall is shown in 1890, during a midwinter snowstorm. Below is the beautiful Mall of today.

"Work on Million-Dollar Mall Is Now 90 Percent Completed," *Washington Post*, October 4, 1936, M15. (©1890, 1936. The Washington Post. Reprinted with permission.)

(figure 71). The "not so many years ago" was almost a full century, as if seventy-five years of tree planting and park development had never happened. Then the article laid out the myth so familiar to us today: L'Enfant's original plans were "revived" in 1901 by the Park Commission, "which recommended to Congress that spoliation of the area be arrested and a program of development inaugurated"; the Interior Department finally carried out this development with a million dollars of Public Works funds. The topper was a juxtaposition of before-and-after photographs under the heading "What 46 Years of Progress Did for the Mall!" Below, the newly cleared east-west axis to the Washington Monument seen from the windows of the Capitol building, which elevated the viewer into the space defined by the obelisk in the distance; above, a view, nearer to the ground, purporting to show a snow-covered Mall in 1890. The organization of both images along orthogonals receding into the distance suggests a common view, with the leafless trees, tilting utility poles, and criss-crossing tracks in the 1890 photo contrasting with the clean orderly lines of the modern Mall. The problem is that these are not the same views at all. The historic photo was not a view of the Mall but of Sixth Street looking due north toward the old B&P railroad station, probably from the vantage point of a pedestrian bridge that crossed over the railroad tracks and connected the parkland east of Sixth Street to the parkland west of it. If there was one spot on the Mall in 1890 where a photographer could avoid picturing the Mall's parkland, this was it. The newspaper's choice of picture made the before-and-after comparison a hatchet job, in more than one sense of the word.[93]

The final realization of the planners' "great space" created a stunning new system of national representation at the cost of the Mall's picturesque parks, Victorian structures, and working neighborhoods—as well as the web of local attachments these places had engendered. The monumental core represented a triumph of vision—in both senses, optical and imaginative—over a living ground that had evolved for roughly a century. The Mall project anticipated the subsequent history of modernist planning in the twentieth century, fundamentally one long, sustained assault on the historical ground of cities in the interest of creating one or another spatial utopia.

The clearing of the Mall destroyed the traditional markers of place to create a purified space that would be seen and understood as a new national order, universal and timeless. As the project took form it had far-reaching reverberations. It drastically reconfigured the capital's memorial landscape by creating a highly charged commemorative center where new monuments would now compete for prized space. Whereas the equestrian statues and other monuments of the nineteenth century spread through the warp and weft of L'Enfant's street system, the monumental core

of the twentieth century was an intentional hole in the city's fabric, a separate precinct meant to be isolated from the environment around it. The older commemorative landscape could not avoid change as neighborhoods evolved, transportation systems modernized, and the building stock turned over. The monumental core, on the other hand, was designed to be eternal, a quasi-sacred space sealed off from the normal processes of change.

The automobile punctured that bubble from the beginning. Between the Senate Park Commission's conception of the "Mall system," in 1901, and its final implementation, in 1934–36, even the meaning of the word *parking* changed. In the end the only way to empty the Mall of the nineteenth century was to let the twentieth century invade it. With this invasion, much of the larger monumental core envisaged in the 1901 plan was compromised, especially by social and political activities that did not conform to the original design and spirit of the plan. The Mall could hardly be sealed off from the world around it, as the social changes of the mid-twentieth century would demonstrate, at times painfully, at other times inspiringly.

At the same time, then, that the monumental core destroyed and regularized, it also released new commemorative energies that changed the space and its monuments unpredictably. The very concept of the public monument underwent a transformation, enabling the people who found themselves in the monumental core to engage with the nation's history and its meaning in startling new ways.

5

The Monument Transformed

"So much is said against public monuments," the journalist George Alfred Townsend noted in 1891. Writing about Lincoln's tomb in Springfield, Illinois, he hesitated to add his own set of complaints to the drumbeat of criticism now steadily directed at public statues. But a few sentences later he did anyway.[1]

Statue monuments had become a victim of their own success. By the beginning of the twentieth century, as the cost of manufacturing them continued to decline and the demand for civic art soared, no one could fail to notice their newfound presence in the urban landscape. "Almost any little city big enough to have a guidebook written expressly for itself names three or four pieces," the architect Russell Sturgis observed.[2] Portrait statues, in particular, seemed perfectly suited to representing the great men who were thought to be the makers of history. Advocates of the form insisted that citizens needed to *see* the hero's image in order to emulate his patriotism. Yet as the statue phenomenon grew exponentially, it became increasingly evident that fewer and fewer people were actually looking at them. Commenting on the spread of equestrian statues, the *American Architect and Building News* argued in 1888 that if they did not appeal to the intellect in some way, they soon lost the attention of passersby and became merely "an obstruction to traffic." The art world was soon in full backlash against portrait statues, with many critics complaining that they were practically guaranteed to be failures: dull and repetitive, they were limited to a few simple poses and gestures often copied from antiquity, and then cloaked in modern period costumes that were either banal or downright silly (see figures 25 and 63). One hero melted into another, especially in soldier monuments, which were so commonplace that they could even be ordered from stock catalogues.[3] The Swiss critic Robert Musil's pithy remark of 1926—"there is nothing in this world as invisible as a monument"—capped decades of disillu-

sionment, on both sides of the Atlantic, with the traditional forms of the public monument.[4]

The art establishment in the United States did not openly challenge the didactic premise of the hero monument; indeed, the flood of new immigrants from Europe seemed to make the lessons of patriotic monuments more urgently needed than ever. But when artists and critics surveyed the rising tide of public monuments, they usually complained that the results were simplistic and hackneyed. Commentators found themselves at a loss, having no good idea how to reconcile the clarity demanded by didacticism with the complexity valued in art. Ironically, the high-culture critique of the public monument resonated with the old populist tradition of iconoclasm, which had always viewed didactic monuments with suspicion—as a form of propaganda, fundamentally incompatible with the ideal of republican self-government. Both critiques tended toward the same conclusion, that monuments were, as Whitman had said, "cold and dead." Even in major cities like Washington where monument commissions often went to prominent sculptors, the results rarely lived up to expectation. A columnist for the normally upbeat *Post* wrote in 1901 that the city's statue monuments were "perhaps the most hideous in the world."[5] Glenn Brown, secretary of the American Institute of Architects and one of the prime movers behind the Senate Park Commission, warned in 1900 that new monuments would be held to a higher standard: "the stiff bronze men and horses, so common in our parks at the present time, would not be tolerated."[6]

For the Park Commission's cosmopolitan designers, the problem with the conventional statue monument was more fundamental than mere stiffness or even lack of originality. The problem was systemic. According to their report, the statues in the city's public squares and circles were usually plopped there without much thought about connecting them to a larger landscape design. They were "inserted as independent objects, valued for their historical or memorial qualities or sometimes for their individual beauty, regardless of their effect on their surroundings."[7] In the conventional layouts of public grounds, statues were localized ornaments, spatially contained by their pedestals. Even if the statues had aesthetic value—a rarity, the report suggests—the planners wanted them to function differently. Monuments were not to be mere objects proclaiming a simple heroic lesson—a great man gesticulating on a pedestal or a horse—but rather constellations of elements that coalesced into true spatial compositions. McKim's design for the Lincoln Memorial, for example, included a portrait statue but only as a transitional element in a much more complex multilayered scheme (see figure 59). The memorial was many things at once: a giant text

crowning a colonnaded building, on a sloping podium, approached by a pool and a fountain. Visitors' understanding of the memorial was meant to evolve as they progressed through its multiple elements.

An unmistakable shift was under way. In the new equation, the most important artist was not necessarily the statue maker but the spatial designer—the architect or the landscape designer. Throughout the nineteenth century sculptors were almost always considered the lead designers of monuments. With a few prominent exceptions (the Washington Monument, Grant's Tomb), monuments *were* statues.[8] In the Park Commission plan, statues played a much reduced role, clearly secondary to the system of spatial relations. The commissioners' report is far more inspired by other landscape elements, for example, by fountains and their "gushing, rippling, sparkling, living water . . . infinite in its variations."[9] Statues had a place in the plan, to be sure, but the real action was elsewhere. In this pivotal moment emerged a new notion of the public monument, as a space to be experienced rather than an object to be revered. What the plan proposed for the landscape as a whole—transforming localized grounds into nationalized space—it also proposed for the individual monument. One of the reasons we have trouble understanding the opposition to the 1901 plan and the monumental core it established is that we have so profoundly internalized its way of thinking. But in its own time that thinking was new, and not even the designers could foresee its full ramifications. In particular they could not anticipate that the physical space of the monument would also become a mental and emotional space of engagement, with historical traumas as well as triumphs. The 1901 plan set in motion a campaign against the traditional hero monument that would ultimately transform the psychology of individual monuments and the mood of the memorial landscape as a whole.

The Spatial Monument

Augustus Saint-Gaudens (one of the four Park Commission designers) pioneered this new philosophy of monument design in the late nineteenth century, having imbibed the value of architectural collaboration in his training at the École des Beaux-Arts in Paris. For his 1887 monument to Lincoln in Chicago, for example, his collaborator, the architect Stanford White, designed a novel approach to the statue: a broad flight of steps to an elevated platform surrounded by a continuous semicircular bench that framed the standing figure of Lincoln on its pedestal and also guided

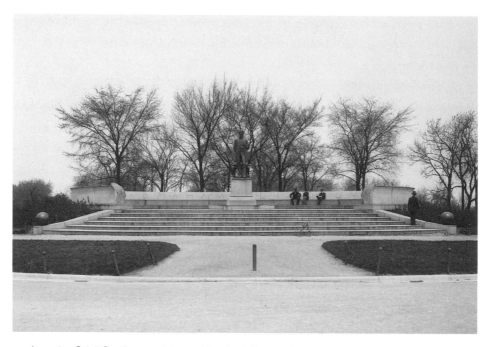

72 Augustus Saint-Gaudens, sculptor, and Stanford White, architect, Monument to Abraham Lincoln ("Standing Lincoln"), Chicago, 1887. (Library of Congress, Prints and Photographs Division.)

the viewer's circulation and response (figure 72). The setting drew viewers into a narrative sequence, requiring them first to see Lincoln from the ground below, as if they were part of an audience for his speech, but then inviting them up into a more intimate, hovering semienclosed space behind the statue that encouraged contemplation. This approach was so far ahead of its time that even as great a critic as Marianna van Griswold Rensselaer, in her brilliant analysis of the statue, gave only cursory attention to the architectural setting.[10]

Following the example of Saint-Gaudens and a few other sculptors in Paris and Europe, some innovative design teams in the United States began to experiment with the relationship of statue to setting. Instead of thinking of the architectural support as simply an ornamental stool to elevate a statue, designers spread subsidiary elements horizontally to create a larger spatial framework. This trend was encouraged by the newly formed National Sculpture Society (NSS), which included architect members and actively encouraged collaboration between the two professions. The lead designer of a monument was still typically the sculptor, and the hero remained elevated in the center of the composition, but a space of engagement below was also beginning to emerge.[11]

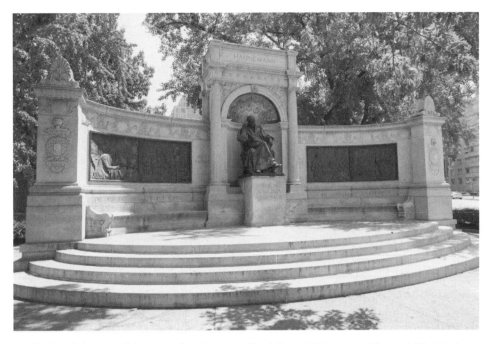

73 Charles Niehaus, sculptor, and Julius Harder, architect, Samuel Hahnemann Memorial, Washington, D.C., 1900. (Photograph by the author, 2008.)

The monument of 1900 to the German founder of homeopathic medicine, Dr. Samuel Hahnemann, located on the east side of Scott Circle, was the first clear example in Washington (figure 73). It was a rare nonmilitary monument, as well as only the second seated-portrait statue (after Greenough's Washington) to be installed outdoors. The American Institute of Homeopathy sponsored the work and gave the contract to a sculptor, Charles Niehaus, after a competition juried by sculptor and architect members of the NSS. Collaborating closely with the architect Julius F. Harder, who had worked on the World's Columbian Exposition in Chicago and written on city planning in New York, Niehaus presented a design that beautifully integrated the contemplative figure of the doctor into an architectural surround defined by a colorful mosaic-work niche and an elliptically curving wall featuring a long bench or exedra and bas-reliefs illustrating the hero's life and career.[12] The whole was elevated on a platform approached by four broad steps, similar to the Lincoln Monument of Saint-Gaudens and White, except here the platform felt more like a shallow room than a hovering open space. The rear elevation was also carefully considered, with a fountain in the center below a panel of inscriptions and a discreet allegorical design in the tympanum above, this central section flanked by curving walls and paths

74 Hahnemann Memorial, rear view. (Photograph by the author, 2008.)

that guided the visitor to the front (figure 74). The complete work was a product of intense planning that sought to guide visitors' movement and experience in space, in a fashion unprecedented in Washington's monuments.

As was customary, the sculptor Niehaus was considered the author of the work; the architect Harder received almost no mention in the press. Russell Sturgis, an architect member of the jury that chose the winning design, was understandably preoccupied with the question of professional turf: was the design primarily architecture or sculpture? But the melding of the two had rendered that question almost irrelevant, producing something qualitatively different from either a building or a statue. Sturgis's suggestion that the result was "on the line between architecture and sculpture" began to express the productive ambiguity of the new monumental type.[13]

The Hahnemann Monument completed a short cross-axis at Scott Circle, with the Scott equestrian in the center and a statue of Daniel Webster on the opposite side. Even though the spatial planning was exemplary, the grouping of Webster, Scott, and Hahnemann made no sense at all. It was yet another example of what the *New York Times* called "statues at random," and its implied pairing of one of the nation's most revered orators and statesmen with a European scientist who had never set foot in

the United States was predictably criticized. The only reason the monument got such a plum site was that the Republican corporate elite, the men who got things done, were behind it. In a couple of decades homeopathy would land in the scientific dustbin, but for the moment the men who mattered still believed in the power of Hahnemann's extraordinary dilutions to cure basic diseases. President Grover Cleveland, a Democrat, originally vetoed the site for the monument, perhaps because of its ties to the Republican party. But that decision was reversed by his Republican successor, William McKinley, recently conqueror of Cuba and the Philippines, who took time out from war and diplomacy to watch his attorney general dedicate the monument. No wonder, then, that some commentators tried to connect the monument with current affairs: one letter writer speculated that it was intended "to remind the people of Washington that nowadays we are apt to get statesmanship in homeopathic [i.e., extremely dilute] doses."[14]

The spatial thinking behind the Hahnemann Monument had not yet penetrated the memorials on the Mall. That would change with the design of the Grant Memorial, awarded by a competition, again juried by NSS members, to a team consisting of the sculptor Henry Shrady and the architect Edward Pearce Casey.[15] Casey, who had trained in Paris at the École des Beaux-Arts, happened to be the son of the army engineer Thomas Casey of Washington Monument fame. Shrady and Casey's design, revealed in a model in 1902 (figure 67), was in effect three monuments in one, which would create a short north-south cross-axis to the main axis of the Mall. In the center was an enormous equestrian statue of Grant elevated on a twenty-two-foot-high pedestal, which was itself raised on a huge open marble platform 250 feet wide and 70 feet deep. The equestrian occupied its own square in the middle of this platform, with reclining lion figures on their own pedestals at the four corners below the hero. From the Mall side, several broad flights of steps approached the platform on either side of this central plaza. At both ends of the platform, separated from the equestrian by large expanses of marble pavement, were two more monuments-within-the-monument, each one a massive sculptural group on a low rectangular base about six feet high. The group to the left (north) represented a cavalry charge, and the one to the right (south) an artillery unit moving into action. Low walls with benches at each end of the platform created semienclosed spaces around these extraordinary combat groups, offering the viewer on the platform a more intimate and self-contained experience of the dramas unfolding within. When the monument was finally put in place twenty years later, the structure of the composition related clearly to the Capitol building behind, with the transcendent Grant echoing the Capitol dome and the two lower groups echoing the House and Senate blocks at either side (figure 75). Yet in the

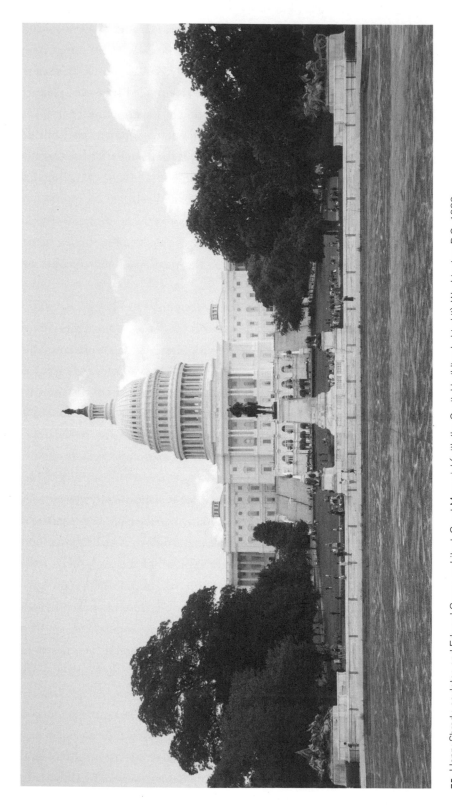

75 Henry Shrady, sculptor, and Edward Casey, architect, Grant Memorial (with the Capitol building behind it), Washington, D.C., 1922. (Photograph by the author, 2008.)

memorial it was as if the outer shell had been torn away to reveal the inner spatial dynamics that separated the commander on his distant perch from his troops struggling on the ground below. Viewers in the space would circulate around the majestically uplifted hero in the center and then find themselves pulled across the platform toward the maelstrom of the combat groups, hovering just above eye level.

McKim's original idea for Union Square had been much simpler: Grant and his two fellow generals, all on horseback, set on high pedestals to open up the plaza below and allow the eye and body to move freely through it (see figure 57). Together, the three statues would utter one message of disciplined command, consistent with the now disciplined landscape they would face. Shrady and Casey's design made the plaza much more complex and multivocal. By lowering the combat groups and integrating them into the horizontal expanse of the platform, the design created opportunities for the viewer to identify with the common soldier and witness the disorientation of battle. The monument's platform ceased to be a mere passageway through the plaza to the Mall, and instead pulled the viewer into a vortex. And unlike Hahnemann's Monument, this design reached no closure: it was a space of struggle without resolution. Thus the project went far beyond anything the planners had envisaged for the Mall and helped to open up a new space of introspection in the monumental core itself.

The realization of this innovative design was still decades away. In the meantime the art establishment had the beginnings of a track record of reform that promised to reshape the popular image of the public monument. Nevertheless, the campaign ran into resistance soon enough, and with each individual monument the planners and art advisors learned their limits the hard way. The first case to disrupt the reform campaign was a memorial project for Commodore John Barry initiated by the Ancient Order of Hibernians in America and other Irish American organizations. Although the finished monument now stands, forgotten, in Franklin Park, its design was a cause célèbre in the American art world in the first decade of the twentieth century.

The monument campaign began in 1906 in typical fashion, initiated by civic organizations eager to demonstrate their national legitimacy. For the Irish American groups Barry was a perfect choice, an Irish-born sailor who had become an American naval hero in the Revolutionary War. Singled out for commemorative honors, he would join the parade of Revolutionary heroes in Washington that was soon to include French, German, and Polish officers. Once again the design was chosen by competition, juried this time by a distinguished "advisory panel" of cosmopolitan

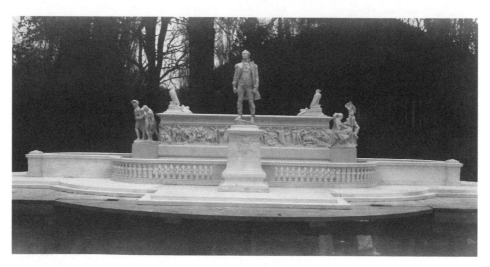

76 Andrew O'Connor, plaster model of Commodore Barry Monument, 1909. (National Archives, Record Group 42.)

artists including the architect Daniel Burnham of the Senate Park Commission, the painter Frank Millet, and the sculptor Herbert Adams. Their choice of an innovative design by Andrew O'Connor, an expatriate sculptor working in Paris, confirmed the new trends favored by the Senate Park Commission, but then ran into a storm of criticism from the very organizations that had initiated the monument campaign.[16]

O'Connor's design consisted of a huge fountain plaza with a complex sculptural program that put Barry into the larger historical context of the Irish diaspora (figure 76). No architect has come to light for the project, though it is doubtful that O'Connor could have worked without one. In the front and center the statue stood on its pedestal, raised on a shallow platform approached by two continuous steps. Behind the pedestal, and separated by a basin of water, was a long low altar, decorated with relief sculpture and punctuated by a figural group at either end. These supporting elements formed an island inside the fountain's basin, evoking the island of Ireland. Viewers circling the basin and gazing at the sculpture within would see an elaborate program recounting the tragic history of the island and the displacement of its people. A frieze of figures on the front of the altar, read from right to left (east to west), began with the first "rude uncivilized" inhabitants, depicted in the nude; proceeded to their subjection by the English king; and culminated in a dense mass of writhing, stumbling figures "who, in their distress, look longingly toward the west." The two freestanding sculptural groups at the ends of the altar contrasted ancient and modern Ireland: on the right (east), a figure of Erin, mother of Ireland, surrounded by

77 Plaster model of Commodore Barry Monument, detail of emigrant group. (National Archives, Record Group 42.)

allegorical fogs and "vapors of ancient tradition"; and, on the left (west), the exodus of her progeny, nude and downcast, "to the land of liberty" (figure 77).[17]

The total effect of the design was extraordinary for removing Barry from the usual celebratory tale of the American Revolution and situating him instead in a traumatic narrative about the exile of the Irish people amid British repression. Rather than

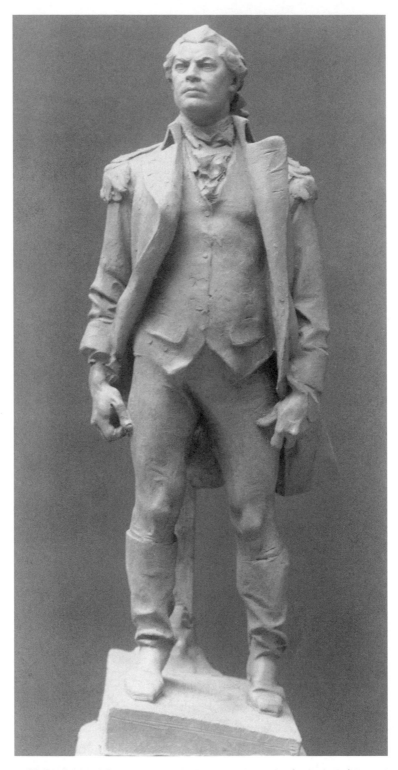

78 Plaster model of Commodore Barry Monument, detail of central statue. (National Archives, Record Group 42.)

simply confirm the triumphant finality of the American Revolution, the monument offered a much more complex international story without a clear resolution. To underline the point, O'Connor put Barry in a highly unconventional and unstable pose, on a sharply sloping plinth, the left foot several inches below the right foot (figure 78). To early twenty-first-century eyes he looks a bit like a freestyle skateboarder, but a century ago he made a very different impression. With his huge, knobbly hands curling into fists, this anticlassical figure—so unlike the repetitive portrait statues on view throughout Washington—evoked a scrappy commander holding fast to the prow of a rocking ship.

Following on the heels of Shrady and Casey's winning design in the Grant Memorial, O'Connor's design seemed to confirm the emergence of a new idea of commemoration, one beginning to allow a space for reflection on the traumas of history, not simply for celebration of its triumphs. The jury's enthusiastic choice of the design shows once again that cosmopolitan reformers such as Burnham were not the pack of retrograde classicists they are sometimes made out to be. Had this design been realized, it would have been the most unconventional monument in the United States, akin to Rodin's controversial public projects in France of the 1880s and 1890s. In fact, O'Connor's sculptural idiom was clearly indebted to Rodin's—in the oversized hands and feet, the odd poses with straining necks and torsos, and the expressive surface modeling with its scooped-out hollows and prominent ridges that defied traditional anatomical realism. As if to cement the connection, O'Connor's design directly appropriated poses from Rodin's *Gates of Hell* and *Age of Bronze* (see figure 77).

All this deeply offended the Irish American groups that had simply wanted an ordinary hero monument like those in Lafayette Square and throughout the capital. "We want a statue to compare with other statues in the City—for instance, Lafayette's, Rochambeau's, Farragut's, and Garfield's," explained congressman Michael E. Driscoll, who spearheaded the protests. Instead they got a sprawling, multilayered composition about "their misfortunes and their miseries," whose hero looked to them "more like a Bowery swaggering tough than a dignified American commander of the Revolutionary period." Driscoll and his allies were clear that representations of "great misfortunes in the history of the Irish race have no place on a pedestrian statue in honor of Commodore Barry in one of the public parks of the City of Washington."[18] This was supposed to be a statue in the mold of those that already decorated Washington's public grounds: a figure of a great man in a parklike setting meant to be soothing and edifying, not challenging. To the sponsors, the idea that a heroic statue could be about "misfortune" made no sense at all. This was precisely why the Freedmen's Memorial to Lincoln by Thomas Ball had transformed the horror of slavery

into a tale of white moral triumph. Driscoll and the rest of the Irish American power brokers never expected that Barry would stand against a Rodin-inflected backdrop of Irish hell.

Bursting into view in the newspapers and on the floor of Congress, this controversy may be the first recorded example in the United States of a serious conflict between the new cosmopolitan ideal of commemoration, with its space for traumatic history, and the traditional model of monumental history as honorific and uplifting. The Irish American organizations, wanting nothing to do with the new trends, made a point of reminding Washington's political elite that they represented "two million Irish voters in this country."[19] Their message was heard loud and clear. After appealing directly to President Taft, they managed to get the jury's choice overturned and to replace O'Connor's design with a monument in line with their expectations: a conventionally bland portrait statue, set on a pedestal with an equally conventional allegorical figure, designed by the sculptor John J. Boyle (figure 79). They steamrolled over the public opposition of several professional arts organizations such as the American Institute of Architects and the American Federation of the Arts, and the private objections of major figures such as the sculptor Daniel Chester French and the architect Cass Gilbert. For these municipal art reformers, the outcome was a disaster, setting back their budding campaign to put public monuments under the control of professional art experts. The Irish American groups had used their "political pull" to circumvent the authority of a duly constituted professional jury.[20] Ironically it was the exact opposite of the process by which the Freedmen's Memorial was built in the 1870s. There, African Americans had donated almost all of the money but held no authority over the design; in the Barry case, the Irish American groups that persuaded the federal government to put up all the funds ultimately wrested control of the design process. O'Connor tried to compromise with them, but they were dead set against him; all that survives of his design are photographs of the models and a small bronze version of the central statue of Barry, commissioned by the French government and now in the collection of the Musée d'Orsay.[21]

The monument was eventually dedicated in 1914 before an immense throng of Irish Americans gathered from around the country. A reluctant President Woodrow Wilson, who agreed only at the last minute to speak at the dedication ceremony, used the occasion to throw a few thinly disguised barbs at the ethnic group behind the monument. "Some Americans need hyphens in their names," he declared, referring to the very organizations assembled before him which often used the hyphenated term *Irish-American*. Barry, Wilson declared, "was an Irishman who became an American." Although Wilson's jab at Irish Americans had nothing to do with the design

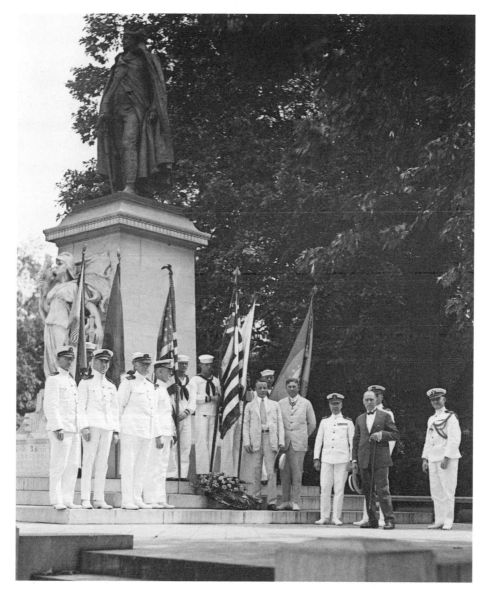

79 John J. Boyle, sculptor, Barry Monument, Washington, D.C., 1914. Photograph by National Photo Co., August 2, 1924. (Library of Congress, Prints and Photographs Division.)

of the monument, his stance resembled that of the municipal art reform movement.[22] Both wanted to limit the political clout of interest groups that interfered with their own vision of national unity under progressive leadership. At least in regard to the Barry Monument, their effort ultimately succeeded. The monument eventually became marginal as the unified monumental core envisaged by the Senate Park Commission emerged and developed. Although the site along Fourteenth Street in Franklin Park looked like a good bet in 1909, being close to many prominent mon-

uments erected in the neighborhood during the preceding few decades, the site lost its luster and was absorbed into the larger monumental periphery once the center took more definitive shape. Anniversary celebrations continued to take place at the Barry Monument and other peripheral locations as the new Mall was emerging— the one in figure 79 was organized in 1924 by the Sons of Revolution on Barry's 185th birthday—but these did not halt the inevitable process of obsolescence. The periphery became, in effect, a vast open-air warehouse for the projects of "ethnic" groups and other "lobbies" that somehow lacked the credentials or the desire to be, as Wilson remarked, fully "American."

The Assault on the Heroic Statue

It may seem strange that the same elite professionals who favored a homogenizing space of national unity would gravitate toward a design such as O'Connor's, which downplayed Barry's American achievements and opened up an altogether different history—the long painful story of Irish dispossession. Ironically, the Irish American sponsors wanted a statue that would turn Barry into an American icon, while the artist and his reformer champions chose a monument meant to plumb the trauma of the Irish soul. The explanation lies in the reformers' agenda. If they hoped to do away with the usual "invisible" public monument, the art they embraced instead sometimes led them in unexpected directions. The professional experts on the Barry jury were interested in a memorial that could articulate an idea in space; ideas are often surprising and controversial. But the reformers wanted them anyway. Typical hero monuments, in their view, were bereft of ideas, which is why they were ignored. As Charles Moore would later explain when he was head of the Commission of Fine Arts in Washington, "The ordinary commonplace work of a sculptor . . . is not interesting to me." An artistic memorial needed an "intellectual conception" to raise it above the empty conventions of portrait statuary.[23]

It should come as no surprise, then, that some of the best-known national icons in Washington's commemorative landscape came under attack from the art reformers. Having gained an institutional foothold when Congress and President Taft established the Commission of Fine Arts (CFA) in 1910, the reformers proceeded on a campaign against traditional statue monuments. Although Taft had double-crossed them in the Barry case, he did his penance by packing the original CFA with former members of the Park Commission and survivors of the Barry fiasco, men such as Daniel Burnham and Frank Millet, who had chosen O'Connor's design, and

Daniel Chester French and Cass Gilbert, who had defended it. They were determined not only to put an end to the old political system of monument building, but to remove some of the worst products of that system from the city's landscape. Shortly after his appointment, Millet told the newspapers that Washington was a "scrap heap for poor statues," and he argued that it was time to "substitute fountains or some other type of memorial for the statue." Similar reactions against "statue mania" were arising across the Atlantic as well, and coming to the attention of metropolitan reformers in the United States.[24] Soon enough there were reports in the papers that Clark Mills's long-notorious equestrian statue of Jackson was headed for removal, as was Vinnie Ream's monument to Admiral Farragut, which was competent if plodding, especially when compared to Saint-Gaudens's amazing monument to the same man in New York City.[25] Greenough's enormous statue of Washington had already been removed from the Capitol grounds in 1908 and placed inside the Smithsonian building, so anything seemed possible.

The reformers did manage to remove the stiff, jowly portrait statue of Dupont in his eponymous circle and replace it in 1921 with a more fashionable fountain designed by the Lincoln Memorial team of Henry Bacon and Daniel Chester French (figures 25 and 80). As the old formula of the hero statue lost its credibility, a new allegorical sculpture emerged, modernized and elegantly languid. Here, French's twisting female bodies, representing the Sea, Wind, and Stars, invite children not to emulate virtue but to sport in the water. Aside from this single success, however, the reform campaign did not ultimately succeed in clearing out the discredited remnants of the old nineteenth-century memorial landscape. What the planners could not accomplish directly, they did manage to achieve indirectly. By drawing tourists to the monumental core and progressively eroding the nineteenth-century streetscape to make ever more room for automobiles, planners profoundly altered the role of the statue monument in the city. Good and bad examples of nineteenth-century memorial practice remained standing but suffered alike. The modernization of the capital and its monumental core helped speed the obsolescence of the older monuments that had once defined the city's commemorative map.

The most striking example was the demise of the equestrian statue, which over a few decades lost the undisputed prestige it had held for two thousand years. What had been the most distinguished commission a sculptor could receive—even an innovator like Saint-Gaudens was desperate to secure one early in his career—lapsed into anachronism in the wink of an eye. After a dozen equestrian monuments were erected in the capital from 1853 to 1910, making the city perhaps the largest modern repository of the form in the world, the last important equestrian statue of a U.S. mil-

80 Daniel Chester French, sculptor, Henry Bacon, architect, Dupont Fountain, Washington, D.C., 1921. (Library of Congress, Prints and Photographs Division.)

itary commander was put in place in 1919, in Shrady's memorial to Grant. A handful of equestrians were erected from 1920 to 1976, but these were all marginal in one way or another. As a headline from the *Post* proclaimed in 1926, "New Statues for District Shun Horse."[26] The railroad, the electric streetcar, and finally the automobile all made the horse increasingly incongruous: command became a matter of control over machines and systems rather than over animals. As one critic explained in 1896, prompted by an equestrian statue of Grant in Brooklyn, the "personal prowess" of the commander no longer mattered much: "It is brains, not muscle, that wins in these times."[27] The symbolic impact of the equestrian type as a metaphor of command has now virtually disappeared, resurfacing only in odd moments, as when President George W. Bush gave his Hurricane Katrina speech in New Orleans in front

of a replica of Mills's equestrian statue of Andrew Jackson. Equestrian monuments have continued to live in popular culture primarily in legends about the meaning of the horse's feet—if two feet are off the ground, the rider died in battle, one foot off the ground means the rider was wounded, and so on. These legends are venerable: the CFA began to receive inquiries about them as early as the 1920s.[28] They have survived despite many well-known counterexamples, not least among them the equestrian Jackson, whose horse rears on two feet even though Jackson survived the battle and went on to become president of the United States.

Although twentieth-century planners had nothing to do with the cultural phenomenon of obsolescence, their design schemes exacerbated the trend. The Thomas equestrian, one of the finest examples of the genre, suffered as landscape planners and traffic engineers gradually destroyed the elegant grounds of the circle named after it. In 1919, the architect Irving Payne recommended removing the ornamental flower beds that had been prominently featured in postcards of the circle for years, because "bright colors tend to focus the attention on details rather than on the mass composition as a unified whole." He could not have better expressed the new monocultural orthodoxy of spatial planning ushered in by the Park Commission plan. The flowers were duly removed and the "composition" reduced to four small identical ornamental trees. Meanwhile, the area around the circle also changed dramatically, as the Fourteenth Street corridor became a major traffic artery and the old houses were either torn down or converted to commercial use. To address the traffic problem, engineers in the 1930s widened Fourteenth Street so radically that it sliced off two sides of the circular park. Thomas Circle became an ellipse (figure 81). Crosswalks to the shrunken park were removed to speed traffic flow, thus eliminating even the pretense of pedestrian access to the statue grounds.[29] Until 2006, when the circle was restored to its original shape and pedestrian access reestablished, the Thomas statue stood stranded in a barren traffic median, like a curious ancient ship moored in the middle of a busy modern harbor. The horse on its bronze ridge—somewhere in rural Tennessee, we are supposed to imagine—seems poised to take flight and bear his rider to a better place, beyond the rushing traffic, the bland grids of the nearby office buildings and hotels, and the daily battles of urban life.

All the statues in L'Enfant's streets and intersections were vulnerable to changes like these in the urban fabric. But the newly developed monumental core was even more instrumental in hastening their obsolescence. Sixteenth Street and East Capitol Street, the two spines around which many of the city's statues clustered, lost much of their significance once the decisions were made in 1907–11 to locate the new Grant and Lincoln memorials on either end of the Mall. As noted earlier, this victory for

81 View of Thomas Circle. Photograph by Esther Bubley for the U.S. Office of War Information, 1943. (Library of Congress, Prints and Photographs Division.)

the plan of 1901 established the center-periphery dynamic that would rule the commemorative landscape ever after. A few powerful players tried to prevent that from happening in the first decade of the twentieth century. Mary Henderson, a key property owner and entrepreneur on Sixteenth Street, wanted to create an alternative monumental precinct along that avenue. She offered the vision of a commanding "Avenue of the Presidents," which would ascend gradually from the White House and Lafayette Square to Meridian Hill, twice the elevation of Capitol Hill. Securing the two great memorials to Grant and Lincoln for that avenue would almost certainly have made the vision come true. Although she was too late to dislodge Grant from the Botanic Garden site, she did make a serious effort to win the Lincoln site by engaging the noted architect John Russell Pope, who worked up a stunning proposal for a temple monument atop Meridian Hill aligned exactly with the Sixteenth Street axis. Despite the prestige Pope lent the project, the CFA in 1911 decided on the Mall location in compliance with the 1901 plan.[30] Henderson eventually had to settle for a monument to President James Buchanan in Meridian Park, proposed in 1914 and finished in 1930. The monument to Buchanan, the Pennsylvanian who served a single ineffectual term immediately preceding Lincoln, represented an enormous comedown. Although the inscription pompously declared Buchanan "the incorruptible statesman whose walk was on the mountain ranges of the law," he was remembered primarily as the stooge of Southern slave interests in the run-up to the Civil War. His monument was beautifully designed in the new spatial mode as a low horizontal wall fronting on a plaza; in the center of the wall a bronze figure of Buchanan sits writing, with allegories of Diplomacy and Law at either end (figure 82). The lofty sentiments and subtle spatial design could not save the monument or Sixteenth Street from becoming ever more marginal while the new Mall began to take shape.

The East Capitol Street axis suffered an even more dramatic fall from grace as its two major monuments—Greenough's Washington in front of the Capitol building and the Freedmen's Memorial in Lincoln Park—were also eclipsed by the far more grandiose spatial configuration of the Washington Monument and the Lincoln Memorial. With the removal of Greenough's statue in 1908 and the decision to build the Lincoln Memorial on the Mall in 1911, the Freedmen's Memorial looked more and more like a lonely outpost in a residential neighborhood passing out of vogue. Landscape designers responded by making a laughable effort to redo Lincoln Park to compete with the nascent monumental core. First, in 1911, they cleared a short, straight "entrance mall" to create an axial approach to the Freedmen's Memorial, "replacing the previous circuitous walk system" (figure 83). Some years later the rest of

82 (top) Hans Schuler, sculptor, and William Gordon Beecher, architect, Buchanan Memorial, Washington, D.C., 1930. (Photograph by the author, 2008.)

83 (bottom) "Lincoln Park," *National Geographic Magazine*, March 1915, 259.

the park's meandering walks were eliminated entirely and replaced with a formal, symmetrical layout more in character with the "Lincoln Mall." None of these changes, however, made the Freedmen's Memorial any more noticeable or relevant. Even though Ball's image of emancipation retained some of its iconic power—as late as 1940, it was reproduced on a U.S. postage stamp to commemorate abolition—the Freedmen's Memorial was no longer the essential monument to Lincoln that it had been in the late nineteenth and early twentieth centuries.[31]

Suffering

The shift from the Freedmen's Memorial of 1876 to the Lincoln Memorial of 1922 marked a sea change in the history of the public monument. Thomas Ball had designed his group of Lincoln and the slave as a small-scale model in his studio without any site in mind, and then shopped it around to various cities interested in erecting a monument to Lincoln. As the planners would say, the group was an "independent" object, and indeed Ball had some success selling it to art collectors in various sizes and formats before it was transformed into a colossal public monument.[32] (In the Victorian era, sculptors made models in clay that could be reproduced by skilled laborers in any material at any size.) The sculpture of the hero could inspire whether it sat on a mantelpiece in a parlor or on a pedestal in a park, the difference being one of degree rather than kind. The "independence" of the sculpture from its setting gave it an objectivity—an apparently constant truth residing in the object, no matter where it stood in relation to an audience. Even if no object can ever attain this ideal of objectivity—since viewers always see it in different ways—artists and viewers alike accepted the ideal and bent their perceptions toward it.

The Lincoln Memorial from the beginning was a different animal in a site-specific habitat, inseparable from its location at the end of the Mall. Using McKim's proposal of 1901 as a starting point, the architect Henry Bacon conceived of the monument as a dynamic culmination of the long east-west axis. The sculptor Daniel Chester French, in close collaboration with Bacon, thought through every detail of his colossal statue in relation to various viewing points and distances along this axis.[33] The monument was more than a harmonious element of the larger "Mall system"; it shaped the very character of that system.

The Freedmen's Memorial distilled a complicated, violent, unresolved history into one heroic object—a fixed image of moral triumph achieved by the inspired leader-

ship of a single great man. Walking out of that nineteenth-century landscape of seeming moral certainty and into the inner precincts of the Lincoln Memorial, viewers confront an entirely different sense of history, full of tragic dilemmas and hard choices. Bacon and French did not merely integrate a monument into its surroundings. Their design opened up a space for subjective experience, in which viewers would come to understand Lincoln's achievement by immersing themselves in the emotional history of suffering and endurance that he himself had experienced. This shift toward the subjective helps explain why the memorial later became so instrumental in the Civil Rights movement, though its "message" about emancipation was even more evasive than that of the Freedmen's Memorial.

In its psychology the Lincoln Memorial took a startling leap beyond McKim's original proposal. McKim had suggested an open colonnade whose primary commemorative function was to hold up a giant stone placard bearing words from the Gettysburg Address. The words themselves, floating in space, would culminate the axis. On the slope below this structure would stand the bronze effigy of their author, a still and isolated figure above the lavish turbulence of the fountain beneath him. This extraordinarily elegant solution created multiple stages of transcendence. Lincoln as a human figure was elevated above the historical strife suggested by the fountain, and his words were in turn removed from their historical context of creation and lifted to a nearly sacred status at the top of the composition. It was no longer the man himself who was the pinnacle of the monument but his aphorisms, which outlived him. The Gettysburg Address was the ideal choice because the text itself relied on multiple levels of abstraction, at once distilling a moral cause from the unspeakable violence of the war and framing that cause in the logical terms of a "proposition" about equality rather than in the concrete human terms of slavery, which went unmentioned.[34] For visitors the approach to the end of the axis and the summit of the monument would thus have been a journey of ever-increasing transcendence, toward a not quite reachable realm of eternal truth purified of human conflict. Under the colonnade, the words still floating above, visitors would have been able to gaze westward through the monument, toward the hills of northern Virginia, out over a reunited and supposedly reconciled land.

Bacon transformed this conception by converting what McKim had planned as an open-air experience into an enclosed temple, dim and sequestered. Instead of sequencing the elements on progressively higher levels, Bacon's structure spread three major elements on an elevated horizontal axis, somewhat akin to what Shrady and Casey had done (on an open platform) with the Grant Memorial (figure 84). In the

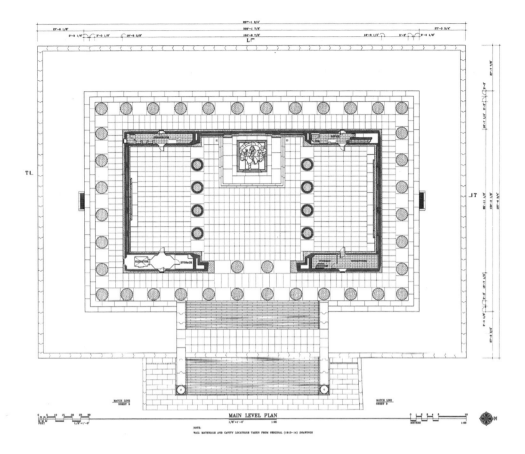

84 Henry Bacon, Lincoln Memorial, 1922, main level plan. (Historic American Buildings Survey, Report no. DC-3.)

center of this cross-axis was the colossal effigy of Lincoln seated on a throne, beckoning the visitor who approached from afar on the main axis. The rooms to either side—divided from the central space by open colonnades but invisible from the approach on the main axis—were each dedicated to one of Lincoln's most famous wartime speeches, the Gettysburg Address in the south room and the Second Inaugural in the north room, the texts carved in stone on the side walls. Unlike most monumental inscriptions, which are typically the abstract pronouncements of an unknown speaker or, when the hero's own words, short extracts chosen for rhetorical effect, these were unabridged texts, complete products of Lincoln's mind and hand. This distinguishes them absolutely from the short central inscription behind the statue, which was carefully worded by Bacon's friend Royal Cortissoz to avoid the issue of slavery altogether and to deliver a message of reconciliation that would be acceptable to Southern whites (figure 85). Even though Bacon liked the inscription and approved

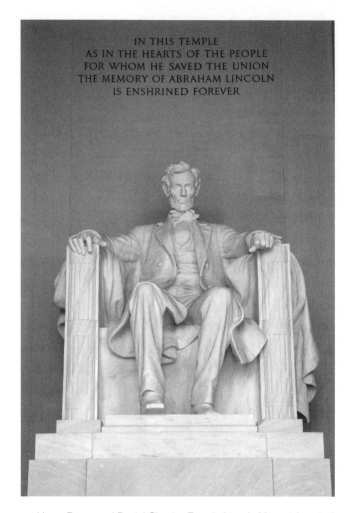

IN THIS TEMPLE
AS IN THE HEARTS OF THE PEOPLE
FOR WHOM HE SAVED THE UNION
THE MEMORY OF ABRAHAM LINCOLN
IS ENSHRINED FOREVER

85 Henry Bacon and Daniel Chester French, Lincoln Memorial, central room. (Photograph by the author, 2008.)

of its shift away from Lincoln as emancipator to Lincoln as unifier, his design actually undermined the inscription by redistributing the focus of the memorial across the three distinct but interconnected rooms, each a submemorial with its own weight.[35] Where McKim had envisioned a progressive ascent along the main axis through stages that are each left behind, Bacon created a space of discovery counter to the main axis in which visitors would shift back and forth from room to room, each experience modifying the other.

The somber image of Lincoln dominates the visitors' initial experience and by virtue of its sheer size looms as a palpable presence throughout the interior. The enormous side rooms, by contrast, are lavish in their emptiness. To read the huge text panels on those side walls, viewers have to stand back and experience the full

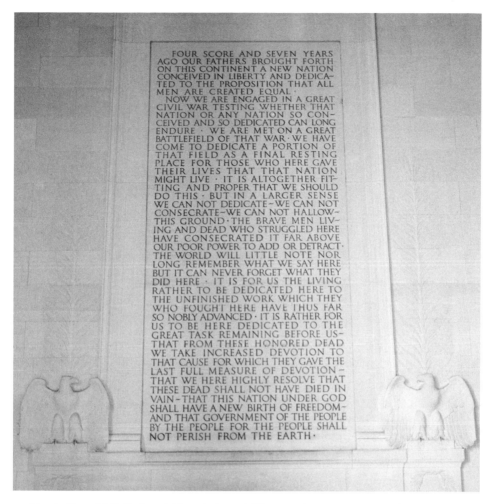

86 Lincoln Memorial, Gettysburg Address text panel. (Photograph by the author, 2008.)

scope of each space. Bacon arranged the scale of the text and the space so that the ideal viewing position was directly between the two central columns leading into the room. From this spot viewers can read the entire speech without craning their necks and can turn around to see the statue. An elegant classical frame surrounds each text, with carved eagles at the base (figures 86 and 87). In the Gettysburg panel, the eagles sit just outside the frame, whereas in the Second Inaugural panel the eagles are incorporated into the frame and the pilasters become fasces, bundles of rods signifying union; these shifts subtly suggest the movement from disunion to reunion. Everything about the presentation—the sumptuous scale of the space, the superb materials, the architectural framing, and the painted decoration above— transforms the ordinary act of reading into an extraordinary experience. A number

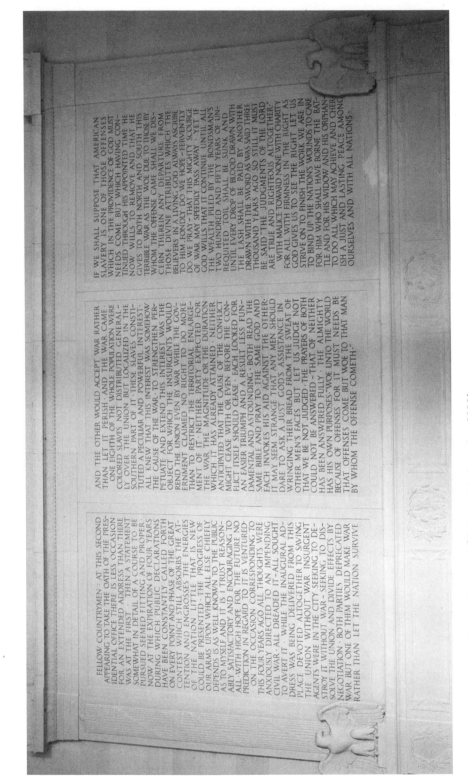

87 Lincoln Memorial, Second Inaugural text panel. (Photograph by the author, 2008.)

of commentators, particularly in the early days of the memorial, assumed that because the speeches were so familiar they could no longer have any real impact.[36] These critics misunderstood the aura of the memorial's space, its power to breathe new life into a venerable text. Unlike the disembodied placard in McKim's scheme, the texts here become in effect the speaking presence of an unseen Lincoln, complementing the visible presence of the silent statue in the center. The Lincoln of the Gettysburg Address, speaking while the outcome of the war was anyone's guess, offers the tantalizing hope that the sacrifice of the Union dead will lead the nation to a rebirth, poised to fulfill its founding ideals of liberty and equality. The Lincoln of the Second Inaugural, speaking on the eve of victory, jettisons the abstractions of Gettysburg and delivers a biblical message of divine retribution for the offense of "American slavery," "every drop of blood drawn with the lash . . . paid by another drawn with the sword." Taken together these words speak to the cruel unforeseen twists and turns of history ("All dreaded [the war], all sought to avert it") and to Lincoln's shifting attempts to master those events, to find in them some kind of providential mission.

These are complex thoughts, not easily summarized: we might say that they circle around the intertwined themes of aspiration and suffering. But the important point is that instead of offering a simple resolution for the viewer to absorb, they open up the immense interior space to questions, problems, possibilities, and mixed emotions. Didacticism alone, of the kind represented by Cortissoz's inscription, could not fill the space; it would remain hollow, mere emptiness. What fills that space ultimately is the subjective experience of those who confront it.

This is true above all of the central room with its colossal effigy. The statue is by now so familiar, so often reproduced in public media and private snapshots, that it can easily lapse into the kind of fixed objecthood characteristic of the traditional monument. If we view it simply as an object meant to impart a lesson, we might easily criticize it for its lack of content, particularly the failure to represent emancipation in even the most cursory way. But this was not the way the sculpture was meant to be addressed, and to experience its force now requires some effort and will. Raised on a high throne, the colossal Lincoln holds a pose that is majestically upright, much like the Olympian figure Taft and Roosevelt and others wanted him to be. As we head up the steps toward it, we move in and out of the statue's gaze until, at the center of the inner colonnade, Lincoln's eyes seem to stare directly toward us. But even here his gaze does not return ours; his eyes look through us into the distance (see figure 85). Lincoln's look is inward, not externally focused. If all this seems to make the figure

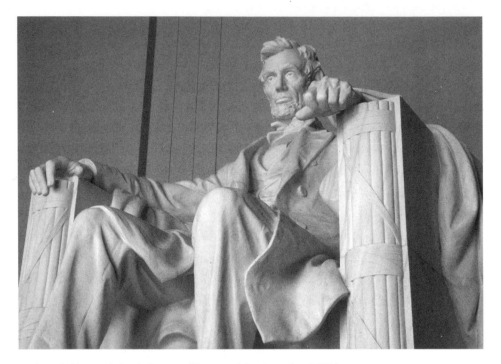

88 Lincoln Memorial, detail of statue. (Photograph by the author, 2008.)

godlike, removed from our world, it is to magnify his own interior struggle to epic proportions.

French made sure to include the cues, entry points for us as viewers to identify with that human struggle. First there is the riot of curves in Lincoln's hair and coat, and then the odd asymmetry of his face with its nose slightly off kilter, all so at odds with the perfectly straight vertical rods that decorate his chair (the bundled fasces, a symbol of union).[37] Then there are the hands—hands that betray Lincoln's inner tension, the strain of thought just beneath his apparently inscrutable exterior (figure 88). These are meant to draw attention: they extend beyond even the throne's armrests and practically compel us to move closer, even though Lincoln's gaze becomes more remote as we do so. Often crucial in figural sculpture, hands are especially so in Lincoln's case. They are, after all, the hands that wrote the words engraved in the building's side halls. Nineteenth-century sculptors were always tempted to put a pen or a document in those hands, to make them productive. French avoided that literal reference and left the hands empty and restless. They do not act in a conventional sense but they do seem to move and speak. Three fingers of the right hand grip the chair arm, while the left hand curls into a fist with the thumb stretched outward. Those who know Saint-Gaudens's work well should recognize an homage to his seated

Lincoln in Chicago, but French reworked that prototype in significant ways; Saint-Gaudens had Lincoln's right hand resting on his leg and the left hand in a more static fist. Try holding your hands as French's figure does, and you will begin to feel the subtle muscular stress that spreads up the forearms to the shoulders and neck. Even though it will not occur to most viewers to identify with Lincoln at a muscular level, the statue beckons them nonetheless to make sense of its interior complexity, its restless repose. When this visual experience of the statue is matched with the experience of Lincoln's thought and voice in the side rooms, the possibilities for subjective engagement multiply and intensify throughout the memorial.

Ultimately, as viewers we are asked not to celebrate Lincoln's triumph but to experience in our own way the tragic load he had to carry. Lincoln appears colossal, great to be sure, but equally a victim of his greatness, awaiting his own martyrdom. This is above all what distinguishes the memorial from Ball's sculptural statement, and even from the sophisticated spatial design of McKim. The mural scheme by Jules Guerin is the memorial's only real effort to rescue a sense of historical closure. The horizontal murals above the text panels in the side rooms are supposed to resolve the contradictions of the war and the memorial in transcendent, idealized images of emancipation and reunification (figure 89). In other words, they are supposed to represent the "great ends" for which Lincoln suffered and died. The murals are not up to the task, however, in part because they are so high up and in part because their visual language is so obscure in comparison with the directness of the sculpture and the texts. The murals avoid conventional abolitionist iconography but replace it with a fashionable mural style of the early twentieth century, still steeped in the assumptions of African backwardness and white majesty. Yet they are so out of place visually and so overwhelmed by the rest of the memorial that their transcendent message of closure is almost entirely lost.

The preeminent scholar of the Lincoln Memorial, Christopher Thomas, has pointed out that the memorial could not be overtly triumphal, because the Republican sponsors needed to avoid offending the white South. Certainly, they did not want the monument to rub the former Confederates' noses in Lincoln's victory.[38] But if a sense of restraint helps explain why they avoided simple heroic formulas, it does not account for the psychological space that the memorial created instead. Nor is Lincoln's martyrdom a sufficient explanation. The idea that Lincoln died for the nation's sin—particularly the sin of slavery—struck a chord in a predominantly Christian country, but few sculptors in the nineteenth century explored this theme, preferring instead the tried and true conventions of heroic statuary. Even Saint-Gaudens's brilliantly subdued monument to Lincoln in Chicago represented him as an orator and

89 Lincoln Memorial, detail of Emancipation Mural by Jules Guerin. (Photograph by the author, 2008.)

intellect at the peak of his powers rather than a lonely figure brooding on the vicissitudes of history.

Ironically, what makes the Lincoln Memorial seem so authentic today—its engagement of the viewer in the tragic struggle of human history—sprang from cultural anxieties and artistic complaints peculiar to the late nineteenth century. By this time cosmopolitan critics and designers saw conventional Civil War monuments as simpleminded: they reduced the Civil War—the most complex and devastating in the nation's history—to a bunch of ordinary soldiers looking dressed up for a military parade, as if the details of their uniform were more important than the history they helped make. The monuments lacked meaning, intensity, grit. This artistic critique dovetailed with a broader cultural anxiety that the United States, in its new affluence, was becoming overcivilized and effeminate. The way to reestablish true masculinity and strengthen the fiber of the nation, according to Teddy Roosevelt, was through dedication to the "strenuous life," a "life of toil and effort, or labor and strife." Roosevelt would often return to the example of the Civil War generation and explain that, rather than seek an "easy peace," they persevered in the face of massive human costs. "We could have avoided all this suffering simply by shrinking from strife," Roosevelt argued.

> And if we had thus avoided it, we would have shown that we were weaklings, and that we were unfit to stand among the great nations of the earth. . . . Praise the God of our fathers that the ignoble counsels of peace were rejected; that the suffering and loss, the blackness of sorrow and despair, were unflinchingly faced, and the years of strife endured; for in the end the slave was freed, the Union restored, and the mighty American republic placed once more as a helmeted queen among nations.[39]

It is important to make clear that this idealization of toil and pain and strife was a preoccupation of affluent men, the white collar corporate class. Most of the nation's (and the world's) people were already all too familiar with the strenuous life and would gladly have exchanged it for a bit more comfort. But affluent men shaped culture, and their ideas carried real weight. The earlier model of progress as a simple unfolding of divine Providence shifted to a model of human struggle requiring sacrifice and suffering. By the time the United States invaded Cuba in the Spanish-American War of 1898, these ideas were in the air, ready to be tested and vindicated. Though Roosevelt had combat experience in Cuba that was briefer and less traumatic than the typical soldier had in the Civil War, he managed to put himself in danger and thereby gain a platform of real experience from which he could advocate the new

ideal more forcefully. Faced with criticism that the war was unjustified aggression, crassly appealing to what William James called the "battle instinct" of men, Roosevelt and others dismissed the critics as "obstructionists," out of step with the times. An article in the popular middle-class magazine *Century* titled "The Nobler Side of War" used the new ideal to recast war in this light: "We think of war, nowadays, not so much as being a means of making others suffer as an occasion of giving ourselves up to suffering. Surely in the war against Spain it was the idea not of inflicting injury upon an enemy so much as the idea of sacrificing one's self for a cause—for the cause of country and humanity—that drew gentle souls into the dangers of war and of tropical pestilence."[40]

"Giving ourselves up to suffering" could easily have been the slogan for the new monuments to Lincoln and Grant erected on either end of the Mall axis. The ideal of unflinching commitment in the face of suffering and despair was precisely the sort of "intellectual conception" that the stock soldier monument lacked. The currency of this ideal in the early twentieth century helps explain why such challenging memorial designs could have been imagined and indeed accepted. And even though they originated in unique cultural circumstances that have come and gone, the space of tragic suffering they introduced into the Mall still has an authenticity in our own time, perhaps even more so now. The Lincoln and Grant memorials anticipated changes that would not crystallize for another sixty years, when the Vietnam Veterans Memorial appeared.

The Viewer's Maelstrom

Less literary and more visceral than its counterpart across the Mall, the Grant Memorial, when it was finally dedicated in the old Botanic Garden in 1922, instantly overturned the American war memorial tradition. Whereas much of the drama of the Lincoln Memorial emerged in Lincoln's own words, the memorial to Grant was animated by the anonymous figures of soldiers engaged in desperate action. By introducing these large groups of common soldiers, the sculptor Henry Shrady effectively transformed the work from an officer monument into a much broader memorial, not to the ordinary soldier alone but, more radically, to warfare itself. Shrady devoted many years and much of his professional life to the combat groups, expanding and intensifying them far beyond the outline he provided in the plaster model of 1902.

In both the cavalry and artillery groups, Union soldiers are propelled into combat with an unseen enemy. Instead of witnessing a collision of two opposing armies,

90 Henry Shrady, Grant Memorial, detail of artillery group. (Photograph by the author, 2008.)

viewers see the battle only through the effects it has on the individual soldiers strug-
gling to do what they have been ordered.

In the artillery scene are six figures, three in the rear sitting on a cart that pulls
the cannon and the other three riding horses in front. The figures in the rear huddle
together in stilled poses, bundled against the cold, isolated in their misery from the
turmoil around them. Moving toward them on the platform, we see that one soldier
leans forward, bracing himself against the wind, and another nestles his head in the
shoulder of his downcast comrade, who leans away (figure 90). In their posture and
affect these passengers are the opposite of the men ten feet in front of them, who are
in furious movement—as if the space between horsemen and passengers were an
unbridgeable chasm. A signal bearer on the leftmost horse twists violently backward,
while the two drivers beside him struggle desperately to control their rearing horses.
In the confusion of straining bodies and tightly packed, flailing animals, no single
view allows us to grasp the action. As we move around the group and peer through
the crevices in its composition, different aspects of the drama appear but do not co-
alesce into a single unified story. From one side, for example, we see that the wheel
driver lunges forward precariously out of his saddle, but we have no idea why; in front

91 Grant Memorial, detail of artillery group. (Photograph by the author, 2008.)

92 Grant Memorial, detail of artillery group. (Photograph by the author, 2008.)

we can just barely see through a crack between the horses that his right hand holds
on to one of the reins for dear life (figure 91). Is he lunging with the reins to stop his
horse from crashing or to keep himself from falling? Shift to the other side and new
questions arise. Most of the soldier's body is now hidden; we see only his head tilted
backward, his mouth open and eyes closed, suffering intense physical agony, per-
haps from a gunshot or a shell (figure 92).

So it is with the cavalry scene on the other end of the platform. Walking around
it, we get a disorienting succession of fragmentary views that reveal the dangerously
limited perspective of any soldier within the charging group (figures 93–95). Ap-
proaching from the Mall side (the west) we see a downed horse and can just glimpse
a forearm reaching around to hug the horse's neck; directly above this calamity an
officer is leading the charge, his horse plunging forward while its head rears back.
When we climb up to the platform and move around the group, we see that the fallen
horse and rider have opened up a hole in the center of the charge. As we look into
this hole and gradually shift our position, the differing reactions of the riders in
back come into view. One shields his face as his horse lifts both front legs; others
rush forward, unaware of—or just on the point of discovering—the void left by the

93 (top) Grant Memorial cavalry group, viewed from the west. (Photograph by the author, 2008.)

94 (bottom) Grant Memorial cavalry group, viewed from the east. (Photograph by the author, 2008.)

95 Grant Memorial cavalry group, viewed from the south. (Photograph by the author, 2008.)

fallen horse. From the Capitol side (the east), both the void and the fallen rider disappear, and the charge seems to rush smoothly ahead.

In both scenes, the composition frustrates clear views and legible readings. Each one is organized around a central void or gap, which corresponds to a breach in perception and understanding. Without a coherent narrative to make sense of the overall action, the viewer naturally gravitates to the individual men and their fragmentary perspectives. Every figure in the two groups is absorbed single-mindedly in his own danger or duress or duty; their absorption, in turn, draws us into their world and makes our encounter with them strangely intimate despite the extremity of their

situation. "I can guess at the thoughts of each man," one observer wrote, registering the psychological engagement the monument seemed to demand.[41] Battle emerges as a maelstrom for both the individual soldier and the viewer: neither can hope to control or even understand it.

What do we make of Grant in all this? Like the statue of Lincoln in Bacon's memorial, the figure of the commander looms above in majestic isolation (figure 96). Grant sits firm, slouching under a heavy cloak, the weight emphasized by deeply undercut folds falling in diagonals. His hat is pulled low over a noticeably grizzled face. His horse, by contrast, is eager and expectant, neck upright and ears pricked. Where Grant bends, his body slackening just perceptibly into horizontal folds, all the surfaces of the horse tauten, as if vibrating to the battle below. Grant's horse "snuffs the battle from afar," like the commander's horse in Ward's equestrian monument to Gen. Thomas (see figure 33). But the two narratives are noticeably different. Thomas follows the lead of his horse and looks for the battle in the distance, whereas Grant is smothered by cloak and hat, encased in his own sphere of thought—like his soldiers, absorbed in a world of his own. The commander remains a distant figure, presiding in silence over the suffering he asks his soldiers obediently to endure.

Grant's grandson, writing in 1926 as director of the CFA, described the relation of commander to soldier as "detachment": "It was the sculptor's desire and intention to create the impression of movement and activity and the confusion of battle in the two lower groups, with a central figure rising above such confusion and expressing detached calmness and thought."[42] This disjunction between the common soldier's "confusion" and the commander's "detachment" is the basic artistic premise of the memorial, but it should be stressed that viewers on the platform cannot share equally in the two points of view; they approach the battle through the soldier's narrower lens. The commander's perspective is at once fuller and more impersonal, disconnected from the smaller-scale events—a thrown rider, a desperate horse—that make or break the individual soldier's life.

Conceived in the heyday of the "strenuous life," this memorial may well have been an outgrowth of Shrady's own belief in the nobility of war's sacrifices, but when experienced on site his sculpture is a shocking rebuff to military pomp and display. Its unflinching investigation of the individual's immersion in battle—"investigation" is no euphemism here: Shrady put years of research and observation into the project and eventually died from the strain—undermines easy platitudes about the tonic of strife. In this monument there is no simple unifying narrative of male valor, no romance or pageant that frames the action within. The composition dissolves into frag-

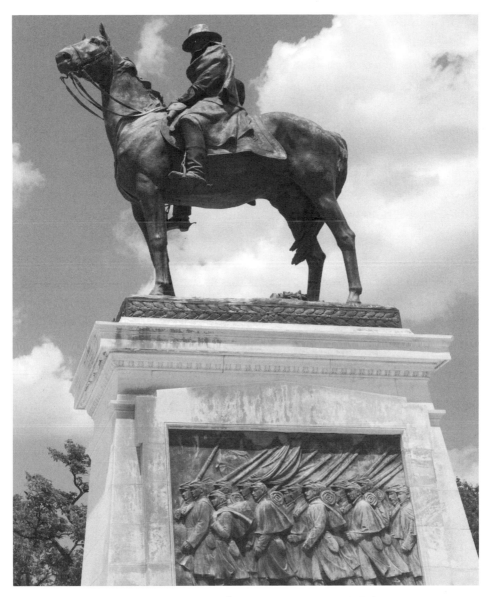

96 Grant Memorial, equestrian statue of Grant. (Photograph by the author, 2008.)

ments, individualized stories played out at different speeds and from different per-
spectives. In this way Shrady's work of sculpture echoes Stephen Crane's novel *The
Red Badge of Courage* (1895), which charts the continually shifting combat experience
of one raw soldier over the course of two days of battle. Not siding with one cause or
the other, the monument, like the novel, imagines an experience common to all sol-
diers in combat, Union, Confederate, or otherwise. Yet where Crane's protagonist
ultimately finds his valor at the end of the day, the soldiers in Shrady's work have

no ending in which their suffering acquires meaning and heroic agency. Neither the rapid blur of the cavalry charge, which might right itself or tumble in disaster, nor the slow suffering of the men in the artillery cart, points toward an outcome. The men in the cart are perhaps the most tragic figures of the whole monument: denied the privilege of action, they can only sit helplessly and endure, evoking the prolonged trauma that soldiers had to face day in and day out.

Shrady's work is all the more astonishing given that there was nothing comparable in the American war memorial tradition. Nineteenth-century Civil War memorials in towns and battlefields usually avoided representation of combat death or stress in favor of generic figures of intact, upright infantrymen.[43] Grieving allegories sometimes appeared, as in the Navy Monument (1877) at the foot of Pennsylvania Avenue, later redubbed the Peace Monument. These were stock devices that represented conventionalized sentiments—telling us what we are supposed to feel—rather than figures designed to engage viewers subjectively. The first freestanding monument in Washington to represent a battlefield casualty was the equestrian memorial to William Tecumseh Sherman (1903) south of the Treasury Building near the White House grounds. Two allegorical groups, representing war and peace, decorated the pedestal; the war group—one of the strangest sculptural compositions in all of Washington—featured a dead soldier pecked by vultures lying beneath a female allegory of war, "a terrible woman who tramples humanity under feet."[44] Shrady's sculpture had nothing to do with this venerable emblematic tradition. He rejected allegory and its coded meaning in favor of a sculpture that would close the psychological distance between viewer and representation.

The Grant Memorial has nothing to explain or exalt the soldiers' suffering, nothing comparable to Guerin's mural scheme for the Lincoln Memorial or even to Lincoln's speeches, vexed as they are. Shrady, a good Union man like most of his audience, no doubt took for granted the nobility of the Union cause. Yet without any redemptive narrative, his intense focus on the individual experience of combat threatened to turn the monument's soldiers from heroes into victims, and the monument's viewers from reassured citizens into traumatized witnesses.

The Victim Monument

To label either the Grant or the Lincoln Memorial a victim monument is anachronistic—an imposition of present-day categories of thought on a work that predates them. When O'Connor represented Irish victims of political oppression in

his design for the Barry Monument, there was no adequate vocabulary to describe the point of these scenes. They were simply "misfortunes" or "miseries" that had no place in an honorific monument. A century later the landscape has shifted remarkably. In 2002, a huge monument to the victims of the Irish potato famine—the Irish Hunger Memorial—was dedicated on a prime piece of real estate in lower Manhattan, with the full support of Irish American civic groups and politicians. The victim monument has become entrenched in our consciousness, embraced by groups across the political spectrum. In Washington, the memorial to Japanese Americans interned during World War II (2000), reluctantly approved by Ronald Reagan as part of a negotiated settlement, now stands about four blocks from a memorial to victims of communism sponsored by former refugees from Soviet communism with the help of established conservative organizations (2007). In the memorials to Lincoln and especially Grant we can see the beginning of this shift. Their attention to suffering opened a space for a new consciousness of trauma and victimization, even though neither monument was yet couched in the vocabulary of victimhood we have come to recognize today.

In the nineteenth and early twentieth centuries, the very idea of a victim monument was still an oxymoron. Victimization is a state of powerlessness, "when action is of no avail," as the psychiatrist Judith Herman has explained.[45] Traditionally, as Carlyle made so clear, monuments celebrated heroism, the very opposite of powerlessness. They reaffirmed the power of great men to take action, to transform the world for the better or save it from peril. Fires, hurricanes, yellow fever epidemics, shipwrecks, or other traumas, no matter how devastating, did not merit monumental commemoration, other than the occasional recognition provided at the victims' gravesites. In Europe the major exception to this rule was the plague memorial, especially those erected throughout the Hapsburg Empire in the late seventeenth and early eighteenth centuries. Yet even these were heroic, intent on showing the triumph of Christian faith over pestilence.[46]

Although wars produced victims on a massive scale, the memorials to war dead that began to appear in the nineteenth century were justified in the language of heroic sacrifice rather than victimization. In Washington, war memorials usually took the form of monuments to commanders. Before World War I the only monument to common war dead built in the capital was the Navy Monument, erected (in the words of its inscription) "in memory of the officers seamen and marines of the United States Navy who fell in defense of the union and liberty of their country 1861–1865." Although common soldier monuments became widespread elsewhere in the country, they adhered to the same rhetoric and staked their public claims on the moral duty

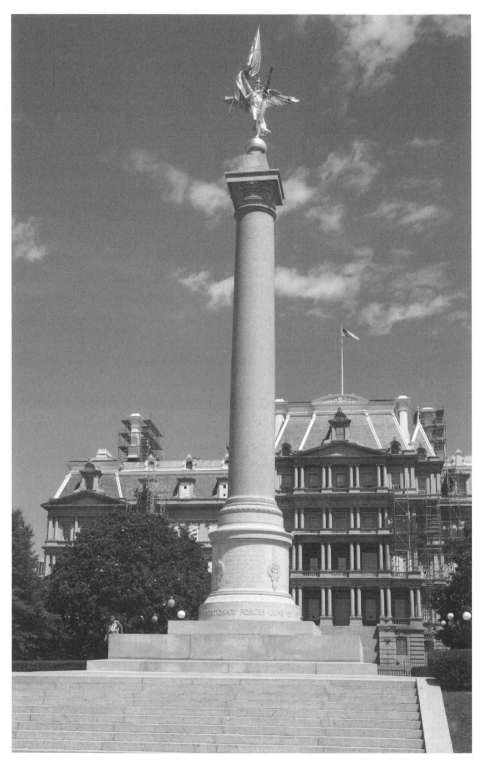

97 Daniel Chester French, sculptor, and Cass Gilbert, architect, First Division Monument, Washington, D.C., 1924. (Photograph by the author, 2008.)

and willing sacrifice of these men, not on their tragic fate as victims of a calamity.

In the early twentieth century, signs of change emerged. A few local disaster monuments began to appear, outside churches or cemeteries, simply to mark the tragedy of lost lives. This phenomenon remains largely unresearched and unwritten, but early sculptural examples include a fountain memorial in a public park to more than a thousand victims of the fire on the steamboat *Slocum* in New York (1906); a decorated shaft along a highway in the Florida Keys commemorating the victims of the 1935 hurricane (1937); a large memorial on a Texas highway with the names of 296 children and adults who died in a school explosion (1939); and a relief sculpture in a park commemorating ninety-one men who died in a West Virginia mine disaster (1940).[47] War memorials too showed signs of change. Although they continued to rely on the rhetoric of heroic sacrifice, increasingly they listed the individual names of those who served and died. The practice of inscribing names on war memorials had begun in Prussia and France in the 1790s and first appeared in the United States in a few Revolutionary battle monuments erected in the mid-nineteenth century. Some Civil War monuments took up the practice but with great inconsistency. Not until World War I did the practice become more uniform, and when it did, war memorials brought both the scale and the irreducible individuality of loss into the commemorative landscape.[48]

The earliest monument in Washington to carry the names of ordinary soldiers was also the capital's first World War I monument. Dedicated in 1924 to the nearly six thousand dead of the Army's First Division, the memorial was located southwest of the White House within the north-south axis of the monumental core (figure 97). Daniel Chester French's gilded statue of Victory atop a tall white granite column gave the monument a triumphal tone, in line with the intent of the sponsoring veterans' association to display "the spirit of triumphant sacrifice and service." But down below, on a base designed by Cass Gilbert, the names of all the division's war dead were listed on large horizontal bronze plaques set into the granite plinth, only visible when the spectator approached within a few feet of the column (figure 98). To make room for all the names, their presentation had to differ from that of the didactic inscriptions on the base: the lettering was shrunk to three-eighths of an inch in height and cast in metal rather than cut into the granite. The sheer number of names was unprecedented in an American war memorial and for its designers "constituted a problem of unusual difficulty." This was an interesting transitional moment in memorial design. Although the designers envisioned a spatial setting—a wide terrace around the shaft that would provide space for rest and quiet "study"—they clung to the belief that the names had to be affixed to the shaft itself, the honorific center of the

98 First Division Monument, detail of names on plinth. (Photograph by the author, 2008.)

monument.[49] Later this belief would fade. The names of the division's dead in World War II and in the Vietnam War would be installed on separate blocks added at the east and west ends of the terrace, though the size and format of the names would remain the same. (The Vietnam Veterans Memorial repeated these same names five years later in its own more comprehensive list.)

In 1931 a memorial to the District of Columbia's servicemen in World War I, not far from the current location of the Korean War Veterans Memorial, also included a complete list of the dead. The names were inscribed on a circular temple, originally intended as a bandstand; "living memorials" like this became more common after World War I as statue monuments increasingly passed out of favor. The memorial has now taken on a more elegiac cast, neglected and swallowed by the woods that have grown up just north of Independence Avenue.

Introducing memorials to war dead in the monumental core stirred some controversy. Many on the CFA and in the larger art community worried about a new proliferation of war memorials and from the start advocated less intrusive alternatives, such as flagpoles or fountains. Naming the dead had the potential to expand the size and scope of war memorials dramatically, but there is little evidence that the CFA had grasped those implications yet. The art establishment was focused on avoiding a repetition of the Civil War memorial phenomenon, which it believed had left a hodgepodge of monuments littering the streets of the capital and the country. The first step was to prevent the forty-two individual army divisions that had fought in Europe from each erecting its own independent monument. Instead, in the spirit of the plan of 1901, the CFA suggested coordinating a scheme "for the erection of a great memorial to the world war," preferably at the terminus of the north-south axis from the White House (where the Jefferson Memorial stands now). When that effort failed and it became clear that the First Division would get its own monument, the CFA proposed scaling down the original column monument to a smaller fountain memorial, but again to no avail.[50] In the mid-1930s, the Second Division proposed its own memorial in the Ellipse, not far from the First Division's, and it appeared that the CFA's nightmare might come true. The Second Division was equally deserving, with combat losses roughly equal to those of the First, so there was no good rationale for allowing one in the monumental core and not the other. The *Post* warned that this logic would eventually lead to the destruction of the park in the Ellipse and its conversion into a landscape of battle memorials like Gettysburg.[51] It was as if a new war for territory were now under way, the army divisions pressing forward to secure their memorial positions and the CFA and other concerned parties trying to hold an

imaginary "Maginot Line" against the monumental invasion. Ultimately the planning bodies were able to hold that line, but only after the Second Division secured a position near Constitution Avenue.

The addition of three World War I memorials to common soldiers, two of which featured long lists of names of the dead, underscored the new recognition of loss in the monumental core. Although this demonstrated a shift from the purely triumphal model of commemoration, the World War I memorials lacked the psychological engagement of those to Lincoln and Grant. The new memorials relied instead on traditional didactic reassurances of the nobility of death in a higher cause.

The same can be said of the first civilian disaster monument erected in Washington, commemorating the wreck of the *Titanic* in 1912, which killed fifteen hundred people. The disaster actually spawned two memorials in or near the monumental core: the so-called Butt-Millet fountain, erected in the Ellipse in 1914, dedicated to two prominent men lost in the accident, one of them Frank Millet of the CFA; and the larger, more comprehensive Titanic Memorial, installed in 1931 just outside the monumental core about a half mile upriver from the Lincoln Memorial. Unlike the newly emerging local disaster monuments, which did not need to justify themselves with didactic content, the *Titanic* memorials in Washington were expected somehow to confirm the moral greatness of the nation. Thus the handful of wealthy women who ran the Titanic Memorial campaign framed it as a popular initiative by American women, not to remember the victims per se, but to honor the "brave men," as the inscription would later proclaim, who "gave their lives that women and children might be saved." The Butt-Millet fountain, though erected by men for men, grew out of a similar need to reassert male chivalry in response to inexplicable catastrophe. Male valor, not victimization, was the rationale for the monuments, and in that respect they mimicked the traditional rhetoric of the war memorial.[52]

The Titanic Memorial, installed on a spectacular site along the Potomac riverbank, featured a white granite plaza and low exedra designed by Henry Bacon, with an enigmatic male figure raised on a simple pedestal in the center (figure 99). Silhouetted against the sky above the river, the statue by Gertrude Vanderbilt Whitney depicted a seminude body, arms outstretched to suggest a cross. With the figure's head tilting slightly upward and the drapery flowing behind in a diagonal, the body poised ambiguously to dive or soar, the sculpture evoked a Christian allegory of sacrifice and resurrection. When this glittering memorial was dedicated in the midst of the Great Depression, nearly twenty years after the shipwreck, it must have seemed strangely incongruous amid the massive human suffering that much of the country was experiencing. The memorial regained a peculiar aptness in 1936 when a huge flood

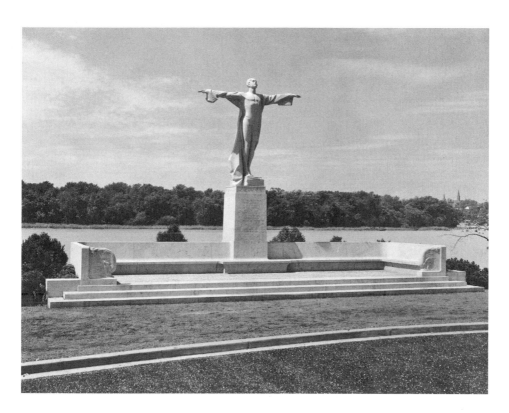

99 (top) Gertrude Vanderbilt Whitney, sculptor, and Henry Bacon, architect, Titanic Memorial, Washington, D.C., 1931. Photograph by Leet Brothers, ca. 1930. (American Sculpture Photograph Study Collection, Smithsonian American Art Museum, S0002533.)

100 (bottom) Titanic Memorial in Potomac flood. Photograph in *Work: A Journal of Progress*, September 1936, 13.

nearly sank it, leaving the statue floating just above the Potomac, a poignant reminder of the original disaster that had once captured the nation's attention (figure 100).[53] But in the 1960s the monument finally hit an iceberg in the form of the Kennedy Center, whose construction forced its relocation to a new riverbank spot in southwest Washington far from the monumental core, where it now stands in relative obscurity.

Triumphal Gigantism

The trend toward the victim monument succeeded in introducing new moods and subjects into the commemorative landscape, but it certainly did not end the era of the traditional hero monument. After 1925, the production of statue monuments declined overall as the critique of statues gained greater traction and the living memorial movement grew in popularity. Yet even so, celebratory statues continued to be in demand, and, ironically, they seemed to grow larger and more assertive the more they diverged from the new memorial trends.

A case in point was the Jefferson Memorial (1943), strategically located at the south end of the cross arm created by the plan of 1901. By the mid-1930s, when the campaign for the national monument got under way, Franklin Roosevelt and the Democrats saw it as a way to put their imprint on the capital's monumental core, which, until then, had been dominated by Republican plans and Republican heroes. Jefferson was to the Democrats, in effect, what Lincoln was to the Republicans, a patron saint.[54] In general terms, the Jefferson Memorial followed the model of the Lincoln Memorial: a templelike structure housing a colossal effigy. But there the resemblance ended.

John Russell Pope's temple form (modified by his associates after his death) was circular, domed, and open on four sides, less a hushed space for psychological engagement than a platform to inspire the mind to soar. The statue by Rudolph Evans adhered to the conventional nineteenth-century hero formula: a standing figure in period costume holding an important document in his hand, in this case the Declaration of Independence. On the walls and cornice surrounding the statue appear excerpts from Jefferson's writings, cherry-picked to put his thoughts and achievements in the most favorable light. "I have sworn upon the altar of God eternal hostility against every form of tyranny over the mind of man," the main inscription on the cornice declares. The whole ensemble, unlike the Lincoln Memorial, is decidedly upbeat and inspirational.

But the designers could not entirely avoid one major problem: Jefferson's complicity with slavery, which undermined practically every ideal inscribed on the monument. Although barely a hint of Jefferson's inner conflict on the issue disturbs the triumphal surface of this monument, slavery is the repressed always threatening to return. Even before DNA testing confirmed Jefferson's affair with his slave Sally Hemings—which had been rumored since their own lifetimes—his tortuous attempts to reconcile his Enlightenment outlook with the slave system on which he depended had opened a window onto that most fundamental of national tragedies. The inscriptions on the memorial flatten out this complicated history and make him sound like an abolitionist, as the historian James Loewen has argued.[55] "Commerce between master and slave is despotism," the monument declares, without any trace of irony.

The triumphal monument with the greatest impact in the mid to late twentieth century, however, was probably the Marine Corps War Memorial (1954), erected across the Potomac in Arlington Cemetery, roughly on axis with the Mall. Here the monumental core's tendency toward gigantism was combined with a comic-book realism to create a superhero monument that would have horrified the cosmopolitan planners of 1901. The work is often seen as a monument to the American triumph in World War II, but the memorial actually commemorates the institution of the Marine Corps and its role in all American military undertakings; the pedestal is continually updated with the names of each subsequent war and major operation. The sculptor Felix de Weldon based the figure composition on a celebrated World War II news photograph taken by Joe Rosenthal atop Mount Suribachi on the Japanese-held island of Iwo Jima—hence the popular misnomer "Iwo Jima Memorial." It is now well known that the soldiers in the photograph were not under fire at the time it was taken. The mountaintop had been captured dramatically a few hours earlier and a smaller flag hoisted then; the Rosenthal photo recorded a different group of Marines raising a second, larger flag after combat on the mountaintop had ceased.[56] Nevertheless, combat operations elsewhere on Iwo Jima continued for weeks, and, tragically, three of the men who appeared in the Rosenthal photograph later died in the battle for the island. The de Weldon monument, not surprisingly, avoids this historical complexity. But even more important, the monument creates the aura of battle by transforming the two-dimensional photograph into a dynamic three-dimensional group organized around the crossing diagonals of the men and the flagpole (figure 101). Although Shrady's groups at the Grant Memorial are far more evocative of the lived realities of combat experience, de Weldon's has become the popular combat standard. Ironically, it has the supersized, superheated look of

101 Felix de Weldon, sculptor, and Edward F. Field, architect, Marine Corps Memorial, Arlington, Va., 1954. (Photograph by the author, 2008.)

socialist propaganda sculpture produced in that same time period in the Communist bloc. Both sought to overwhelm the viewer with huge iconic images of ordinary men empowered by an irresistible inner force, whether the spirit of socialism or the spirit of democracy.

The same midcentury populist language of American triumphalism achieved tragicomic results in the Boy Scout Memorial (1964), which secured a prized spot on the Ellipse not far from the Mall (on the site where the first national Boy Scout Jamboree had been held three decades earlier). The fact that boys raised the money for the project with dimes collected from around the country must have made it difficult for Congress to turn down. The architect William Deacy designed the now de rigueur plaza space, with its circular pool of water surrounded by benches, at the head of which stood a squat pedestal supporting a group of three standing figures by the sculptor Donald De Lue (figure 102). The group is one of the city's oddest: a

102 Donald De Lue, sculptor, and William Deacy, architect, Boy Scout Memorial, Washington, D.C., 1964. (Photograph by the author, 2008.)

striding figure of a Boy Scout—in "a pair of obsolete leggings circa 1940," as one critic put it—followed by huge male and female allegories with comic-book physiques. Critics panned it mercilessly, especially the combination of boy in period dress and timeless allegorical figures. There was nothing intrinsically wrong with such a combination; Saint-Gaudens, among others, had used it to great effect in several memorable monuments. But De Lue's variation failed for many reasons, not the least of which was the overinflated heroism of the allegories, which made them, like de Weldon's soldiers, look like socialist realist exemplars. Frank Getlein, the art critic of the *Washington Star*, later wrote that it was like using Beethoven's Ninth to sign off the nightly news: "Today Mrs. American Housewife tried to make a cheese soufflé; it fell and we now bring you musical selections from the end of the world."[57]

As Getlein suggested, De Lue's sculptural group brought the allegorical tradition to its own absurd end. Even though that tradition had been temporarily rescued by Saint-Gaudens, French, and others, De Lue's modern updating only made it look more jarring. The allegories behind the Boy Scout were so enigmatic that they required an inscription in the nearby pavement to identify them: "The two symbolical figures represent the sum of the great ideals of past civilizations developed through the centuries and now at best as delivered by American manhood and womanhood to the present generation." The male figure, the inscription went on, symbolized patriotism, loyalty, honor, courage, and other qualities typically identified as masculine; the female figure symbolized "the spiritual qualities of good citizenship, enlightenment," and so on. The words pointed backward to ideals that were beginning to unravel—traditional gender roles and the comforting notion of America as the appointed keeper of world civilization—while the figures themselves pointed elsewhere, to pop-culture superheroes and totalitarian propaganda. The total package was pure camp (and not the Boy Scout kind). Three months after its dedication, the Tonkin Gulf resolution would catapult the United States into an escalating war with North Vietnam and an intense period of social protest and discontent. The monument's avid rhetoric must have looked even stranger during the upheavals of the 1960s, if anyone was bothering to pay attention to it.

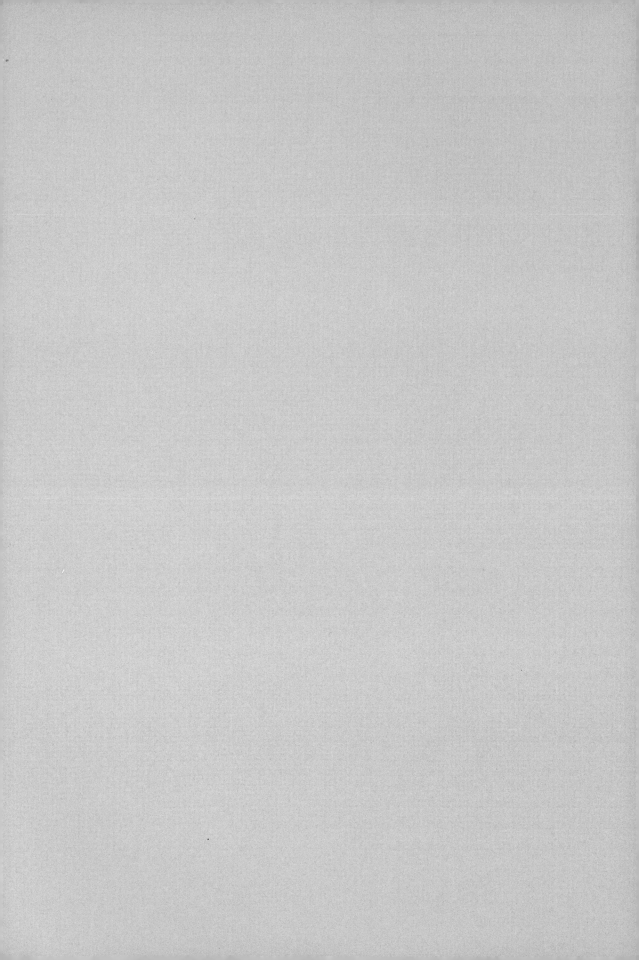

6

The Conscience of the Nation

By the late 1930s the monumental core had emerged, spectacularly. It was already luring new public monuments and making the older statues in L'Enfant's street layout increasingly irrelevant. Even more important, the core had begun to give birth to a new psychology of memorial space, exemplified in the Grant and Lincoln memorials—a space of engagement with loss and suffering, dimensions of historical experience missing in the celebratory landscape that focused on individual triumphs. Although most subsequent monuments in the core area carried less emotional weight than these two great Union memorials, their increasing attention to the tragic burdens of history—through innovations such as listing names of the dead and recognizing civilian victims—was changing the mood of the memorial landscape.

Yet the huge open tract of the Mall had a strange doubleness, a positive and negative charge. It was, on the one hand, a dominant national space that attracted and stored new commemorative energy and, on the other, an uninviting, immeasurable blankness like the giant obelisk in its midst. The Park Commission designers at the turn of the century had expected the cleared Mall still to be a pleasing formal garden like the European prototypes they admired, with a smattering of well-behaved visitors strolling on prescribed paths. It turned out to be at once more powerful and less pleasant. As a result, the use patterns typical of the nineteenth-century public grounds became irrelevant. Although more people than ever came to the monumental core as tourism grew, the space in its center was oddly "empty of life and movement," as the *Star* remarked in 1964.[1] Choked by rings of automobiles and circulating sightseeing buses that dropped off visitors at attractions on the perimeter, the interior of the Mall seemed a dead zone in comparison with the richly wooded, flowered grounds of the past.

This impression of lifelessness, however, was not entirely accurate. If on a nor-

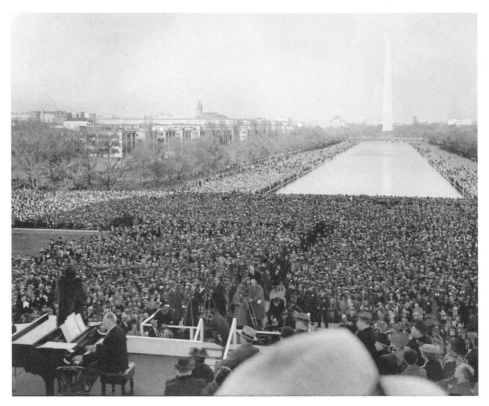

103 Marian Anderson concert at Lincoln Memorial, Easter Sunday, 1939. Photograph by Robert S. Scurlock. (Scurlock Studio Records, Archives Center, National Museum of American History, Behring Center, Smithsonian Institution.)

mal day the Mall's great vista was a vacuum, on extraordinary days it would be filled and humanized in a an entirely new way. Beginning in 1939, with the now fabled concert of Marian Anderson on the steps of the Lincoln Memorial (figure 103), Americans of all colors and beliefs came to the Mall to rally and counterrally, initially for civil rights and later for other causes, particularly opposition to the U.S. intervention in Vietnam. The Mall designers thought they had created a vast space of national unity, in which any expression of political or social differences would be out of place. Demonstrators capitalized on that state-sponsored fiction of universality, appropriated it for their own ends, and in the process made the Mall the nation's premier setting for political assembly and protest. Just as the Union memorials at either end of the Mall had created new spaces to confront the complexities of American history, the vast area in between them became a collective space of introspection, of national soul-searching. But visitors were coming now not just to reflect on history but to try to change it.

This unexpected transformation of the Mall's space by its users eventually helped shape the memorials that were added later to the monumental core. The most decisive change came with the Vietnam Veterans Memorial of 1982 (VVM), an epochal work that had as much impact on the Mall as the Washington Monument had a century earlier. The VVM cannot be understood apart from the social upheavals that spilled into the Mall in the mid-twentieth century. The memorial was at once a culmination of trends that had already altered the Mall and the beginning of a new era in the memorial landscape. Like the great rallies on the Mall, the VVM has dramatically changed our perception of the landscape. Every monument proposed after it has had to reckon one way or the other with its enormous impact.

Sightseeing

Ever since the Smithsonian Institution was built in the 1850s and its national scientific collection was put on view, visitors to the capital had a reason to venture into the Mall. With the cultivation of the Smithsonian grounds, the arboretum of the nearby Agriculture Department, and the Botanic Garden, visitors could engage in a form of picturesque horticultural tourism, exploring the leafy bowers and gardens from one end of the Mall to the other. The completion of the Washington Monument in the mid-1880s then shook up tourist itineraries by creating an irresistible attraction without any visible connection to either the picturesque landscape around it or the commemorative landscape of the city as a whole. Stripped of an obvious didactic meaning, the monument functioned more purely as a "sight" in the double sense—a thing to be seen and a lens through which to see.

By clearing the Mall around this massive sight, the twentieth-century planners intensified the phenomenon of sightseeing. The memorials to Grant and Lincoln at either end of the Mall were not only compelling spaces in their own right but also viewing platforms from which to see the great expanse of the Mall and the obelisk in its center. On the perimeter of the Mall, the "white palaces" were screened by rows of trees and served by ring roads so that they could draw crowds of tourists without disturbing the space of sight in the Mall's interior. The twentieth century witnessed a steady infilling of this perimeter, beginning with the new National Museum in 1910 (now called the Natural History Museum), the Freer Gallery of Art in 1923, the National Gallery of Art in 1941, the National Museum of American History in 1964, and the Hirshhorn and Air and Space museums in the mid-1970s. Other attractions started to fill the streets bordering the Mall as well, from the old Bureau of Engrav-

ing and Printing on Fifteenth Street (1880) to the various neoclassical palaces on Constitution Avenue, such as the Pan American Union by the architect Paul Cret (1910), and the National Archives by John Russell Pope (1935).

The results were predictable: an increasing concentration of tourists in the monumental core, while the older memorial landscape outside it atrophied. Nineteenth-century visitors in horse-drawn cabs had elaborately criss-crossed the city for miles to see the heroic statues and other high points of that landscape, from the Freedmen's Memorial to Lincoln, east of the Capitol, to the grand equestrians in the circles north of the White House. Now, sped to the monumental core in automobiles, streetcars, and sightseeing buses, visitors could "do" Washington in one central circuit. In 1939, the renowned journalist Alfred Friendly reported on the still novel sightseeing-bus experience and described how tourists would be "whipped off to the White House, given time to ride to the Monument top, be herded through the Bureau of Engraving and Printing, given a quick look-see at the Pan American Union, Lincoln Memorial and National Museum, and be turned over to the speed-up technique and almost unintelligible spiel of the Capitol guides." That same year, the film director Frank Capra put Jimmy Stewart on one such bus and captured the rush of sights in a montage for the movie *Mr. Smith Goes to Washington*. Some sightseeing buses still drove past the older statues outside the monumental core, part of "rubbernecking" tours in which riders were treated to as many as "359 points of interest in two hours." Unlike the cabs of the nineteenth century, however, these buses did not take the time to stop; their quick detour through the old statue landscape was not meant to compete with the more important sights in the center.[2]

Mr. Smith ended his sightseeing tour at the Lincoln Memorial, which by then had overtaken the Washington Monument as the single most visited monument in the capital, with more than a million visitors per year. (The very practice of counting visits resulted directly from the concentration of visitors in the core area; it would have been hopelessly impractical in the dispersed grounds of the older memorial landscape.) As a tourist destination, the Lincoln Memorial worked on different levels. It was a viewing platform, a backdrop for snapshot photography, and, as Jefferson Smith discovered, a place to experience the emotional gamut of America, and ultimately, of himself (see figure 3). For all these reasons, the memorial became the psychological anchor of the Mall. Though the monument was built on landfill, in a place that did not even exist in Lincoln's lifetime, with no relics from Lincoln or his time, it soon acquired the status of a "shrine," the spiritual counterpart to the Washington Monument's amusement ride.[3] On any given day, several thousand people climbed the

memorial's steps and crowded its space, in a communal experience that had no counterpart in the old-fashioned statue landscape of the city's squares and traffic circles.

The Moral Core

The traditional statue landscape of Washington offered individual heroes as ends in themselves, models of personal character that confirmed, by induction, the nation's character. If the nation's heroes were great, so then was the nation. Almost always they materialized on a high pedestal, disconnected from the worldly forces and beliefs that had propelled them into action. They were the mountain peaks, rising above the geology that created them. In one respect the Washington Monument was the logical extreme of this landscape, for, stripped of all didactic character lessons, the shaft became a heroic peak in its purest and most abstract form.

Despite the rise of the public statue and the seeming profusion of collective memory, that memory was remarkably vacuous, empty of social and historical process. Even the extraordinary Grant Memorial, which put ordinary soldiers so compellingly into the larger context of battle, deliberately offered no hint of why they were fighting in the first place; only the fight mattered. Although this may reflect the individual soldier's perspective, that helps explain why the memorial would never become the shrine that Lincoln's did. The Lincoln Memorial, by contrast, seemed to resonate with collective meaning and purpose, and, in so doing, answered an evident need in the monumental core.

The Lincoln Memorial was supposed to resolve the question Lincoln himself had posed at the battlefield of Gettysburg: can a nation founded on one great idea—that all men are created equal—long endure? In its glorious stony permanence, the memorial's answer seemed to be a resounding Yes! Yet this sense of closure, as we have seen, was deeply misleading, undermined by the subjectivity inherent in the memorial's space. The Lincoln Memorial carried an impossible collective burden: to demonstrate that a unified national community could reemerge from a deadly Civil War and a lapsed Reconstruction. In actuality, the memorial reopened the very issue that had divided the nation and confounded its identity in the first place, the issue of slavery and its legacy. No matter what white officialdom said, Lincoln and his memorial were not about an abstract, denatured process of reunification. It hardly mattered that the inscription behind French's statue tried to sweep the whole subject of slavery under the rug. The rest of the memorial was saturated with it, as were

Lincoln's image and his place in history. The visitors to the memorial lived in slavery's aftermath, which was far from settled, as they would soon be reminded.

The first reminder came the day the memorial was dedicated, when the organizers of the event segregated the audience, seating black visitors in the rear. This created a huge controversy, mostly in the black press, while the white press dutifully broadcast more comforting images of national unity. Soon thereafter, African American groups began to appropriate the memorial for their own ends. The monument lent itself well to interpretation and counterinterpretation, because its spaces effectively brought the subjective experience of visitors to the forefront. Black veterans assembled there on Memorial Day to assert their civic presence; "pilgrimages" were made there to hear ministers affirm that Lincoln's true importance rested on emancipation rather than reunion. But these events barely intruded on white consciousness until the Marian Anderson concert, in 1939, ushered in a new era.[4]

Anderson, one of the most celebrated contralto singers of her era, had been invited by Howard University to give a concert in Washington. The Daughters of the American Revolution (DAR), whose new building and concert hall, adjacent to the Pan American Union, was one of the monumental core's recently added attractions, refused to allow their (tax-exempt) hall to be used for the event, on the explicit grounds that Anderson was not white. In retrospect this is hardly surprising, given that in Washington, a segregated city in the Southern mode, no hotel would allow even an internationally famous black performer like Anderson to stay overnight. Seizing the moment, the NAACP intervened and arranged, with the cooperation of the Roosevelt administration, to hold the concert on the steps of the Lincoln Memorial, with French's statue as the event's backdrop. The concert, given on Easter Sunday, metamorphosed into a semiofficial event, introduced by the secretary of the interior and attended by a swath of Washington's white political establishment. It reached an unprecedented racially mixed throng of seventy-five thousand, arrayed below the memorial and around the reflecting pool, not to mention a national audience on live radio (see figure 103). The event was a tacit protest against the DAR and the Jim Crow system of segregation that the DAR helped legitimize. But more explicitly it was an affirmation of core American values, of equal justice and opportunity, mocked openly by the DAR and much of the white nation. The idea was to put Anderson and the NAACP on the side of Lincoln and America and, by implication, the DAR and the whole Jim Crow system on the wrong side, the un-American side. So the concert began with Anderson singing "My Country, 'Tis of Thee," while several U.S. senators reportedly cried. The historian Scott Sandage has shown how the head of the NAACP made sure to

avoid fostering "propaganda for the Negro," choosing instead to emphasize national principles. Thus the event successfully distinguished itself from prior attempts by African Americans to appropriate the memorial that were more easily ignored as the work of special interest groups advancing their own agenda rather than a common American cause. Indeed, some of the newspapers covering the event did not even mention the role of the NAACP.[5]

The Anderson concert established the Mall as more than a national stage set designed by art professionals. It was now a space of moral principle, defined by the citizens who occupied it. This idea was already embedded in the psychology of the Lincoln Memorial, but the drama of the event revealed the full potential of that new memorial psychology. A so-called minority group had shown Americans how to fulfill their democratic potential in the nation's public space.

Assembling on the Mall, Americans discovered, was a uniquely powerful act, different from protest at the institutional sites of elected government, the White House and the Capitol. When the first march on Washington occurred, in 1894, by the group known as Coxey's Army, the protesters went to the Capitol to press directly for government benefits; so did the Bonus Army in 1932. Both movements were suppressed as illegitimate efforts by ragtag mobs to interfere with the orderly process of representative democracy. (Political demonstrations at the Capitol were still banned in the mid-twentieth century.) The Mall's status as the premier commemorative space, removed from the realm of politics, lent itself to a different sort of protest. The Anderson concert, and events that followed its precedent, deliberately distanced themselves from "lobbying" actions. Although their organizers had concrete political goals, on the Mall they staked out a different and more ambitious rhetorical territory, engaging in a quasi-religious campaign to return the nation to its true moral bearings. In 1957, when Martin Luther King Jr. and other black civil rights leaders planned a "prayer pilgrimage" to the Lincoln Memorial, King declared that there would be "no picketing, no poster walking and no lobbying." The purpose of the event was not to press for a particular program or remedy but "to arouse the conscience of the nation in favor of racial justice." The civil rights leaders were well aware of Coxey's Army and the Bonus March, and wanted to make sure that their own activity was seen in a different light.[6] The movement peaked in the massive March on Washington for Jobs and Freedom, in August 1963, where King, at the Lincoln Memorial, delivered his most famous speech. Like the Anderson concert, the March on Washington was a racially mixed event, organized with the cooperation of the president, in this case John F. Kennedy. The key tactic, once again, was to use Lincoln

104 March on Washington, August 28, 1963. Photograph by Scurlock Studio. (Scurlock Studio Records, Archives Center, National Museum of American History, Behring Center, Smithsonian Institution.)

and the Mall to remind Americans that "we represent the core of what this country believes in" (figure 104).[7]

Precisely because the Mall was a nonplace, empty of routine human comfort and local attachment, it could become an extraordinary core of moral significance, the location of the nation's conscience. The Mall was a vacuum waiting to be filled. Americans witnessed the spectacle of group after group asking them to reflect on their fundamental identity as national citizens and to rededicate themselves to the core beliefs of the nation. Here was a collective process of soul-searching, of national introspection out in the open on an unprecedented scale.

The process peaked in the mid to late 1960s, when the Mall became an ever more frequent site of demonstrations against the Vietnam War. Unlike the earlier civil rights organizers, antiwar groups openly agitated for specific political solutions—initially the deescalation of the war, and later total withdrawal of U.S. forces from Southeast Asia. Thus rallies on the Mall were often combined with marches on the White House or the Capitol and were frequently met by counterprotests from the American Nazi party, conservative church groups, and anticommunist organizations. Attention

shifted from the Lincoln Memorial to the Washington Monument and even occasionally to the Grant Memorial, because of its proximity to the Capitol building. In 1965, as several hundred antiwar protesters marched from the Washington Monument toward the Capitol, opponents met them at the Grant Memorial and splashed them with red paint; fittingly, the monument became a site of mock combat. The following year another band of protesters, ejected from a Congressional hearing, regrouped at the Grant Memorial and used its platform and balustrade as a soapbox.[8] (One wonders whether the huge reflecting pool installed in front of the Grant Memorial in 1970 may have been intended, in part, to impede movement between the monument and the Mall.)

As such activity occurred more often, the Mall became a space for self-conscious political theater, sometimes directed against cherished American symbols. In 1969, for example, protesters at the Washington Monument hauled down the American flags at the monument's base and replaced them with Viet Cong flags.[9] The carefully orchestrated unity of the civil rights actions no longer held fast. Divisions within the protest movement, and between the protesters and those mobilized in reaction to them, were dramatized. Increasingly, the Mall's space of conscience seemed to be fracturing beyond repair.

Yet throughout this period of intense struggle, the masses of people who assembled on the Mall—sometimes crowds even larger than the throng at the 1963 March on Washington—clung to the idea that their America was the right one. The most militant among them rejected American nationalism outright, but far more of those assembled still believed in an underlying American virtue worth preserving. "We're here because we love our country," a banner proclaimed at the historic antiwar rally of 250,000 in November 1969. It was an appeal to a national conscience still thought to be viable. Even the openly revolutionary Black Panthers, calling in 1970 for a new Constitution, assembled on the steps of the Lincoln Memorial because they wanted to lay claim to some piece of the American moral tradition (figure 105).[10]

As this example demonstrates, the Lincoln Memorial continued to play a role, though less dramatically than in the glory days of Anderson and King. Although it was sometimes the object of "guerilla theater"—in the most publicized example, the Vietnam Veterans against the War deposited a coffin in front of Lincoln's statue and tried to block the memorial's entrance as part of a coordinated campaign targeting several national "shrines" in December 1971—the memorial emerged more often in the press as a quiet space of reflection and dialogue, sometimes between tourists and demonstrators. By now this story line had become a cultural trope, no doubt fueled in part by real life but also by mass-culture products such as *Mr. Smith Goes to Wash-*

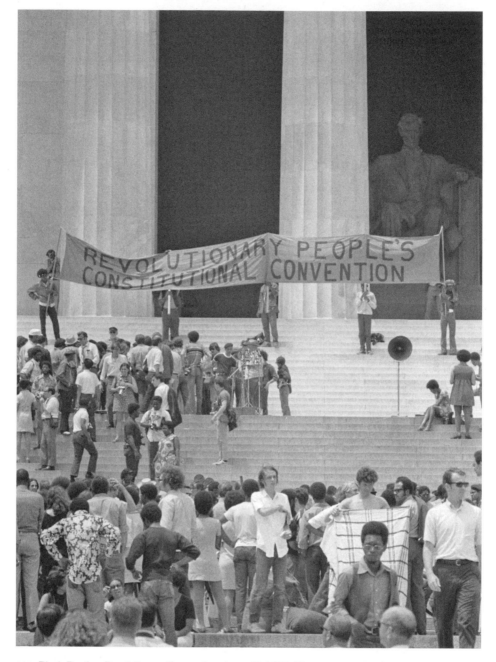

105 Black Panther Revolutionary Convention, June 19, 1970. Photograph by Thomas J. O'Halloran. (Library of Congress, Prints and Photographs Division.)

ington. The conflation of reality and fiction reached a bizarre level when President Richard Nixon, in a reprise of Jefferson Smith's agonized late-night visit to the monument, made an impromptu appearance at the memorial well after midnight on May 9, 1970. The incident made front-page news the following day. Like Smith, Nixon

was "under exceptional strain," the *New York Times* reported, barricaded in a city over-run by student demonstrators in the wake of the Kent State shootings and his deci-sion to bomb Cambodia. Unable to sleep, he set off for the memorial with his valet and a hastily assembled Secret Service escort. There he encountered a small group of students, apparently trying to catch some sleep, and started to talk to them. Ac-counts of the conversation vary. "I was trying to relate to them in a way they could feel that I understood their problems," Nixon later told reporters. The memorial could not have been a more appropriate setting for this sort of empathic communication: the president and his young opponents coming together, sharing their struggles with the heavy weight of history. But unlike the introspective Lincoln, frozen in marble, the actual president filled the moment with didactic monologue. As the crowd grew, Nixon's talk ranged from Neville Chamberlain to the environment to foreign travel. Afterward, a student from Syracuse said, "He was trying so hard to relate on a per-sonal basis, but he wasn't really concerned with why we were here." In the absence of an epiphany, Nixon and the students went their separate ways. The unity and con-sensus once promised by the Mall were as elusive as ever.[11]

That incipient malaise was caught and magnified in a brief film sequence set on the Mall in the 1971 classic *The French Connection*. The energy and emotion that an-imated the space in times of protest were conspicuously lacking here. Instead a des-olate, alienating landscape filled the screen: the nation's monumental core became the ironic backdrop for a tense negotiation between two gangsters trying to close a drug deal away from police surveillance. Shot on the centerline of the east-west axis, with the Grant Memorial and Capitol looming in the background, the empty land-scape of the Mall seemed stripped of everything but the mute signs of power in the distance. No space of conscience was visible here. This was the other Washington, the bitter world of money and power that lurked at the Mall's edges and vied with its collective idealism to define the nation's self-image. In *Mr. Smith* the sacred core tri-umphed. In *The French Connection* its chances looked bleak.

The Birth of the Therapeutic Memorial

In the end, however, the sacred center revived. It did so because of an exceptional and unlikely monument: the Vietnam Veterans Memorial. Maya Lin's sunken black walls, dedicated in 1982, at once brought new life to the Mall and rescued the public monument from what appeared certain oblivion. No single work since the Washington Monument has done more to change the direction of the memorial landscape.

In the mid-1970s, landscape designers finally carried out some improvement projects intended to make the Mall's space less barren and more hospitable to people on foot. The inner roads between the Grant Memorial and the Washington Monument were eliminated and replaced with gravel footpaths, lined with benches. Huge temporary office buildings for the Navy dating from World War I, just north of the Lincoln Memorial reflecting pool, were demolished and the whole area relandscaped as a park called Constitution Gardens. The designer, David Childs, rather than resurrect the formal scheme for this area in the plan of 1901, created a more naturalistic landscape with curving paths and an irregularly shaped lake; the design had echoes of Downing's original scheme for the Mall, as well as the old fish ponds near the Washington Monument.[12] All this happened in anticipation of the Bicentennial of 1976, which President Nixon had hoped to celebrate at the end of his term; Watergate, of course, interfered with his plans.

While Washington's landscape designers were changing the space and trying to humanize it, the newer public monuments erected in or near the monumental core were just as haphazard as ever and becoming increasingly irrelevant as figural sculpture suffered a steep decline in prestige and credibility. From 1950 to 1980, no monuments were erected inside the east-west or north-south axes aside from the Boy Scout Memorial on the Ellipse (1964), which was hopelessly obsolete from the moment it appeared. Just outside those two axes, however, a hodgepodge of new statue monuments went up despite the efforts of planners and officials to limit them. West of the Ellipse and north of Constitution Avenue appeared portrait statues of José Artigas by Juan Blanes (1950), and Simón Bolívar by Felix de Weldon (1959), given by the governments of Uruguay and Venezuela, respectively; a de Weldon group of Red Cross rescue workers, in commemoration of the Red Cross dead (1959); and a seated figure of Albert Einstein, by Robert Berks (1979). On the Capitol grounds, Congress erected a monument to Senator Robert Taft (1959), of all people, a Republican from the old antiwar, antiunion wing of the party. With the exception of the Artigas statue, which was actually modeled in the nineteenth century, all these works were more or less unsuccessful attempts to update a dying sculptural tradition. The same could be said of the monuments erected farther outside the center, such as Paul Manship's disastrously awkward and oversize statue of Theodore Roosevelt, on Roosevelt Island in the Potomac (dedicated 1967); with a few minor adjustments it could have represented Lenin or Mao.

Yet a few of these outlying monuments still attracted passionate audiences, at least at their dedications. The monument to the nineteenth-century Ukrainian poet and national hero Taras Shevchenko, in the Dupont Circle neighborhood, drew upwards

106 Leo Mol, sculptor, and Radoscav Zuk, architect, Taras Shevchenko Memorial, Washington, D.C., 1964. (Photograph by the author, 2003.)

of a hundred thousand people to its dedication in 1964 during the height of the Cold War. Erected by Ukrainian American organizations, fiercely anti-Soviet, the monument was intended as a weapon in what its sponsor Lev Dobriansky called the "psychopolitical struggle" with the Soviet Union, which had its own propaganda machine dedicated to Shevchenko.[13] Now that the Cold War is finished and in the history books, the memorial has lost its once-fiery charge and serves rather as a backdrop for the neighborhood's gay population. On sunny days, they are suitably juxtaposed with the swelling musculature of the colossal Shevchenko and his swirling Prometheus nearby (figure 106).

Robert Berks's monument to the renowned African American educator Mary McLeod Bethune in Lincoln Park, positioned to face the Freedmen's Memorial, is another case in point. The dedication in 1974 drew about twenty thousand people to an area that was rapidly gentrifying, after having become a black neighborhood in

107 Robert Berks, sculptor, Mary McLeod Bethune Monument, Washington, D.C., 1974. (Photograph by the author, 2008.)

the mid-twentieth century. The monument itself was a multiple first, the first free-standing monument in the capital to a woman, and the first to an African American. It was sufficiently important that Ball's Freedmen's Memorial group was rotated 180 degrees, away from the Capitol building and toward the figure of Bethune standing with two children. This shift in orientation represented the final eclipse of East Capitol Street's monumental axis, as the two monuments now faced inward within Lincoln Park (figure 107). Berks clearly intended the Bethune monument to be in dialogue with the Freedmen's Memorial, and in certain respects the two works mirror each other. Both celebrate heroic figures who are raising up a still-unformed generation. Both heroes have their arms outstretched, Bethune with a scroll in her left hand, Lincoln with a scroll in his right. In Berks's composition the children have more agency than Ball's freed slave: they stand and gesture toward Bethune, as if meeting her halfway. Looking toward the horizon, the future, she offers opportunity; they must seize it. All this is communicated in the muddy globs of clay that make the figures look weighty and brittle at the same time, as if the traditional solidity of Ball's figures

was no longer credible in a world unsettled by enormous social, political, and racial transformations. Yet for all its creative interaction with Ball's Lincoln memorial, the Bethune monument did not succeed in rescuing that memorial (or itself) from the relentless process of obsolescence. Today few tourists, or even Washingtonians, know these monuments at all.[14]

The decline of the public monument in the middle of the twentieth century is especially evident in war memorials. Before the Vietnam Veterans Memorial, no new soldier monuments had been erected anywhere in the city since 1936, although monuments such as the Marine Corps War Memorial continued to be added across the river in Arlington. This was a victory for the planners, who had been trying to stop new war memorial construction ever since World War I. At the same time, existing war memorials seemed rapidly to wane in significance. That happened not just because the older generations of veterans from the Civil War and World War I were disappearing, but also because the American faith in war as an instrument of democracy had been seriously shaken in the Vietnam War era. The differences between two major events held at the First Division Memorial furnish a striking indication of this change. Veterans of the First Division sponsored two additions to this World War I memorial, one for its World War II dead, in 1957, and the other for its Vietnam War dead, in 1977. In both cases, several thousand new names of combat dead were added to the monument, on blocks at either end of the plaza, and ceremonies with veterans of the division were held. The World War II ceremonies received laudatory coverage in the national press. The *New York Times* praised the "Fighting First" and the common American soldier; the former commander of the division gave a fiery speech declaring that in the age of nuclear warfare, the division was "ready to defeat any aggression from a branch fire to an atomic holocaust" (although he did not explain how the division would repel the latter). By 1977, two years after the fall of Saigon to the communists of North Vietnam, this rhetoric of American invincibility must have seemed naive at best. In any event, the *Post* and the *Times* completely ignored the Vietnam War ceremonies, even though the First Division's losses in relative terms were substantially higher in the Vietnam War than in World War II. Its losses in World War II (4,325) represented about 1 percent of the total American military deaths, whereas its losses in the Vietnam War (3,079) were more than 5 percent of the total. Here was a remarkable indication of how the bitter controversy over the Vietnam War had disrupted century-old patterns of soldier commemoration.[15]

It is deeply ironic, then, that the Vietnam Veterans Memorial would reinvigorate the American tradition of the war memorial and rekindle public and scholarly interest in the whole phenomenon of monument building. But the VVM did so on new

and different terms. The VVM was the capital's first true victim monument—a monument that existed not to glorify the nation but to help its suffering soldiers heal. Maya Lin's design has bequeathed to us a therapeutic model of commemoration that has become the new common sense of our era but has also opened up difficult questions that have yet to be resolved, or even considered.

The VVM was a first in many respects. It was the capital's first comprehensive war memorial, dedicated to all U.S. troops who served in a national war rather than a subset from a particular branch, division, or locality. The memorial was more profoundly national in scope than any of the previous memorials erected to the heroes of the Civil War or the world wars. Even the Tomb of the Unknown Soldier in Arlington Cemetery, which included remains of the dead from World War I, World War II, Korea, and Vietnam and served as a national focal point for ritual services on Memorial Day and Veterans Day, did not satisfy the felt need for comprehensive recognition of the nation's servicemen.[16] The VVM was the first—and is still the only—war memorial in the capital and the nation that claims to include the names of all the U.S. dead. Maya Lin's sunken black granite walls were designed, first and foremost, with this intention—to carry the names of the fifty-eight thousand U.S. servicemen who lost their lives in the war. The explicit healing purpose of the monument drove this logic of comprehensiveness. Once born, though, the new type could be adapted to other purposes. The Korean War Veterans Memorial and the World War II memorial are also comprehensive, though quite different in tone and content from Lin's prototype; neither one attempts the reproduction of individual names at the heart of her design.

Dedicated in 1982, Lin's walls have since become the most talked-about, most written-about monument in American history. The memorial is now so popular a fixture on the Mall that we can forget how radical her proposal once was and how close her critics came to stopping it altogether. Lin herself has called her work an antimonument—a negation of traditional monumentality. She brought into material form an attitude that had long been articulated in modernist circles. The British art historian Herbert Read, writing in the late 1930s in the aftermath of the catastrophes of World War I and the Spanish Civil War, had declared that in the modern world "the only logical monument would be some sort of negative monument." A negative monument, he assumed, would have to be "a monument to disillusion, to despair, to destruction."[17] Lin, however, found a way to break this logic that conflated negation and disillusion. She did not intend her memorial to deliver a message of protest against war (as did Picasso's huge mural *Guernica*, about which Read was writing).

The break with tradition was more fundamental: her memorial avoided delivering *any* message. The meaning was to be generated by the viewers themselves, in their experience of the place.

If this sounds vaguely familiar, that is because the "antimonument" idea tapped into an old American tradition of iconoclasm that long predated modernist ideas of negation. After all, it was in 1800 that John Nicholas had proposed a "blank tablet" for Washington on which "every man could write what his heart dictated." Like the blank tablet, Lin's simple wall of names awaits completion by individual viewers—and indeed the notes and other memorabilia visitors have left at the wall make manifest that internal process, like the act of writing Nicholas contemplated. On the one hand, Lin's design was a work of high conceptual art totally alien to the veterans who sponsored the monument; on the other, it represented an aspiration toward "living memory" that must have resonated with the antiauthoritarian, democratic impulses of many in their constituency.

As many have already pointed out, the idea of a nontraditional, nondidactic war memorial was not Lin's alone. She submitted a design in response to an open competition, whose program specified that the memorial must list the names of all the American war dead; must avoid political interpretations of the war, pro or con; and must harmonize with its tranquil park setting in the new Constitution Gardens. The memorial's statement of purpose, while affirming that it would "provide a symbol of acknowledgment of the [soldiers'] courage, sacrifice, and devotion to duty," ended in this way: "The Memorial will make no political statement regarding the war or its conduct. It will transcend those issues. The hope is that the creation of the Memorial will begin a healing process."[18] Lin's genius lay in her ability to create a simple and beautiful solution to this novel and difficult program.

Thus the nation's first "therapeutic" memorial was born—a memorial made expressly to heal a collective psychological injury. It is surely no coincidence that the monument campaign that led to Lin's selection began at about the time that "post-traumatic stress disorder" entered the official psychiatric diagnostic manual.[19] The man who hatched the campaign, Jan Scruggs, was a Vietnam combat veteran experiencing symptoms of post-traumatic stress. Scruggs wanted the monument to serve a dual healing function: for the veterans themselves, who had endured not only the trauma of combat but a crushing rejection from society afterward, and for the nation that had been so bitterly divided over the justice of the cause. The last thing he and his fellow veterans in charge of the monument campaign wanted was to reignite the political conflicts that were still fresh in everyone's mind, in part because they had

108 Joseph Brown, sculptor, *56 Signers of the Declaration of Independence*, Constitution Gardens, Washington, D.C., 1984. (Photograph by the author, 2008.)

been so dramatized in protests on the Mall itself. The monument was intended to rally Americans around the simple idea that the veterans of the war needed recognition and support; later in the chapter we will examine the question of whether the memorial's explicit "acknowledgment of the courage, sacrifice, and devotion to duty" of the U.S. servicemen was in itself a political statement.

The memorial was located in a new section of the Mall that had not been filled by protesters because it had been occupied instead by temporary naval buildings until their demolition in 1971. The entire fifty-acre site, reborn as Constitution Gardens, rested on landfill. The lake on the east side of the site was carefully screened from both Constitution Avenue to the north and the Reflecting Pool to the south and, as a result, feels like a self-contained park. It gets much less foot traffic than other areas of the Mall and feels tranquil even in high tourist season. A monument to the signers of the Declaration of Independence (1984)—a group of signed granite blocks set on the ground in a semicircle—is situated on a small island there (figure 108). Though roughly contemporaneous with Lin's monument, and also in tune with its landscape setting, the Signers memorial is definitely off the beaten track. Lin had this same

109 Maya Lin, entry for the Vietnam Veterans Memorial competition, drawing on competition board, mixed media, 1981. (Library of Congress, Prints and Photographs Division, Vietnam Veterans Memorial Fund Slide Collection, LC DIG ppmsca-09504.)

soothing solitude in mind when she designed her entry, for the west end of Constitution Gardens (figure 109). Her proposal did not envision the memorial as a crowded tourist magnet like the Lincoln Memorial. Whereas that memorial was sited conspicuously on a high platform at the end of the east-west axis, the VVM site was screened by trees, and Lin hid the memorial even further by situating the walls below grade. The approach through Constitution Gardens created a moment of surprise: visitors would happen upon the walls unfolding in front of them, a revelation reminiscent of those Downing had had in mind for the Mall.[20]

This quiet, secluded experience seemed the opposite of the collective marches and assemblies held out in the open, which had defined the image of the Mall in the period from the civil rights movement to the antiwar struggle. Nevertheless, Lin's design was an outgrowth of that recent history. The experience she wanted to create developed organically from the Mall's twentieth-century psychology, with its introspective quality already evident in the Lincoln Memorial and the axis to the Capitol. Lin wanted to turn that introspective experience further inward. "I thought the experience of visiting the memorial," she said later, "should be a private awakening, a private aware-

ness of that loss." For her, memorial spaces were not "stages where you act out, but rather places where something happens within the viewer."[21] Although her emphasis on the subjectivity of viewer response was already inherent in the spatial turn public monuments began to take in the early twentieth century, her understanding of that subjective process as fundamentally private belonged to a more recent cultural turn—away from political activism and ritual and toward self-exploration.

The Revival of the Sacred Center

Lin's winning entry shows the basic idea of the monument as built: two reflecting black granite walls joined at an oblique angle and sunk below grade (see figure 109). They are visible in front from a massive slope cut out of the earth. But her original concept also reveals some key differences. The walls in her sketch emerge directly from the grassy slope, their forms "growing out of the earth," as Lin explained in her competition statement. No walkway or ramp guides visitors to the monument or through it. Lin's own drawings were so abstract and eerily empty of people that when her entry was chosen the winner, the competition organizers immediately ordered a new illustration to show what the memorial might look like in its actual setting (figure 110). This illustration is a remarkable glimpse into how Lin and the sponsors initially thought the memorial would work. Once again, there are no paths anywhere. A total of sixteen visitors, mostly single or in pairs, are, as Lin had imagined, "walking into the grassy site" above and below the walls, each approaching the memorial in their own unguided and idiosyncratic way.

Shortly after the monument opened in 1982, visitors still sometimes approached this way. Now it is possible only by breaking the rules, early in the morning when no one is looking. Descending on the grass rather than the prescribed pathway creates a very different experience. The path is essentially a ramp, located where the slope and the structure meet, so that the slant in the earth is always on one side of the ramp and the retaining wall on the other. Out in the open on the grass slope, however, visitors see and feel a wide cavity in the ground looming in front of them. As they descend, their bodies sink into this ditch while the two walls reach up and around them in an architectural embrace. As Patrick Hagopian has pointed out, the chronological listing of the names of the dead in the order they died, which Lin envisioned as a "circle" beginning and ending at the center, makes far more sense if visitors descend this way and experience both walls at once.[22] Even more important, the grassy approach makes one aware how profoundly Lin's design upset the spatial logic of the

110 Paul Oles, illustration of Maya Lin's winning design for the Vietnam Veterans Memorial, 1981. (Library of Congress, Prints and Photographs Division, Vietnam Veterans Memorial Fund Slide Collection, LC-DIG ppmsca-05608.)

1901 plan and returned awareness to the ground plane, albeit in a novel way. While the ground swallows visitors descending in front, the surrounding space is opened up in reflections on the sunken black granite walls—as if the Mall's spatial system were turned upside-down.

The brilliant text Lin wrote to accompany her design entry, often quoted, is worth repeating here: "Brought to a sharp awareness of such a loss, it is up to each individual to resolve or come to terms with this loss. For death is in the end a personal and private matter, and the area contained within this memorial is a quiet place, meant for personal reflection and private reckoning."[23] Although Lin's assumptions about death belong to a particular time in history when mourning ritual was waning and grief became "privatized," it is still striking that she brought these attitudes to the design of a *public* monument: despite the location of her monument in the heart of the nation's capital, she insisted that the memorial encounter was solitary and private rather than social and collective.

Of course this vision had to change even before the memorial was complete. Given the site, the consulting architects were forced to anticipate crowds. Narrow stone walk-

ways were installed along the base of the walls, keeping a narrow strip of grass be-
tween the walkway and the wall. Eventually, when the crowds materialized and showed
no sign of diminishing, and more and more visitors left offerings at the bottom of
the walls, the strip of grass disappeared, the walkway was widened, and the grassy
slope in front was placed strictly off-limits.[24] (In 2007, signs at the memorial declared,
"'Honor Those Who Served' Please Stay On Sidewalks.") The very success of the me-
morial made the unregulated approach to it impossible to maintain. Visitors had to
be herded along the walls, and the open ground immediately in front had to be re-
placed by a stone flooring, which gave the monument the feeling of an architectural
room. The grassy slope became secondary, a backdrop seen peripherally or in the
reflections on the wall itself.

Now, as visitors follow the authorized walkway and descend from one point of
the V or the other, the wall is always close at hand. This simple condition profoundly
changes the experience but by no means diminishes it: in fact, viewers become even
more intimately connected to the walls themselves. At the top of either ramp the wall
is a mere sliver of granite on the ground; the wall then steadily expands in height and
scope on the way down. It is as if visitors to the Washington Monument were able to
start at the nine-inch capstone on top and watch the shaft expand as they descend. The
names on the wall begin to unfold as continuous lines, which are not plumb with the
top of the wall but rather angled downward to echo the viewer's descent. After forty
or fifty steps down the ramp the wall overtops most viewers, who now find themselves
in a semienclosed contemplative place, hushed and removed from the world above.
By this point, with the list of names towering above and spreading out to either side
seemingly without end, the scale of the war's losses is much more palpable.

In the final design stage, the size of the lettering became a crucial issue because
it determined the overall size of the memorial and shaped the viewers' engagement
with the names. At the First Division memorial, to inscribe nearly six thousand names
in granite had been considered impossible. Conventional wisdom dictated that let-
ters carved into stone had to be at least one inch high to be readable, so it was un-
derstandable that the First Division chose instead to cast bronze plaques with raised
lettering, which allowed the names to be shrunk to little more than a quarter inch in
height and compressed into a much smaller area. At the VVM, Lin insisted on carv-
ing the names directly in the granite at five-eighths of an inch high, a size that had
become technologically possible with computer-aided engraving techniques. (By con-
trast, the lettering in the Lincoln Memorial's speech panels is nearly five inches high.)
Anything larger than five-eighths inch would have made Lin's walls far too big, but

she had other reasons as well. She wanted to make reading the names a more intimate act, more like reading a book than a billboard. Shrinking the font brought viewers even closer to the granite surface and prompted them to touch the names as they would the page of a book. The smaller font also created an effect of all-over tracery in the black granite—"like a beautiful fabric," Lin said—which enhanced the mysteriousness of the polished stone (figure 111).[25] When viewed up close, the names seem to be suspended on a transparent surface, and the focus of viewers shifts back and forth between the patterns of text on top and the reflections emerging behind. Bringing viewers close to the wall not only enhances the intimacy of this encounter, but also magnifies their role by making their own reflection in the wall stand out amid the names and the scenery around them.

Another key point of contention surrounding the names was the order in which they would be listed. In the First Division Monument, the names were organized by unit first, rank second, and alphabet third. Thus the presentation recorded not only the names of the dead but the hierarchical command structure of the army, reaffirming the importance of military organization and the officer class that served it. In the VVM, Lin did away with all distinctions of unit and rank, insisting that the names be listed chronologically by date of death. This scheme equalized the soldiers in death and made the actual event of their deaths what mattered.

Lin's original design offered no moral explanations to guide visitors through this long list of names, not even the simple reference to glorious death that appears in Edwin Lutyens's famously abstract World War I Cenotaph in London. Lin's idea was rigorously antididactic: the visitors to the monument—not the monument itself—were supposed to create the moral understanding of the event. Seeing themselves reflected in the wall, mingled with the names and the scenery, would remind them that their own thoughts and reactions were as much the subject matter of the memorial as the soldiers being commemorated. In this respect, Lin's design *exceeded* the competition instructions. Although the memorial's statement of purpose reaffirmed the soldiers' courage, sacrifice, and devotion, her design said nothing about them aside from their names and the order of their deaths. She took the minimalist approach, circulating in the art world since the 1960s, of locating meaning not in the object itself but in the viewer's experience of it. Although elements added later to the memorial compromised her scheme, they could not destroy the fundamental subjectivity of the memorial.

The only guidance Lin's design offered was the physical journey itself. From the beginning Lin imagined the experience of the memorial as a spatial passage. She had

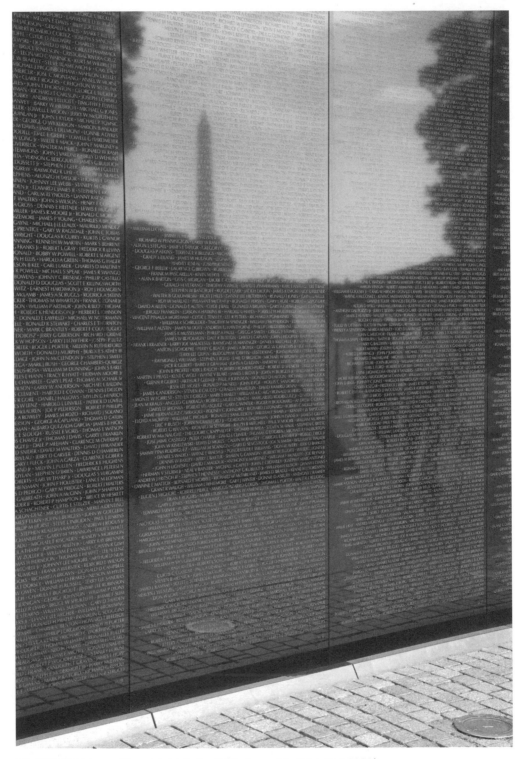

111 Vietnam Veterans Memorial, detail of wall. (Photograph by the author, 2008.)

been deeply moved by Lutyens's great World War I memorial at Thiepval, which was essentially a set of intersecting passageways inscribed with names of the missing, and closer to home by Woolsey Hall at Yale, which had an open memorial room— again inscribed with the names of war dead—through which she and thousands of other students regularly passed on their way to class. Lin designed a simple, but novel passage: a descent followed by a reascent. The first part of the passage culminates in the center of the memorial, where viewers come to an awareness of the full scale of the war's loss. But then the walls point up and out toward national landmarks, the Washington Monument to the east and the Lincoln Memorial to the west. Leaving the memorial's stark reminder of death, visitors rejoin the national life of the Mall. We might call this journey a redemptive experience, but it would be more apt to call it a process of recovery—more psychological than religious.

Instead of seeing this process in Lin's terms as a solitary quest for meaning, we need to understand that the very collectivity of the process is intrinsic to the memorial's therapeutic function. Indeed, the space is therapeutic in a way that Lin herself could not possibly have imagined. As many visitors have noted, the memorial offers a shared space and a shared experience, and that very collectivity gives it a power lacking in more "private" arenas of grief. Some relatives of the dead, for example, have said that they feel the presence of their lost loved one more at Lin's wall than at the actual grave.[26] This is not merely striking proof that the visible name can have more power than the invisible remains of the body. It is also a testament to the highly charged significance of the memorial's collective space, where the process of coming to grips with death is social and participatory, inviting action as much as reflection, and creating bonds with others that transcend the solitary ego.

For the soldiers who survived the war, and the families of those who did not, this multifaceted experience constitutes a communal act of recognition, and indeed, restitution. The memorial brings together the national community to witness the soldier restored to a place of honor in the quasi-sacred landscape of the nation's monumental core. That collective act of restitution, as Judith Herman notes in her study *Trauma and Recovery*, is one of the essential steps in the process of recovery from trauma because it rebuilds "the survivor's sense of order and justice." Following a time when the survivors had suffered prolonged scapegoating and ostracism, the memorial's new space of recognition and restitution was "probably the most significant public contribution to the healing of [Vietnam] veterans."[27]

With more than four million visitors per year, the VVM quickly became the most popular memorial in the monumental core. The rituals of engagement it inspired—

taking rubbings of names, leaving personal notes and mementos—changed how we interact with public monuments and suddenly made them once again a living force, rather than a dying tradition. Taking the stance of an antimonument, ironically, the VVM gave the public monument a new sense of purpose. Above all, it revived the Mall as a sacred center, oriented now around the processes of healing and reconciliation. Although the Lincoln Memorial had officially been a monument *to* reconciliation, it did not work as a space *of* reconciliation—at least, not in the way its sponsors intended. The VVM achieved a new standard of commemoration that would be widely imitated but virtually impossible to equal.

Backlash

This outcome makes it more difficult now to understand why powerful conservatives once lambasted Lin's design as dishonorable and worked hard to stop it from becoming realized. Just as Read had assumed that a "negative monument" would be an expression of disillusion and despair, the conservative critics drew certain obvious conclusions from Lin's negation of traditional monumentality. For them, the wall was quite simply an inversion of the usual honorifics of Washington's public monuments: below ground rather than above, black rather than white, and so forth. The critics found predictable meanings in this inversion. Black meant "shame," underground walls meant "dishonor." The very absence of positive messages about the soldiers had to be a negative message: the monument was antiwar and antiveteran.[28]

Removed from this dispute by several decades, we might be tempted to dismiss it as yet another overheated monument controversy. But this one carried real weight. First, it resulted in significant changes to Lin's design. Second, even if the critics deliberately misread Lin's intentions, they nonetheless had a point. For they were grappling with a monument that was not in fact heroic, a monument designed on an entirely different premise. Although the prestigious location, the elegantly inscribed names, and the overall formal beauty of the work all combined to "honor" the soldiers, Lin's design did nothing to identify them as heroes who had fought to uphold national or cultural ideals. That was what many of the most vocal critics wanted. They wanted an Iwo Jima memorial, or even a Tripoli memorial (had they known of it). What was the point of erecting a monument to soldiers if not to reaffirm that they were heroes fighting for what was right? In the either/or logic of war (us versus them, friend versus enemy, good guys versus bad guys), soldiers who were not heroes became victims. The critics were stumbling into the realization that Lin's work was a

victim monument, not meant to glorify the deeds of the soldiers but to console and reconcile the survivors who had experienced the tragedy of their loss. Her abstract design was reprehensible precisely because it succeeded in giving this new kind of monument a compelling form.[29]

Ultimately, the critics were fighting a losing battle against a tide that had long been coming. They failed to stop Lin's project, but, with support from some elements in the Reagan administration, they succeeded, over Lin's strenuous objections, in forcing the veterans in charge of the campaign to add two elements: a flagpole and statues of three servicemen. Later, the Fine Arts Commission required that these additional elements be located away from the walls in a small copse of trees. Although this solution satisfied neither Lin nor her critics, it did allow the walls to be experienced on their own terms.[30]

The statues, by Frederick Hart, installed in 1984, fail the "Iwo Jima" test. Although they are much smaller, closer to the ground, and more scrupulously realistic than de Weldon's figures, they are not heroically active. Hart's figures wait, anxiously scanning the horizon or, more literally, Lin's walls in the distance. The statues are too passive and ambiguous to counteract the much stronger therapeutic appeal of Lin's walls. The flagpole, however, is far more decisive than the sculpture, with its clear statement on the base that "the flag affirms the principles of freedom for which they fought and their pride in having served under difficult circumstances." This was exactly the sort of political statement the original competition program had prohibited, and it did not even accurately represent the views of Vietnam veterans, many of whom, in the end, rejected the official rationale for the war and questioned their own service.[31]

These two elements were the most conspicuous changes to Lin's design, but the sponsors themselves initiated another, less noticeable addition to her design. Again over her objections, the sponsors decided to introduce—in the center of her design, where the two walls meet—a simple didactic inscription, in two parts.[32] The first part, the "prologue," before the first name at the top of the right wall: "In honor of the men and women of the armed forces of the United States who served in the Vietnam War. The names of those who gave their lives and of those who remain missing are inscribed in the order they were taken from us." The second part, the "epilogue," after the last name at the bottom of the left wall: "Our nation honors the courage, sacrifice and devotion to duty and country of its Vietnam veterans. This memorial was built with private contributions from the American people" (figure 112). This is just the sort of imposed "message" that Lin had avoided, and most scholars and critics writing on the memorial ignore it. The inscription sits uneasily on Lin's walls because

112 Vietnam Veterans Memorial, detail of inscription. (Photograph by the author, 2008.)

its fixity is so much at odds with the moving experience those walls try to create. Lin's design is a physical and emotional passage meant to activate visitors—to have them feel the descent, sense the walls enclosing them, touch the ridges of the names, see the changing reflections, generate their own response. The whole phenomenon of leaving offerings at the wall is one extension of this process—a way in which visitors create their own contributions, continually remaking the memorial, however fleetingly.[33] The inscription, in contrast, assumes a stationary viewer, standing before the text, passively absorbing its lesson. So effectively do Lin's walls shape the experience of the monument that they seem to render the inscription practically invisible, just as the powerful experience of the speeches and statue at the Lincoln Memorial overwhelms Guerin's didactic murals.

Yet the added inscription matters because it points to a deeper problem. At first glance, the inscription simply repeats the traditional rhetoric of heroic sacrifice that had first appeared in the memorial's statement of purpose. This was the very rhetoric that many antiwar veterans themselves had repudiated. Not only does the opening sentence make the message of "honor" explicit, but the next one asserts that the dead "gave" their lives—a simple verb that implies an act and an actor, a choice made. Yet the end of that same sentence brings a reversal: their lives were "taken" from us. The "give and take" of the inscription points to multiple interpretations of these deaths, which is how Lin had wanted it all along. What the inscription avoids, despite its invocation of the standard military values of courage, sacrifice, and devotion to country, is a statement of moral purpose. These men served "in" the war, but what did they serve "for"? To what moral end, if any, did they did give their lives? The inscription brings the soldiers right to the brink of heroic agency but then pulls back, because it fails to declare that their actions were effective or even purposeful. Unlike the inscription on the flagpole, here there is none of Lutyens's "glory," no fight for "freedom," no higher cause that justified their deaths.[34] In the end the didactic push of the inscription justifies the soldiers not as heroic agents but as honorable victims who deserve our recognition.

The Dilemma of the Therapeutic Memorial

The inscription is important because it reveals a key problem inherent in this new, therapeutic model of memorialization. If we can erect monuments to victims rather than heroes, then whose suffering deserves to be commemorated, and why? Who

deserves the therapy of a public monument? The memorial's statement of purpose emphasized the special trauma endured by soldiers in Vietnam. "These servicemen and women underwent challenges equal to or greater than those faced in earlier wars. They experienced confusion, horror, bitterness, boredom, fear, exhaustion, and death. . . . The unique nature of the war . . . subjected the Vietnam soldier to unimaginable pressures. . . . While experiences in combat areas were brutal enough in themselves, their adverse effects were multiplied by the maltreatment received by veterans upon their return home."[35] Never before had statements like this been used to justify a war memorial. The typical rationale rested on the soldiers' heroism, as in the First Division Monument, where the inscription singled out the unit's "special pride of service and high state of morale never broken by hardship nor battle." Rather than assert a triumph over hardship, the Vietnam veterans' statement of purpose focused on the hardship itself. But that does not explain why their particular set of victims deserved the special recognition of a memorial, while others did not.

For example, only those U.S. soldiers who died from hostilities or accidents in the combat zone have their names engraved on the wall; soldiers who died from exposure to Agent Orange or from suicide do not. The memorial managers get the names from the Department of Defense, which has its own criteria for determining who is killed in action, but nothing in the memorial's statement of purpose suggests that official determinations such as these should be followed automatically, especially when other deaths can also be attributed to combat experience. In 2000, after a grassroots campaign by families of men who do not appear on the wall, Congress authorized the addition of a plaque on the memorial grounds to recognize additional victim groups, though without individual names (figure 113).[36] The new plaque, installed on the pavement in the vicinity of the soldier statues, avoids loaded terms such as *Agent Orange* and *suicide* and honors instead the more generic category of service personnel who "later died as a result of their service": a highly misleading statement, since servicemen who died back home of combat injuries incurred in Vietnam do in fact get their names inscribed on the wall. The plaque suggests, falsely, that the timing of death is the critical criterion, when the type of death is really the issue. The plaque set off a controversy that reignited some of the earlier criticism of the memorial. An op-ed piece in the *Wall Street Journal* declared that "the addition of the plaque to the memorial reinforces the stereotype of the Vietnam War veteran as victim." Although one of the letters published in response vigorously defended the victim designation and argued that it should be broadened to encompass noncombat veterans and family members, others decried the "virus of victimization" overtaking society. As late as 2004, more than twenty years after the dedication of the memorial, one family

113 American Battle Monuments Commission, plaque to war victims not listed on Vietnam Veterans Memorial, 2004. (Photograph by the author, 2008.)

was still fighting to add the name of a former prisoner of war who had committed suicide shortly after returning home from seven years in captivity.[37]

The most immediate effect of the memorial, however, was to raise the question of why other veterans of U.S. wars in the twentieth century had not yet received the same recognition. The VVM led directly to the Vietnam Women's Memorial (1993), the Korean War Veterans Memorial (1995), and the World War II Memorial (2004), setting off a competition for prized space on the Mall. Both the Korean War and World War II memorials were entrusted to the American Battle Monuments Commission, which had been formed after World War I to build American soldier cemeteries in Europe.[38] It is not surprising, then, that both monuments moved in a different direction from the VVM even as they appropriated some of its basic elements. The Korean War Memorial combined soldier statues and a black granite wall into one com-

position and added didactic inscriptions ("Freedom Is Not Free") and a reflecting pool. Instead of names of the dead, the walls included casualty statistics and etched images of faces that personalize the conflict. The result is a jumble of elements, meant to evoke the hardship and difficulty of the ordinary soldier. The nineteen soldier figures—the most dramatic and interesting element of the whole—appear to move slowly on patrol through rugged terrain, their bodies covered by rain ponchos, bent under the weight of their gear, and blocked by stone slabs in front of them. This is no victory party. The circular reflecting pool nearby was meant to be a quiet, shaded place where visitors could reflect on loss and sacrifice, but as the National Park Service Web site has acknowledged, the pool is "misunderstood" and has turned into a wishing well. In therapeutic spaces, visitors follow their own inclinations.[39]

Although the chain reaction set off by the VVM was primarily about which U.S. soldiers (or servicewomen) deserved recognition, there are even larger questions about why the trauma of American veterans deserves recognition more than the trauma of others who have endured violence, disaster, or oppression. "There is no public monument for rape survivors," Judith Herman has written.[40] Her book argues that the "private" atrocity of rape directed at women and the "public" atrocity of warfare directed at men produce the same traumatic syndrome; yet the collective response to the one differs radically from the collective response to the other. Which victim deserves a monument is a fundamentally political question, whose answer depends on the meanings that society assigns to the trauma. The severity of the suffering, in itself, is not the deciding factor.

Try a thought experiment: suppose a group of former antiwar activists proposed to erect a national monument to the four young people shot dead by National Guardsmen at an antiwar rally at Kent State University in 1970. Merely suggesting the possibility no doubt raises hackles among some readers. To go to the other end of the political spectrum, suppose a well-connected group of Vietnamese immigrants proposed a national memorial to the South Vietnamese soldiers who fought on the same side as the Americans. The South Vietnamese army suffered far more casualties, and many of the survivors now live with their families as U.S. citizens. One final hypothetical project, more difficult to classify: suppose a group of Vietnamese adoptees in the United States proposed a memorial to the million or more noncombatants in Vietnam, many of them children, who were killed or disabled or orphaned by the very forces trying to "save" them. Honoring Vietnamese victims of a U.S. war might seem odd, yet here they are living in the United States, like the Irish before them, part of a diaspora with a complex political history. Are any of these victims really less

deserving of national recognition than the men who drowned with the *Titanic*? Even more fundamental, what makes these victims less deserving than the American soldiers themselves?[41]

We now officially recognize that war traumatizes soldiers. Although some still view combat the way Teddy Roosevelt did, as ennobling or purifying, many more emphasize the terrible emotional toll on those who engage in it.[42] But we barely acknowledge the trauma that soldiers wreak on others, even on noncombatants whom they are trying to save (from communism or dictatorship or extremism). The overwhelmingly lethal firepower of the U.S. military, combined with the political need to minimize American losses, makes it inevitable that in U.S.-led wars in foreign lands, civilians will be maimed, killed, and orphaned in far greater numbers than American troops. In fact, one of the many reasons American soldiers suffer post-traumatic stress is that the strain of harming or killing noncombatants can become intolerable. Yet honoring the trauma of the soldiers serves only to silence the trauma of their victims, who melt into invisibility. They have no lists of names on the Mall and never will.

"Could there ever be a more ingenious act of substituting private grief for public guilt?" the minimalist sculptor Robert Morris has rhetorically asked about Lin's VVM. "Has there ever been a more svelte Minimal mask placed over governmental culpability?"[43] Morris may be right to suggest that grief for the soldiers displaces concern for their victims, but he is wrong to ascribe intention to this process. Lin did not intend to silence other victims, any more than most visitors do when they see the memorial. But the memorial makes a choice of whom to acknowledge and whom not to. In that choice a politics of honor emerges.

Therapeutic memorials, then, can never be entirely nonpolitical or nondidactic. To justify its very existence, the therapeutic monument must assign a meaning, implicit or explicit, to the traumatic event that makes its victims worthy of collective recognition. The sponsors of the VVM thought theirs was neutral, but they were thinking only about their own trauma, not about the belief system that made their monument and their list of names possible and made other monuments and other lists impossible. Behind the neutral facade of Lin's walls were politically charged assumptions about whose death deserved recognition and why. Conservative critics of Lin's design sensed this, and never bought the sponsors' claims of neutrality. The critics believed that the memorial made an unpatriotic assumption: that American soldiers had been transformed from heroes to victims (of an unjust or badly managed or unpopular war). In retrospect, we can see that the critics were both right and wrong. The ground on which soldiers were commemorated had in fact shifted, away from

heroism and toward victimization. But this shift neither demoted nor dishonored them. It validated and indeed honored the soldiers' experience in a new way, in a society where victimhood had acquired political legitimacy.

By inviting people to confront the names of the dead and embark on a healing journey, the VVM drew its visitors into a silent web of agreement with the memorial's premise. On their feet, or in their wheelchairs, visitors who came by the millions helped reinforce the memorial's assumption that these names were the Vietnam War's real victims, the ones who mattered so much that they merited recognition on the pilgrimage route in the symbolic heart of the nation's capital. Visitors who identified instead with the war's other victims could easily find themselves alienated, unable to accept the healing proffered by the memorial.

To give just one example, older adoptees from Vietnam—many of them flown to the United States when Saigon was captured by the North Vietnamese—have sometimes reacted much differently from other Americans who share neither their history nor their perspective. They are acutely aware that American soldiers may once have seen them or their Vietnamese parents as "gooks," indistinguishable from the enemy.[44] From outside the memorial's assumed audience—the American GI and his community—the therapeutic journey looks much less universal. With a change in perspective, the walls can become marked by absence, the absence of suffering communities that have no official claim on "honor." For all the memorial's openness to multiple interpretations, it turns out to be more closed and single-voiced than we usually realize.

The Spread of the Victim Monument

In 1980, the same year that Congress authorized the VVM, it authorized the construction of a U.S. Holocaust Memorial Museum on the Mall. To those who have been reading the past several pages and wondering why on earth Americans would commemorate non-American victims, the example of the Holocaust Memorial is particularly striking. This is a memorial museum dedicated to remembering primarily the six million *European* Jews killed by the Nazis' program of genocide, and secondarily the five million other civilian victims targeted by the Nazis—Poles, Slavs, Romani, leftists, and homosexuals. The memorial opened in 1993, more than ten years *before* the World War II memorial dedicated to the American troops who had helped defeat the Nazi perpetrators. Moreover, the memorial was funded by the federal gov-

ernment, in contrast to the VVM, whose construction was financed by a private sub-
scription campaign.

For the Western world—Europe and North America, at least—the Holocaust was
the defining tragedy of the twentieth century, the most extreme case of victimization
possible. As James Young wrote in 1993, putting the Holocaust Memorial on the Mall
would "set a national standard for suffering." Once again, however, the scale and
uniqueness of the tragedy do not explain the decision to build the memorial. Politi-
cal reasons, rooted in U.S. foreign policy in the Middle East and electoral politics at
home, played a crucial role, as scholars have already pointed out. These factors also
shaped the debates among sponsors and supporters over how much the memorial
should emphasize the "core" experience of Jewish victimization over other Nazi cam-
paigns of mass murder and other genocides in the twentieth century.[45]

When the Holocaust Memorial opened in 1993, it instantly became the most im-
portant alternative to Lin's model of the "antimonument." Located on Fifteenth Street,
just south of the Mall, the building faces west in full view of the Washington
Monument. Like Lin, the sponsors wanted their work to be a living memorial, which
in their case meant a center of ongoing exhibition, teaching, archival research, and
advocacy.[46] In one sense Lin's monument was also an archive: a complete record of
the names of the dead (as established by the military and its criteria). But whereas
her archive is limited to a "closed" set of names engraved permanently in granite,
the Holocaust Memorial has the flexibility to gather new materials or reorganize old
ones, to change its focus and its intentions. The container will remain more or less
the same, but the exhibitions and programming can evolve over time. Moreover, Lin's
memorial is radically simplifying and antididactic, whereas the museum is sprawl-
ing and didactic. The museum seeks to personalize the tragedy by putting faces on
the victims, showing where they lived and how they died. Photographs, artifacts, and
texts proliferate in its exhibition spaces, lending historical credibility to the story and
intensifying the emotional identification with the victims. Whereas personal artifacts
do actually show up at Lin's walls as donations from visitors, the Holocaust museum
supplies its own carefully screened and arranged selection. Visitors follow museum
protocol: they look but do not touch, absorb the museum's contents but do not pre-
sume to leave a personal contribution.

The Holocaust museum is not really a therapeutic memorial at all, but a warning,
meant to shock visitors into realizing that such an event must never happen again.
The building—a tour de force by the architect James Freed—recalls the industrial ar-
chitecture of the death camps. The visitor's passage through the building is a spatial

114 James Freed, architect, Holocaust Memorial Museum, Washington, D.C., 1993, detail of "Think about What You Saw." (Photograph by the author, 2003.)

and emotional journey through open light spaces into cramped dark spaces, over ramps and bridges, and through doorways that evoke the "selections" of victims in the camp. The experience is shattering. How do we process the photograph of a man staring into the camera moments before his execution, or of a disabled child stripped naked and terrified, about to be dragged to her death? What do we make of the picture of the two beautiful boys arriving at Auschwitz, worried and knowing at the same time? How do we fathom the moral collapse that not only perpetrated these mass murders but documented them with such bureaucratic pride and efficiency? How to "think about what you saw" (figure 114)? At the end of the journey we emerge from this horrifying display into a pristine, hexagonal room called the Hall of Remembrance, where we can attempt to assimilate the experience before returning to the Mall. This is a transitional space, for reflection and ceremony, but hardly for recovery, as the passage through Lin's monument is. Compared with the experience of

Lin's walls, the passage through the Holocaust Memorial is far more private, internal, and silent, as visitors struggle to come to terms with what they encounter.

If anything, the Holocaust Memorial is traumatizing rather than therapeutic. Psychologists have a term for this: *secondary trauma*, caused, not by experiencing a traumatic event directly, but by witnessing it secondhand. Rustom Bharucha's reaction after visiting the remains of the concentration camp at Dachau might well apply to the Holocaust Memorial: "Back in the desolate anonymity of one's Munich hotel, one suffers with the memory of Dachau." He goes on, "Is not this suffering essentially narcissistic, masochistic, parasitic, unproductive, even factitious?"[47] These are strong words, but they raise an important question: what do we do with the emotional suffering that the museum visit generates? How do we move beyond melancholy wallowing or perverse enjoyment? Recovery, Judith Herman argues, ultimately requires reintegration and action, and neither is facilitated by the museum experience, which is passive and ultimately directed inward to the visitor's own psychic struggle with tragedy beyond comprehension.[48]

A "productive" memorial must make an impact beyond its enclosed space. It must work against the impulse to memorialize itself, that tendency to become absorbed in its own reason for existence. It must seek connections to the world outside its own. The old-fashioned hero monument, so the thinking went, was productive because it inspired citizens to emulate the virtues of the hero. Lin's therapeutic monument was productive in a new sense: it helped a segment of society heal and recover from national tragedy. The Holocaust Memorial, too, is supposed to help produce an outcome: "never again." But the question remains how the memorial can transform the passive suffering of individual visitors into determined collective action, or how to move from reflection ("think about what you saw") to intervention. That transformation requires mediating steps.

The Holocaust Memorial labors with a contradiction. On the one hand, it presents the Holocaust as a unique event without parallel in modern history. On the other, it tries to connect the event to current affairs, using the lessons of the Holocaust to advocate on behalf of other victims of state terror and extermination. The memorial has a standing "committee of conscience" that issues bulletins on contemporary genocide, and it has programming and Web materials that engage broadly with these concerns. All these are worthy and indeed necessary initiatives, but they do not create a space for visitors to act. They are traditionally didactic tools meant to disseminate knowledge to a receptive audience. The permanent exhibit, by focusing on the "core" story of Jewish victimization, is not designed to provoke thinking about parallels in the present or the future. For example, the exhibit devotes significant space to the

U.S. government's unwillingness to help stop the tragedy in progress, but fails to connect that moral failure to more recent ones, such as the reluctance of the United States and Europe to intervene in Rwanda or Darfur.[49] Even with the institution's active attention over a period of years to the genocide in Darfur, its temporary exhibits on the subject are off the main tourist circuit and undervisited. A core-periphery dynamic at work within the space itself inevitably marginalizes these contemporary concerns. There is simply no clear infrastructure within the museum to help visitors generalize their new knowledge to today's problems and thereby get involved. Readers may well object that I am holding the memorial to an impossible moral standard, far beyond that of any other discussed so far. But this memorial, more than any other, is a cry of moral outrage, and it invites, indeed demands, a high standard of moral engagement—both a consistent application of moral principles and a willingness to move its visitors to defend those principles. Otherwise its claims to conscience ring hollow and it simply bolsters one group's victimization at the expense of others.

Although it is difficult, if not impossible, to measure the impact of the memorial on its visitors (much less on world affairs), the Holocaust museum has certainly had an effect on other memorials. Its archival approach—at once documenting and personalizing human suffering—has created a new model for victim monuments, which has helped to shape other works such as the Oklahoma City National Memorial, dedicated to the 169 victims of Timothy McVeigh's terrorist bombing. The influence of the Holocaust Memorial has even reached backward to reshape the radically different Vietnam Veterans Memorial. The VVM Fund's sponsors, with the approval of Congress, are now working to create an underground visitors center that will supplement the names on Lin's walls with historical context and with images and stories of the soldiers who served and died. In effect, this will be a museum designed to supplement the original wall. The sponsors worry that as the war recedes further into history, younger visitors know less and less about it and their sense of connection dissipates. The impulse to supplement Lin's simple archive of names with more specific personal information—which visitors to the memorial have been doing spontaneously since it opened—is an attempt to ward off the memorial's decline into obsolescence. But at the same time the "museumizing" of the VVM is a profound change from the original concept. As the VVMF's Web site declares, "'What was once *The Wall That Heals* has now become *The Wall That Educates.*' The Center will continue the important legacy of teaching young people about the Vietnam War and the sacrifices of those who served when called upon by their country." The original rationale for the memorial said nothing about teaching and little about the importance of

sacrifice. In one stroke, the sponsors have transformed the monument into an openly didactic instrument.[50]

The campaign for the Holocaust Memorial also lent urgency to long-standing efforts to commemorate the United States' own perpetration of racial internment during World War II, the forced evacuation and imprisonment of 120,000 Japanese Americans (more than two-thirds of whom were U.S. citizens). The U.S. action was by no means genocidal, but it was a shameful policy driven by a combination of wartime hysteria and ongoing racism—one that received no attention in the huge memorial to Franklin Delano Roosevelt, completed in 1997 in West Potomac Park, even though Roosevelt had signed the internment order and had justified the action under his own wartime powers.

At the close of the Reagan administration, Congress passed legislation formally apologizing for the action, establishing a reparations fund for the internees, and authorizing a memorial that would permanently acknowledge the injustice of the internment. Japanese Americans sponsored, funded, and planned the memorial, which took more than a decade to complete. Unfortunately for them, it was dedicated on Veterans Day in 2000, just two days after the presidential election day, when the nation's attention was riveted on what would become a long and bitterly disputed contest over the vote count in Florida.[51]

The memorial is located in one of L'Enfant's odd triangles—this one between Louisiana Avenue, New Jersey Avenue, and D Street, just north of the Mall and in sight of the Capitol. The design uses the whole triangle, combining a garden, fountain, and plaza (figure 115). Despite its proximity to both the Capitol and the Mall axis, the ensemble is quiet and often empty.

The official name of the monument is the Japanese American Memorial to Patriotism, an odd choice for a memorial that commemorates forced removal and imprisonment. The memorial actually combines two purposes in one: it records the internment experience, marking the names and locations of the camps, and it honors the U.S. military service of Japanese American soldiers, recording the names of more than eight hundred who died in the war effort. One of the bitterest ironies of the whole episode is that thousands of young Japanese American men were serving their country in the war even as their own government was systematically stripping their family members of the most basic rights to home and freedom. While marking the injustice of this policy, the monument's inscriptions tell a story of Japanese Americans' loyalty persisting despite the federal government's betrayal of them. The inscriptions include an excerpt from the "Japanese American Creed," written in 1940 by Mike

115 Davis Buckley Architects, Nina Akamu, sculptor, Japanese American Memorial to Patriotism, Washington, D.C., 2000. (Photograph by the author, 2008.)

Masaoko of the Japanese American Citizens League (JACL): "I am proud that I am an American of Japanese ancestry. I believe in this nation's institutions, ideals and traditions; I glory in her heritage; I boast of her history; I trust in her future."

The selection of this inscription opened up long-standing rifts in the Japanese American community. A dissenting faction on the memorial's board objected to the choice of Masaoko because he and the JACL had cooperated (and indeed collaborated) with the internment; moreover, the quotation and the memorial as a whole emphasized loyalty at the expense of "the broad diversity of experiences, opinions, values, and choices of Japanese Americans." As Lawrence Hashima has pointed out, the memorial does little to recognize acts of resistance to the internment by Japanese Americans, or to honor those who fought in court to seek redress.[52] The same point could be made about the Vietnam Veterans Memorial, whose inscription emphasizes the soldiers' loyalty and does nothing to remember veterans who openly questioned or even renounced their duty to the nation.

The Masaoko inscription was approved despite a petition campaign to the National Park Service (NPS) to remove it. The director of the NPS responded that the complex story of the internment "cannot be completely told in a memorial," and that pamphlets interpreting the monument could be revised "if scholarly research indicates a change in the traditional narrative is required."[53] A pamphlet, though, can never have

116 Japanese American Memorial to Patriotism, detail of inscription. (Photograph by the author, 2008.)

the authority of a monumental inscription. A pamphlet is ephemeral, implying a human author writing at a particular time in a particular context; an inscription is permanent and seems to issue from some eternal origin beyond human passions and politics.

The problem of collaboration versus resistance at issue in the Japanese American community, however, is virtually invisible to visitors outside the community who do not know its history. Outsiders surely focus first on the tallest and most central element in the plaza—a bronze sculptural group of two massive cranes, their wings joined in a vertical profile, struggling within a barbed wire net. The sculpture speaks to the incarceration and suffering of the innocent, and to the solidarity of family and community amid oppression. Standing at this central point and turning around, visitors see the names of the internment camps in large capital letters. Across from the sculpture, on the wall of the fountain, is the dramatic inscription, "Here We Admit a Wrong," taken from a speech by President Reagan as he signed the legislation authorizing redress (figure 116).

The placid surface of the pool of water behind, and the overall serenity of the garden surrounding it, make an unexpected setting for this extraordinary statement—an explicit acknowledgment of U.S. wrongdoing that has no precedent among Washington's monuments. The only other inscription in Washington at all comparable is

the passage from the Second Inaugural in the Lincoln Memorial, which comes close to a collective admission of guilt for the crime of slavery, though it is couched in conditional if-then statements. The Japanese American Memorial to Patriotism, despite its emphasis on loyalty to the nation, makes a strong statement that the collective "we" recognize a national moral failure. Its presence near the monumental core can only raise questions about why other oppressed minorities—most notably African Americans and Indians, whose histories of oppression span centuries—do not have monuments with similarly explicit acknowledgment of the nation's culpability.

The National Museum of the American Indian (NMAI), opened in 2004, does tell the stories of such tragedies as the Trail of Tears—the forced march of eastern Cherokee to the arid West—but does so, understandably, from the point of view of the affected tribe. In the context of the museum, the government and the majority white culture take no official responsibility for perpetrating the crime, except to allow the story to be told. The overall message of the NMAI is not the explicit "never again" of the Holocaust Memorial, or its implicit equivalent in the Japanese American Memorial. The NMAI is more concerned to replace the old image of the vanishing Indian with the authentic voices of the tribes themselves, to underscore the resilience of their traditions despite systematic oppression and continuing barriers to opportunity.[54]

Lest we think that the impulse to commemorate victims comes only from within marginal or oppressed groups, the conservative political establishment in Washington set aside whatever reservations it may have had about the "virus of victimization" to help sponsor the capital's newest victim monument: a memorial "to the more than 100 million victims of communism," which now stands a few blocks north of the Japanese American Memorial. Even though this is surely the largest number of victims ever commemorated in one monument, it is a relatively modest space, considerably smaller than the Japanese American Memorial, with only an eight-foot allegorical statue in the center on a low pedestal marked with two short inscriptions. Originally the sponsors had wanted to erect a $100 million museum comparable to the Holocaust Memorial, but for lack of funds they had to scale back the project drastically. Lev Dobriansky, the key organizer of the Shevchenko Memorial, was also a prime mover behind this project, along with prominent conservatives from think tanks and other "movement" organizations. Dobriansky's personal journey from the heroic Shevchenko Memorial to the Victims of Communism perfectly illustrates the larger cultural drift from the last stage of the hero monument to the newly ascendant victim monument.[55]

At its dedication in 2007, President George W. Bush gave the monument a

117 George W. Bush at the dedication of the Victims of Communism Memorial (Thomas Marsh, sculptor), Washington, D.C., June 12, 2007. (Alex Wong/Getty Images.)

national seal of approval by delivering the keynote address (figure 117). (At the dedication of the Japanese American Memorial no official higher than Cabinet level had attended.) Bush stood directly in front of the statue, a bronze replica of the plaster *Goddess of Liberty* that Chinese students had created and set up in Tiananmen Square during the democracy movement of 1989; yet his administration expanded

ties with the very communist regime that brutally suppressed that movement and destroyed the sculptural symbol reincarnated here.[56] This is one of many contradictions that mark the monument. According to its inscription, it is dedicated to the "victims of communism" and "those who love liberty" but, inexplicably, the monument ignores the millions of people who lost their liberty and lives to right-wing dictatorships and other fascist or quasi-fascist regimes. Bush's dedication speech, for example, mentioned the Miskito Indian victims of Sandinista Nicaragua but said nothing about the Indians slaughtered by paramilitary forces in Guatemala, or the disappeared in Argentina, or the hundreds of thousands of civilians massacred by the South Korean military during the Korean War—all regimes allied with the United States.[57] In these various inclusions and exclusions, the political favoritism of the enterprise becomes readily apparent, and the sincerity of the appeal to liberty is seriously compromised. The invidious distinctions of the victim monument here come into sharp relief.

Beyond the Victim Monument

In Billy Collins's poem "Statues in the Park," a narrator in the shadow of some forgotten equestrian statue reflects on the problem of commemoration:

> I wondered about the others
> who had simply walked through life
> without a horse, a saddle, or a sword—
>
> pedestrians who could no longer
> place one foot in front of the other.
>
> I pictured statues of the sickly
> recumbent on their cold stone beds,
> the suicides toeing the marble edge,
>
> statues of accident victims covering their eyes,
> the murdered covering their wounds,
> the drowned silently treading the air.[58]

The turn toward the victim in the twentieth century has not yet embraced these common casualties of everyday life, those who still receive little collective acknowledgment, much less memorial honors. The victim memorials of our time each distinguish themselves by asserting a unique wrong that is supposed to set its victims apart

from the ordinary tragedies of human existence. Yet as these memorials multiply, they call their own uniqueness into question. A nagging issue always threatens to surface: why one person's murder, or one group's suffering, can be more important than another's. Whose death is publicly "grievable," to put the question in Judith Butler's terms, and why?[59] The old-fashioned hero monument unabashedly made distinctions of value, elevating some men over others. But such distinctions are much more problematic for victims. If heroism is exceptional—a debatable point—suffering is, without question, universal. Victims are everywhere, crossing boundaries of nation, class, race, and gender. Who is to say that the death of a soldier in combat counts more than the suicide of a tortured prisoner of war? Or that the unexpected death of a civilian in the World Trade Center counts more than a routine homicide a few blocks away, more than the everyday deaths of noncombatants in war zones across the globe? One wonders how memorials of healing or of conscience will ever really succeed if they do not reach out beyond their own boundaries of victimhood and embrace what we might call "coalitions of the suffering," alliances that find strength in alleviating one another's injury rather than ignoring or belittling it. Otherwise we risk inflicting the very terror and trauma on others that we find so excruciating to endure in our own lives. In the absence of a broader identification, which, in the words of the Franklin Delano Roosevelt Memorial, "recognizes that the whole world is one neighborhood and does justice to the whole human race," our own victim monuments will simply be matched by others.[60]

7

An End to War, an End to Monuments?

In August 2001, construction began on the World War II Memorial, the first new monument to be erected on the Mall's east-west centerline since the great triumvirate of Grant, Washington, and Lincoln was laid out and built according to the Senate Park Commission plan of 1901. A few weeks later, on September 11, a Boeing 757 jet hijacked by terrorists hurtled freely toward the capital's air space, putting all its major monuments and structures at risk. At the last minute, just before reaching Washington, the plane made a 330 degree turn over the Beltway and crashed into the Pentagon, in what was the most significant surprise attack on U.S. territory since Pearl Harbor drew the nation into World War II.[1]

Both these events have put their stamp on Washington's memorial landscape. It is sheer coincidence that they occurred almost simultaneously, but their subsequent histories are hard to disentangle. The prominent inscription of President George W. Bush's name at the World War II Memorial's entrance (figure 118)—not without precedent but more conspicuous here than on any previous monument in Washington—virtually begs us to connect his "war on terror," undertaken in the aftermath of September 11, and America's mid-twentieth-century war against fascism.[2] The memorial's physical obstruction of the axis between the Washington Monument and the Lincoln Memorial, where the most significant democratic assemblies of the twentieth century took place, echoes the obstructions put up in and around the Mall to ward off terrorist attacks. The proliferation of these security measures, combined with the new prominence of military memorials on the Mall, has given the landscape a defensive posture, befitting a nation living under constant threat.

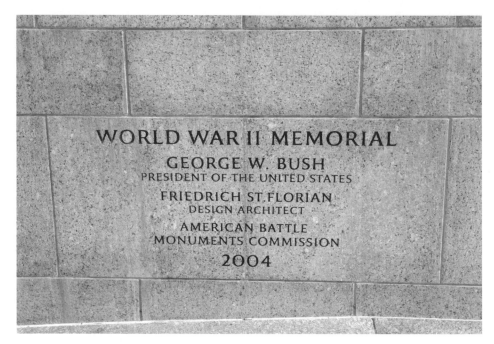

118 Friedrich St. Florian, architect, World War II Memorial, Washington, D.C., 2004, detail of dedicatory inscription on north wall of east entrance. (Photograph by the author, 2008.)

The Security Landscape

The World War II Memorial arrived on the Mall as an antidote to much of its twentieth-century history. The memorial is a rejoinder particularly to Lin's Vietnam Veterans Memorial—white granite instead of black, plaza instead of park, loud instead of hushed, overflowing with words and images instead of stripped down and minimalist (figures 119 and 120). Whereas the VVM lists the names of the dead, the World War II Memorial lists names and places of battle. Although both memorials feature walls below grade that honor the war's dead, the World War II "Wall of Freedom" (with a field of more than four thousand gold stars, each one representing one hundred dead) is inaccessible, behind a semicircular pool and out of reach. Personal offerings—still an important aspect of the experience at the VVM—are impossible at the wall of stars and discouraged elsewhere at the monument.[3] The VVM avoided rendering final judgment on the war; the World War II Memorial splashes its messages of righteous force and moral triumph from one end of the space to the other. The VVM suggested the limits of American military power; the World War II Memorial nostalgically celebrates the nation's military supremacy.

The World War II Memorial is decidedly not a psychological space, not a place for

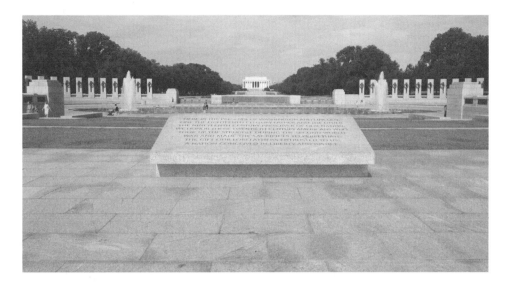

119 (top) World War II Memorial, east entrance. (Photograph by the author, 2008.)

120 (bottom) World War II Memorial, Rainbow Pool. (Photograph by the author, 2008.)

reflection and reckoning. The roar of the fountains fills the space, and the inscriptions trumpet their messages of determination and rectitude. "They had no right to win. Yet they did," proclaims one inscription about the Battle of Midway. "You are about to embark upon the great crusade toward which we have striven these many months," says General Dwight D. Eisenhower, using a word with new associations

since September 11. "We are determined," says General George Marshall, "that before the sun sets on this terrible struggle our flag will be recognized throughout the world as a symbol of freedom on the one hand and of overwhelming force on the other." The pillars representing individual states and U.S. territories wrap around the various blocks of stone labeled as regions of the world, an apt spatial metaphor for America's global military dominance (see figure 120). This is a space not for internal reckoning but for acclamation, pure and simple. "Victory on Land, Victory at Sea, Victory in the Air," declares the memorial at its north and south pavilions, where great bronze eagles reinforce the message by suspending huge wreaths of victory over the visitors who pass beneath.

But the monument's greatest victory is probably its conquest of the Mall. The memorial took over the so-called Rainbow Pool, a key part of the axial composition connecting the Washington Monument to the Lincoln Memorial. From the beginning the site of the memorial was its single most controversial feature—not surprising, given that this was the first major change proposed to the central vista of the 1901 plan. The memorial was to go in the very center of the center, the most symbolically charged national space imaginable. Supporters insisted that it would not affect the vista, while opponents declared that it would forever alter the nature of the space. In the end, the U.S. Congress had to intervene directly in the controversy by passing legislation in 2001 quashing a lawsuit that might have delayed construction for years or even derailed the project altogether.[4]

Dedicated in 2004, in the midst of a new war in Iraq, the memorial in its supremely central location stands as a monument to the superpower status of the United States, at a time when the nation has an unprecedented superiority in military resources over the rest of the world. With a defense budget equal to almost half the total military spending in the world—nearly ten times more than the next largest national military budget—the United States enjoys a lopsided military advantage that would have been greatly envied by American commanders in World War II.[5] Nevertheless, nostalgia pervades the memorial. It is a wistful reminder of better times, when the nation united in spirit and sacrifice to smash its enemies and achieve absolute victory. In the twenty-first century, absolutes now seem unreachable. The nation, despite its incredible military prowess, finds itself adrift in a sea of threats. Vulnerable to small guerrilla insurgencies and facing shadowy enemies that lurk outside state authority, the United States has fallen into a permanent state of war, no longer able to reenact the story told in the World War II Memorial or live up to its rhetoric of righteous victory. As of this writing, the U.S. armed conflicts in Iraq and Afghanistan have dragged on longer than World War II, with no promise of definitive resolution. War

121 Friedrich St. Florian, winning design entry for the World War II Memorial, 1996. (Courtesy of studio amd.)

has become endless in both senses of the word—without definite duration or clear objectives. Behind the World War II Memorial's triumphalism, then, is a palpable sense of insecurity.

Originally, the architect, Friedrich St. Florian, wanted to tell a story of death and loss, more in tune with the VVM. His winning design in the 1996 design competition, though much larger and more intrusive than the final design, told that side of the story more forcefully (figure 121). Two huge earthen berms planted with white roses were designed to frame the Rainbow Pool on the north and south ends; although these were meant to shelter interior spaces required by the competition program, they had the appearance of a burial mound scooped out in the middle. At the interior edge of each berm was a colonnade of twenty-five columns, their capitals cut off— a repetition of the broken-column motif commonly used for children's graves in nineteenth-century cemeteries.

Over a period of several years, multiple regulatory reviews forced St. Florian to eliminate the interior spaces and scale down the memorial, and in the process his design lost its original tragic note. The broken columns representing the states were replaced by pillars with open rectangular slots, an obscure allusion to death lost on most visitors. Other elements were added in response to criticisms or suggestions of one sort or another, and the design became an accumulation of motifs, stitched

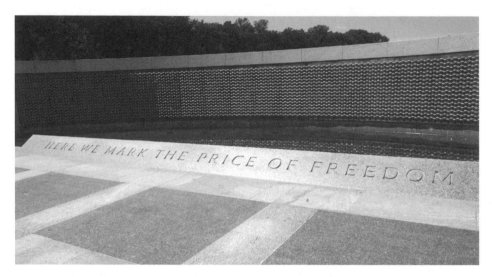

122 World War II Memorial, "Freedom Wall" with "Field of Stars." (Photograph by the author, 2008.)

together with great professionalism but lacking the original scheme's simplicity.[6] Raymond Kaskey's twenty-four relief panels in identical format on the downhill approach create a kind of comic-book history of the war; the few panels showing dead or wounded soldiers form a minor note in the whole. At the memorial's west end, the central wall of four thousand gold stars, meant to represent the four hundred thousand American war dead, cannot compete with the spectacular jets of water in the pool and the huge array of vertical elements around it; the wall had to be slung low to preserve the vista to the Lincoln Memorial. Tucked behind a small pool, the wall is impossible to reach without stepping into the water, which is forbidden. Instead, visitors encounter a huge didactic inscription that doubles as a barrier: "Here We Mark the Price of Freedom" (figure 122).

Martial words and images dominate the memorial's main space. The common soldier, though represented in the small bronze reliefs on the approach ramps, is actually overshadowed by the commanders, whose prominent inscriptions take center stage in the design—a reversal of the twentieth-century trend. The design has been compared to fascist parade-ground architecture because of its classicizing vocabulary. If there is an echo of fascism, though, it is not in the surface neoclassicism (which hardly belonged to the Nazis alone) but in the monument's authoritarian certitude. A long series of incremental changes and additions, essentially made by committee, brought about this outcome.

Stylistically, it is more revealing to compare the memorial to the original Park Commission plan, especially to the terraces and fountains of the "monument garden" at

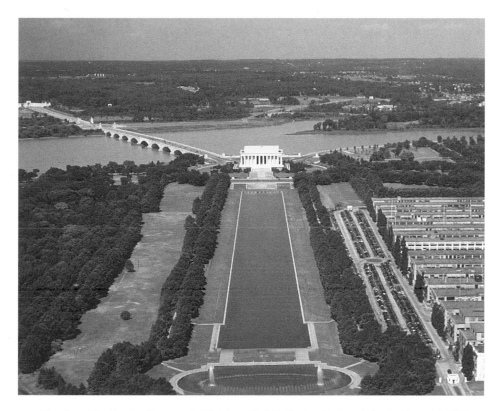

123 View from Washington Monument of Rainbow Pool, Reflecting Pool, and Lincoln Memorial, 1940. (Visual Resources Collection of the History of Art and Architecture Department, University of Pittsburgh.)

the base of the Washington Monument. The final design resuscitates and updates the grandiloquent design vocabulary of the 1901 plan at its most elaborate. At the same time, though, the memorial as a whole irrevocably alters that plan's vision of the site as a setting for the Lincoln Memorial. The long Reflecting Pool and the much shorter transverse Rainbow Pool were designed as an elegant but relatively empty area of visual repose to enhance the grandeur of approach to the Lincoln Memorial (figure 123). Rick Olmsted, by 1920 the sole surviving member of the Senate Park Commission, obsessively supervised the design of the pools, subtly modifying the dimensions that the monument's architect, Henry Bacon, originally proposed.[7] The World War II Memorial supposedly "preserved" Olmsted's Rainbow Pool but completely transformed it by sinking it below grade and surrounding it north and south with dramatic vertical elements. Moreover, the wall of stars and its adjacent fountains have severed the old connection between the Rainbow Pool and the Reflecting Pool that leads to the Lincoln Memorial. Visitors looking at the wall from the west side of the Rainbow Pool, on the centerline of the axis, now find the view of the Reflect-

124 View from World War II Memorial west toward Lincoln Memorial. (Photograph by the author, 2008.)

ing Pool and the Lincoln Memorial blocked. If they shift to the right or left of the wall, the Lincoln Memorial comes back into view, but the physical approach is blocked by cascading water (figure 124). The sight of pedestrians strolling just above the fountains barely ten feet away makes it appear that there is a direct route, but to reach those pedestrians who are so tantalizingly close, visitors must backtrack through the plaza, exit through the north or south pavilion, and circle all the way around toward the Reflecting Pool. The decision makers could easily have created circulation ramps around the "Wall of Freedom" instead of fountains, allowing visitors to move directly from the memorial plaza toward the Lincoln Memorial. Instead they decided to enclose the plaza on the west end and create a more self-contained space—an understandable move but a drastic alteration to Olmsted's landscape, couched, as we have seen before, in the misleading rhetoric of historic preservation. The Rainbow Pool is no longer experienced as part of the approach to the Lincoln Memorial but as the interior space of an entirely new work.

The whole west end of the Mall has become a circuitous route for pedestrians. A spiral ha-ha wall installed around the Washington Monument, cleverly and elegantly

125 View of the eastern approach to the Washington Monument. (Photograph by the author, 2008.)

designed by the firm of Laurie Olin, creates a visually unobtrusive barrier against truck bombers, but also rechannels pedestrians along a fixed circular walkway rather than a more direct axial route (figure 125).[8] Although it is still possible to walk straight through the site by climbing the three-foot-high walls and ducking under the ropes that surround the monument's circular plaza, the experience is discouraging to say the least. At the base of the hill below the monument, a new visitor's lodge now blocks the axial approach from the east. The axial approach to the World War II Memorial is often blocked by ropes that encircle the grassy terraces on the descent; visitors follow the side ramps that are decorated with Kaskey's bronze panels. All these new circulation patterns at the Washington Monument and the World War II Memorial, added up, effectively eliminate the direct axial communication envisaged in the plan of 1901.

At first glance this might seem to be a return to the nineteenth-century idea of curving walks through public grounds, but the new circulation patterns have none of the old meandering spirit. On the new routes it becomes obvious that the goal is to control access rather than to invite exploration. One look at the entrance to the

Washington Monument—a miserable security box with tinted windows, more suited
to a prison or top-secret government agency—shows graphically how the majestic
open national space cleared by the early twentieth-century planners has now come
back to haunt us. The attack of September 11 exploited the vulnerability of American
air space and, by extension, the vulnerability of the symbolic landscape, whose power
rests on the command of space. The Mall's powerful spatial flow attracts enemies as
well as citizens—especially those shadowy enemies that lurk beyond the reach of the
military. The new impulse to carve up the Mall's spatial flow may help ward off some
of the nation's enemies but will also result in greater control of its citizens. The mech-
anisms of defense and of control merge, and it becomes increasingly difficult to tell
which goal they serve.

The Two FDRs, the Two World War IIs

Not too far from the World War II Memorial is the Franklin Delano Roosevelt Me-
morial (1997), where World War II also looms large. Designed by the landscape ar-
chitect Lawrence Halprin for a seven-acre site in the Tidal Basin, the FDR Memorial
is similarly huge and overblown, with a multiplicity of elements including water and
figural sculpture. But the memorial now comes across in a much different light than
it did in the late 1990s, thanks in large part to the World War II Memorial.

Walking through the two memorials today, one cannot help thinking that the World
War II Memorial is an answer not only to Lin's memorial but to the FDR Memorial
as well. The inscriptions offer the most immediate contrast. The World War II Me-
morial delivers a snippet of FDR's Pearl Harbor speech (1941), invoking America's
"righteous might" and calling for "absolute victory," whereas in his own memorial
he says, "I hate war" (from a speech in 1936) (figure 126). In the World War II Me-
morial, he celebrates the women who "have riveted the ships and rolled the shells";
in the FDR Memorial, he talks of the need to build peace on social justice: "More
than an end to war, we want an end to the beginnings of all wars" (1945).

The FDR Memorial's choice of inscriptions aroused the particular ire of the po-
litical right, who saw them as a liberal catechism for the 1990s. Critics on both the
right and the left also took the memorial to task for its shoddy history and cult of per-
sonality, which suppressed historical contradictions such as the Japanese internment.
With the World War II Memorial in place, though, the FDR Memorial now offers an
interesting counterpoint. The inscriptions remind us that military might was not the
only concern of that period and that movements for peace and social justice have roots

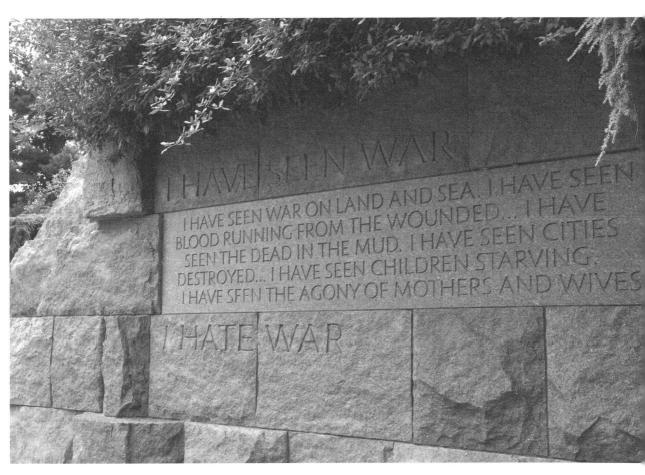

126 Lawrence Halprin, landscape architect, Franklin Delano Roosevelt Memorial, Washington, D.C., 1997, detail of "I Hate War." (Photograph by the author, 2008.)

in American culture long predating their spectacular reemergence in the late 1950s and 1960s. More important, the layout of the memorial into multiple outdoor rooms, furnished with sculpture diverse in format and style, provides an opening for thought and discussion, even though FDR's voice monopolizes the inscriptions and leaves out unflattering discrepancies. We could say the same of the Lincoln Memorial, after all. Despite its enormous size, the FDR Memorial is more intimately scaled than its World War II counterpart. At the FDR Memorial, visitors move through a sequence of well-calibrated variations in mood, sound, and vista. Its deliberate irregularities of form and circulation, not to mention its diverse tree plantings, evoke the nineteenth-century Mall, while its spaces of encounter and revelation build on the psychological developments of the twentieth-century Mall. The addition of the wheelchair statue after the memorial was dedicated, a move lambasted by many as the height of

"political correctness," simply enhances the memorial's open-ended quality, in effect creating a dialogue between the private Roosevelt and the public image of strength he carefully fashioned.[9] Many would have preferred a stronger image and inscription, but the addition still makes an impact. Only a few years later, one wonders what all the fuss was about, what harm anyone could see in this new statue, especially when it has inspired so many in the disabled community.

Political factions and lobbies have shaped the nation's monuments throughout its history. If one objects to the "disability lobby" changing the FDR Memorial, then it would be logical to object to the "veterans lobby" guiding the World War II Memorial. If the FDR Memorial is "politically correct," so too is the World War II Memorial, with its images of women on tractors, African Americans volunteering for duty, and Russian soldiers cheerfully greeting American troops. Each of these "politicized" images involves historical omissions and contradictions. The empowerment of women was merely temporary; the U.S. military treated its African American recruits as second-class citizens; behind the goodwill gestures between Russian and American troops, a cold war was brewing.

The Vulnerability of Memory

In 1995, James Reston Jr. worried in the *New York Times* that "coming to Washington is turning into a martial experience." He was reacting to the wave of new war memorials planned for the Mall in the aftermath of the Vietnam Veterans Memorial. But the problem, as we have seen, goes back much further. Criticism of military monuments began in the nineteenth century: even after the Civil War, William Dean Howells warned against "a standing-army in bronze and marble." Many nineteenth-century observers lamented the "militarism" of the capital's memorial landscape, which became an issue as soon as the first statue monuments began to appear. Washington's twentieth-century planners tried hard, as we have seen, to stop or at least contain the spread of war memorials after World War I and World War II.[10]

If the martial spirit of Washington's memorial landscape has survived every effort to contain it, it has evolved considerably since the heyday of the equestrian statue. The most obvious change is one of focus, from great commanders to mass armies. The new focus first became an issue in the Grant Memorial's combat groups, developed further in the naming of common soldiers after World War I, and culminated in the explicitly comprehensive Vietnam Veterans Memorial, which ignored

traditional distinctions of rank entirely. The second major change is concentration: from the commander statues spread out in the streets of the capital to the clustering of soldier memorials on the Mall's west end, where they have reshaped the original axis between the Washington Monument and the Lincoln Memorial.

The most recent change, which Reston seems to have anticipated, is the attempt to control the psychology of memorial space to return to simpler feelings of moral triumph. "Every war, it seems, now has to have its own triumphal memorial," Reston wrote, and, ironically, the fault lay in the least triumphal memorial of all, the VVM.[11] This trend has reached an apex in the World War II Memorial, although the nostalgic remembrance of the comforting closure brought by "overwhelming force" now goes hand in hand with a new sense of vulnerability brought about by the escalating costs and uncertainties of maintaining military supremacy in the twenty-first century. That sense of vulnerability has marked the commemorative landscape itself, by rerouting its visitors through roundabout circuits and surveillance devices.

Perhaps the biggest vulnerability, however, comes not from a shadowy enemy without but from apathy within. It is the essential vulnerability of collective memory that sooner or later it will disappear. Someday, we worry, our war memorials will turn into monumental albatrosses, empty of visitors, because the veterans they honor will pass away and become too distant from living kin and other social networks with a stake in remembering them. This has certainly happened with Civil War memorials (witness the Grant Memorial) and World War I memorials (witness the District of Columbia war memorial). The First Division Memorial stays barely alive only because the unit carried over into subsequent wars and updated the monument to keep current with its living veterans; like the Marine Corps War Memorial in Arlington, the work became a monument to an ongoing institution rather than a specific event. Absent this possibility, the World War II and Korean War memorials may soon grow obsolete. Now Jan Scruggs, of the Vietnam Veterans Memorial Fund, claims that the retreat from living memory is already under way at Maya Lin's wall.[12]

The inevitable erosion of memory puts pressure on each of these memorials to dramatize its lasting significance. One can only guess how this will happen in the planned visitors center at the Vietnam Veterans Memorial. The original rationale for the memorial rested on the uniqueness of the trauma suffered by American soldiers in Vietnam. Now that the memorial has performed its act of restitution to those soldiers and their trauma is receding from active memory, there will be strong reasons to shift the rationale in the opposite direction—to make the veteran of Vietnam more representative of the tradition of American military service and sacrifice. Already, the VVM Fund's official Web site is declaring that the center will be a didactic space focusing

on the theme of sacrifice for country, even though many American soldiers in the Vietnam War were ambivalent about, if not hostile to, that very ethic of sacrifice.[13]

The idea of bringing an end to war and an end to the conditions that create war—which motivated Wilson in World War I and Roosevelt in World War II, and even Eisenhower as he left the presidency—disappears from a commemorative system that is expected to reaffirm the honor of the military in each succeeding war, just or unjust, misconceived or not. The original moral cause that once seemed to justify the extraordinary loss of life fades into a more generalized ethic, which insists that mass sacrifice, in the end, must always confirm the moral legitimacy of the nation. The militarization of the memorial landscape helps to sustain the inevitability of war's repetition.[14]

But even as memorials to successive wars proliferate on the Mall, we cannot know whether the commemorative system will save individual monuments from oblivion. It is possible that the visitors of the future will find a way to appropriate the system for different moral ends. After all, the Lincoln Memorial was once intended to be the Mall's supreme expression of post–Civil War national "reconciliation," a whites-only affair that abandoned millions of African Americans to segregation and disenfranchisement. Who could have predicted that the memorial would become the country's most powerful symbolic space for civil rights and racial equality? Or that one day crowds would gravitate there to mark the election that brought a black man to the presidency? The lesson to be learned is that the subjectivity of memorial space, once unleashed, cannot be so easily controlled. How the war memorials of today will be seen tomorrow hinges, ultimately, on the nation's feelings about war and the institutions that support it. In a context of war without end, the future of the war memorial on the Mall will depend on how Americans come to terms with the prospect of living in a world that offers little hope for lasting peace.

The Closing of the Mall

Even if most observers understand that the Mall's memorial landscape can never remain fixed, neither in reality nor in the subjective imagination of its visitors, efforts continue to take control of the commemorative system and seal off at least some of it from further change. The planning authorities in charge of caring for the landscape have an understandable interest in maintaining it as is and preventing it from being overrun by new monuments. This is especially true of the National Capital Planning Commission (NCPC) and the Commission of Fine Arts (CFA) in Washington, two

agencies established to preserve the vision of the Senate Park Commission plan of 1901. Their very mission carries with it an inherent conservatism.

Toward that end the NCPC and Congress have officially declared that the great cross-axes of the Mall now constitute a "substantially completed work of civic art." The most sacred part of the sacred center has been set aside as a reserve area closed to new memorial construction. Legislation in 2003 expanded that reserve area in the western half of the Mall to encompass all of Constitution Gardens and West Potomac Park, including the Tidal Basin. A number of unbuilt projects have been grandfathered, though, including two highly controversial ones, the Martin Luther King Memorial in the Tidal Basin and the Vietnam Veterans Memorial visitors center in Constitution Gardens. The National Museum of African American History and Culture is also in the pipeline for an exemption. Otherwise, most new monument projects will be encouraged to settle back into L'Enfant's outlying parks and streets, the periphery that came into being when the monumental core first took shape.[15]

The whole idea of the Mall as a "work of civic art"—a complete and finite system subject to careful regulation by planning experts and art professionals—may be the most important legacy (and fiction) of the 1901 plan. Although the Park Commission designers envisaged future memorials farther out in West Potomac Park and elsewhere, the two great axes on the Mall were always meant to be an inviolable spatial composition. As much as these two axes seemed abstract and eternal, however, like the Washington Monument in the center, they enshrined a particular historical cluster of memories. The long east-west axis terminated by its huge monuments to Lincoln and Grant obviously emerged from the nineteenth-century preoccupation with the Civil War. How could it be otherwise, when the war's aftermath still actively shaped the politics and culture of that moment? But by the mid-twentieth century, the Civil War was receding in memory, and the demonstrations on the Mall were shifting its focus toward more contemporary concerns. The introduction of new war memorials within and alongside the east-west axis continued to shift attention away from the Civil War and toward the nation's military interventions abroad in World War II and the Cold War. It is hardly surprising that a memorial landscape built on nineteenth-century concerns would have to be dramatically updated in the twentieth century to keep it from becoming obsolete. And there is no more reason to think that the landscape system of today will meet the needs of the future.[16]

Any attempt to halt the evolution of the system is therefore bound to fail. At this point the planners in Washington need to dispense with their century-old mission of saving the 1901 plan and start thinking about how to open up the memorial landscape to greater change. The sooner we all abandon the idea that the National Mall

is a "completed work of civic art," the easier it will be to face its future. In this spirit, I offer one simple suggestion for consideration.

A Modest Proposal

The proposal begins with a moratorium on new monuments in Washington, lasting at least ten years. (Monuments already authorized and in progress would be allowed to move ahead.) During the moratorium period, the Mall would host commemorative work of a different kind. Artists, designers, students, civic associations would all be encouraged to create ephemeral monuments—temporary installations, interventions, and reinterpretations throughout the landscape. The capital has witnessed a few of these already; Krzysztof Wodiczko's *Hirshhorn Projection* of 1988 is one of the most celebrated (figure 127). But the possibilities could expand exponentially if wide latitude were granted as to location, format, subject matter, and design.

At the end of the moratorium period, an independent body would be assembled to undertake a thorough appraisal of the project, with as much outside study and as much widely representative public input as possible. This body would then make a broad-based recommendation, either to continue the moratorium or to propose a new set of principles for the memorial landscape of the future.

Shifting the ground from the permanent to the ephemeral would alter the system dramatically. The idea would be to treat the memorial landscape more as an open conversation than a quest for an immutable national essence. The advantages would be numerous. No project could last long enough to become ossified or obsolete. Designers would be much freer to embrace debate and difference, without worrying that controversy would defeat the project. Projects could give much greater weight to the antimonumental impulse that has been such a deep and enduring theme in American culture. Nicholas's tablet—on which people write what their hearts dictated— would be perfectly in place here. No group, however powerful, could lock up the most valuable memorial real estate. The sacred center would become less sacred. Coalitions and perspectives that are never represented in the memorial landscape would emerge experimentally. More voices would find room for expression, creating a far more open, democratic sphere of memory. Imagining how such a landscape would actually *look* is impossible, but whatever forms it took, it would be a living landscape, diverse and open to change.

Obviously such a program would require many detailed guidelines—who would

127 Krzysztof Wodiczko, *Hirshhorn Projection*, 1988. (© Krzysztof Wodiczko, Courtesy Galerie Lelong, New York.)

be allowed to participate, how they would be funded, what rules they would have to follow, and so on. It would not be difficult to overcome these bureaucratic hurdles if there were the will to do so. In the end, though, this is not a decision that scholars or planners or artists can make. Nor should it be. To take such a dramatic step would require a more widespread shift in thinking, in the sense of what is possible. Already, the sight of millions of people spilling over the National Mall in January 2009 to witness the inauguration of an African American president suggests how many Americans want to believe that a new possibility has arrived. It remains to be seen whether the country can begin to heal its divisions and face the future with an inner confidence that matches its outer might. But it is possible that one day we may come to Washington with new eyes, that we—citizens not only of the United States but of the world—may step outside the limited perspectives of our own group, tribe, or, indeed, nation. And if we do that, we may find new "chords of memory"—to use Lincoln's great phrase—that bind us to others and create the platforms of sympathy and understanding we so urgently need.

Notes

1 *Annals of Congress*, House of Representatives, 6th Cong., 2nd sess., December 5, 1800, 803.

2 John Quincy Adams, *Memoirs of John Quincy Adams, Comprising Portions of His Diary from 1795 to 1848*, ed. Charles Francis Adams (Philadelphia: J. B. Lippincott and Co., 1874), 8:433.

3 Thucydides, *History of the Peloponnesian War*, trans. Charles Forster Smith (Cambridge, Mass.: Harvard University Press, 1928), 2:43; remarks by Stephen Greenblatt, in Maya Yang Lin, *Grounds for Remembering: Monuments, Memorials, Texts* (Berkeley, Calif.: Doreen B. Townsend Center, 1995), 23, available online at http://repositories .cdlib.org/townsend/occpapers/3/; Kathleen Wren Christian, "Poetry and 'Spirited' Ancient Sculpture in Renaissance Rome: Pomponio Leto's Academy to the Sixteenth-Century Sculpture Garden," in *Aeolian Winds and the Spirit of Renaissance Architecture*, ed. Barbara Kenda (London: Routledge/Taylor and Francis, 2006), 103–24.

4 Walt Whitman, "Washington's Monument, February 1885," in *Leaves of Grass* (Philadelphia: David McKay, 1900), 502; see also John Hollander, *The Gazer's Spirit: Poems Speaking to Silent Works of Art* (Chicago: University of Chicago Press, 1995), 206–7.

5 Thomas Carlyle, "Hudson's Statue," in *Latter-Day Pamphlets* (1851; reprinted, Boston: Phillips, Sampson, 1855), 332; "The Washington Monument, and Mr. Story's Design," *Atlantic Monthly*, April 1879, 524.

6 Quantitative comparisons are difficult to make because the concept of the public monument was too elastic to be defined with precision. In the nineteenth-century United States, the major competitors to Washington, by any definition, were New York, Brooklyn, and Philadelphia, but Washington certainly had more statue monuments than any of them, judging from the Smithsonian's online Inventory of American Sculpture (combined with records of statues destroyed or relocated); see http://siris-artinventories .si.edu. Washington held its own with major European capitals such as London, Paris,

and Berlin, and in certain categories, such as equestrian monuments, outstripped these much larger cities.

7 Two early but forceful examples of the art critique are Clarence Cook, "Monuments of America," *Chatauquan*, June 1886, 525; and Susan Hayes Ward, "Fine Arts," *The Independent* (New York), August 13, 1891, 8. This critique reached a fever pitch after World War I, with arts organizations and magazines publishing searing attacks on the monument industry, e.g., the American Federation of the Arts' official statement circulated in *American Magazine of Art*, March 1919, 180–83 (quotation on 180). The letter to the *Post* was titled "Monument to Barnum Next," by Charles A. Carpenter, *Washington Post*, April 22, 1901, 10. For living memorials, see A. M. Shanken, "Planning Memory: Living Memorials in the United States during World War II," *Art Bulletin* 84, no. 1 (2002): 130–47. Shanken focuses on World War II, but the living memorial movement was equally serious after World War I.

8 *Annals of Congress*, House of Representatives, 6th Cong., 2nd sess., December 5, 1800, 803.

9 Jürgen Habermas, *The Structural Transformation of the Public Sphere: An Inquiry into a Category of Bourgeois Society* (Cambridge, Mass.: MIT Press, 1989); Benedict R. O'G. Anderson, *Imagined Communities: Reflections on the Origin and Spread of Nationalism* (London: Verso, 1983).

10 Frederick Turner, "Washington as a Pilgrimage Site," in *The National Mall: Rethinking Washington's Monumental Core*, ed. Nathan Glazer and Cynthia R. Field (Baltimore: Johns Hopkins University Press, 2008), 79–92; Jeffrey F. Meyer, *Myths in Stone: Religious Dimensions of Washington, D.C.* (Berkeley and Los Angeles: University of California Press, 2001), 7–11. Many observers have made this analogy but none, to my knowledge, have studied the actual visiting patterns of Washington to see how well the analogy applies in practice.

11 "The Complete Text of Lincoln's Famous Gettysburg Address in Bronze," *Monumental News*, February 1907, 119.

12 David Atkinson and Denis Cosgrove have written that "public monuments, especially those intended to encapsulate an imagined national spirit or identity, seek to materialize ideas of the sacred, the mystical, and the transcendental"; see "Urban Rhetoric and Embodied Identities: City, Nation, and Empire at the Vittorio Emanuele II Monument in Rome, 1870–1945," *Annals of the Association of American Geographers* 88 (March 1998): 28–49 (quotation on 30). The indispensable reference on "aura" is Walter Benjamin's "The Work of Art in the Age of Mechanical Reproduction," in *The Continental Aesthetics Reader*, ed. Clive Cazeaux (1936; reprinted, London: Routledge, 2000), 322–43.

13 Paul Goldberger, "Down at the Mall: The New World War II Memorial Doesn't Rise to the Occasion," *New Yorker*, May 31, 2004, 82. Goldberger is echoed by Witold Rybczynski, who writes that "the broad sweep of the Mall recalls the expansiveness of the western plains"; "'A Simple Space of Turf': Frederick Law Olmsted Jr.'s Idea for the Mall," in Glazer and Field, *The National Mall*, 63.

14 Carlyle, "Hudson's Statue," 324.

15 The phrase comes from James Reston Jr., "The Monument Glut," *New York Times*, September 10, 1995, SM48. For more on monuments and the issue of closure, see Kirk Savage, "The Past in the Present: The Life of Memorials," *Harvard Design Magazine*, Fall 1999, 14–19.

16 A great deal has been written on the distinction between memory and history, much of it at cross purposes. Collective memory has become an important subject of historical investigation, but the people doing the remembering obviously do not follow the same rules historians do. Many scholars romanticize collective memory without facing up to the mischief it can do. At the same time, collective memory can preserve traditions and truths that sometimes elude the grasp of professional historians. For a recent overview of the theoretical literature on this topic, see Kirk Savage, "History, Memory, and Monuments: An Overview of the Scholarly Literature on Commemoration," at www.cr.nps.gov/history/resedu/savage.htm.

17 Bruce Catton, "A Pilgrimage to Washington," *Holiday*, June 1959, 54.

18 Paul Schwartzman and Eli Saslow, "Across the Country, 'It's Like a New Aura,'" *Washington Post*, November 6, 2008, A1; Matt Mendelsohn, "Memorial Day," *New York Times*, November 6, 2008, A33; "After Obama Win, Washington Reflects," National Public Radio, November 5, 2008.

19 John William Reps, *Monumental Washington: The Planning and Development of the Capital Center* (Princeton, N.J.: Princeton University Press, 1967), 137. Perhaps the earliest and most astute architectural critic to praise the twentieth-century plan for the Mall was Montgomery Schuyler, "The Nation's New Capital," *New York Times*, January 19, 1902, SM4. Reps's comments are echoed in the second edition of *Worthy of the Nation: Washington, DC, from L'Enfant to the National Capital Planning Commission*, by Frederick Albert Gutheim and Antoinette J. Lee (Baltimore: Johns Hopkins University Press, 2006), 3 ("Washington, DC, is the nation's finest urban achievement"); and in Cynthia R. Field, "When Dignity and Beauty Were the Order of the Day: The Contribution of Daniel H. Burnham," in Glazer and Field, *The National Mall*, 53. Jon A. Peterson, the preeminent urban planning historian of Washington, has published extensively on the achievement of the early twentieth-century planning of the Mall as "a benchmark of modern urbanism," most recently in his essay "The Senate Park Commission Plan for Washington, D.C.: A New Vision for the Capital and the Nation," in *Designing the Nation's Capital: The 1901 Plan for Washington, D.C.*, ed. Sue Kohler and Pamela Scott (Washington, D.C.: U.S. Commission of Fine Arts, 2006), 1–47.

20 See, for example, Lewis Mumford, *Sticks and Stones: A Study of American Architecture and Civilization* (New York: Boni and Liveright, 1924), 123, 141; and Mumford's subsequent analyses in *The Culture of Cities* (New York: Harcourt, Brace, and Company, 1938) and *The City in History: Its Origins, Its Transformations, and Its Prospects* (New York: Harcourt, Brace, and Company, 1961); Edmund N. Bacon, *Design of Cities* (New York: Viking, 1967), 208; Mel Scott, *American City Planning since 1890: A History Commemorating the Fiftieth Anniversary of the American Institute of Planners* (Berkeley and

Los Angeles: University of California Press, 1969), 51–54; Daniel Urban Kiley, "A Critical Look at the McMillan Plan," in *The Mall in Washington, 1791–1991*, ed. Richard W. Longstreth (Washington, D.C.: National Gallery of Art, 2002), 297–303.

21 Kiley, "A Critical Look at the McMillan Plan," 299; Reps, *Monumental Washington*, 66; Wilcomb E. Washburn, "Planning Washington," in *The Federal City: Plans and Realities*, ed. Frederick Albert Gutheim (Washington, D.C.: Smithsonian Institution Press, 1976), 86. The major exception to this scholarly pattern of neglect is James M. Goode's indispensable *Outdoor Sculpture of Washington, D.C.: A Comprehensive Historical Guide* (Washington, D.C.: Smithsonian Institution Press, 1974).

22 See, for example, Spiro Kostof, *The City Shaped: Urban Patterns and Meanings through History* (Boston: Little, Brown, 1991), 217, 234. This old chestnut, promulgated by Montgomery Schuyler (see note 19) among many others, was disputed by Daniel D. Reiff in *Washington Architecture, 1791–1861: Problems in Development* (Washington, D.C.: U.S. Commission of Fine Arts, 1971), 119–20; and by Frederick Albert Gutheim in *Worthy of the Nation: The History of Planning for the National Capital* (Washington, D.C.: Smithsonian Institution Press, 1977), 77.

23 *Maryland Journal*, September 26, 1791, reprinted in numerous newspapers, e.g., *Litchfield Monitor*, November 9, 1791, 1.

24 Pamela Scott, "'This Vast Empire': The Iconography of the Mall, 1791–1848," in *The Mall in Washington, 1791–1991*, ed. Richard W. Longstreth (Washington, D.C.: National Gallery of Art, 2002), 37–58. The phrase "empire of liberty" appears early—for example, in a July 4, 1792, speech given in Georgetown extolling the plan of the new capital, reprinted from the *George-Town Weekly Ledger* in the *Salem Gazette*, August 7, 1792, 1.

25 De Benneville Randolph Keim, *Washington and Its Environs: A Descriptive and Historical Hand-Book to the Capital of the United States of America* (Washington, D.C.: N.p., 1879), 244; *Washington Post*, August 4, 1891, 9.

26 The key player at the American Institute of Architects was Glenn Brown, who made it his mission to overthrow the dominance of the Army Corps of Engineers, which had responsibility for public buildings and grounds in the capital (including the location of public monuments, the landscaping of parks, and so on). The story of Brown's largely successful campaign has been studied in Tony P. Wrenn, "The American Institute of Architects Convention of 1900: Its Influence on the Senate Park Commission Plan," in *Designing the Nation's Capital*, 49–73; Alan Lessoff, *The Nation and Its City: Politics, "Corruption," and Progress in Washington, D.C., 1861–1902* (Baltimore: Johns Hopkins University Press, 1994), 261–63; and William Brian Bushong, "Glenn Brown, the American Institute of Architects, and the Development of the Civic Core of Washington, D.C." (PhD diss., George Washington University, 1988).

27 Ralph Waldo Emerson, *Nature: A Facsimile of the First Edition* (1836; reprinted, Boston: Beacon Press, 1985), 13.

28 Elbert Peets, *On the Art of Designing Cities: Selected Essays of Elbert Peets*, ed. Paul D. Spreiregen (Cambridge, Mass.: MIT Press, 1968), 78, 95. Peets was a maverick: although he greeted the clearing of the Mall with enthusiasm and shed no tears over "the old trees felled and the pretty lawns plowed" (p. 88), he resisted large-scale urban

renewal schemes and advocated the preservation of old neighborhoods and historic structures. He reserved his most withering criticism for the picturesque gardening tradition of the nineteenth century.

29 Bruno Zevi, *Architecture as Space: How to Look at Architecture*, trans. Milton Gendel (New York: Horizon Press, 1957), 22, originally published in Italian as *Saper vedere l'architettura* (Turin: Einaudi, 1948).

30 U.S. Congress, Senate Committee on the District of Columbia, *The Improvement of the Park System of the District of Columbia*, ed. Charles Moore, 57th Cong., 1st sess., 1902, S. Rep. 166, 35. The "Mall system" was a subsystem within the larger "park system" of the capital.

31 Lewis Mumford, "The Death of the Monument," in *Circle: International Survey of Constructive Art*, ed. Leslie Martin, Ben Nicholson, and Naum Gabo (1937; reprinted, New York: Praeger, 1971), 263–70.

32 Peets, *On the Art of Designing Cities*, 92

33 Kaseman Beckman Amsterdam Studio, *Pentagon Memorial Description*, Washington, D.C.: Pentagon Memorial Project, ca. 2003, at http://memorial.pentagon.mil/description.htm (accessed August 19, 2007).

1. A MONUMENT TO A DECEASED PROJECT

1 L'Enfant quoted in Elizabeth Sarah Kite, *L'Enfant and Washington* (Baltimore: Johns Hopkins University Press, 1929), 150.

2 T. Loften, quoted in Joseph Passonneau, *Washington through Two Centuries: A History in Maps and Images* (New York: Monacelli Press, 2004), 35; Frederick Albert Gutheim, *Worthy of the Nation: The History of Planning for the National Capital* (Washington, D.C.: Smithsonian Institution Press, 1977), 19–21.

3 Kenneth R. Bowling, *The Creation of Washington, D.C.: The Idea and Location of the American Capital* (Fairfax, Va.: George Mason University Press, 1991), 182–207; Joel Achenbach, *The Grand Idea: George Washington's Potomac and the Race to the West* (New York: Simon and Schuster, 2004).

4 On "empire of liberty," see introduction, note 24. Concerns about the capital's location in the slaveholding South appeared early; see Bowling, *The Creation of Washington, D.C.*, 7, 103, 215.

5 Charles Dickens, *American Notes for General Circulation* (Paris: Baudry's European Library, 1842), 146.

6 L'Enfant quoted in Pamela Scott, *Capital Engineers: The U.S. Army Corps of Engineers in the Development of Washington, D.C., 1790–2004* (Alexandria, Va.: U.S. Army Corps of Engineers, Office of History, 2005), 4. Lewis Mumford gives extensive attention to the military foundations of European urban planning in *The City in History: Its Origins, Its Transformations, and Its Prospects* (New York: Harcourt, Brace, and Company 1961); see also Spiro Kostof, *The City Shaped: Urban Patterns and Meanings through History* (Boston: Little, Brown, 1991).

The literature on L'Enfant and his plan is vast. Highlights include Elbert Peets's various essays written in the 1920s and 1930s that are collected in Elbert Peets, *On the Art of Designing Cities: Selected Essays of Elbert Peets*, ed. Paul D. Spreiregen (Cambridge, Mass.: MIT Press, 1968); John William Reps, *Monumental Washington: The Planning and Development of the Capital Center* (Princeton, N.J.: Princeton University Press, 1967); Gutheim, *Worthy of the Nation*; Daniel D. Reiff, *Washington Architecture, 1791–1861: Problems in Development* (Washington, D.C.: U.S. Commission of Fine Arts, 1971); Bowling, *The Creation of Washington, D.C.*; Pamela Scott, "'This Vast Empire': The Iconography of the Mall, 1791–1848," in *The Mall in Washington, 1791–1991*, ed. Richard W. Longstreth (Washington, D.C.: National Gallery of Art, 2002), 37–58; Richard W. Stephenson, *A Plan Whol[l]y New: Pierre Charles L'Enfant's Plan of the City of Washington* (Washington, D.C.: Library of Congress, 1993); C. M. Harris, "Washington's Gamble, L'Enfant's Dream: Politics, Design, and the Founding of the National Capital," *William and Mary Quarterly*, 3rd ser., 56, no. 3 (1999): 527–64; Scott W. Berg, *Grand Avenues: The Story of the French Visionary Who Designed Washington, D.C.* (New York: Pantheon, 2007).

7 For a good summary, see Scott, "'This Vast Empire,'" 42–45. A perceptive analysis can also be found in Iris Miller, *Washington in Maps: 1606–2000* (New York: Rizzoli International Publications, 2002), 15–21.

8 Examples include Harriet Prescott Spofford, "Streets of Washington," *Harper's New Monthly*, August 1868, 412; "Washington Sketches," *Harper's Bazaar*, July 6, 1878, 436; H. J. Broune, "A Tale of Two Capitals," *North American Review*, June 1894, 759–60; Julian Ralph, "Our National Capital," *Harper's New Monthly*, April 1895, 660; "Washington to Honor L'Enfant," *Philadelphia Inquirer*, December 27, 1908, 8; "Planned Secure City," *Washington Post*, August 19, 1917, AH11; "Capitol's Defense: Washington Was Planned to Make Government Secure," *Los Angeles Times*, November 9, 1920, I15.

9 L'Enfant quoted in Kite, *L'Enfant and Washington*, 62. A handwritten draft of a letter by L'Enfant to Jefferson does allude to artillery defense, but it appears that the passage deals with protection from external threats rather than internal ones (discussed in Kite, *L'Enfant and Washington*, 37). On scholarly interpretations of L'Enfant's notes, see Scott, "'This Vast Empire.'" Sarah Luria compares L'Enfant's plan to his illustrations for a "chain of sentinels" in a federal military manual, but she sees this as a visual metaphor for "imagined community" rather than a scheme of occupation; Sarah Luria, *Capital Speculations: Writing and Building Washington, D.C.* (Hanover, N.H.: University Press of New England, 2006), 29–30. The only recent scholar to give any credence to the military aspect of L'Enfant's plan is Margaret E. Farrar, *Building the Body Politic: Power and Urban Space in Washington, D.C.* (Urbana: University of Illinois Press, 2008), 41.

10 Mark Traugott, "Barricades as Repertoire: Continuities and Discontinuities in the History of French Contention," *Social Science History* 17, no. 2 (1993): 309–23; Spiro Kostof, *The City Shaped: Urban Patterns and Meanings through History* (Boston: Little, Brown, 1991), 230–32; Zeynep Çelik, Diane G. Favro, and Richard Ingersoll, eds., *Streets: Critical Perspectives on Public Space* (Berkeley and Los Angeles: University of California Press, 1994), 181.

11 Thomas Jefferson, *Notes on the State of Virginia* (1784; reprint, New York: Palgrave, 2002), query 19, p. 197.

12 L'Enfant quoted in Kite, *L'Enfant and Washington*, 47, 53, 66.

13 L'Enfant quoted in ibid., 65.

14 L'Enfant quoted in ibid., 65.

15 Richard L. Cleary, *The Place Royale and Urban Design in the Ancien Régime* (New York: Cambridge University Press, 1998), 12, 201.

16 Harris, "Washington's Gamble, L'Enfant's Dream," 536–37.

17 Reps, *Monumental Washington*, 17; Scott, "'This Vast Empire,'" 41.

18 *Maryland Journal*, September 26, 1791, reprinted in *Dunlap's American Daily Advertiser*, October 7, 1791, 2. L'Enfant's point A was subject to tidal flooding and on some early maps seems to fall within Tiber Creek; see John W. Reps, *Washington on View: The Nation's Capital since 1790* (Chapel Hill: University of North Carolina Press, 1991), 61, 67. L'Enfant's 1791 plan shows the creek tamed within the artificial watercourse of the Washington canal, safely north of point A.

19 For more on the equestrian project, see Kirk Savage, "The Self-Made Monument: George Washington and the Fight to Erect a National Memorial," in *Critical Issues in Public Art: Content, Context, and Controversy*, ed. Harriet F. Senie and Sally Webster (Washington, D.C.: Smithsonian Institution Press, 1998), 8–10.

20 On the oak forest, see A. R. Spofford, "Washington City," in *Johnson's New Universal Cyclopedia* (New York: A. J. Johnson and Son, 1878), 4:1257; De Benneville Randolph Keim, *Washington and Its Environs: A Descriptive and Historical Hand-Book to the Capital of the United States of America* (Washington, D.C.: N.p., 1879), 29; and Frederick Law Olmsted, "Index to Trees about the Capitol," in *Report of the Secretary of the Interior*, 47th Cong., 2nd sess., 1883, H. Exec. Doc. 1, pt. 11, 917. On the "grand manner," see Kostof, *The City Shaped*, 209–26.

21 Thomas Jefferson, *Papers*, ed. Julian P Boyd, L. H. Butterfield, Charles T. Cullen, and John Catanzariti (Princeton, N.J.: Princeton University Press, 1950–present), 23:397.

22 "The Waiting Girl in New York to Her Friend in Philadelphia," *Literary World*, February 6, 1847, 13; "Washington," *Ladies' Companion*, June 1842, 75; Wilhelmus Bogart Bryan, *A History of the National Capital from Its Foundation through the Period of the Adoption of the Organic Act* (New York: Macmillan Company, 1914), 1:262, 561, 2:16–17; Olmsted, "Index to Trees about the Capitol," 917; "Pennsylvania Avenue," Historic American Buildings Survey Report no. DC-706, 1993, 4. (The Historic American Buildings Survey is an extensive collection of the Library of Congress's Built in America database, which documents achievements in architecture, engineering, and design in the United States and its territories. The database is accessible online at http://lcweb2.loc.gov/ammem/collections/habs_haer and can be searched by document title or number. Subsequent citations of items in this database will be cited by report name, number, and date.)

23 The phrase *waste ground* appears in Joseph B. Varnum Jr., "The Seat of Government

of the United States," *Merchants' Magazine and Commercial Review*, February 1848, 149; George Alfred Townsend, "The New Washington," *Harper's New Monthly*, February 1875, 313; Constance McLaughlin Green, *Washington: A History of the Capital, 1800–1950* (Princeton, N.J.: Princeton University Press, 1962), 1:316; Scott, "'This Vast Empire,'" 46.

24 David R. Doyle and Alan Dragoo, "Where Freedom Stands," National Geodetic Survey, ca. 1993, www.ngs.noaa.gov/PUBS_LIB/freedom_stands.html (accessed August 29, 2007).

25 Peets, *On the Art of Designing Cities*, 88.

26 Silvio A. Bedini, *The Jefferson Stone: Demarcation of the First Meridian of the United States* (Frederick, Md.: Professional Surveyors Pub. Co., 1999), 1.

27 Andreas Huyssen, *Present Pasts: Urban Palimpsests and the Politics of Memory* (Stanford, Calif.: Stanford University Press, 2003), 3; Michael G. Kammen, *Mystic Chords of Memory: The Transformation of Tradition in American Culture* (New York: Knopf, 1991), 3.

28 Harris, "Washington's Gamble, L'Enfant's Dream," 531.

29 Ibid., 530, 548; Jefferson, *Papers*, 24:229–30, 385–86; Savage, "The Self-Made Monument," 8.

30 Harris, "Washington's Gamble, L'Enfant's Dream," 553.

31 Richard Wrigley and Matthew Craske, eds., *Pantheons: Transformations of a Monumental Idea* (Aldershot, U.K.: Ashgate, 2004), esp. chaps. 3, 4, and 6.

32 Harris, "Washington's Gamble, L'Enfant's Dream," 553.

33 Some of these participants include Robert Goodloe Harper, Harrison Gray Otis, and Henry Lee on the Federalist side, and John Nicholas, John Randolph, and Nathaniel Macon on the republican side. For a good account of the 1800 election, see Joanne B. Freeman, *Affairs of Honor: National Politics in the New Republic* (New Haven, Conn.: Yale University Press, 2001).

34 *Annals of Congress*, 6th Cong., 1st sess., December 23, 1799, 284–85; John C. Van Horne and Lee W. Formwalt, eds., *The Correspondence and Miscellaneous Papers of Benjamin Henry Latrobe* (New Haven, Conn.: Yale University Press, 1984), 1:162; Jeffrey A. Cohen and Charles E. Brownell, eds., *The Architectural Drawings of Benjamin Henry Latrobe* (New Haven, Conn.: Yale University Press, 1994), 268–85; C. Ford Peatross, ed., *Capital Drawings: Architectural Designs for Washington, D.C., from the Library of Congress* (Baltimore: Johns Hopkins University Press, 2005), 13; Rubil Morales-Vásquez, "Redeeming a Sacred Pledge: The Plans to Bury George Washington in the Nation's Capital," in *Establishing Congress: The Removal to Washington, D.C., and the Election of 1800*, ed. Kenneth R. Bowling and Donald R. Kennon (Athens: Ohio University Press, 2005), 154–55; Savage, "The Self-Made Monument," 9–10.

35 The plans by Dance are published in Jill Lever, *Catalogue of the Drawings of George Dance the Younger (1741–1825) and of George Dance the Elder (1695–1768): From the Collection of Sir John Soane's Museum* (London: Azimuth Editions, 2003), 103–5. The full text of the mausoleum bill does not survive, and the debates as recorded in the *Annals of Congress* do not allude to a specific site for the mausoleum project.

36 *Annals of Congress*, 6th Cong., 2nd sess., December 5, 1800, 802.

37 Barry Bergdoll, *European Architecture, 1750–1890* (New York: Oxford University Press, 2000), 112.

38 *Annals of Congress*, 6th Cong., 2nd sess., December 5, 1800, 803.

39 Jürgen Habermas, *The Structural Transformation of the Public Sphere: An Inquiry into a Category of Bourgeois Society* (Cambridge, Mass.: MIT Press, 1989).

40 Nicholas quotation in *Annals of Congress*, 6th Cong., 2nd sess., December 5, 1800, 800; Nathaniel Hawthorne, *The English Notebooks*, ed. Thomas Woodson and Bill Ellis (1870; reprint, Columbus: Ohio State University Press, 1997), 413.

41 Victor Hugo, *Notre-Dame de Paris* (1831; reprint, Paris: Charpentier, 1850), 255–56, 267 (translation my own). On the context of Hugo's thinking, see Françoise Choay, *The Invention of the Historic Monument*, trans. Lauren M. O'Connell (Cambridge: Cambridge University Press, 2001), 9. I am grateful to the reader for the University of California Press who suggested that I elaborate this point.

42 Savage, "The Self-Made Monument," 12; *Journal of the Senate of the United States of America*, 6th Cong., 2nd sess., March 3, 1801, 139; Jefferson, *Papers*, 32:385.

43 "National Ingratitude," *Poulson's American Daily Advertiser*, May 31, 1811, 2; Thomas Jefferson to John Dickinson, March 6, 1801, Thomas Jefferson Papers, 1606–1827, American Memory, Library of Congress, http://memory.loc.gov/cgi-bin/query/r?am mem/mtj:@field(DOCID+@lit(tj090102)); *Washington City Weekly Gazette*, November 25, 1815, 4; "Architecture," *Poulson's American Daily Advertiser*, June 15, 1811, 2.

44 Morales-Vásquez, "Redeeming a Sacred Pledge," 167–72. See also Savage, "The Self-Made Monument," 12–13.

45 "Heroes and Monuments," *Carolina Centinel*, April 28, 1821, 2, reprinted from the *Washington City Gazette*; R. D. W. Connor, "Canova's Statue of Washington," *Publications of the North Carolina Historical Commission*, bulletin no. 8 (1910): 14–27. For an example of the press coverage, see "Canova's Statue," *Boston Commercial Gazette*, May 6, 1819, 1, reprinted from the *Baltimore Chronicle*.

46 Gary B. Nash, "Slaves and Slaveowners in Colonial Philadelphia," *William and Mary Quarterly*, 3rd ser., 30, no. 2 (April 1973): 255.

47 Frederic Bancroft, *Slave Trading in the Old South* (New York: Frederick Ungar Publishing, 1959), 54–56; Green, *Washington*, 53–55, 95–98; John Davis, "Eastman Johnson's 'Negro Life at the South' and Urban Slavery in Washington, D.C.," *Art Bulletin* 80, no. 1 (1998): 67–92; Bernard Reilly, *American Political Prints, 1766–1876: A Catalog of the Collections in the Library of Congress* (Boston: G. K. Hall, 1991), 93.

48 Bryan, *A History of the National Capital*, 2:17–24.

49 Savage, "The Self-Made Monument," 13.

50 The vote in the House to seek permission to move Washington's remains was 109 in favor, 76 opposed; broken down along sectional lines, Northern representatives voted 77–29 for the measure, while Southern representatives voted 47–32 against it. In the one recorded vote in the Senate, Northerners voted 22–2 in favor, while Southerners split 7–7. For the commission to Horatio Greenough for the statue of Washington,

Northern representatives voted 76–21 in favor, Southern representatives 38–29 in favor; Northern senators voted 23–2 in favor, Southern senators 8–7 against.

51 "Washington," *Cincinnati Weekly Herald and Philanthropist*, January 31, 1844, 3; S. G. W. Benjamin, "Sculpture in America," *Harper's New Monthly*, April 1879, 662; "In Bronze and Marble," *Washington Post*, April 25, 1881, 3; Horatio Greenough, *Letters of Horatio Greenough, American Sculptor*, ed. Nathalia Wright (Madison: University of Wisconsin Press, 1972), 174, 177. The most comprehensive analysis of Greenough's Washington can be found in Vivien Green Fryd, *Art and Empire: The Politics of Ethnicity in the United States Capitol, 1815–1860* (New Haven, Conn.: Yale University Press, 1992), 62–87, but there is still no definitive study of the statue's reception in the nineteenth century.

52 Greenough, *Letters of Horatio Greenough*, 309; Nathalia Wright, *Horatio Greenough: The First American Sculptor* (Philadelphia: University of Pennsylvania Press, 1963), 133.

53 Fryd discusses manifest destiny in the Capitol's sculptural program, but not specifically in relation to Greenough's Washington; see *Art and Empire*, 98–100. Classic studies of manifest destiny include Albert Katz Weinberg, *Manifest Destiny: A Study of Nationalist Expansionism in American History* (Baltimore: Johns Hopkins University Press, 1935); Frederick Merk, *Manifest Destiny and Mission in American History: A Reinterpretation* (New York: Knopf, 1963); and Reginald Horsman, *Race and Manifest Destiny: The Origins of American Racial Anglo-Saxonism* (Cambridge, Mass.: Harvard University Press, 1981). For a more recent overview, see David Stephen Heidler and Jeanne T. Heidler, *Manifest Destiny* (Westport, Conn.: Greenwood Press, 2003).

54 Janet A. Headley, "The Monument without a Public: The Case of the Tripoli Monument," *Winterthur Portfolio* 29, no. 4 (1994): 247–64.

55 Fryd, *Art and Empire*, 200–208.

56 Quotation from *Gales and Seaton's Register of Debates in Congress*, February 13, 1832, 1797; Horatio Greenough, "Aesthetics at Washington," in *A Memorial of Horatio Greenough, Consisting of a Memoir, Selections from His Writings, and Tributes to His Genius*, ed. Henry C. Tuckerman (1853; reprint, New York: B. Blom, 1968), 73; Charles E. Fairman, *Art and Artists of the Capitol of the United States of America* (Washington, D.C.: Government Printing Office, 1927), 222, 224; Charles Sumner to Horatio Greenough, February 28, 1841, quoted in Sylvia E. Crane, *White Silence: Greenough, Powers, and Crawford, American Sculptors in Nineteenth-Century Italy* (Coral Gables, Fla.: University of Miami Press, 1972), 77.

57 William M. Morrison, *Morrison's Strangers' Guide to the City of Washington, and Its Vicinity* (Washington, D.C.: William M. Morrison, 1844), 19–22; Nathaniel Hawthorne, "Chiefly about War Matters by a Peaceable Man," in *The Complete Works of Nathaniel Hawthorne* (Boston: Riverside Press, 1883), 12:306, originally published in different form in the *Atlantic Monthly* in 1862; "Art at the Capitol," *New York Times*, February 17, 1875, 6.

58 "Dayton's Speech on the Statues," *The John-Donkey*, May 13, 1848, 310; B.B., "The Art-Decorations of the Capitol at Washington," *The Independent* (New York), July 22, 1858, 1; B.B., "Persico's Columbus," *The Independent* (New York), September 29, 1859, 1;

Benjamin, "Sculpture in America," 662; "In Bronze and Marble," 3; "High Art in the Senate," *Washington Post*, February 2, 1886, 1. B.B.'s intelligent arguments against allegorical and mythological subjects are exemplary of many others less well put.

59 "Wilful Blindness," *National Era*, February 1, 1849, 18.

60 Frederick L. Harvey, *History of the Washington National Monument and Washington National Monument Society* (Washington, D.C.: Government Printing Office, 1903), 26–28. On the de Wailly design, see Bergdoll, *European Architecture, 1750–1890*, 112–14. For a thorough account of the possible European sources of Mills's design, see Pamela Scott, "Robert Mills's Washington National Monument" (MA thesis, University of Delaware, 1985), 27–53.

61 Joseph B. Varnum Jr., "The National Washington Monument and Other Kindred Subjects," *Literary World*, November 30, 1850, 425.

62 Pamela Scott, "Robert Mills and American Monuments," in *Robert Mills, Architect*, ed. John Morrill Bryan (Washington, D.C.: American Institute of Architects Press, 1989), 166–71. Scott argues that there is no evidence that structural concerns motivated the location of the monument off axis, and that historical and aesthetic reasons were more probable; her interpretation, however, also lacks direct support in the archival record. It is quite possible that all of these factors were in play. The shift to higher ground not only alleviated structural difficulties but also made the monument more visible, required much less regrading, and avoided the removal of Jefferson's historic meridian stone.

63 Harvey, *History of the Washington National Monument*, 45–48, 151–52.

64 Lloyd J. Graybar, "Winthrop, Robert Charles," in *American National Biography* (New York: Oxford University Press, 1999), 23:670–72.

65 Winthrop quoted in Harvey, *History of the Washington National Monument*, 129.

66 Winthrop quoted in ibid., 130.

2. COVERING GROUND

1 Charles Dickens, *American Notes for General Circulation* (Paris: Baudry's European Library, 1842), 146.

2 George Alfred Townsend, "The New Washington," *Harper's New Monthly*, February 1875, 319.

3 Ibid., 320.

4 A. J. Downing, "Explanatory Notes to Accompany the Plan for Improving the Public Grounds at Washington" (February 1851), in Wilcomb E. Washburn, "Vision of Life for the Mall," *AIA Journal* 47, no. 3 (1967): 54–55; Daniel D. Reiff, *Washington Architecture, 1791–1861: Problems in Development* (Washington, D.C.: U.S. Commission of Fine Arts, 1971), 113–20; Therese O'Malley, "'A Public Museum of Trees': Mid-Nineteenth-Century Plans for the Mall," in *The Mall in Washington, 1791–1991*,

ed. Richard W. Longstreth (Washington, D.C.: National Gallery of Art, 2002), 61–76. For more on Downing, see David Schuyler, *Apostle of Taste: Andrew Jackson Downing, 1815–1852* (Baltimore: Johns Hopkins University Press, 1996).

5 Andrew Jackson Downing, *Rural Essays*, ed. George William Curtis (1853; reprint, New York: Da Capo, 1974), 163, 81, 505 (among many others).

6 James J. Gibson, *The Ecological Approach to Visual Perception* (1979; reprint, Hillsdale, N.J.: Lawrence Erlbaum Associates, 1986), 3; James Elkins, Review of David Summers, *Real Spaces: World Art History and the Rise of Western Modernism*, *Art Bulletin* 86, no. 2 (2004): 375.

7 *Oxford English Dictionary*, 2nd ed., s.v. *space*.

8 S. C. Clarke, "Stanton Place," *Washington Post*, February 28, 1886, 5.

9 "Notes of an Invalid," *Christian Register and Boston Observer*, September 23, 1837, 150. Other early examples of the term *public space* in the nineteenth century include: "Notes of European Travel," *Southern Literary Messenger*, June 1855, 342; "Recent English Cases," *Monthly Law*, July 1863, 555; George E. Waring Jr., "Public Squares and Public Spaces," *Scribner's Monthly*, July 1877, 403; T. Buckler Ghequiere, "Richmond County Court-House, Virginia," *American Architect and Building News*, June 23, 1877, 199; "Michigan Supreme Court Abstract," *Albany Law Journal* 25, no. 13 (1882): 257; and "Buying Houses and Land," *Washington Post*, November 21, 1886, 2.

10 *Oxford English Dictionary*, 2nd ed., s.v. *grounds*.

11 Joseph B. Varnum Jr., "The Seat of Government of the United States," *Merchants' Magazine and Commercial Review*, February 1848, 149.

12 On the oak forest, see chapter 1, note 20. On erosion, see Frederick Law Olmsted, "Index to Trees about the Capitol," in *Report of the Secretary of the Interior*, 47th Cong., 2nd sess., 1883, H. Exec. Doc. 1, pt. 11, 916. On foraging livestock, see Constance McLaughlin Green, *Washington: A History of the Capital, 1800–1950* (Princeton, N.J.: Princeton University Press, 1962), 1:316; "Lafayette Square," Historic American Buildings Survey, Report no. DC-676, 1993, 5; and *Report of the Secretary of the Interior*, 39th Cong., 1st sess., 1866, H. Exec. Doc. 1, pt. 2, 805.

13 Downing, *Rural Essays*, 303–4.

14 For a complete account, see Vivien Green Fryd, *Art and Empire: The Politics of Ethnicity in the United States Capitol, 1815–1860* (New Haven, Conn.: Yale University Press, 1992), 109–24.

15 Downing, *Rural Essays*, 164.

16 Ibid.

17 George Santayana, *The Sense of Beauty: Being the Outlines of Aesthetic Theory* (1896; reprint, New York: Modern Library, 1955), 92–93. For the nineteenth-century German theoretical underpinnings of his position, see Robert Vischer, *Empathy, Form, and Space: Problems in German Aesthetics, 1873–1893*, trans. Harry Francis Mallgrave and Eleftherios Ikonomou (Santa Monica, Calif.: Getty Center for the History of Art and the Humanities, 1994).

18 Downing, *Rural Essays*, 107. For an incisive examination of the theme of violence in

garden design, see Martin Jay, "No State of Grace: Violence in the Garden," in *Sites Unseen: Landscape and Vision*, ed. Diane Harris and D. Fairchild Ruggles (Pittsburgh: University of Pittsburgh Press, 2007), 45–60.

19 Downing, *Rural Essays*, 81.

20 Daniel Reiff claims that Downing's layout "carefully kept the central portion [of the Mall] quite open," but drawing a centerline through Downing's map shows that the vista would have been thoroughly blocked; see Reiff, *Washington Architecture*, 120.

21 Marc Treib, "Moving the Eye," in *Sites Unseen: Landscape and Vision*, ed. Diane Harris and D. Fairchild Ruggles (Pittsburgh: University of Pittsburgh Press, 2007), 75.

22 From Downing's "Explanatory Notes" in Washburn, "Vision of Life for the Mall," 54–55.

23 Raymond Williams, *The Country and the City* (New York: Oxford University Press, 1973), 124.

24 Dell Upton, *Another City: Urban Life and Urban Spaces in the New American Republic* (New Haven, Conn.: Yale University Press, 2008), 329.

25 Downing, quoted in O'Malley, "'A Public Museum of Trees,'" 74.

26 Reiff, *Washington Architecture*, 117–18; Pamela Scott, *Capital Engineers: The U.S. Army Corps of Engineers in the Development of Washington, D.C., 1790–2004* (Alexandria, Va.: U.S. Army Corps of Engineers, Office of History, 2005), 72–73.

27 Olmsted to W. Hammond Hall, March 28, 1874, in *Parks, Politics, and Patronage, 1874–1882*, vol. 7 of *The Papers of Frederick Law Olmsted*, ed. Charles E. Beveridge, Carolyn F. Hoffman, and Kenneth Hawkins (Baltimore: Johns Hopkins University Press, 2007), 53.

28 "Wants Botanic Garden Open," *Washington Post*, September 27, 1909, 14; "William Saunders," *New York Times*, September 14, 1900, 6. For more on Saunders and Smith, see Pamela Scott, "'The City of Living Green': An Introduction to Washington's Street Trees," *Washington History* 18, nos. 1–2 (2006): 26–31.

29 Francis R. Kowsky, *Country, Park, and City: The Architecture and Life of Calvert Vaux* (New York: Oxford University Press, 1998), 47.

30 Frederick L. Harvey, *History of the Washington National Monument and Washington National Monument Society* (Washington, D.C.: Government Printing Office, 1903), 24, 54–56.

31 Wilhelmus Bogart Bryan, *A History of the National Capital from Its Foundation through the Period of the Adoption of the Organic Act* (New York: Macmillan Company, 1914), 2:404, 425–27.

32 Harvey, *History of the Washington National Monument*, 60. For more on this episode, see Kirk Savage, "The Self-Made Monument: George Washington and the Fight to Erect a National Memorial," in *Critical Issues in Public Art: Content, Context, and Controversy*, ed. Harriet F. Senie and Sally Webster (Washington, D.C.: Smithsonian Institution Press, 1998), 17–18.

33 Joseph B. Varnum Jr., "The National Washington Monument and Other Kindred Subjects," *Literary World*, November 30, 1850, 426.

34 Harvey, *History of the Washington National Monument*, 64.

35 *Frank Leslie's Illustrated Newspaper*, April 25, 1857, 321; "The Washington National Monument," *Philadelphia Inquirer*, May 22, 1872, 4.

36 Joseph B. Varnum Jr., "The Seat of Government of the United States," *Merchants' Magazine and Commercial Review*, April 1848, 369, which quotes "Headley's Address to the Art-Union."

37 Varnum, "The National Washington Monument and Other Kindred Subjects," 425. See also Varnum, "Monumental Structures," *New York Observer and Chronicle*, June 15, 1854, 189. For Varnum's father and his vote, see *American National Biography*, 22:278–79, and the *Annals of Congress*, House of Representatives, 6th Cong., 2nd sess., December 23, 1800, 865. On sensationalist psychology, see Jan Goldstein, *The Post-Revolutionary Self: Politics and Psyche in France, 1750–1850* (Cambridge, Mass.: Harvard University Press, 2005), 73–75.

38 "Bill Seeks to Form Monument Board," *Washington Star*, January 7, 1960, clipping in Vertical File, Outdoor Sculptures—Udall Controversy, Kiplinger Library, Historical Society of Washington, D.C.

39 "Lafayette Square," Historic American Buildings Survey, Report no. DC-676.

40 Michael Edward Shapiro, *Bronze Casting and American Sculpture, 1850–1900* (Newark: University of Delaware Press, 1985), 34–35; "Mills' Equestrian Statue of Jackson," *New York Times*, January 13, 1853, 4; "History of the Jackson Statue," *New York Daily Times*, January 22, 1853, 3; *Oration of the Hon. Stephen A. Douglas, on the Inauguration of the Jackson Statue, at the City of Washington, January 8, 1853* (Washington, D.C.: L. Towers, 1853), 5–6.

41 "The Appropriation Bill," *New York Times*, March 9, 1853, 2. For examples of the voluminous criticism of Mills's Jackson, see B.B., "The Art-Decorations of the Capitol at Washington," *The Independent* (New York), July 22, 1858, 1; "The Home of the Brazen Horse," *Washington Star*, December 7, 1878, clipping in Thomas Lincoln Casey Papers, Box 119, Society for the Preservation of New England Antiquities; James Jackson Jarves, "Monuments in America," *New York Times*, October 15, 1879, 5; "Thackeray on Jackson's Statue," *New York Times*, January 2, 1883, 3; "The Pessimist," *Washington Post*, July 14, 1901, 18.

42 Quotation from "Our Washington Letter," *The Independent* (New York), February 8, 1900, 376. A more charitable critic wrote in 1884 that the capital was still, "unavoidably in the circumstances, in the military phase"; O. B. Frothingham, "Washington as It Should Be," *Atlantic Monthly*, June 1884, 841. On the British precedent, see Holger Hoock, "The British Military Pantheon in St Paul's Cathedral: The State, Cultural Patriotism, and the Politics of National Monuments, c. 1790–1820," in *Pantheons: Transformations of a Monumental Idea*, ed. Richard Wrigley and Matthew Craske (Aldershot, U.K.: Ashgate, 2004), 81–105.

43 "It Is a City of Statues," *Washington Post*, August 4, 1891, 9.

44 *Congressional Globe*, 39th Cong., 1st sess., 1866, 4231.

45 Thomas Carlyle, "Hudson's Statue," in *Latter-Day Pamphlets* (1851; reprint, Boston: Phillips, Sampson, 1855), 323–70.

46 Friedrich Wilhelm Nietzsche, "On the Utility and Liability of History for Life," in *Un-*

fashionable Observations, trans. Richard T. Gray (Stanford, Calif.: Stanford University Press, 1995; German edition originally published 1873), 97–100.

47 Congressman E. O. Stannard to Gen. Orville Babcock, May 6, 1874, National Archives and Records Administration, record group (hereafter RG) 42, entry 87; George J. Olszewski, *Lincoln Park, Washington, D.C.* (Washington, D.C.: Office of Archeology and Historic Preservation, Division of History, National Park Service, 1968), 6–8. For more on the monument, see Kirk Savage, *Standing Soldiers, Kneeling Slaves: Race, War, and Monument in Nineteenth-Century America* (Princeton, N.J.: Princeton University Press, 1997), 89–120.

48 Olszewski, *Lincoln Park*, 12–20; "Lincoln Park," Historic American Buildings Survey, Report no. DC-677, 1993. On the tree, see "Memories in Foliage," *Washington Post*, May 14, 1891, 5; "Famous Tree: History May Be Read in Growing Wood," *Boston Globe*, May 21, 1905, SM7; Ernest Ingersoll, *Rand, McNally & Co.'s Handy Guide to the City of Washington* (Chicago: Rand, McNally & Company, 1893), 68. Ingersoll identified it as a sycamore tree, but it was an Oriental plane tree.

49 "The Lincoln Monument," *New York Times*, April 15, 1876, 1.

50 For a recent appraisal, see Harold Holzer and Sara Vaughn Gabbard, eds., *Lincoln and Freedom: Slavery, Emancipation, and the Thirteenth Amendment* (Carbondale: Southern Illinois University Press, 2007).

51 Savage, *Standing Soldiers, Kneeling Slaves*, 114–17.

52 "The Lincoln Monument"; "Abraham Lincoln: Unveiling of the Monument Built by the Colored People," *Boston Globe*, April 15, 1876, 1; Raconteur, "Capital Gossip," *Chicago Daily Tribune*, April 22, 1876, 2.

53 De Benneville Randolph Keim, *Washington and Its Environs: A Descriptive and Historical Hand-Book to the Capital of the United States of America* (Washington, D.C.: N.p., 1879), 38; *Roose's Companion and Guide to Washington and Vicinity* (Washington, D.C.: Gibson Bros, 1889), 31; Ingersoll, *Rand, McNally & Co.'s Handy Guide to the City of Washington*, 68; "Personal Impressions: A Young Lady's Letter from Washington," *Los Angeles Times*, September 10, 1897, 10; Olszewski, *Lincoln Park*, 8. On its iconic status, see Freeman Henry Morris Murray, *Emancipation and the Freed in American Sculpture: A Study in Interpretation* (Washington, D.C.: N.p., 1916), 26–32.

54 "History of the Statue," *Washington Post*, November 20, 1879, 4.

55 Quotation from "Ward's Statue of Gen. Thomas," *New York Times*, May 3, 1879, 1; "The Fine Arts," *Harper's Weekly*, May 24, 1879, 413; "The Statue of Thomas," *New York Times*, November 18, 1879, 1; "History of the Statue," 4.

56 "It Is a City of Statues," 9; "Equestrian Monuments—The War of Secession," *American Architect and Building News*, October 31, 1891, 65; Lorado Taft, "Required Reading for the Chautauqua Literary and Scientific Circle," *The Chautauquan: A Weekly Newsmagazine*, January 1896, 387; Russell Sturgis, "Sculpture," *Forum*, October 1902, 254.

57 "The Statue of Thomas," quotation on 1; "Thomas Circle," Historic American Buildings Survey, Report no. DC-687, 1993.

58 Scott, *Capital Engineers*, 78; H. K. Bush-Brown, "Sculpture in Washington," in *Papers*

Relating to the Improvement of the City of Washington, District of Columbia (Washington, D.C.: Government Printing Office, 1901), quotation on 71.

59 Baltimore and Ohio Railroad Company, *Guide to Washington* (Washington, D.C.: Press of J. D. Lucas, 1892), 48.

60 On the mnemonic tradition, see Frances A. Yates, *The Art of Memory* (London: Routledge and Kegan Paul, 1966), 1–49. The idea that orientation in the city depends on cognitive maps comes from Kevin Lynch, *The Image of the City* (Cambridge, Mass.: MIT Press, 1960), though I follow Jonathan Hale's suggestion that the cognitive map should be thought of as an operational understanding rather than an image; see his "Cognitive Mapping: New York vs. Philadelphia," in *The Hieroglyphics of Space: Reading and Experiencing the Modern Metropolis*, ed. Neil Leach (London: Routledge, 2001), 31–42.

61 Scott, "'The City of Living Green'"; Alan Lessoff, *The Nation and Its City: Politics, "Corruption," and Progress in Washington, D.C., 1861–1902* (Baltimore: Johns Hopkins University Press, 1994), 84–86; Scott, *Capital Engineers*, 112–13; Green, *Washington*, 1:316; "Trees in Washington," *Chicago Tribune*, September 25, 1892, 36; Peter Henderson, "Street Trees of Washington," *Harper's New Monthly*, July 1888, 285–88; "The New Washington," *Century Illustrated Magazine*, March 1884, 649–50; "Red Oaks in the Mall," *Washington Post*, November 14, 1898, 7.

62 Julian Ralph, "Our National Capital," *Harper's New Monthly*, April 1895, 660.

63 Cindy Sondik Aron, *Working at Play: A History of Vacations in the United States* (New York: Oxford University Press, 1999), 138. For similar examples, see "Washington's Shade Trees," *Saturday Evening Post*, reprinted in *San Antonio Express*, August 25, 1899, 8; Clifford Howard, "District of Columbia," *Californian Illustrated Magazine*, March 1893, 446; *American Architect and Building News*, December 13, 1902, 88.

64 Henry James, *The American Scene* (New York: Harper and Brothers, 1907), 322–23.

65 Myths associated with trees is a major theme throughout Simon Schama, *Landscape and Memory* (New York: Knopf, 1996); and Thomas J. Campanella, *Republic of Shade: New England and the American Elm* (New Haven, Conn.: Yale University Press, 2003).

66 Downing, *Rural Essays*, 164–65.

67 For references to memorial trees in the seventeenth and eighteenth centuries, see "The Surrender of Burgoyne—Memorial Tree," *Hartford Daily Courant*, October 17, 1877, 2; and Gayle Brandow Samuels, *Enduring Roots: Encounters with Trees, History, and the American Landscape* (New Brunswick, N.J.: Rutgers University Press, 1999), 29. For memorial trees in the nineteenth century, see, for example, Campanella, *Republic of Shade*, 62; and "Memorial Trees," *The Independent* (New York), May 22, 1851, 88.

68 "The Capitol Grounds," *New York Times*, November 17, 1874, 3; "Washington Notes," *New York Times*, April 30, 1877, 2; "Charles Sumner's Tree," *Los Angeles Times*, October 3, 1882, 3.

69 "Sights at the Capitol," *Washington Post*, August 18, 1889, 19.

70 "Famous Tree"; "Washington Trees Associated with Memories of Famous Men," *Washington Post*, July 28, 1907, R7.

71 "Trees in Washington"; "Historic Trees Here," *Washington Post*, May 25, 1902, 24; "Trees as Monuments," *Washington Post*, August 7, 1904, 12; "Famous Tree."

72 "Washington Letter," *Herald of Gospel Liberty*, April 28, 1887, 270; Ralph, "Our National Capital," 660.

73 Quotation in "Washington for the Brides," *Washington Post*, May 7, 1886, 2; Catherine Cocks, *Doing the Town: The Rise of Urban Tourism in the United States, 1850–1915* (Berkeley and Los Angeles: University of California Press, 2001); "Phases of Washington," *New York Times*, February 28, 1892, 10; "Tourists Fill Washington: National Capital the Mecca of Many Sightseers," *New York Times*, April 16, 1894, 11; "As Seen by Tourists: 'Doing' Washington under a Professional Guide's Direction," *Washington Post*, October 4, 1896, 18.

74 Olmsted to Honorable J. R. Morrill, January 22, 1874, in *Parks, Politics, and Patronage*, 37.

75 The earliest solid example of a conflict I have found is the 1901 installation of the Logan equestrian statue in Iowa Circle (renamed Logan Circle), which required the removal of a fountain, trees, and shrubs; "Statues vs. Nature," *Washington Post*, May 5, 1901, 26.

76 George J. Olszewski, *History of the Mall, Washington, D.C.* (Washington, D.C.: U.S. Office of History and Historic Architecture, Eastern Service Center, 1970), 35–37.

77 "Smithsonian Hounds Again," *Washington City Gazette*, January 18, 1880, clipping in Thomas Lincoln Casey Papers, box 119, Society for the Preservation of New England Antiquities; George P. Lathrop, "A Nation in a Nutshell," *Harper's New Monthly*, March 1881, quotations on 544; Keim, *Washington and Its Environs*, 30; Anne Hollingsworth Wharton, *Social Life in the Early Republic* (Philadelphia: J. B. Lippincott Company, 1902), 51.

78 James, *The American Scene*, 323; *National Geographic Magazine*, March 1915, 224.

79 Frederick Law Olmsted, "'A Healthy Change in the Tone of the Human Heart' (Suggestions to Cities)," *Century Illustrated Magazine*, October 1886, 964; Henry Adams, *The Education of Henry Adams: An Autobiography* (New York: Time, 1964), 1:36.

80 Olmsted, "'A Healthy Change in the Tone of the Human Heart,'" 964–65; Olmsted, "Index to Trees about the Capitol," 913, 920.

81 Olmsted, "Index to Trees about the Capitol," 913–15.

82 "The Poisoned Air of the Capital," *New York Times*, January 28, 1882, 1.

83 Frederick Law Olmsted, "Public Parks and the Enlargement of Towns," in *Writings on Public Parks, Parkways, and Park Systems*, vol. 1 of *The Papers of Frederick Law Olmsted, Supplementary Series*, ed. Charles E. Beveridge and Carolyn F. Hoffman (Baltimore: Johns Hopkins University Press, 1997), 189; Olmsted, "Notes on the Plan of Franklin Park and Related Matters," in *Writings on Public Parks, Parkways, and Park Systems*, 481.

84 Olmsted, "Index to Trees about the Capitol," 922.

85 "Boon to Speed Lovers," *Washington Post*, November 4, 1902, 12. One such family appears in a photograph published in Peter R. Penczer, *Washington, D.C., Past and Present* (Arlington, Va.: Oneonta Press, 1998), 42.

86 Donald E. Press, "South of the Avenue: From Murder Bay to the Federal Triangle," *Records of the Columbia Historical Society* 51 (1984): 51–70; Jon A. Peterson, *The Birth of City Planning in the United States, 1840–1917* (Baltimore: Johns Hopkins University Press, 2003), 84; Ralph, "Our National Capital," 660. For a more evenhanded treatment of the subject, see James Borchert, *Alley Life in Washington: Family, Community, Religion, and Folklife in the City, 1850–1970* (Urbana: University of Illinois Press, 1980); and "Archaeological Investigations: National Museum of the American Indian Site, Washington, D.C.," Architectural History and Historic Preservation Division of the Smithsonian Institution, 1997, www.si.edu/oahp/nmaidig/start.htm (accessed January 22, 2008).

87 "The Inundated Mall," *Washington Post*, February 13, 1881, 1; *Washington Post*, June 3, 1878, 4; "The Hoodlum's Howl," *Washington Post*, August 26, 1879, 4; Esther Nganling Chow, "From Pennsylvania Avenue to H Street, NW: The Transformation of Washington's Chinatown," in *Urban Odyssey: A Multicultural History of Washington, D.C.*, ed. Francine Curro Cary (Washington, D.C.: Smithsonian Institution Press, 1996), 191.

 Demographics for the Missouri and Maine Avenue blocks were compiled from the enumeration schedules of the U.S. Census of Population in 1900 and 1920, available in the Ancestry.com database, www.ancestry.com/. The house numbers of dwellings recorded in the enumeration schedules were cross-checked against Sanborn fire insurance maps, available in the database Digital Sanborn Maps, 1867–1970, http://sanborn.umi.com/.

88 "Archaeological Investigations"; 1900 U.S. Census.

89 *Report of the Secretary of the Interior*, 46th Cong., 3rd sess., 1880, H. Exec. Doc. 1, pt. 5, vol. 2, 440; *Statutes at Large of the United States of America, from December, 1881, to March, 1883* (Washington, D.C.: Government Printing Office, 1883), 126–27. For background on this act, see Lucy G. Barber, *Marching on Washington: The Forging of an American Political Tradition* (Berkeley and Los Angeles: University of California Press, 2003), 5–6.

90 Olmsted, "Index to Trees about the Capitol," 922.

91 Grace Greenwood, "Occasional Washington Notes," *New York Times*, May 19, 1874, 4.

92 The earliest newspaper accounts of the trip to the top I have found begin in October 1882, but it is clear from these that the practice was already well established; "Washington Monument," *Chicago Daily Tribune*, October 16, 1882, 6.

3. THE MECHANIC MONSTER

1 Frederick L. Harvey, *History of the Washington National Monument and Washington National Monument Society* (Washington, D.C.: Government Printing Office, 1903), 295; Louis Torres, *"To the Immortal Name and Memory of George Washington": The United States Corps of Engineers and the Construction of the Washington Monument* (Washington, D.C.: Government Printing Office, 1985), 82–84.

2 Eugene Lawrence, "The Washington Monument," *Harper's Weekly*, November 29, 1884, 789.

3 Torres, *"To the Immortal Name and Memory of George Washington,"* 82.

4 *Britannica Concise Encyclopedia*, 2006, s.v. *Washington Monument*.

5 Michael Dear, "Monuments, Manifest Destiny, and Mexico," *Prologue Magazine*, Summer 2005,www.archives.gov/publications/prologue/2005/summer/mexico-1.html; "A Visit to Wyoming Monument," *National Magazine*, September 1858, 250; Margot Gayle and Michele Cohen, eds., *The Art Commission and the Municipal Art Society Guide to Manhattan's Outdoor Sculpture* (New York: Prentice Hall, 1988), 104.

6 *Annals of Congress*, 6th Cong., 2nd sess., December 5, 1800, 804.

7 *Frank Leslie's Illustrated Newspaper*, April 25, 1857, 321; "Editor's Easy Chair," *Harper's New Monthly*, August 1874, 437; *New York Daily Tribune*, July 1, 1875, 6.

8 Alan Lessoff, *The Nation and Its City: Politics, "Corruption," and Progress in Washington, D.C., 1861–1902* (Baltimore: Johns Hopkins University Press, 1994), 113, 118–20.

9 Pamela Scott, *Capital Engineers: The U.S. Army Corps of Engineers in the Development of Washington, D.C., 1790–2004* (Alexandria, Va.: U.S. Army Corps of Engineers, Office of History, 2005), 72–73.

10 Lessoff, *Nation and Its City*, 96, 169–72; Scott, *Capital Engineers*, 81.

11 Thomas Lincoln Casey (hereafter TLC) to Silas Casey, March 4, 1878, Thomas Lincoln Casey Papers, Historic New England (hereafter Casey Papers).

12 TLC to Silas Casey, April 1, 1878, Casey Papers. See also letters of January 23, 1878, and October 1, 1877.

13 *Congressional Record*, 45th Cong., 3rd sess., February 28, 1879, 2095.

14 TLC to Silas Casey, July 28, 1878, Casey Papers; Torres, *"To the Immortal Name and Memory of George Washington,"* 65.

15 TLC to Silas Casey, August 10, 1880, May 20, 1881, Casey Papers.

16 Kirk Savage, "The Self-Made Monument: George Washington and the Fight to Erect a National Memorial," in *Critical Issues in Public Art: Content, Context, and Controversy*, ed. Harriet F. Senie and Sally Webster (Washington, D.C.: Smithsonian Institution Press, 1998), 20.

17 Henry Van Brunt, *Architecture and Society: Selected Essays of Henry Van Brunt*, ed. William A. Coles (Cambridge, Mass.: Harvard University Press, 1969), 198.

18 James Jackson Jarves, "Washington's Monument," *New York Times*, March 17, 1879, 5; *Congressional Record*, 45th Cong., 1st sess., April 2, 1878, 2203–6; *American Architect and Building News*, July 27, 1878, 5; Henry Van Brunt, "The Washington Monument," part 1, *American Art Review* 1 (1879): 12. For discussion of the class inflections of this language, see Savage, "The Self-Made Monument," 20–21.

19 "Notes from Washington, D.C.," *Scientific American*, May 30, 1874, 340; "Editor's Easy Chair," *Harper's New Monthly*, August 1874, 436; *American Architect and Building News*, July 8, 1876, 217; "The Washington Monument—A New Plan," *Baltimore Sun*, December 28, 1878, 1; "Washington, the National Monument . . . History and Description of the Great Chimney," *Philadelphia Inquirer*, June 22, 1881, 1. The sculptor William Wetmore Story used the metaphor repeatedly in a widely published letter to William W. Corcoran, head of the Joint Commission, dated November 3, 1878, copy in Casey Papers.

20 *American Architect and Building News*, July 27, 1878, 5; William Dean Howells, "Question of Monuments," *Atlantic Monthly*, May 1866, 649.

21 *American Architect and Building News*, August 17, 1878, 53; *Congressional Record*, 45th Cong., 1st sess., April 2, 1878, 2204, February 28, 1879, 2094; "Editor's Easy Chair," *Harper's New Monthly*, April 1885, 810.

22 Savage, "The Self-Made Monument," 21.

23 James Jackson Jarves, "Monuments in America," *New York Times*, October 15, 1879, 5; Van Brunt, "The Washington Monument," 7–8.

24 F. Nietzsche, "On the Utility and Liability of History for Life," in *Unfashionable Observations*, trans. Richard T. Gray (1873; reprint, Stanford, Calif.: Stanford University Press, 1995), 110–11.

25 Walt Whitman, *Democratic Vistas and Other Papers* (London: Walter Scott, 1888), 59; Henry W. Bellows, "The Century Gone and the Century to Come in Our National Life," *Unitarian Review and Religious Magazine*, July 1876, 52.

26 William W. Story to William W. Corcoran, May 1, 1879, in William W. Corcoran Papers, Library of Congress (hereafter Corcoran Papers); *New York Times*, January 13, 1879, 8.

27 Henry Van Brunt, "Grant's Memorial: What Shall It Be?" *North American Review*, September 1885, 283; Van Brunt, "The Washington Monument," part 2, *American Art Review* 1 (1879): 63–65.

28 Lewis Mumford, *Sticks and Stones: A Study of American Architecture and Civilization* (New York: Boni and Liveright, 1924), 123.

29 TLC to Larkin Mead, July 25, 1882, in Records of the Washington National Monument Society, National Archives and Records Administration, RG 42, entry 436 (hereafter Washington Monument Records). When the obelisk was finished, he told a reporter that construction was "the sole jurisdiction of Congress"; *Washington Evening Star*, February 21, 1885, 3.

30 TLC to Corcoran, April 20, 1882, Washington Monument Records; Torres, *"To the Immortal Name and Memory of George Washington,"* 54–55, 89; TLC to Silas Casey, July 28, 1878, Casey Papers.

31 Letter from Corcoran to Story, March 23, 1880, Corcoran Papers. A fascinating letter from the sculptor Larkin Mead to Senator Justin S. Morrill, chairman of the powerful Committee on Public Buildings and Grounds, January 11, 1881, details the web of patronage, Justin S. Morrill Papers, Library of Congress (hereafter Morrill Papers).

32 *Washington Gazette*, March 28, 1880, and December 22, 1878, clippings in Casey Papers.

33 *Congressional Record*, 45th Cong., 2nd sess., February 28, 1879, 2096; and June 8, 1880, 4284. The appropriation in 1880 was in H.R. 6266 (Sundry Civil Appropriations Bill), with the simple line, "For continuing the work on the Washington Monument, one hundred and fifty thousand dollars."

34 Mead to Morrill, November 29, 1880, and March 29, 1881, Morrill Papers; Corcoran to Story, May 13, 1880, Corcoran Papers. In 1878–79, several newspapers reported that Mead's plan for the obelisk had been approved by Congress, and this idea seems to

have stuck; e.g., *Trenton State Gazette*, June 12, 1878, 2; *Washington Star*, July 15, 1878, and *Cincinnati Gazette*, May 19, 1979, last two clippings in Casey Papers. Harvey's account of the history of the monument makes no mention of this episode, but this is not surprising. It is a self-serving account that depicts the Washington Monument Society as helping to advance Casey's idea of a simple obelisk, when in fact the society initially favored Mead's plan, then switched to Story's redesign, and then switched back to the Mead proposal.

35 James Jackson Jarves, "Clay Touched by Genius," *New York Times*, November 27, 1880, 1.

36 TLC to Corcoran, April 20, 1882, Washington Monument Records; Proceedings of the Joint Commission, March 29 and April 24, 1882, Washington Monument Records.

37 *New York Sun*, April 11, 1883, and *Critic*, August 9, 1884, both clippings in Casey Papers.

38 *Annals of Congress*, 6th Cong., 2nd sess., December 9, 1800, 806.

39 *Critic*, August 9, 1884, clipping in Casey Papers; Larkin Mead to Edward Clark, December 12, 1882, Washington Monument Records.

40 Proceedings of the Joint Commission, December 18, 1884, Washington Monument Records; *Washington Evening Star*, February 21, 1885, 3.

41 TLC to Gen. John Newton, December 18, 1884, Washington Monument Records.

42 Torres, *"To the Immortal Name and Memory of George Washington,"* 55–56. Marsh is most famous for his book *Man and Nature*, arguably the first tract of the environmental movement.

43 Marsh to George F. Edmunds, February 9, 1879, published in *Memorial of the Committee of the National Monument Association Relative to the Completion of the Washington Monument*, 46th Cong., 2nd sess., April 29, 1880, H. Doc. 37.

44 "Inside of the Washington Monument," *Harper's Weekly*, May 18, 1889, 402.

45 Casey to Gen. John Newton, December 8, 1885, Washington Monument Records.

46 "Inside of the Washington Monument," 403.

47 *New England Magazine*, June–July 1887, 88; "Inside of the Washington Monument"; "White House Changes," *Washington Post*, July 17, 1889, 7.

48 Lawrence, "The Washington Monument," 789.

49 "Towering to the Sky," *Inter-Ocean of Chicago*, November 30, 1884, clipping in Casey Scrapbook.

50 "Washington Monument," *Chicago Daily Tribune*, November 8, 1882, 4.

51 Ernest Ingersoll, *Rand, McNally & Co.'s Handy Guide to the City of Washington* (Chicago: Rand, McNally & Company, 1893), 106; "Washington Monument," *Critic*, May 10, 1884, clipping in Casey Papers.

52 "Inside of the Washington Monument," *Harper's Weekly*, May 18, 1889, 402; *Washington Republic*, October 20, 1883, and "Towering to the Sky," both clippings in Casey Papers; "Washington Monument," *Chicago Daily Tribune*, November 8, 1882, 4.

53 Lawrence, "The Washington Monument."

54 The photograph Holmes described, the first surviving example of aerial photography

in the world, was a view of Boston taken by James Wallace Black in 1860 from a tethered balloon at twelve hundred feet; Oliver Wendell Holmes, "Doings of the Sunbeam," *Atlantic Monthly*, July 1863, 12.

55 Le Corbusier, *Aircraft* (London: The Studio, 1935), 76.

56 Roland Barthes, *The Eiffel Tower and Other Mythologies,* trans. Richard Howard (Berkeley and Los Angeles: University of California Press, 1997), 3–17; Victor Hugo, *Notre-Dame de Paris* (1831; reprint, Paris: Charpentier, 1850), 167–202; Michel de Certeau, "Walking in the City," in *The Practice of Everyday Life* (Berkeley and Los Angeles: University of California Press, 2002), 91ff; Ralph Waldo Emerson, *Nature: A Facsimile of the First Edition* (1836; reprint, Boston: Beacon Press, 1985), 13; Meir Wigoder, "The 'Solar Eye' of Vision: Emergence of the Skyscraper-Viewer in the Discourse on Heights in New York City, 1890–1920," *Journal of the Society of Architectural Historians* 61, no. 2 (2002): 152–69.

57 "The Washington Monument," *New York Times*, December 7, 1884, 8; *Memorial of the Committee of the National Monument Association Relative to the Completion of the Washington Monument.*

58 When to great fanfare the capstone was put into place on top of the monument on December 6, 1884, one journalist reported that "opera glasses from all parts of the city pointed in that direction"; Kate Foote, "Letter from Washington," *The Independent* (New York), December 18, 1884, 4.

59 "Towering to the Sky," clipping in Casey Papers.

60 O. B. Frothingham, "Washington as It Should Be," *Atlantic Monthly*, June 1884, 843.

61 Foote, "Letter from Washington," 5.

62 F. Marion Crawford, "Washington as a Spectacle," *Century Magazine*, August 1894, 494–95.

63 Ingersoll, *Rand, McNally & Co.'s Handy Guide to the City of Washington*, 103.

64 One way to measure this is to look through the photographs of the monument collected by the Library of Congress; overwhelmingly the photographs prefer the picturesque views over the formal axial view.

65 Foote, "Letter from Washington," 5; Clarence Cook, "Monuments of America," *Chautauquan*, June 1886, 526.

66 *Boston Evening Transcript*, February 24, 1885, 7.

67 Quoted in Harvey, *History of the Washington National Monument*, 290.

68 Walt Whitman, "Washington's Monument, February, 1885," in *Leaves of Grass* (Philadelphia: David McKay, 1900), 502.

69 *Frank Leslie's Illustrated Newspaper,* December 20, 1884, 278–79.

70 Henry Van Brunt, "The Washington Monument," in *American Art and American Art Collections,* ed. Walter Montgomery (Boston: E. W. Walker, 1889), 1:355; Montgomery Schuyler, "The Nation's New Capital," *New York Times,* January 19, 1902, SM4.

71 *The Dedication of the Washington National Monument* (Washington, D.C.: Government Printing Office, 1885), 61; Schuyler, "The Nation's New Capital," SM4.

72 Will Carleton, *City Ballads* (New York: Harper and Brothers, 1886), 149; *Washington Evening Star*, January 11, 1908, 9.

4. INVENTING PUBLIC SPACE

1 Elbert Peets, "Washington" (1937), reprinted in *On the Art of Designing Cities: Selected Essays of Elbert Peets*, ed. Paul D. Spreiregen (Cambridge, Mass.: MIT Press, 1968), 67.

2 U.S. Congress, Senate Committee on the District of Columbia, *The Improvement of the Park System of the District of Columbia*, ed. Charles Moore, 57th Cong., 1st sess., 1902, S. Rep. 166, 48.

3 Frederick Law Olmsted Jr., "Landscape in Connection with Public Buildings in Washington," in *Papers Relating to the Improvement of the City of Washington, District of Columbia*, comp. Glenn Brown (Washington, D.C.: Government Printing Office, 1901), 32.

4 As Elbert Peets wrote, the new Mall opened up "vistas of a dome [L'Enfant] never saw and a mighty obelisk that never came to his dreams"; Peets, *On the Art of Designing Cities: Selected Essays of Elbert Peets*, ed. Paul D. Spreiregen (Cambridge, Mass.: MIT Press, 1968), 88.

5 For a broad statement of the impact of "space" on urban development, see Malcolm Miles, *The Uses of Decoration: Essays in the Architectural Everyday* (Chichester: Wiley, 2000), 72–74.

6 See, for example, Jon A. Peterson's work, most recently, "The Senate Park Commission Plan for Washington, D.C.: A New Vision for the Capital and the Nation," in *Designing the Nation's Capital: The 1901 Plan for Washington, D.C.*, ed. Sue Kohler and Pamela Scott (Washington, D.C.: U.S. Commission of Fine Arts, 2006), 1–47.

7 John William Reps, *Monumental Washington: The Planning and Development of the Capital Center* (Princeton, N.J.: Princeton University Press, 1967), 195.

8 See "The Segregated Center," later in this chapter.

9 U.S. Congress, *The Improvement of the Park System of the District of Columbia*, 16; U.S. Congress, Senate Committee on the District of Columbia, *The Mall Parkway: Hearing before the Committee on the District of Columbia of the United States Senate*, 58th Cong., 1st sess., March 12, 1904, 18.

10 Quoted in Pamela Scott, "'A City Designed as a Work of Art,'" in *Designing the Nation's Capital: The 1901 Plan for Washington, D.C.*, ed. Sue Kohler and Pamela Scott (Washington, D.C.: U.S. Commission of Fine Arts, 2006), 79.

11 Quoted in Howard Gillette, *Between Justice and Beauty: Race, Planning, and the Failure of Urban Policy* (Baltimore: Johns Hopkins University Press, 1995), 262 n. 93.

12 Daniel Burnham, "White City and Capital City," *Century Illustrated Magazine*, February 1902, 620.

13 Pamela Scott, *Capital Engineers: The U.S. Army Corps of Engineers in the Development of Washington, D.C., 1790–2004* (Alexandria, Va.: U.S. Army Corps of Engineers, Office of History, 2005), 116.

14 Scott, "'A City Designed as a Work of Art,'" 75–76; Alan Lessoff, *The Nation and Its City: Politics, "Corruption," and Progress in Washington, D.C., 1861–1902* (Baltimore: Johns Hopkins University Press, 1994), 255–65; Gillette, *Between Justice and Beauty,* 101–2.

15 Frederick Law Olmsted to Honorable J. S. Morrill, January 22, 1874, in *Parks, Politics, and Patronage, 1874–1882,* vol. 7 of *The Papers of Frederick Law Olmsted,* ed. Charles E. Beveridge, Carolyn F. Hoffman, and Kenneth Hawkins (Baltimore: Johns Hopkins University Press, 2007), 37.

16 Henry James, *The American Scene* (New York: Harper and Brothers, 1907), 327.

17 U.S. Congress, *The Improvement of the Park System of the District of Columbia,* 36. For a more in-depth examination of the reformers' critique of the nineteenth-century memorial landscape, see chapter 5.

18 Timothy Davis notes quite rightly that the plan's park proposals outside the Mall area have been largely ignored by scholars, but the planners themselves and their promoters are largely to blame because they consciously emphasized the Mall as a spectacular centerpiece in order to build enthusiasm for the plan; see Davis, "Beyond the Mall: The Senate Park Commission's Plans for Washington's Park System," in *Designing the Nation's Capital: The 1901 Plan for Washington, D.C.,* ed. Sue Kohler and Pamela Scott (Washington, D.C.: U.S. Commission of Fine Arts, 2006), 137.

19 De Witt C. Chipman to Hon. N. P. Chipman, February 17, 1874, in National Archives and Records Administration, RG 42, entry 87.

20 U.S. Congress, *The Improvement of the Park System of the District of Columbia,* 9, 23.

21 Pamela Scott, "'This Vast Empire': The Iconography of the Mall, 1791–1848," in *The Mall in Washington, 1791–1991,* ed. Richard W. Longstreth (Washington, D.C.: National Gallery of Art, 2002), 43; Marc Treib, "Moving the Eye," in *Sites Unseen: Landscape and Vision,* ed. Dianne Harris and D. Fairchild Ruggles (Pittsburgh: University of Pittsburgh Press, 2007), 74–76; Elizabeth S. Kite, *L'Enfant and Washington* (Baltimore: Johns Hopkins University Press, 1929), 56–58.

22 Burnham quoted in Scott, "'A City Designed as a Work of Art,'" 79.

23 Kite, *L'Enfant and Washington,* 57; U.S. Congress, *The Improvement of the Park System of the District of Columbia,* 29, 44; Scott, "'This Vast Empire,'" 40–41. Michael J. Lewis is one of the few scholars to emphasize the difference between the "congenial" Mall of L'Enfant's plan and the "national forum" envisaged by the McMillan Commission; see his essay "The Idea of the American Mall," in *The National Mall: Rethinking Washington's Monumental Core,* ed. Nathan Glazer and Cynthia R. Field (Baltimore: Johns Hopkins University Press, 2008): 14–15, 25.

24 Scott, "'A City Designed as a Work of Art,'" 78–79.

25 Spiro Kostof, *The City Shaped: Urban Patterns and Meanings through History* (Boston: Little, Brown, 1991), 226, 264–66.

26 Kite, *L'Enfant and Washington,* 56.

27 Scott, "'This Vast Empire,'" 41–42.

28 Treib, "Moving the Eye," 67–68. For a somewhat different analysis, see Cynthia R. Field, "Interpreting the Influence of Paris on the Planning of Washington, D.C., 1870–1930," in *Paris on the Potomac: The French Influence on the Architecture and Art of Washington, D.C.*, ed. Cynthia R. Field, Isabelle Gournay, and Thomas P. Somma (Athens: Ohio University Press, 2007), 127–28.

29 Walter Benjamin, *One-Way Street, and Other Writings*, trans. Edmund Jephcott and Kingsley Shorter (London: Verso, 1979), 78; quoted in Anthony Vidler, *Warped Space: Art, Architecture, and Anxiety in Modern Culture* (Cambridge, Mass.: MIT Press, 2000), 85.

30 Peets, *On the Art of Designing Cities*, 47.

31 To use Erik Erikson's famous distinction, the new Mall was to be a "totality" (in which inside and outside must be absolutely separated) rather than a "whole"; Erikson, "Wholeness and Totality: A Psychiatric Contribution," in *Totalitarianism: Proceedings of a Conference Held at the American Academy of Arts and Sciences March 1953*, ed. Carl J. Friedrich (Cambridge, Mass.: Harvard University Press, 1954), 161.

32 This effect is called "forced perspective" and is commonly used in film sets and theme park design. In this case, the forced perspective was intensified in the Capitol-obelisk axis because the ground slopes gradually upward toward the monument.

33 *Washington Star*'s original endorsement is January 15, 1902; critical letters appeared in the *Washington Post*, May 12, 1902, 10, and June 11, 1902, 10.

34 "Report by F. L. Olmsted on Proposed Changes in Assumed Grades of Mall Roadways," April 24, 1927, in Records of the National Capital Planning Commission, National Archives and Records Administration, RG 328 (hereafter NCPC Records), entry 1, box 1A.

35 U.S. Congress, *The Mall Parkway*, 17.

36 The Daguerre monument was moved to the grounds of the National Portrait Gallery, and the Gross monument to Jefferson Medical College in Philadelphia (where until recently Eakins's *Gross Clinic* was housed). The Downing urn has been moved several times, most recently to the Enid A. Haupt garden adjacent to the original Smithsonian building.

37 Charles Moore, *The Life and Times of Charles Follen McKim* (Cambridge, Mass.: Riverside Press, 1929), 116, quoted in Margaret E. Farrar, *Building the Body Politic: Power and Urban Space in Washington, D.C.* (Urbana: University of Illinois Press, 2008), 51.

38 The Navy Monument, erected in 1877 to commemorate Civil War sailors, stood on the Capitol grounds just on the edge of the Mall.

39 U.S. Congress, *The Improvement of the Park System of the District of Columbia*, 50; Scott, "'A City Designed as a Work of Art,'" 114–23.

40 For a broad reading of parallel developments in American cultural memory, see David W. Blight, *Race and Reunion: The Civil War in American Memory* (Cambridge, Mass.: Harvard University Press, 2001).

41 Burnham, "White City and Capital City," 620.

42 Spiro Kostof, "His Majesty the Pick: The Aesthetics of Demolition," in *Streets: Critical Perspectives on Public Space*, ed. Zeynep Çelik, Diane G. Favro, and Richard Inger-soll (Berkeley and Los Angeles: University of California Press, 1994), 9–22; Anna Notaro, "Resurrecting an Imperial Past: Strategies of Self-Representation and 'Masquer-ade' in Fascist Rome (1934–1938)," in *The Hieroglyphics of Space: Reading and Experiencing the Modern Metropolis*, ed. Neil Leach (London: Routledge, 2002), 59–69.

43 Demographics for the Missouri and Maine Avenue blocks were compiled from the enumeration schedules of the U.S. Census of Population in 1900 and 1920, available in the Ancestry.com database, www.ancestry.com/. The house numbers of dwellings recorded in the enumeration schedules were cross-checked against Sanborn fire insurance maps, available in the database Digital Sanborn Maps, 1867–1970, http://sanborn.umi.com/.

44 "Archaeological Investigations: National Museum of the American Indian Site, Washington, D.C.," Architectural History and Historic Preservation Division of the Smithsonian Institution, 1997, www.si.edu/oahp/nmaidig/start.htm (accessed January 22, 2008). On alleys see James Borchert, *Alley Life in Washington: Family, Community, Religion, and Folklife in the City 1850–1970* (Urbana: University of Illinois Press, 1980). Margaret Farrar fruitfully explores the metaphor of contamination in the antialley discourse, but her work does not explore the direct displacement involved in the clearing of the Mall; see Farrar, *Building the Body Politic*, 67–74.

45 On the nomenclature of "Murder Bay," see Reps, *Monumental Washington*, 44; Donald E. Press, "South of the Avenue: From Murder Bay to the Federal Triangle," *Records of the Columbia Historical Society* 51 (1984): 51–70; and Jon A. Peterson, *The Birth of City Planning in the United States, 1840–1917* (Baltimore: Johns Hopkins University Press, 2003), 84. Constance McLaughlin Green is much more sensitive to the racism embedded in this epithet; see Green, *Washington: A History of the Capital, 1800–1950* (Princeton, N.J.: Princeton University Press, 1962), 302, 361, 393.

46 William Anthony Tobin, "In the Shadow of the Capitol: The Transformation of Washington, D.C., and the Elaboration of the Modern U.S. Nation-State" (PhD diss., Stanford University, 1994), 66–67. The planners' combination of ignorance and condescension can be seen in Burnham's statement that residents of dilapidated areas could become "so degraded by long life in the slums that they have lost all power of caring for themselves"; quoted in Paul Boyer, *Urban Masses and Moral Order in America, 1820–1920* (Cambridge, Mass.: Harvard University Press, 1978), 272.

47 "Condemned Plots for U.S. Buildings Cost $1,276,589," *Washington Post*, June 23, 1932, 18; George J. Olszewski, *History of the Mall, Washington, D.C.* (Washington, D.C.: U.S. Office of History and Historic Architecture, Eastern Service Center, 1970), 88, 92–93; Karen Solit, *History of the United States Botanic Garden, 1816–1991* (Washington, D.C.: Government Printing Office, 1993), 41.

48 "Fight Was Near Capitol," *New York Times*, July 29, 1932, 3; Daniel B. Maher, "One Slain, 60 Hurt as Troops Rout B.E.F. with Gas Bombs and Flames," *Washington Post*, July 29, 1932, 1. There were Bonus Army encampments on the Maine Avenue side as well, which were cleared after the initial skirmishes took place along Pennsylvania Avenue.

49 Peets, *On the Art of Designing Cities*, 92. Witold Rybczynski argues that the twentieth-century Mall was "not intended to be an urban space; it belongs to the entire continent"; see "'A Simple Space of Turf': Frederick Law Olmsted Jr.'s Idea for the Mall," in Glazer and Field, *The National Mall*, 63.

50 Many photographs of the park into the 1890s show sheep on the park's meadows; see, for example, the Library of Congress Prints and Photographs catalogue.

51 Quoted in Christopher A. Thomas, *The Lincoln Memorial and American Life* (Princeton, N.J.: Princeton University Press, 2002), 64.

52 For a good overview, see David Summers, *Real Spaces: World Art History and the Rise of Western Modernism* (London: Phaidon, 2003), 130–37, 201–50.

53 Lewis Mumford, *The City in History: Its Origins, Its Transformations, and Its Prospects* (New York: Harcourt, Brace, and Company, 1961), 406.

54 Felix Cotton, "Beauty of Washington Centered upon Its Great Number of Trees," *Washington Post*, June 6, 1926, F6.

55 "Traffic in District Called Big Problem," *Washington Post*, March 28, 1925, 5; "Double-Decked Street Proposal Is Opposed," *Washington Post*, January 16, 1927, 2.

56 "May Dance in Comfort," *Washington Post*, February 13, 1901, 10.

57 "District Downtown Storage Garage Is New Parking Plan," *Washington Post*, August 8, 1924, 4.

58 "Use of Public Space for Parking Cited," *Washington Post*, February 13, 1927, 16.

59 Minutes of the eighth meeting of the National Capital and Park Planning Commission (NCPPC), December 10–11, 1926, indicate the urgency of planning Mall roads "in aid of traffic"; NCPC Records, entry 1, box 1. See also "Formal Designing Is Considered for Developing Mall," *Washington Post*, March 19, 1927, 24; "Fine Arts Plans Relief for Congestion in Mall," *Washington Post*, December 12, 1927, 18; "Mall-Triangle Traffic," *Washington Post*, November 15, 1929, 6.

60 An illustration of the expressway plan is published in Cliff Tarpy, "The Battle for America's Front Yard," *National Geographic*, June 2004, 65.

61 Peets, *On the Art of Designing Cities*, 95.

62 William T. Partridge, Memorandum to Frederic A. Delano, February 21, 1939, in NCPC Records, entry 7, file 535/Mall.

63 Robert J. Lewis, "Needed: A Miracle on the Mall," *Washington Star*, September 13, 1964, SM4, clipping in Grant Memorial vertical file, Library of the Architect of the Capitol.

64 In the first decade after publication of the plan, the heads of the Agriculture Department, the Botanic Garden, and the Army Corps' Office of Public Buildings and Grounds were united in their opposition to the Mall makeover; see, for example, Lessoff, *The Nation and Its City*, 262–63.

65 "Current Comment," *Ohio Farmer*, April 16, 1904, 14.

66 Charles A. Birnbaum and Julie K. Fix, eds., *Pioneers of American Landscape Design II: An Annotated Bibliography* (Washington, D.C.: U.S. Department of the Interior, 1995), 134.

67 U.S. Congress, *The Mall Parkway*, 10–11.

68 Scott, "'A City Designed as a Work of Art,'" 100. It was not quite clear how or even whether Congress authorized the location of this building: a few years later, one senator complained that the matter had been pushed through during a congressional recess; see "Oppose Use of Mall," *Washington Post*, June 16, 1911, 4.

69 "Axman Invades Mall," *Washington Post*, June 19, 1904, E1.

70 "Fight to Save Trees," *Washington Post*, October 18, 1907, 11. On the history behind the Crittenden tree, see "Trees in Washington," *Chicago Tribune*, September 25, 1892, 36; "Early Summer Doings at Nation's Capital," *New York Times*, June 9, 1901, 20; "Historic Trees Here," *Washington Post*, May 25, 1902, 24; "Trees as Monuments," *Washington Post*, August 7, 1904, 12; and "Famous Tree: History May Be Read in Growing Wood," *Boston Globe*, May 21, 1905, SM7.

71 U.S. Congress, Committee on the Library, *Concerning the Location of the Grant Memorial in the Botanic Garden in the City of Washington*, 60th Cong., 1st sess., 1908, H. Rep. 1302, 9, 12; "Head Gardener Defied Congress for Decades," *New York Times*, July 14, 1912, SM12; *Congressional Record*, House, 60th Cong., 1st sess., April 6, 1908, 4449; "Leave Those Trees Alone!" *Washington Post*, October 8, 1907, 6. For similar sentiments, see "Still Trespassing on the Mall," *Washington Star*, October 6, 1907, part 2, 4; "Stay the Ax!" *Washington Star*, October 17, 1907, 4.

72 "To Wipe Out Mall," *Washington Star*, October 10, 1907, 11.

73 "A Showy Sham," *Washington Star*, January 14, 1908, 4; "Group of Le Notre–McKim Tree-Butchers and Nature Butchers," *Washington Star*, January 14, 1908, 1; "Leave Those Trees Alone!" *Washington Post*, October 8, 1907, 6; *Lexington Herald*, April 21, 1908, 5. The scholarly discussion of the opposition typically begins and ends with the *Star*'s 1908 cartoon.

74 *Congressional Record*, 60th Cong., 1st sess., April 6, 1908, 4451, and March 25, 1908, 3931.

75 "Still Trespassing on the Mall," *Washington Star*, October 6, 1907, part 2, 4.

76 "Leave Those Trees Alone!" *Washington Post*, October 8, 1907, 6.

77 Letter to the editor by Mary F. Henderson, *Washington Post*, October 29, 1907, 12.

78 *Washington Star*, October 18, 1907, 4. The writer was Edward Wilton Donn Jr., an architect who would later become well known for his neocolonial design of the Memorial House at the George Washington National Birthplace Monument.

79 According to the *Post*, protests were coming not just locally but from all parts of the country; "Cables to Save Trees," *Washington Post*, October 17, 1907, 11. Opponents were working on several fronts, in the courts and in Congress. In January 1908 a citizen's petition to block the Grant Memorial site was dismissed by the District's Supreme Court. Meanwhile, Taft and the Grant Memorial commission succeeded in blocking committee approval for the various congressional resolutions to change the site, so that they could not come before the full House for a vote. In the spring of 1908, several House representatives made a last-ditch effort to force a floor vote,

and they nearly succeeded. These opponents of the Botanic Garden site managed to muster a majority for their side, a remarkable development given that a solid block of veterans organizations insisted on moving the project forward as planned. It is clear from the House debate that resentment against the McMillan Plan ran deep. Although they were in the majority, the opponents fell short of the two-thirds vote they needed to bring their bill to the floor. See "Woodman, Spare That Tree," *Atlanta Constitution*, January 3, 1908; *Washington Post*, January 14, 1908, 5; "Refuse to Change Site," *Washington Post*, March 26, 1908, 4; *Congressional Record*, 60th Cong., 1st sess., April 6, 1908, 4451–52; "Location Is Still Problem," *Grand Forks Herald*, April 9, 1908, 7; "Would Hasten Monument," *Washington Post*, April 20, 1908, 12; "The Botanical Gardens, One Man's Life Work," *Washington Post*, November 15, 1908, SM6.

80 U.S. Congress, *Concerning the Location of the Grant Memorial in the Botanic Garden in the City of Washington*, 5–6.

81 *Congressional Record*, 60th Cong., 1st sess., April 6, 1908, 4451–52.

82 *New York Times*, July 14, 1912, SM12.

83 "The Botanical Gardens, One Man's Life Work"; "The Crittenden Peace Oak," *New York Times*, May 19, 1928, 8.

84 A survey of the Botanic Garden's surviving trees done in 1932 lists the Crittenden oak. Hand-written annotations to that list made in 1938 by the chief clerk of the Architect of the Capitol show that more than half those trees had died, but the Crittenden tree is one of only two on the list that remain unmarked; U.S. Congress, House Committee on Public Buildings and Grounds, *Hearings before the Committee on Public Buildings and Grounds, on H. Res. 221 and 222*, 74th Cong., 1st sess., 1935, annotations on p. 25, in Vertical File—Trees, Library of the Architect of the Capitol. The Crittenden tree does not appear on a list of saved trees published in "Work on Million-Dollar Mall Now Is 90 Percent Completed," *Washington Post*, October 4, 1936, M15.

85 Thomas, *The Lincoln Memorial and American Life*, 36–81, 213.

86 Ibid., 95–97.

87 U.S. Congress, Joint Committee on the Library, *Establishment of a National Botanical Garden: Hearing before a Joint Committee on the Library*, 66th Cong., 2nd sess., May 21, 1920, 7.

88 Lieut. Col. U. S. Grant 3rd, "Washington's Parks," *Washington Post*, October 9, 1927, R5.

89 Mrs. Charles Edward Russell, "On the Destruction of Trees in the Mall," *Washington Post*, January 6, 1934, 8; Theresa Russell, "On the Destruction of Trees in the Mall," *Washington Post*, January 2, 1934, 6; Harlan E. Glazier, "The Mall Trees," *Washington Post*, January 23, 1934, 8.

90 Katherine Rowland, "Protesting Tree Destruction," *Washington Post*, January 10, 1934, 6.

91 G. Winfield Hurd, "Mall Loses Historic 'Arbor Day' Elm," *Washington Post*, December 16, 1934, B3. The NCPPC's meetings were not open to the public, and within a few years long-simmering opposition to its plans and methods would burst into the

open; see Gerald G. Gross, "City Pattern Long Obsolete, They Say," *Washington Post*, October 8, 1939, B5.

92 "Complaint of a 'Cliff Dweller,'" *Washington Post*, October 26, 1933, 6.

93 "Work on Million-Dollar Mall Is Now 90 Percent Completed."

5. THE MONUMENT TRANSFORMED

1 George Alfred Townsend, "'Gath' at Lincoln's Tomb," *Washington Post*, March 9, 1891, 7.

2 Russell Sturgis, "Sculpture," *Forum*, October 1902, 248.

3 *American Architect and Building News*, July 28, 1888, 657. "It is beyond question that a portrait statue, erected outdoors, is in the nature of the case one of the most difficult of art problems, and that the chances are vastly against the success of such works"; William Howe Downes, "Monuments and Statues in Boston," *New England Magazine*, November 1894, 353. Kirk Savage, *Standing Soldiers, Kneeling Slaves: Race, War, and Monument in Nineteenth-Century America* (Princeton, N.J.: Princeton University Press, 1997), 182.

4 Robert Musil, *Posthumous Papers of a Living Author*, trans. Peter Wortsman (New York: Archipelago Books, 2006), 64. For American examples, see, among many other sources, James Jackson Jarves, "Monuments in America," *New York Times*, October 15, 1879, 5; Clarence Cook, "Monuments of America," *Chautauquan*, June 1886, 524; and "Statues at Random," *New York Times*, February 6, 1902, 8. For the campaign against statue monuments in France, see June Hargrove, *The Statues of Paris: An Open-Air Pantheon* (New York: Vendome Press, 1989), 256–60; and Sergiusz Michalski, *Public Monuments: Art in Political Bondage, 1870–1997* (London: Reaktion Books, 1998), 45–46. For the decline of the statue monument in early twentieth-century Italy, see Anna Notaro, "Resurrecting an Imperial Past: Strategies of Self-Representation and 'Masquerade' in Fascist Rome (1934–1938)," in *The Hieroglyphics of Space: Reading and Experiencing the Modern Metropolis*, ed. Neil Leach (London: Routledge, 2002), 62.

5 Savage, *Standing Soldiers, Kneeling Slaves*, 182–84; Sturgis, "Sculpture," 261; Downes, "Monuments and Statues in Boston," 356; Henry Van Brunt, "Grant's Memorial: What Shall It Be?" *North American Review*, September 1885, 282; "The Pessimist," *Washington Post*, July 14, 1901, 18.

6 Brown quoted in John A. Baker, "Boulevard to Bridge," *Washington Post*, February 26, 1900, 3.

7 U.S. Congress, Senate Committee on the District of Columbia, *The Improvement of the Park System of the District of Columbia*, ed. Charles Moore, 57th Cong., 1st sess., 1902, S. Rep. 166, 80.

8 Savage, *Standing Soldiers, Kneeling Slaves*, 66.

9 U.S. Congress, *The Improvement of the Park System of the District of Columbia*, 82.

10 Marianna van Griswold Rensselaer, "St. Gaudens's Lincoln," *Century Magazine*, November 1887, 37–39.

11 This subject has been little studied. For some suggestive comments, see Michalski, *Public Monuments*, 39–41; and C. Chevillot, "Urbanisme: Le Socle," in *La sculpture française au XIXe siècle* (Paris: Réunion des Musées Nationaux, 1986), 241–53.

12 Benjamin F. Bittinger, *Historic Sketch of the Monument Erected in Washington City under the Auspices of the American Institute of Homeopathy, to the Honor of Samuel Hahnemann* (New York: Knickerbocker Press, ca. 1900). For Harder's approach to planning, see Julius F. Harder, "The City's Plan," *Municipal Affairs*, March 1898, 25–45.

13 Sturgis, "Sculpture," 262.

14 "Statues at Random," *New York Times*, February 6, 1902, 8; Charles A. Carpenter, "Monument to Barnum Next," *Washington Post*, April 22, 1901, 10; Cecil Clay, "Homeopathic Statesmanship," *Washington Post*, April 29, 1901, 10. On Cleveland's veto, see *Transactions of the Fifty-Second Session of the American Institute of Homeopathy* (Philadelphia: Sherman and Co., 1896), 78–80.

15 For an account of the competition, see Dennis Robert Montagna, "Henry Merwin Shrady's Ulysses S. Grant Memorial in Washington, D.C.: A Study in Iconography, Content and Patronage" (PhD diss., University of Delaware, 1987), 8–59.

16 A summary of the process is laid out in a letter to Michael E. Driscoll from Secretary of War Jacob Dickinson, chairman of the Barry Statue Commission, April 8, 1909, in Records of the John Barry Statue Commission, National Archives and Records Administration, RG 42 (hereafter Barry Statue Records), entry 338.

17 Written description of design in Barry Statue Records, entry 339. Partially reprinted in Owen Flanders, "Too Irish for the Irish," *Washington Post*, May 30, 1909, SM1.

18 Letter from Rep. Michael E. Driscoll to Col. Bromwell, March 15, 1909, Barry Statue Records, entry 337. Similar sentiments came from several Irish American organizations, for example, letter from Division No. 6, Ancient Order of Hibernians, to Senator George Peabody Wetmore, February 16, 1909, Barry Statue Records, entry 337. See also "Art Reform Is On," *Washington Post*, November 18, 1910, 1; M. F. O'Donoghue, "Not an Irish Design," *Washington Post*, June 1, 1909, 4.

19 "Views of Visitors in Washington," *Washington Post*, February 11, 1910, 6.

20 "Taft Assures Hibernians," *New York Times*, March 7, 1909, 2; "Barry Model Is O.K.," *Washington Post*, November 26, 1910, 2; letters from Cass Gilbert, July 22, 1909, from the American Institute of Architects, July 22, 1909, from the American Federation of the Arts, July 22, 1909, from Daniel Chester French, April 6, 1910, and from the Art Association of Indianapolis, April 26, 1910, all in Barry Statue Records, entry 337; "Art and Political Pull," *Indianapolis News*, May 13, 1910, clipping in Barry Statue Records, entry 337.

21 "Offers New Barry Statue," *Washington Post*, July 1, 1909, 16; "Quandary on Barry Statue," *Washington Post*, July 16, 1909, 3; Andrew O'Connor, *Le commodore John Barry*,

1906–1909, bronze sculpture, Musée d'Orsay, Paris, France, inventory number RF 3865, JdeP 79, included in the museum's catalog of works at www.musee-or say.fr/en/collections/index-of-works/home.html (accessed February 26, 2008).

22 "Wilson Condemns Foreign Alliances," *New York Times*, May 17, 1914, 11. Wilson's appearance at the unveiling was a surprise: he did not appear on the program because he decided only at the last minute to accept the invitation to speak; "America Must Stand Alone, without Entangling Alliances, Says President," *New York Herald*, May 17, 1914, 1, clipping in Barry Statue Records, entry 339.

23 Letter from Charles Moore, Chairman, Commission of Fine Arts, to General Mark L. Hersey, February 15, 1921, in Records of the Commission of Fine Arts, National Archives and Records Administration, RG 66 (hereafter Records of CFA), entry 4—Art-Criticisms. Moore recommended going to an architect because he thought the architect was more likely to be able to organize an intellectual conception in space.

24 "Plan to Embellish Mall," *Washington Post*, July 19, 1910, 10; "Paris Statuomania," *New York Times*, August 14, 1910, 4; "Statues of Paris," *Washington Post*, October 17, 1910, 6. For more on French disenchantment with the spread of statue monuments, see Hargrove, *The Statues of Paris*, 254–60.

25 "Art Reform Is On," *Washington Post*, November 18, 1910, 1; "Now It's the Farragut Statue," *Washington Post*, November 26, 1910, 6.

26 Felix Cotton, "New Statues for District Shun Horse," *Washington Post*, August 29, 1926, SM3. The equestrian statues erected between 1850 and 1920 were all represented as military commanders in the Revolutionary War, the War of 1812, the Mexican-American War, or the Civil War: Andrew Jackson (1853, Lafayette Square), George Washington (1860, Washington Circle), Winfield Scott (1874, Scott Circle), James B. McPherson (1876, McPherson Square), Nathaniel Green (1877, Stanton Square), George Thomas (1879, Thomas Circle), Winfield Scott Hancock (1896, Pennsylvania Avenue and Seventh Street, NW), John A. Logan (1901, Logan Circle), William T. Sherman (1903, Ellipse), George McClellan (1907, Connecticut and California Avenues), Philip Sheridan (1908, Sheridan Circle), Count Casimir Pulaski (1910, Pennsylvania Avenue and Tenth Street, NW), and Grant (1919, Mall). After 1920, the list shrinks and consists mostly of Methodist ministers and foreign heroes: Joan of Arc (1922, Meridian Hill), Frederick Asbury (1924, Sixteenth Street and Mt. Pleasant), Jose de San Martin (1925, Judiciary Square), Simón Bolívar (1959, Eighteenth Street and Avenue C, NW), George Washington (1959, Washington Cathedral grounds), John Wesley (1961, Wesley Seminary grounds), and Bernardo de Galvez (1976, Twentieth Street and Virginia Avenue, NW).

27 "Equestrian Statues," *Brooklyn Eagle*, December 7, 1897, 6; "The New Statue for the Union League," *Brooklyn Eagle*, September 16, 1894, 21.

28 There is considerable correspondence on this chestnut from Charles Moore and Lorado Taft, both chairmen of the CFA, in the 1920s and 1930s, in Records of CFA, entry 4—Equestrian Statues.

29 "Thomas Circle," Historic American Buildings Survey, Report no. DC-687, 1993.

30 Mary F. Henderson, "Grant Memorial Site," *Washington Post*, October 29, 1907, 12;

Sue A. Kohler and Jeffrey R. Carson, *Sixteenth Street Architecture* (Washington, D.C.: Commission of Fine Arts, 1978), 325–28.

31 U.S. Department of War, *Report of the Chief of Engineers, U.S. Army*, 62nd Cong., 2nd sess., 1911, H. Doc. 124, pt. 3, 2971; George J. Olszewski, *Lincoln Park, Washington, D.C.* (Washington, D.C.: Office of Archeology and Historic Preservation, Division of History, National Park Service, 1968), plate III; William Howard Taft, "Washington: Its Beginning, Its Growth, and Its Future," *National Geographic Magazine*, March 1915, 221–92, photograph of Lincoln Park on p. 259; "Lincoln Park," Historic American Buildings Survey, Report no. DC-677, 1993, 14.

32 Savage, *Standing Soldiers, Kneeling Slaves*, 77–83.

33 The best monograph on the memorial is Christopher A. Thomas, *The Lincoln Memorial and American Life* (Princeton, N.J.: Princeton University Press, 2003).

34 The rhetorical structure of the speech is brilliantly analyzed in Garry Wills, *Lincoln at Gettysburg: The Words That Remade America* (New York: Simon and Schuster, 1992).

35 Thomas, *Lincoln Memorial*, 64–70, 130–31.

36 Elbert Peets, *On the Art of Designing Cities: Selected Essays of Elbert Peets*, ed. Paul D. Spreiregen (Cambridge, Mass.: MIT Press, 1968), 102–3; Dixon Wecter, *The Hero in America: A Chronicle of Hero-Worship* (New York: Scribner's, 1941), 254.

37 On the effect of this asymmetry, see "Reading Lincoln's Face," *New York Times*, August 15, 2007, A20.

38 Thomas, *Lincoln Memorial*, 55.

39 Theodore Roosevelt, "In Praise of the Strenuous Life," in *The American Reader: Words That Moved a Nation*, ed. Diane Ravitch (New York: Harper Collins, 2000), 335. Dennis Montagna connects Shrady's design for the Grant Memorial to the masculine ideal of strife, in "Henry Merwin Shrady's Ulysses S. Grant Memorial in Washington, D.C.," 134, 142–43, 168.

40 "The Nobler Side of War," *Century Illustrated Magazine*, September 1898, 794, quoted in Montagna, "Henry Merwin Shrady's Ulysses S. Grant Memorial," 169.

41 Quoted in Dennis Robert Montagna, "A Monument for a New Century," *Army Magazine*, July 1, 2003, www.ausa.org/webpub/DeptArmyMagazine.nsf/byid/CCRN-6CCS9H.

42 U.S. Grant 3rd to Brig. Gen. A.S. Daggett, January 16, 1926, in Records of CFA, entry 4—Equestrian Statues.

43 European war memorials showing wounded or dying defenders of the nation were much more common; see Savage, *Standing Soldiers, Kneeling Slaves*, 248 n. 3.

44 De Benneville Randolph Keim, *Sherman: A Memorial in Art, Oratory, and Literature by the Society of the Army of the Tennessee with the Aid of the Congress of the United States of America* (Washington, D.C.: Government Printing Office, 1904), 29.

45 Judith Herman, *Trauma and Recovery* (New York: Basic Books, 1992), 34.

46 There are one or two apparent exceptions in the United States, but these too tend to prove the rule. The Monumental Church in Richmond, for example, whose entrance

featured a tomb for the victims of the 1811 Richmond Theatre fire, is better understood as part of a much older church tomb tradition. The Fort Dearborn Massacre Monument erected in Chicago in 1893 commemorated the white victims of an Indian assault, but the imagery emphasized the heroic resistance and rescue of a white woman. For more on the history of the victim monument, see Kirk Savage, "Trauma, Healing, and the Therapeutic Monument," in *Terror, Culture, Politics: Rethinking 9/11*, ed. Daniel Sherman and Terry Nardin (Bloomington: Indiana University Press, 2006), 103–20.

47 These examples can be found in the Smithsonian American Art Museum's Inventory of American Sculpture, http://americanart.si.edu/art_info/inventories-intro.cfm.

48 Holger Hoock, "The British Military Pantheon in St Paul's Cathedral: The State, Cultural Patriotism, and the Politics of National Monuments, c. 1790–1820," in *Pantheons: Transformations of a Monumental Idea*, ed. Richard Wrigley and Matthew Craske (Aldershot, U.K.: Ashgate, 2004), 89. Early examples in the United States of war memorials with names of the dead include obelisks erected at Concord, Massachusetts, and Wyoming, Pennsylvania, in the mid-1830s.

49 Silvina Fernandez-Duque, "First Division Monument," National Park Service, 2006, www.nps.gov/whho/historyculture/first-division-monument.htm (accessed November 28, 2007); "First Division Monument, Washington, D.C.," *American Architect and the Architectural Review*, December 3, 1924, 525.

50 "Approve Clean-Up of Water Street," *Washington Post*, September 24, 1921, 2; Gertrude R. Brigham, "Statue of Victory Will Top Shaft of First Division Memorial Monument," *Washington Post*, April 22, 1923, 7; Fernandez-Duque, "First Division Monument."
 Art and architecture magazines at the time were full of articles lambasting Civil War soldier monuments and warning against a similar repetition in response to World War I; see, for example, a special issue of the *American Magazine of Art*, May 1919, 233–75; and the bibliography in *Architectural Record* 46 (1919): 278.

51 "Save the Ellipse," *Washington Post*, September 25, 1935, 8.

52 "To Men Who Died for Women," *New York Times*, April 29, 1912, 3; "Mrs. H. P. Whitney Wins," *New York Times*, January 8, 1914, 5. For more on the context, see Steven Biel, *Down with the Old Canoe: A Cultural History of the Titanic Disaster* (New York: W. W. Norton and Company, 1996), 35–37.

53 "Repairing River's Damage," *Work: A Journal of Progress*, September 1936, 13.

54 The classic account is Merrill D. Peterson, *The Jefferson Image in the American Mind* (1960; reprint, Charlottesville: University of Virginia Press, 1998), 361, 377–78, 420–32.

55 James W. Loewen, *Lies across America: What Our Historic Sites Get Wrong* (New York: Simon and Schuster, 2007), 307–12, has the most careful historical analysis of the inscriptions.

56 The fullest account is Karal Ann Marling and John Wetenhall, *Iwo Jima: Monuments, Memories, and the American Hero* (Cambridge, Mass.: Harvard University Press, 1991).

57 Frank Getlein, "A Tribute, Yes—But Is It Art?" *Washington Star*, April 6, 1969, clipping in Records of CFA, entry 17—Project Files–Boy Scout Memorial. Another ex-

ample is John McKelway, "Rambler," *Washington Star*, November 10, 1964, clipping in Vertical Files—Memorials A–B, Washingtoniana Division, Washington, D.C., Public Library.

6. THE CONSCIENCE OF THE NATION

1 Robert J. Lewis, "Needed: A Miracle on the Mall," *Washington Star*, September 13, 1964, SM4, clipping in Grant Memorial vertical file, Library of the Architect of the Capitol.

2 Alfred Friendly, "Take a Deep Breath, Folks, the Capital's Tourist Peak Is Yet to Come," *Washington Post*, July 23, 1939, B3; Luther B. Huston, "To Nation's Capital," *New York Times*, April 6, 1941, XX1.

3 Alexander R. George, "Lincoln Shrine Has Awed 20 Million," *Washington Post*, May 25, 1947, B3; "Lincoln Greatest of All Americans, Robsion Declares," *Washington Post*, February 13, 1927, 2.

4 Scott A. Sandage, "A Marble House Divided: The Lincoln Memorial, the Civil Rights Movement, and the Politics of Memory, 1939–1963," *Journal of American History* 80 no. 1 (1993): 135–67; "A.M.E. Zion Convention Praised by Governors," *Washington Post*, August 5, 1926, 17.

5 Ernest K. Lindley, "Voice from the Temple," *Washington Post*, April 12, 1939, 9; Sandage, "A Marble House Divided," quotation on 144.

6 Quotations from "50,000 Expected Here for Civil Rights Rally," *Washington Post and Times Herald*, May 17, 1957, B1; "Washington Pilgrimage," *New York Times*, May 19, 1957, E12.

7 Sandage, "A Marble House Divided," quotation on 161. For a historical overview of political protest in Washington, see Lucy G. Barber, *Marching on Washington: The Forging of an American Political Tradition* (Berkeley and Los Angeles: University of California Press, 2002).

8 On the Grant Memorial protests, see Cabell Phillips, "350 Vietnam Protesters Are Arrested in Capital," *New York Times*, August 10, 1965, 3; and Leroy F. Aarons, "17 Arrested in House Hearing Disorders," *Washington Post*, August 17, 1966, A1. For reporting on the broader context, see, for example: "Protest on Vietnam in Capital Today," *New York Times*, April 17, 1965, 3; "Throng of 20,000 Marches in Protest of Vietnam War," *Washington Post*, November 28, 1965, A1; Ben A. Franklin, "New Left Vanguard Arrives for Inaugural Protest," *New York Times*, January 19, 1969, 57; Paul W. Valentine, "Viet Victory Backers to Rally Here April 4," *Washington Post*, March 21, 1970, B5; and "Vignettes of a Peaceful Peace Rally," *Washington Post*, April 25, 1971, 16.

9 Nicholas von Hoffman, "Television Blackout," *Washington Post*, November 17, 1969, D1.

10 John Herbers, "250,000 War Protesters Stage Peaceful Rally in Washington," *New York Times*, November 16, 1969, 1; Richard Harwood, "Largest Rally in Washington

History Demands Rapid End to Vietnam War," *Washington Post*, November 16, 1969, A1; Ivan C. Brandon and Joseph D. Whitaker, "1,000 Attend Panther Meeting," *Washington Post*, June 20, 1970, B1.

11　"87 Arrested in Protest at Lincoln Memorial," *New York Times*, December 29, 1971, 32; Don Oberdorfer, "Dawn at Memorial: Nixon, Youths Talk," *Washington Post and Times Herald,* May 10, 1970, A1; Robert B. Semple Jr., "Nixon, in Pre-Dawn Tour, Talks to War Protesters," *New York Times*, May 10, 1970, 1.

12　Nicholas Adams, *Skidmore, Owings & Merrill: SOM since 1936* (London: Phaidon, 2007), 290.

13　Lev Dobriansky, *The Vulnerable Russians* (New York: Pageant Press, 1967), 405. Dobriansky was the prime mover behind the monument campaign, and he devotes a chapter in his book to the history of the monument. On the dedication, see "Eisenhower Calls for War against Tyranny," *Los Angeles Times*, June 28, 1964, B1; Ben A. Franklin, "Eisenhower Raises Issue of Freedom," *New York Times*, June 28, 1964, 39; and "Shevchenko Statue Here Unveiled by Eisenhower," *Washington Star*, June 28, 1964, clipping in Records of the Commission of Fine Arts, National Archives and Records Administration, RG 66, entry 17—Project Files–Shevchenko Memorial.

14　Charlayne Hunter, "20,000 at Unveiling of Statue to Mary Bethune in Capital," *New York Times*, July 11, 1974, 11; "Voice of the Courier: Bethune Statue Unveiled," *New Pittsburgh Courier*, July 20, 1974, 7.

15　"The Fighting First," *New York Times,* August 24, 1957, 14; "First Division Unit Expands Memorial," *New York Times,* August 25, 1957, 45; Susanna McBee, "First Division Dedicates Memorial to War Dead," *Washington Post and Times Herald,* August 25, 1957, A14; Silvina Fernandez-Duque, "First Division Monument," National Park Service, 2006, www.nps.gov/whho/historyculture/first-division-monument.htm (accessed November 28, 2007). Since 1977, a Desert Storm addition has also been made, listing twenty-seven dead.

16　G. Kurt Piehler, *Remembering War the American Way* (Washington, D.C.: Smithsonian Institution Press, 1995).

17　Maya Ying Lin, *Grounds for Remembering: Monuments, Memorials, Texts* (Berkeley, Calif.: Doreen B. Townsend Center, 1995), 13, http://repositories.cdlib.org/townsend/occpapers/3/; Herbert Read quotations from *London Bulletin*, October 1938, 6, reprinted in Ellen C. Oppler, ed., *Picasso's Guernica* (New York: Norton, 1988), 217.

18　Quoted in Jan C. Scruggs and Joel L. Swerdlow, *To Heal a Nation: The Vietnam Veterans Memorial* (New York: HarperPerennial, 1992), 53. Charles L. Griswold makes the point that the VVM is "therapeutic" in "The Vietnam Veterans Memorial and the Washington Mall: Philosophical Thoughts on Political Iconography," in *Critical Issues in Public Art: Content, Context, and Controversy*, ed. Harriet F. Senie and Sally Webster (Washington, D.C.: Smithsonian Institution Press, 1992), 92. The most probing analysis of the concept of "healing" in the memorial can be found in Patrick Hagopian, *The Vietnam War in American Memory: Veterans, Memorials, and the Politics of Healing* (Amherst: University of Massachusetts Press, 2009), which came out too late to in-

corporate into my book; my thanks to Prof. Hagopian for sharing some of his thoughts by e-mail.

19 Judith Herman, *Trauma and Recovery* (New York: Basic Books, 1992), 33. For the politics surrounding the psychiatric designation, see Gerald Nicosia, *Home to War: A History of the Vietnam Veterans' Movement* (New York: Carroll and Graf, 2004), 198–209.

20 On Lin's competition entry, see Mary McLeod, "The Battle for the Monument: The Vietnam Veterans Memorial," in *The Experimental Tradition: Essays on Competitions in Architecture*, ed. Hélène Lipstadt (New York: Princeton Architectural Press, 1989), 115–38.

21 Lin, *Grounds for Remembering*, 9, 13.

22 Patrick Hagopian, "The Commemorative Landscape of the Vietnam War," in *Places of Commemoration: Search for Identity and Landscape Design*, ed. Joachim Wolschke-Bulmahn (Washington, D.C.: Dumbarton Oaks, 2001), 335–36.

23 Lin, *Grounds for Remembering*, 11–12.

24 Hagopian, "The Commemorative Landscape of the Vietnam War," 332–35.

25 Lin, *Grounds for Remembering*, 12–14.

26 The best documentation of reactions to the memorial is Laura Palmer's *Shrapnel in the Heart: Letters and Remembrances from the Vietnam Veterans Memorial* (New York: Vintage Books, 1988). See, for example, 95, 115.

27 Herman, *Trauma and Recovery*, 70–71.

28 Kirk Savage, "Uncelebrated War: The Vietnam Veterans Memorial," *Threepenny Review*, Spring 1984, 24–25.

29 For more on this point, see Kirk Savage, "Trauma, Healing, and the Therapeutic Monument," in *Terror, Culture, Politics: Rethinking 9/11*, ed. Daniel Sherman and Terry Nardin (Bloomington: Indiana University Press, 2006), 103–20.

30 Hagopian, *The Vietnam War in American Memory*, discusses in detail the divisions within the Reagan administration over the memorial.

31 Nicosia, *Home to War*, esp. 493.

32 Scruggs and Swerdlow, *To Heal a Nation*, 79–80.

33 Several writers, in different ways, have argued that these highly personal offerings are a response to the impersonality or emptiness of the names, as if visitors are trying to fill a void created by the memorial's abstraction. See, for example, Karal Ann Marling and Robert Silberman, "The Statue Near the Wall: The Vietnam Veterans Memorial and the Art of Remembering," *Smithsonian Studies in American Art* 1 no. 1 (1987): 14; and Marita Sturken, *Tangled Memories: The Vietnam War, the AIDS Epidemic, and the Politics of Remembering* (Berkeley and Los Angeles: University of California Press, 1997), 61. I take the opposite view: that the therapeutic power of the memorial itself summons these offerings. Precisely because the memorial *does* speak to the visitors' therapeutic needs, because it encourages its viewers to engage with it, they feel that their own personal testimonials belong in the collective artifact. To claim

that the memorial, or its list of names, is "depersonalized" is off the mark, since the therapeutic memorial personalizes the viewing experience in a new way. For more on the phenomenon of offerings, see Kristin Ann Hass, *Carried to the Wall: American Memory and the Vietnam Veterans Memorial* (Berkeley and Los Angeles: University of California Press, 1998).

34 This is precisely the point made in two of the most cogent right-wing critiques published after Lin's walls were erected: Tod Lindberg, "Of Arms, Men and Monuments," *Commentary*, October 1984, 51–56; and William Hubbard, "A Meaning for Monuments," *Public Interest*, Winter 1984, 17–30.

35 Scruggs and Swerdlow, *To Heal a Nation*, 53.

36 "New Casualty Category at the Vietnam Memorial," *New York Times*, July 5, 2000, A13. On the official criteria of inclusion, see "Criteria and Sources for Names," Vietnam Veteran's Memorial Fund (VVMF), www.vvmf.org/index.cfm?SectionID=108 (accessed February 27, 2008).

37 Mackubin Thomas Owens, "Vietnam Veterans Aren't Victims," *Wall Street Journal*, July 13, 2000, A26; "Vietnam Victims: A State of Mind?" *Wall Street Journal*, July 21, 2003, A11; Monte Reel, "Suicide May Keep Veteran from Eternal Recognition," *Washington Post*, March 6, 2004, B1. The Department of Defense criteria, as explained on the VVMF Web site, include "deaths occurring anywhere as the result or aftermath of an initial casualty occurring in a combat area."

38 The American Battle Monuments Commission (ABMC) is responsible for a network of American military cemeteries and monuments around the world, commemorating the two world wars. But its mandate has expanded to cover national war memorials in Washington as well. For example, the ABMC was responsible for the design and wording of the plaque added at the VVM, even though the VVM Fund continues to raise money and develop programs for the memorial itself. For recent work on the ABMC, see Carole Blair, V. William Balthrop, and Neil Michel, "Arlington-sur-Seine: War Commemoration and the Perpetual Argument from Sacrifice," in *Proceedings of the Sixth Conference of the International Society for the Study of Argumentation, Amsterdam, June 2006*, ed. Frans H. Eemeren, J. Anthony Blair, Charles A. Willard, and Bart Garssen (Amsterdam: Sic Sat, 2006), 145–52.

39 National Park Service, "Freedom Is Not Free," ca. 2002, www.nps.gov/kwvm/memorial /freedom.htm (accessed August 20, 2006).

40 Herman, *Trauma and Recovery*, 73.

41 Marita Sturken, among others, has noted the absence of Vietnamese names on the VVM; Sturken, "The Wall, the Screen, and the Image: The Vietnam Veterans Memorial," *Representations*, no. 35 (1991): 118–42, esp. 137.

42 On the aftermath of combat experience in Iraq and Afghanistan, see, for example, Bob Herbert, "Help Is on the Way," *New York Times*, November 22, 2008, A19; and a letter to the editor written in rebuttal, *New York Times*, November 25, 2008, A24.

43 Quoted in W. J. T. Mitchell, *Picture Theory: Essays on Verbal and Visual Representation* (Chicago: University of Chicago Press, 1994), 264.

44 Vietnamese Adoptee Network (VAN) listserv; privacy concerns prevent full citation.

45 James E. Young, *The Texture of Memory: Holocaust Memorials and Meaning* (New Haven, Conn.: Yale University Press, 1993), 338; Edward T. Linenthal, *Preserving Memory: The Struggle to Create America's Holocaust Museum* (New York: Viking, 1995), 17–20, 27–28, 262–63.

46 Ibid., 37.

47 Rustom Bharucha, "Between Truth and Reconciliation: Experiments in Theater and Public Culture," in *Experiments with Truth: Transitional Justice and the Processes of Truth and Reconciliation,* ed. Okwui Enwezor (Ostfildern-Ruit: Hatje Cantz, 2002), 379. On secondary trauma, see David B. Pillemer, "Can the Psychology of Memory Enrich Historical Analyses of Trauma?" *History and Memory* 16, no. 2 (2004): 144–48.

48 Herman, *Trauma and Recovery,* 196–97.

49 One point of controversy in the exhibit was whether to mention the Armenian genocide; this was an especially vexed political issue because of Israel's close alliance with Turkey. See Linenthal, *Preserving Memory,* 262–63.

50 Robert Siegel interview with Jan Scruggs, May 30, 2003, *All Things Considered,* National Public Radio; "Vietnam Veterans Memorial Center Overview," Vietnam Veterans Memorial Fund, www.vvmf.org/index.cfm?SectionID=549 (accessed January 1, 2008).

51 Lawrence Hashima, "Public Memories, Community Discord: The Battle over the 'Japanese American Creed,'" paper presented at the annual meeting of the American Studies Association, Washington, D.C., November 10, 2001.

52 Ibid.

53 Letter to Rita Takahashi from National Park Service director Robert Stanton, July 12, 2000, Japanese American Voice, www.javoice.com/nps.html (accessed February 26, 2008).

54 Amanda J. Cobb, "The National Museum of the American Indian as Cultural Sovereignty," *American Quarterly* 57, no. 2 (2005): 485–506.

55 Dinitia Smith, "For the Victims of Communism," *New York Times,* December 23, 1995, A16; John J. Miller, "A Goddess for Victims—The Victims of Communism Memorial Comes to Fruition," *National Review,* May 28, 2007, 28–30. The working group behind the project included Lee Edwards of the Heritage Foundation and Grover Norquist of Americans for Tax Reform, and major financial contributions came from former senator Jesse Helms and Alfred Regnery, the publisher of the *American Spectator.*

56 As reported in the media at the time, the Chinese Foreign Ministry lodged a protest; "China Blasts Bush Tribute to Victims of Communism," Reuters, June 13, 2007, www .reuters.com/article/worldNews/idUSPEK20924820070614 (accessed January 2, 2008).

57 Philip Kennicott, "The Meaning of a Marker for 100 Million Victims," *Washington Post,* June 13, 2007, C1; "For the Record: Excerpts of Bush's Remarks," *Ukrainian Weekly,* July 1, 2007, 5. The full text of President Bush's address can be found in "President Bush Attends Dedication of Victims of Communism Memorial," news release,

The White House, June 12, 2007, www.whitehouse.gov/news/releases/2007/06/20070612–2.html (accessed June 1, 2008).

58 Billy Collins, *The Trouble with Poetry and Other Poems* (New York: Random House, 2005), 9–10.

59 Judith Butler, *Precarious Life: The Powers of Mourning and Violence* (London: Verso, 2004), 32–38. "There are no obituaries for the war casualties that the United States inflicts, and there cannot be. If there were to be an obituary, there would have had to have been a life, a life worth noting, a life worth valuing and preserving, a life that qualifies for recognition" (p. 34).

60 The inscription on the Franklin Delano Roosevelt Memorial is taken from a speech Roosevelt gave in wartime on February 12, 1943.

7. AN END TO WAR, AN END TO MONUMENTS?

1 National Transportation Safety Board, "Flight Path Study—American Airlines Flight 77," February 19, 2002, National Security Archive, George Washington University, www.gwu.edu/%7Ensarchiv/NSAEBB/NSAEBB196/doc02.pdf (accessed August 18, 2006).

2 President Chester Arthur's name is inscribed on the capstone of the Washington Monument, where it is invisible, and William Jefferson Clinton's name appears on a plaque inside the Franklin Delano Roosevelt Memorial's information center. The Vietnam Veterans Memorial and the Korean War Veterans Memorial, to name just two recent examples, do not include names of sitting presidents.

3 E-mail to Travis Nygard, June 17, 2008, from Rosanna Weltzin, acting chief of Visitor Services, National Mall and Memorial Parks.

4 Nicolaus Mills, *Their Last Battle: The Fight for the National World War II Memorial* (New York: Basic Books, 2004), 90–94, 190–91.

5 Figures compiled independently by the Stockholm International Peace Research Institute, "Recent Trends in Military Expenditure," 2007, www.sipri.org/contents/milap/milex/mex_trends.html (accessed December 20, 2007).

6 Mills, *Their Last Battle*, 131–58.

7 Cultural Landscape Program, *Cultural Landscape Report: West Potomac Park, Lincoln Memorial Grounds, National Capital Parks Central* (Washington, D.C.: Government Printing Office, 1999), 18–24, 31–36.

8 Petula Dvorak, "Washington Monument Subtly Fortified," *Washington Post*, July 1, 2005, A1. For more on the circuitousness of pedestrian access, see Judy Scott Feldman, "Turning Point: The Problematics of Building on the Mall Today," in *The National Mall: Rethinking Washington's Monumental Core*, ed. Nathan Glazer and Cynthia R. Field (Baltimore: Johns Hopkins University Press, 2008), 136–39.

9 Sally Stein, "The President's Two Bodies: Stagings and Restagings of FDR and the New Deal Body Politic," *American Art* 18, no. 1 (2004): 33–57. For an example of the right-wing critique of the monument, see Michael Valdez Moses, "A Rendezvous with Density: The FDR Memorial and the Clinton Era," *ReasonOnline*, April 2001, www.reason.com/news/show/27984.html (accessed November 10, 2008).

10 James Reston Jr., "The Monument Glut," *New York Times,* September 10, 1995, SM49; William Dean Howells, "Question of Monuments," *Atlantic Monthly*, May 1866, 647.

11 Reston, "The Monument Glut," SM48.

12 Robert Siegel interview with Jan Scruggs, May 30, 2003, *All Things Considered*, National Public Radio.

13 "Vietnam Veterans Memorial Center Overview," Vietnam Veterans Memorial Fund, www.vvmf.org/index.cfm?SectionID=549 (accessed January 1, 2008).

14 The American Battle Monuments Commission is probably the single most important institution in this regard, having managed the design of the memorials for Korean War veterans and World War II veterans, as well as the plaque added at the VVM. The organization is explicitly dedicated to upholding the ethic of military sacrifice and service.

15 National Capital Planning Commission, *Memorials and Museums Master Plan Sep*tember 2001, 5, www.ncpc.gov/UserFiles/File/2M1_33.pdf (accessed June 4, 2008); *Commemorative Works Act*, Public Law 108–126 as amended (2003), http://uscode.house.gov/download/pls/40C89.txt (accessed June 4, 2008). For maps of the original reserve area and the expanded version adopted by Congress in 2003, see National Capital Planning Commission, "Commemorative Zone Policy," January 2000, www.ncpc.gov/initiatives/pg.asp?p=commemorativezonepolicy (accessed June 4, 2008). On the Martin Luther King Memorial controversy, see Shaila Dewan, "Larger than Life, More to Fight Over," *New York Times*, May 18, 2008, D4. Essentially, the King memorial is an attempt to meld two commemorative models—a huge heroic icon with a contemplative landscape space. Although the nearby Lincoln and Jefferson memorials are also combinations of iconic statuary and contemplative space, within architectural rooms, the scale and bulk of the statue in the King memorial would effectively marginalize the landscape around it. As the controversy has developed, the memorial as a whole has become identified primarily with the statue.

16 One of the more interesting and well-developed proposals for reshaping the Mall in the twenty-first century is the National Coalition to Save Our Mall's Third Century Initiative, www.nationalmall.net (accessed May 24, 2008). For a sobering analysis of the many challenges, see Feldman, "Turning Point," 154–58.

Selected Bibliography

ARCHIVAL SOURCES

Historic New England, Boston, Mass.: Thomas Lincoln Casey Papers
Kiplinger Library, Historical Society of Washington, Washington, D.C.: Vertical files
Library of Congress, Washington, D.C.: William W. Corcoran Papers, Justin S. Morrill Papers
Library of the Architect of the Capitol, Washington, D.C.: Vertical files
National Archives and Records Administration, Washington D.C.: Record Groups 42, 66, 79, 328

DATABASES

American Memory, Library of Congress, http://memory.loc.gov
American Periodical Series, ProQuest
Digital Sanborn Maps, 1867–1970, http://sanborn.umi.com/
Early American Newspapers, NewsBank
Historic American Buildings Survey/Historic American Engineering Record, 1933–present, Library of Congress, http://memory.loc.gov/ammem/collections/habs_haer/
Historical Newspapers, ProQuest
Inventories of American Painting and Sculpture, Smithsonian American Art Museum, http://americanart.si.edu/art_info/inventories-intro.cfm
Making of America, Cornell University Library, http://cdl.library.cornell.edu/moa/
Prints and Photographs Online Catalogue, Library of Congress, www.loc.gov/rr/print/catalog.html
U.S. Congressional Serial Set, NewsBank
United States Federal Census, 1900 and 1920, http://Ancestry.com

PUBLISHED SOURCES

Aarons, Leroy F. "17 Arrested in House Hearing Disorders." *Washington Post*, August 17, 1966, A1, A6.
Achenbach, Joel. *The Grand Idea: George Washington's Potomac and the Race to the West.* New York: Simon and Schuster, 2004.
Adams, Henry. *The Education of Henry Adams: An Autobiography.* 2 vols. New York: Time, 1964.

Adams, John Quincy. *Memoirs of John Quincy Adams, Comprising Portions of His Diary from 1795 to 1848*. Edited by Charles Francis Adams. 12 vols. Philadelphia: J. B. Lippincott and Company, 1874.

Adams, Nicholas. *Skidmore, Owings & Merrill: SOM since 1936*. London: Phaidon, 2007.

Anderson, Benedict R. O'G. *Imagined Communities: Reflections on the Origin and Spread of Nationalism*. London: Verso, 1983.

"Archaeological Investigations: National Museum of the American Indian Site, Washington, D.C." Architectural History and Historic Preservation Division of the Smithsonian Institution, 1997, www.si.edu/oahp/nmaidig/start.htm.

Aron, Cindy Sondik. *Working at Play: A History of Vacations in the United States*. New York: Oxford University Press, 1999.

Atkinson, David, and Denis Cosgrove. "Urban Rhetoric and Embodied Identities: City, Nation, and Empire at the Vittorio Emanuele II Monument in Rome, 1870–1945." *Annals of the Association of American Geographers* 88, no. 1 (1998): 28–49.

Bacon, Edmund N. *Design of Cities*. New York: Viking, 1967.

Baker, John A. "Boulevard to Bridge." *Washington Post*, February 26, 1900, 3.

Baltimore and Ohio Railroad Company. *Guide to Washington*. Washington, D.C.: Press of J. D. Lucas, 1892.

Bancroft, Frederic. *Slave Trading in the Old South*. New York: Frederick Ungar Publishing, 1959.

Barber, Lucy G. *Marching on Washington: The Forging of an American Political Tradition*. Berkeley and Los Angeles: University of California Press, 2002.

Barthes, Roland. *The Eiffel Tower and Other Mythologies*. Translated by Richard Howard. Berkeley and Los Angeles: University of California Press, 1997.

B.B. "The Art-Decorations of the Capitol at Washington." *The Independent* (New York), July 22, 1858, 1.

———. "Persico's Columbus." *The Independent* (New York), September 29, 1859, 1.

Bedini, Silvio A. *The Jefferson Stone: Demarcation of the First Meridian of the United States*. Frederick, Md.: Professional Surveyors Pub. Co., 1999.

Bellows, Henry W. "The Century Gone and the Century to Come in Our National Life." *Unitarian Review and Religious Magazine*, July 1876, 40–55.

Benjamin, S. G. W. "Sculpture in America." *Harper's New Monthly*, April 1879, 657–73.

Benjamin, Walter. *One-Way Street, and Other Writings*. Translated by Edmund Jephcott and Kingsley Shorter. London: Verso, 1979.

———. "The Work of Art in the Age of Mechanical Reproduction." In *The Continental Aesthetics Reader*, ed. Clive Cazeaux, 322–43. 1936. Reprint, London: Routledge, 2000.

Berg, Scott W. *Grand Avenues: The Story of the French Visionary Who Designed Washington, D.C.* New York: Pantheon, 2007.

Bergdoll, Barry. *European Architecture, 1750–1890*. New York: Oxford University Press, 2000.

Bharucha, Rustom. "Between Truth and Reconciliation: Experiments in Theater and Public Culture." In *Experiments with Truth: Transitional Justice and the Processes of Truth and Reconciliation*, ed. Okwui Enwezor, 361–88. Ostfildern-Ruit: Hatje Cantz, 2002.

Biel, Steven. *Down with the Old Canoe: A Cultural History of the Titanic Disaster*. New York: W. W. Norton and Company, 1996.

Birnbaum, Charles A., and Julie K. Fix, eds. *Pioneers of American Landscape Design II: An Annotated Bibliography*. Washington, D.C.: U.S. Department of the Interior, 1995.

Bittinger, Benjamin F. *Historic Sketch of the Monument Erected in Washington City under the Auspices of the American Institute of Homeopathy, to the Honor of Samuel Hahnemann*. New York: Knickerbocker Press, ca. 1900.

Blair, Carole, V. William Balthrop, and Neil Michel. "Arlington-sur-Seine: War Commemo-ration and the Perpetual Argument from Sacrifice." In *Proceedings of the Sixth Conference of the International Society for the Study of Argumentation, Amsterdam, June 2006*, ed. Frans H. van Eemeren, J. Anthony Blair, Charles A. Willard, and Bart Garssen, 145–52. Amsterdam: Sic Sat, 2006.

Blight, David W. *Race and Reunion: The Civil War in American Memory*. Cambridge, Mass.: Harvard University Press, 2001.

Borchert, James. *Alley Life in Washington: Family, Community, Religion, and Folklife in the City, 1850–1970*. Urbana: University of Illinois Press, 1980.

Bowling, Kenneth R. *The Creation of Washington, D.C.: The Idea and Location of the American Capital*. Fairfax, Va.: George Mason University Press, 1991.

Boyer, Paul. *Urban Masses and Moral Order in America, 1820–1920*. Cambridge, Mass.: Harvard University Press, 1978.

Brandon, Ivan C., and Joseph D. Whitaker. "1,000 Attend Panther Meeting." *Washington Post*, June 20, 1970, B1, B8.

Brigham, Gertrude R. "Statue of Victory Will Top Shaft of First Division Memorial Monu-ment." *Washington Post*, April 22, 1923, 7.

Britannica Concise Encyclopedia. Chicago: Encyclopaedia Britannica, 2006.

Broune, H. J. "A Tale of Two Capitals." *North American Review*, June 1894, 759–60.

Bryan, Wilhelmus Bogart. *A History of the National Capital from Its Foundation through the Period of the Adoption of the Organic Act*. 2 vols. New York: Macmillan Company, 1914.

Burnham, Daniel. "White City and Capital City." *Century Illustrated Magazine*, February 1902, 620.

Bush-Brown, H. K. "Sculpture in Washington." In *Papers Relating to the Improvement of the City of Washington, District of Columbia*, compiled by Glenn Brown, 70–77. Washington, D.C.: Government Printing Office, 1901.

Bushong, William Brian. "Glenn Brown, the American Institute of Architects, and the Development of the Civic Core of Washington, D.C." PhD dissertation, George Washing-ton University, 1988.

Butler, Judith. *Precarious Life: The Powers of Mourning and Violence*. London: Verso, 2004.

Campanella, Thomas J. *Republic of Shade: New England and the American Elm*. New Haven, Conn.: Yale University Press, 2003.

Carleton, Will. *City Ballads*. New York: Harper and Brothers, 1886.

Carlyle, Thomas. "Hudson's Statue." In *Latter-Day Pamphlets*, 323–70. 1851. Reprint, Boston: Phillips Sampson, 1855.

Carpenter, Charles A. "Monument to Barnum Next." *Washington Post*, April 22, 1901, 10.

Catton, Bruce. "A Pilgrimage to Washington." *Holiday*, June 1959, 54–63, 191–94.

Çelik, Zeynep, Diane G. Favro, and Richard Ingersoll, eds. *Streets: Critical Perspectives on Public Space*. Berkeley and Los Angeles: University of California Press, 1994.

Certeau, Michel de. *The Practice of Everyday Life*. Berkeley and Los Angeles: University of California Press, 2002.

Chevillot, C. "Urbanisme: Le Socle." In *La sculpture française au XIXe siècle*, 241–53. Paris: Réunion des Musées Nationaux, 1986.

Choay, Françoise. *The Invention of the Historic Monument*. Translated by Lauren M. O'Con-nell. Cambridge: Cambridge University Press, 2001.

Chow, Esther Ngan-ling. "From Pennsylvania Avenue to H Street, NW: The Transformation of Washington's Chinatown." In *Urban Odyssey: A Multicultural History of Washington, D.C.*,

ed. Francine Curro Cary, 190–207. Washington, D.C.: Smithsonian Institution Press, 1996.

Christian, Kathleen Wren. "Poetry and 'Spirited' Ancient Sculpture in Renaissance Rome: Pomponio Leto's Academy to the Sixteenth-Century Sculpture Garden." In *Aeolian Winds and the Spirit of Renaissance Architecture*, ed. Barbara Kenda, 103–24. London: Routledge/Taylor and Francis, 2006.

Clarke, S. C. "Stanton Place." *Washington Post*, February 28, 1886, 5.

Clay, Cecil. "Homeopathic Statesmanship." *Washington Post*, April 29, 1901, 10.

Cleary, Richard L. *The Place Royale and Urban Design in the Ancien Régime*. New York: Cambridge University Press, 1998.

Cobb, Amanda J. "The National Museum of the American Indian as Cultural Sovereignty." *American Quarterly* 57, no. 2 (2005): 485–506.

Cocks, Catherine. *Doing the Town: The Rise of Urban Tourism in the United States, 1850–1915*. Berkeley and Los Angeles: University of California Press, 2001.

Cohen, Jeffrey A., and Charles E. Brownell, eds. *The Architectural Drawings of Benjamin Henry Latrobe*. New Haven, Conn.: Yale University Press, 1994.

Collins, Billy. *The Trouble with Poetry and Other Poems*. New York: Random House, 2005.

Commemorative Works Act, Public Law 108–126 as amended (2003), http://uscode.house.gov/download/pls/40C89.txt.

"The Complete Text of Lincoln's Famous Gettysburg Address in Bronze." *Monumental News*, February 1907, 119.

Connor, R. D. W. "Canova's Statue of Washington." *Publications of the North Carolina Historical Commission*, bulletin no. 8 (1910): 14–27.

Cook, Clarence. "Monuments of America." *Chautauquan*, June 1886, 524–26.

Cotton, Felix. "Beauty of Washington Centered upon Its Great Number of Trees." *Washington Post*, June 6, 1926, F6.

———. "New Statues for District Shun Horse." *Washington Post*, August 29, 1926, SM3.

Crane, Sylvia E. *White Silence: Greenough, Powers, and Crawford, American Sculptors in Nineteenth-Century Italy*. Coral Gables, Fla.: University of Miami Press, 1972.

Crawford, F. Marion. "Washington as a Spectacle." *Century Magazine*, August 1894, 483–96.

Cultural Landscape Program. *Cultural Landscape Report: West Potomac Park, Lincoln Memorial Grounds, National Capital Parks Central*. Washington, D.C.: Government Printing Office, 1999.

Davis, John. "Eastman Johnson's 'Negro Life at the South' and Urban Slavery in Washington, D.C." *Art Bulletin* 80, no. 1 (1998): 67–92.

Davis, Timothy. "Beyond the Mall: The Senate Park Commission's Plans for Washington's Park System." In *Designing the Nation's Capital: The 1901 Plan for Washington, D.C.*, ed. Sue Kohler and Pamela Scott, 137–81. Washington, D.C.: U.S. Commission of Fine Arts, 2006.

Dear, Michael. "Monuments, Manifest Destiny, and Mexico." *Prologue Magazine*, Summer 2005, www.archives.gov/publications/prologue/2005/summer/mexico-1.html.

The Dedication of the Washington National Monument. Washington, D.C.: Government Printing Office, 1885.

Dewan, Shaila. "Larger than Life, More to Fight Over." *New York Times*, May 18, 2008, D4.

Dickens, Charles. *American Notes for General Circulation*. Paris: Baudry's European Library, 1842.

Dobriansky, Lev. *The Vulnerable Russians*. New York: Pageant Press, 1967.

Downes, William Howe. "Monuments and Statues in Boston." *New England Magazine*, November 1894, 353–72.

Downing, Andrew Jackson. *Rural Essays*. Edited by George William Curtis. 1853. Reprint, New York: Da Capo, 1974.

Doyle, David R., and Alan Dragoo. "Where Freedom Stands." National Geodetic Survey, ca. 1993, www.ngs.noaa.gov/PUBS_LIB/freedom_stands.html.

Dvorak, Petula. "Washington Monument Subtly Fortified." *Washington Post*, July 1, 2005, A1.

"Editor's Easy Chair." *Harper's New Monthly*, April 1885, 807–11.

"Editor's Easy Chair." *Harper's New Monthly*, August 1874, 436–40.

Elkins, James. Review of David Summers, *Real Spaces: World Art History and the Rise of Western Modernism*. Art Bulletin 86, no. 2 (2004): 373–81.

Emerson, Ralph Waldo. *Nature: A Facsimile of the First Edition*. 1836. Reprint, Boston: Beacon Press, 1985.

"Equestrian Monuments—The War of Secession." *American Architect and Building News*, October 31, 1891, 65–70.

Erikson, Erik. "Wholeness and Totality: A Psychiatric Contribution." In *Totalitarianism: Proceedings of a Conference Held at the American Academy of Arts and Sciences, March 1953*, ed. Carl J. Friedrich, 156–70. Cambridge, Mass.: Harvard University Press, 1954.

Fairman, Charles E. *Art and Artists of the Capitol of the United States of America*. Washington, D.C.: Government Printing Office, 1927.

Farrar, Margaret E. *Building the Body Politic: Power and Urban Space in Washington, D.C.* Urbana: University of Illinois Press, 2008.

Feldman, Judy Scott. "Turning Point: The Problematics of Building on the Mall Today." In *The National Mall: Rethinking Washington's Monumental Core*, ed. Nathan Glazer and Cynthia R. Field, 135–58. Baltimore: Johns Hopkins University Press, 2008.

Fernandez-Duque, Silvina. "First Division Monument." National Park Service, 2006, www.nps.gov/whho/historyculture/first-division-monument.htm.

Field, Cynthia R. "Interpreting the Influence of Paris on the Planning of Washington, D.C., 1870–1930." In *Paris on the Potomac: The French Influence on the Architecture and Art of Washington, D.C.*, ed. Cynthia R. Field, Isabelle Gournay, and Thomas P. Somma, 117–37. Athens: Ohio University Press, 2007.

———. "When Dignity and Beauty Were the Order of the Day: The Contribution of Daniel H. Burnham." In *The National Mall: Rethinking Washington's Monumental Core*, ed. Nathan Glazer and Cynthia R. Field, 41–54. Baltimore: Johns Hopkins University Press, 2008.

"First Division Monument, Washington D.C." *American Architect and the Architectural Review*, December 3, 1924, 525–30.

Flanders, Owen. "Too Irish for the Irish." *Washington Post*, May 30, 1909, SM1.

Foote, Kate. "Letter from Washington." *The Independent* (New York), December 18, 1884, 4–5.

Franklin, Ben A. "Eisenhower Raises Issue of Freedom." *New York Times*, June 28, 1964, 39.

———. "New Left Vanguard Arrives for Inaugural Protest." *New York Times*, January 19, 1969, 57.

Freeman, Joanne B. *Affairs of Honor: National Politics in the New Republic*. New Haven, Conn.: Yale University Press, 2001.

Friendly, Alfred. "Take a Deep Breath, Folks, the Capital's Tourist Peak Is Yet to Come." *Washington Post*, July 23, 1939, B3, B5.

Frothingham, O. B. "Washington as It Should Be." *Atlantic Monthly*, June 1884, 841–48.

Fryd, Vivien Green. *Art and Empire: The Politics of Ethnicity in the United States Capitol, 1815–1860*. New Haven, Conn.: Yale University Press, 1992.

Gayle, Margot, and Michele Cohen, eds. *The Art Commission and the Municipal Art Society Guide to Manhattan's Outdoor Sculpture*. New York: Prentice Hall, 1988.

George, Alexander R. "Lincoln Shrine Has Awed 20 Million." *Washington Post*, May 25, 1947, B3.

Getlein, Frank. "A Tribute, Yes—But Is It Art?" *Washington Star*, April 6, 1969.

Ghequiere, T. Buckler. "Richmond County Court-House, Virginia." *American Architect and Building News*, June 23, 1877, 199.

Gibson, James J. *The Ecological Approach to Visual Perception*. 1979. Reprint, Hillsdale, N.J.: Lawrence Erlbaum Associates, 1986.

Gillette, Howard. *Between Justice and Beauty: Race, Planning, and the Failure of Urban Policy*. Baltimore: Johns Hopkins University Press, 1995.

Glazier, Harlan E. "The Mall Trees." *Washington Post*, January 23, 1934, 8.

Goldberger, Paul. "Down at the Mall: The New World War II Memorial Doesn't Rise to the Occasion." *New Yorker*, May 31, 2004, 82–84.

Goldstein, Jan. *The Post-Revolutionary Self: Politics and Psyche in France, 1750–1850*. Cambridge, Mass.: Harvard University Press, 2005.

Goode, James M. *Outdoor Sculpture of Washington, D.C.: A Comprehensive Historical Guide*. Washington, D.C.: Smithsonian Institution Press, 1974.

Grant, U. S. "Washington's Parks." *Washington Post*, October 9, 1927, R5.

Graybar, Lloyd J. "Winthrop, Robert Charles." In *American National Biography*, 23:670–72. New York: Oxford University Press, 1999.

Green, Constance McLaughlin. *Washington: A History of the Capital, 1800–1950*. 2 vols. Princeton, N.J.: Princeton University Press, 1962.

Greenough, Horatio. "Aesthetics at Washington." In *A Memorial of Horatio Greenough, Consisting of a Memoir, Selections from His Writings, and Tributes to His Genius*, ed. Henry T. Tuckerman, 61–94. 1853. Reprint, New York: B. Blom, 1968.

———. *Letters of Horatio Greenough, American Sculptor*. Edited by Nathalia Wright. Madison: University of Wisconsin Press, 1972.

Greenwood, Grace. "Occasional Washington Notes." *New York Times*, May 19, 1874, 4–5.

Griswold, Charles L. "The Vietnam Veterans Memorial and the Washington Mall: Philosophical Thoughts on Political Iconography." In *Critical Issues in Public Art: Content, Context, and Controversy*, ed. Harriet F. Senie and Sally Webster, 71–100. Washington, D.C.: Smithsonian Institution Press, 1992.

Gross, Gerald G. "City Pattern Long Obsolete, They Say." *Washington Post*, October 8, 1939, B5, B10.

Gutheim, Frederick Albert. *Worthy of the Nation: The History of Planning for the National Capital*. Washington, D.C.: Smithsonian Institution Press, 1977.

Gutheim, Frederick Albert, and Antoinette J. Lee. *Worthy of the Nation: Washington, DC, from L'Enfant to the National Capital Planning Commission*. 2nd ed. Baltimore: Johns Hopkins University Press, 2006.

Habermas, Jürgen. *The Structural Transformation of the Public Sphere: An Inquiry into a Category of Bourgeois Society*. Cambridge, Mass.: MIT Press, 1989.

Hagopian, Patrick. "The Commemorative Landscape of the Vietnam War." In *Places of Commemoration: Search for Identity and Landscape Design*, ed. Joachim Wolschke-Bulmahn, 311–76. Washington, D.C.: Dumbarton Oaks, 2001.

———. *The Vietnam War in American Memory: Veterans, Memorials, and the Politics of Healing*. Amherst: University of Massachusetts Press, 2009.

Hale, Jonathan. "Cognitive Mapping: New York vs. Philadelphia." In *The Hieroglyphics of Space: Reading and Experiencing the Modern Metropolis*, ed. Neil Leach, 31–42. London: Routledge, 2001.

Harder, Julius F. "The City's Plan." *Municipal Affairs*, March 1898, 25–45.

Hargrove, June Ellen. *The Statues of Paris: An Open-Air Pantheon*. New York: Vendome Press, 1989.

Harris, C. M. "Washington's Gamble, L'Enfant's Dream: Politics, Design, and the Founding of the National Capital." *William and Mary Quarterly*, 3rd ser., 56, no. 3 (1999): 527–64.

Harvey, Frederick L. *History of the Washington National Monument and Washington National Monument Society*. Washington, D.C.: Government Printing Office, 1903.

Harwood, Richard. "Largest Rally in Washington History Demands Rapid End to Vietnam War." *Washington Post*, November 16, 1969, A1, A14.

Hashima, Lawrence. "Public Memories, Community Discord: The Battle over the 'Japanese American Creed.'" Paper presented at the annual meeting of the American Studies Association, Washington, D.C., November 10, 2001.

Hass, Kristin Ann. *Carried to the Wall: American Memory and the Vietnam Veterans Memorial*. Berkeley and Los Angeles: University of California Press, 1998.

Hawthorne, Nathaniel. "Chiefly about War Matters by a Peaceable Man." In *The Complete Works of Nathaniel Hawthorne*, 12:299–345. Boston: Riverside Press, 1883.

———. *The English Notebooks*. Edited by Thomas Woodson and Bill Ellis. 1870. Reprint, Columbus: Ohio State University Press, 1997.

Headley, Janet A. "The Monument without a Public: The Case of the Tripoli Monument." *Winterthur Portfolio* 29, no. 4 (1994): 247–64.

Heidler, David Stephen, and Jeanne T. Heidler. *Manifest Destiny*. Westport, Conn.: Greenwood Press, 2003.

Henderson, Mary F. "Grant Memorial Site." *Washington Post*, October 29, 1907, 12.

Henderson, Peter. "Street Trees of Washington." *Harper's New Monthly*, July 1888, 285–88.

Herbers, John. "250,000 War Protesters Stage Peaceful Rally in Washington." *New York Times*, November 16, 1969, 1.

Herbert, Bob. "Help Is on the Way." *New York Times*, November 22, 2008, A19.

Herman, Judith. *Trauma and Recovery*. New York: Basic Books, 1992.

Hollander, John. *The Gazer's Spirit: Poems Speaking to Silent Works of Art*. Chicago: University of Chicago Press, 1995.

Holmes, Oliver Wendell. "Doings of the Sunbeam." *Atlantic Monthly*, July 1863, 1–15.

Holzer, Harold, and Sara Vaughn Gabbard, eds. *Lincoln and Freedom: Slavery, Emancipation, and the Thirteenth Amendment*. Carbondale: Southern Illinois University Press, 2007.

Hoock, Holger. "The British Military Pantheon in St Paul's Cathedral: The State, Cultural Patriotism, and the Politics of National Monuments, c. 1790–1820." In *Pantheons: Transformations of a Monumental Idea*, ed. Richard Wrigley and Matthew Craske, 81–105. Aldershot, U.K.: Ashgate, 2004.

Horsman, Reginald. *Race and Manifest Destiny: The Origins of American Racial Anglo-Saxonism*. Cambridge, Mass.: Harvard University Press, 1981.

Howard, Clifford. "District of Columbia." *Californian Illustrated Magazine*, March 1893, 441–57.

Howells, William Dean. "Question of Monuments." *Atlantic Monthly*, May 1866, 646–49.

Hubbard, William. "A Meaning for Monuments." *Public Interest*, Winter 1984, 17–30.

Hugo, Victor. *Notre-Dame de Paris*. 1831. Reprint, Paris: Charpentier, 1850.

Hunter, Charlayne. "20,000 at Unveiling of Statue to Mary Bethune in Capital." *New York Times*, July 11, 1974, 11.

Hurd, G. Winfield. "Mall Loses Historic 'Arbor Day' Elm." *Washington Post*, December 16, 1934, B3, B4.

Huston, Luther B. "To Nation's Capital." *New York Times*, April 6, 1941, XX1, XX2.

Huyssen, Andreas. *Present Pasts: Urban Palimpsests and the Politics of Memory*. Stanford, Calif.: Stanford University Press, 2003.

Ingersoll, Ernest. *Rand, McNally & Co.'s Handy Guide to the City of Washington*. Chicago: Rand, McNally & Company, 1893.

James, Henry. *The American Scene*. New York: Harper and Brothers, 1907.

Jarves, James Jackson. "Clay Touched by Genius." *New York Times*, November 27, 1880, 1–2.

———. "Monuments in America." *New York Times*, October 15, 1879, 5.

———. "Washington's Monument." *New York Times*, March 17, 1879, 5.

Jay, Martin. "No State of Grace: Violence in the Garden." In *Sites Unseen: Landscape and Vision*, ed. Diane Harris and D. Fairchild Ruggles, 45–60. Pittsburgh: University of Pittsburgh Press, 2007.

Jefferson, Thomas. *Notes on the State of Virginia*. 1784. Reprint, New York: Palgrave, 2002.

———. *Papers*. Edited by Julian P. Boyd, L. H. Butterfield, Charles T. Cullen, and John Catanzariti. 34 vols. to date. Princeton, N.J.: Princeton University Press, 1950–present.

Kammen, Michael G. *Mystic Chords of Memory: The Transformation of Tradition in American Culture*. New York: Knopf, 1991.

Kaseman Beckman Amsterdam Studio. *Pentagon Memorial Description*. Washington, D.C.: Pentagon Memorial Project, ca. 2003, http://memorial.pentagon.mil/description.htm.

Keim, De Benneville Randolph. *Sherman: A Memorial in Art, Oratory, and Literature by the Society of the Army of the Tennessee with the Aid of the Congress of the United States of America*. Washington, D.C.: Government Printing Office, 1904.

———. *Washington and Its Environs: A Descriptive and Historical Hand-Book to the Capital of the United States of America*. Washington, D.C.: N.p., 1879.

Kennicott, Philip. "The Meaning of a Marker for 100 Million Victims." *Washington Post*, June 13, 2007, C1.

Kiley, Daniel Urban. "A Critical Look at the McMillan Plan." In *The Mall in Washington, 1791–1991*, ed. Richard W. Longstreth, 297–303. Washington, D.C.: National Gallery of Art, 2002.

Kite, Elizabeth Sarah. *L'Enfant and Washington*. Baltimore: Johns Hopkins University Press, 1929.

Kohler, Sue A., and Jeffrey R. Carson. *Sixteenth Street Architecture*. Washington, D.C.: Commission of Fine Arts, 1978.

Kostof, Spiro. *The City Shaped: Urban Patterns and Meanings through History*. Boston: Little, Brown, 1991.

———. "His Majesty the Pick: The Aesthetics of Demolition." In *Streets: Critical Perspectives on Public Space*, ed. Zeynep Çelik, Diane G. Favro, and Richard Ingersoll, 9–22. Berkeley and Los Angeles: University of California Press, 1994.

Kowsky, Francis R. *Country, Park, and City: The Architecture and Life of Calvert Vaux*. New York: Oxford University Press, 1998.

Lathrop, George P. "A Nation in a Nutshell." *Harper's New Monthly*, March 1881, 541–55.

Lawrence, Eugene. "The Washington Monument." *Harper's Weekly*, November 29, 1884, 789.

Le Corbusier. *Aircraft*. London: The Studio, 1935.

Lessoff, Alan. *The Nation and Its City: Politics, "Corruption," and Progress in Washington, D.C., 1861–1902*. Baltimore: Johns Hopkins University Press, 1994.

Lever, Jill. Catalogue of the Drawings of George Dance the Younger (1741–1825) and of George Dance the Elder (1695–1768): From the Collection of Sir John Soane's Museum. London: Azimuth Editions, 2003.

Lewis, Michael J. "The Idea of the American Mall." In *The National Mall: Rethinking*

Washington's Monumental Core, ed. Nathan Glazer and Cynthia R. Field, 11–26. Baltimore: Johns Hopkins University Press, 2008.

Lewis, Robert J. "Needed: A Miracle on the Mall." *Washington Star*, September 13, 1964, SM4.

Lin, Maya Ying. *Grounds for Remembering: Monuments, Memorials, Texts.* Berkeley, Calif.: Doreen B. Townsend Center, 1995, http://repositories.cdlib.org/townsend/occpapers/3/.

Lindberg, Tod. "Of Arms, Men and Monuments." *Commentary*, October 1984, 51–56.

Lindley, Ernest K. "Voice from the Temple." *Washington Post*, April 12, 1939, 9.

Linenthal, Edward T. *Preserving Memory: The Struggle to Create America's Holocaust Museum.* New York: Viking, 1995.

Loewen, James W. *Lies across America: What Our Historic Sites Get Wrong.* New York: Simon and Schuster, 2007.

Luria, Sarah. *Capital Speculations: Writing and Building Washington, D.C.* Hanover, N.H.: University Press of New England, 2006.

Lynch, Kevin. *The Image of the City.* Cambridge, Mass.: MIT Press, 1960.

Maher, Daniel B. "One Slain, 60 Hurt as Troops Rout B.E.F. with Gas Bombs and Flames." *Washington Post*, July 29, 1932, 1, 4–5.

Marling, Karal Ann, and Robert Silberman. "The Statue Near the Wall: The Vietnam Veterans Memorial and the Art of Remembering." *Smithsonian Studies in American Art* 1, no. 1 (1987): 5–29.

Marling, Karal Ann, and John Wetenhall. *Iwo Jima: Monuments, Memories, and the American Hero.* Cambridge, Mass.: Harvard University Press, 1991.

McBee, Susanna. "First Division Dedicates Memorial to War Dead." *Washington Post and Times Herald*, August 25, 1957, A14.

McKelway, John. "Rambler." *Washington Star*, November 10, 1964.

McLeod, Mary. "The Battle for the Monument: The Vietnam Veterans Memorial." In *The Experimental Tradition: Essays on Competitions in Architecture*, ed. Hélène Lipstadt, 115–38. New York: Princeton Architectural Press, 1989.

Mendelsohn, Matt. "Memorial Day." *New York Times*, November 6, 2008, A33.

Merk, Frederick. *Manifest Destiny and Mission in American History: A Reinterpretation.* New York: Knopf, 1963.

Meyer, Jeffrey F. *Myths in Stone: Religious Dimensions of Washington, D.C.* Berkeley and Los Angeles: University of California Press, 2001.

Michalski, Sergiusz. *Public Monuments: Art in Political Bondage, 1870–1997.* London: Reaktion Books, 1998.

Miles, Malcolm. *The Uses of Decoration: Essays in the Architectural Everyday.* Chichester: Wiley, 2000.

Miller, Iris. *Washington in Maps: 1606–2000.* New York: Rizzoli International Publications, 2002.

Miller, John J. "A Goddess for Victims—The Victims of Communism Memorial Comes to Fruition." *National Review*, May 28, 2007, 28–30.

Mills, Nicolaus. *Their Last Battle: The Fight for the National World War II Memorial.* New York: Basic Books, 2004.

Mitchell, W. J. T. *Picture Theory: Essays on Verbal and Visual Representation.* Chicago: University of Chicago Press, 1994.

Montagna, Dennis Robert. "Henry Merwin Shrady's Ulysses S. Grant Memorial in Washington, D.C.: A Study in Iconography, Content and Patronage." PhD dissertation, University of Delaware, 1987.

———. "A Monument for a New Century." *Army Magazine*, July 1, 2003, www.ausa.org/webpub/DeptArmyMagazine.nsf/byid/CCRN-6CCS9H.

Moore, Charles. *The Life and Times of Charles Follen McKim*. Cambridge, Mass.: Riverside Press, 1929.

Morales-Vásquez, Rubil. "Redeeming a Sacred Pledge: The Plans to Bury George Washington in the Nation's Capital." In *Establishing Congress: The Removal to Washington, D.C., and the Election of 1800*, ed. Kenneth R. Bowling and Donald R. Kennon, 148–89. Athens: Ohio University Press, 2005.

Morrison, William M. *Morrison's Strangers' Guide to the City of Washington, and Its Vicinity*. Washington, D.C.: William M. Morrison, 1844.

Moses, Michael Valdez. "A Rendezvous with Density: The FDR Memorial and the Clinton Era." *ReasonOnline*, April 2001, www.reason.com/news/show/27984.html.

Mumford, Lewis. *The City in History: Its Origins, Its Transformations, and Its Prospects*. New York: Harcourt, Brace, and Company, 1961.

———. *The Culture of Cities*. New York: Harcourt, Brace and Company, 1938.

———. "The Death of the Monument." In *Circle: International Survey of Constructive Art*, ed. Leslie Martin, Ben Nicholson, and Naum Gabo, 263–70. 1937. Reprinted New York: Praeger, 1971.

———. *Sticks and Stones: A Study of American Architecture and Civilization*. New York: Boni and Liveright, 1924.

Murray, Freeman Henry Morris. *Emancipation and the Freed in American Sculpture: A Study in Interpretation*. 1916. Reprint, Freeport: Books for Libraries Press, 1972.

Musil, Robert. *Posthumous Papers of a Living Author*. Translated by Peter Wortsman. New York: Archipelago Books, 2006.

Nash, Gary B. "Slaves and Slaveowners in Colonial Philadelphia." *William and Mary Quarterly*, 3rd ser., 30, no. 2 (1973): 223–56.

National Capital Planning Commission. *Commemorative Zone Policy*, January 2000, www.ncpc.gov/initiatives/pg.asp?p=commemorativezonepolicy.

———. *Memorials and Museums Master Plan*, September 2001, www.ncpc.gov/UserFiles/File/2M1_33.pdf.

National Park Service. "Freedom Is Not Free," ca. 2002, www.nps.gov/kwvm/memorial/freedom.htm.

National Transportation Safety Board. "Flight Path Study—American Airlines Flight 77." February 19, 2002. National Security Archive, George Washington University, www.gwu.edu/%7Ensarchiv/NSAEBB/NSAEBB196/doc02.pdf.

Nicosia, Gerald. *Home to War: A History of the Vietnam Veterans' Movement*. New York: Carroll and Graf, 2004.

Nietzsche, Friedrich Wilhelm. "On the Utility and Liability of History for Life." In *Unfashionable Observations*, translated by Richard T. Gray, 83–168. Stanford, Calif.: Stanford University Press, 1995; German edition originally published 1873.

Notaro, Anna. "Resurrecting an Imperial Past: Strategies of Self-Representation and 'Masquerade' in Fascist Rome (1934–1938)." In *The Hieroglyphics of Space: Reading and Experiencing the Modern Metropolis*, ed. Neil Leach, 59–69. London: Routledge, 2002.

Oberdorfer, Don. "Dawn at Memorial: Nixon, Youths Talk." *Washington Post and Times Herald*, May 10, 1970, A1, A11.

O'Donoghue, M. F. "Not an Irish Design." *Washington Post*, June 1, 1909, 4.

Olmsted, Frederick Law. "'A Healthy Change in the Tone of the Human Heart' (Suggestions to Cities)." *Century Illustrated Magazine*, October 1886, 963–65.

―――. "Index to Trees about the Capitol." In *Report of the Secretary of the Interior*, 47th Cong., 2nd sess., 1883. H. Exec. Doc. 1, pt. 11, 913–25.

―――. *Parks, Politics, and Patronage, 1874–1882*. Vol. 7 of *The Papers of Frederick Law Olmsted*, ed. Charles E. Beveridge, Carolyn F. Hoffman, and Kenneth Hawkins. Baltimore: Johns Hopkins University Press, 2007.

―――. *Writings on Public Parks, Parkways, and Park Systems*. Vol. 1 of *The Papers of Frederick Law Olmsted, Supplementary Series*, ed. Charles E. Beveridge and Carolyn F. Hoffman. Baltimore: Johns Hopkins University Press, 2007.

Olmsted, Frederick Law, Jr. "Landscape in Connection with Public Buildings in Washington." In *Papers Relating to the Improvement of the City of Washington, District of Columbia*, compiled by Glenn Brown, 22–34. Washington, D.C.: Government Printing Office, 1901.

Olszewski, George J. *History of the Mall, Washington, D.C.* Washington, D.C.: U.S. Office of History and Historic Architecture, Eastern Service Center, 1970.

―――. *Lincoln Park, Washington, D.C.* Washington, D.C.: Office of Archeology and Historic Preservation, Division of History, National Park Service, 1968.

O'Malley, Therese. "'A Public Museum of Trees': Mid-Nineteenth-Century Plans for the Mall." In *The Mall in Washington, 1791–1991*, ed. Richard W. Longstreth, 61–76. Washington, D.C.: National Gallery of Art, 2002.

Oppler, Ellen C., ed. *Picasso's Guernica*. New York: Norton, 1988.

Oration of the Hon. Stephen A. Douglas, on the Inauguration of the Jackson Statue, at the City of Washington, January 8, 1853. Washington, D.C.: L. Towers, 1853.

Owens, Mackubin Thomas. "Vietnam Veterans Aren't Victims." *Wall Street Journal*, July 13, 2000, A26.

Palmer, Laura. *Shrapnel in the Heart: Letters and Remembrances from the Vietnam Veterans Memorial*. New York: Vintage Books, 1988.

Passonneau, Joseph. *Washington through Two Centuries: A History in Maps and Images*. New York: Monacelli Press, 2004.

Peatross, C. Ford, ed. *Capital Drawings: Architectural Designs for Washington, D.C., from the Library of Congress*. Baltimore: Johns Hopkins University Press, 2005.

Peets, Elbert. *On the Art of Designing Cities: Selected Essays of Elbert Peets*. Edited by Paul D. Spreiregen. Cambridge, Mass.: MIT Press, 1968.

Penczer, Peter R. *Washington, D.C., Past and Present*. Arlington, Va.: Oneonta Press, 1998.

Peterson, Jon A. *The Birth of City Planning in the United States, 1840–1917*. Baltimore: Johns Hopkins University Press, 2003.

―――. "The Senate Park Commission Plan for Washington D.C.: A New Vision for the Capital and the Nation." In *Designing the Nation's Capital: The 1901 Plan for Washington, D.C.*, ed. Sue Kohler and Pamela Scott, 1–47. Washington, D.C.: U.S. Commission of Fine Arts, 2006.

Peterson, Merrill D. *The Jefferson Image in the American Mind*. 1960. Reprint, Charlottesville: University of Virginia Press, 1998.

Phillips, Cabell. "350 Vietnam Protesters Are Arrested in Capital." *New York Times*, August 10, 1965, 3.

Piehler, G. Kurt. *Remembering War the American Way*. Washington, D.C.: Smithsonian Institution Press, 1995.

Pillemer, David B. "Can the Psychology of Memory Enrich Historical Analyses of Trauma?" *History and Memory* 16, no. 2 (2004): 140–54.

Press, Donald E. "South of the Avenue: From Murder Bay to the Federal Triangle." *Records of the Columbia Historical Society* 51 (1984): 51–70.

Ralph, Julian. "Our National Capital." *Harper's New Monthly*, April 1895, 657–74.

Reel, Monte. "Suicide May Keep Veteran From Eternal Recognition." *Washington Post*, March 6, 2004, B1.

Reiff, Daniel D. *Washington Architecture, 1791–1861: Problems in Development*. Washington, D.C.: U.S. Commission of Fine Arts, 1971.

Reilly, Bernard. *American Political Prints, 1766–1876: A Catalog of the Collections in the Library of Congress*. Boston: G. K. Hall, 1991.

Rensselaer, Marianna van Griswold. "St. Gaudens's Lincoln." *Century Magazine*, November 1887, 37–39.

Reps, John William. *Monumental Washington: The Planning and Development of the Capital Center*. Princeton, N.J.: Princeton University Press, 1967.

———. *Washington on View: The Nation's Capital since 1790*. Chapel Hill: University of North Carolina Press, 1991.

Reston, James, Jr. "The Monument Glut." *New York Times*, September 10, 1995, SM48–SM49.

Roose's Companion and Guide to Washington and Vicinity. Washington, D.C.: Gibson Bros., 1889.

Roosevelt, Theodore. "In Praise of the Strenuous Life." In *The American Reader: Words That Moved a Nation*, ed. Diane Ravitch, 333–36. New York: Harper Collins, 2000.

Rowland, Katherine. "Protesting Tree Destruction." *Washington Post*, January 10, 1934, 6.

Russell, Mrs. Charles Edward. "On the Destruction of Trees in the Mall." *Washington Post*, January 6, 1934, 8.

Russell, Theresa. "On the Destruction of Trees in the Mall." *Washington Post*, January 2, 1934, 6.

Rybczynski, Witold. "'A Simple Space of Turf': Frederick Law Olmsted Jr.'s Idea for the Mall." In *The National Mall: Rethinking Washington's Monumental Core*, ed. Nathan Glazer and Cynthia R. Field, 55–65. Baltimore: Johns Hopkins University Press, 2008.

Samuels, Gayle Brandow. *Enduring Roots: Encounters with Trees, History, and the American Landscape*. New Brunswick, N.J.: Rutgers University Press, 1999.

Sandage, Scott A. "A Marble House Divided: The Lincoln Memorial, the Civil Rights Movement, and the Politics of Memory, 1939–1963." *The Journal of American History* 80, no. 1 (1993): 135–67.

Santayana, George. *The Sense of Beauty: Being the Outlines of Aesthetic Theory*. 1896. Reprint, New York: Modern Library, 1955.

Savage, Kirk. "History, Memory, and Monuments: An Overview of the Scholarly Literature on Commemoration." National Park Service, 2006, www.cr.nps.gov/history/resedu/savage.htm.

———. "The Past in the Present: The Life of Memorials." *Harvard Design Magazine*, Fall 1999, 14–19.

———. "The Self-Made Monument: George Washington and the Fight to Erect a National Memorial." In *Critical Issues in Public Art: Content, Context, and Controversy*, ed. Harriet F. Senie and Sally Webster, 5–32. Washington, D.C.: Smithsonian Institution Press, 1998.

———. *Standing Soldiers, Kneeling Slaves: Race, War, and Monument in Nineteenth-Century America*. Princeton, N.J.: Princeton University Press, 1997.

———. "Trauma, Healing, and the Therapeutic Monument." In *Terror, Culture, Politics: Rethinking 9/11*, ed. Daniel Sherman and Terry Nardin, 103–20. Bloomington: Indiana University Press, 2006.

———. "Uncelebrated War: The Vietnam Veterans Memorial." *Threepenny Review*, Spring 1984, 24–25.

Schama, Simon. *Landscape and Memory.* New York: Knopf, 1996.

Schuyler, David. *Apostle of Taste: Andrew Jackson Downing, 1815–1852.* Baltimore: Johns Hopkins University Press, 1996.

Schuyler, Montgomery. "The Nation's New Capital." *New York Times,* January 19, 1902, SM4.

Schwartzman, Paul, and Eli Saslow. "Across the Country, 'It's Like a New Aura.'" *Washington Post,* November 6, 2008, A1.

Scott, Mel. *American City Planning since 1890: A History Commemorating the Fiftieth Anniversary of the American Institute of Planners.* Berkeley: University of California Press, 1969.

Scott, Pamela. *Capital Engineers: The U.S. Army Corps of Engineers in the Development of Washington, D.C., 1790–2004.* Alexandria, Va.: U.S. Army Corps of Engineers, Office of History, 2005.

———. "'A City Designed as a Work of Art.'" In *Designing the Nation's Capital: The 1901 Plan for Washington, D.C.,* ed. Sue Kohler and Pamela Scott, 75–136. Washington, D.C.: U.S. Commission of Fine Arts, 2006.

———. "'The City of Living Green': An Introduction to Washington's Street Trees," *Washington History,* 18, nos. 1–2 (2006): 20–45.

———. "Robert Mills and American Monuments." In *Robert Mills, Architect,* ed. John Morrill Bryan, 143 77. Washington, D.C.: American Institute of Architects Press, 1989.

———. "Robert Mills's Washington National Monument," MA thesis, University of Delaware, 1985.

———. "'This Vast Empire': The Iconography of the Mall, 1791–1848." In *The Mall in Washington, 1791–1991,* ed. Richard W. Longstreth, 37–58. Washington, D.C.: National Gallery of Art, 2002.

Scruggs, Jan C., and Joel L. Swerdlow. *To Heal a Nation: The Vietnam Veterans Memorial.* New York: HarperPerennial, 1992.

Semple, Robert B., Jr. "Nixon, in Pre-Dawn Tour, Talks to War Protesters." *New York Times,* May 10, 1970, 1, 24.

Shanken, A. M. "Planning Memory: Living Memorials in the United States during World War II." *Art Bulletin* 84, no. 1 (2002): 130–47.

Shapiro, Michael Edward. *Bronze Casting and American Sculpture, 1850–1900.* Newark: University of Delaware Press, 1985.

Smith, Dinitia. "For the Victims of Communism." *New York Times,* December 23, 1995, A16.

Solit, Karen. *History of the United States Botanic Garden, 1816–1991.* Washington, D.C.: Government Printing Office, 1993.

Spofford, A. R. "Washington City." In *Johnson's New Universal Cyclopedia,* 4:1256–65. New York: A. J. Johnson and Son, 1878.

Spofford, Harriet Prescott. "Streets of Washington." *Harper's New Monthly,* August 1868, 411–15.

Statutes at Large of the United States of America, from December, 1881, to March, 1883. Washington, D.C.: Government Printing Office, 1883.

Stein, Sally. "The President's Two Bodies: Stagings and Restagings of FDR and the New Deal Body Politic." *American Art Review* 18, no. 1 (2004): 33–57.

Stephenson, Richard W. *A Plan Whol[l]y New: Pierre Charles L'Enfant's Plan of the City of Washington.* Washington, D.C.: Library of Congress, 1993.

Stockholm International Peace Research Institute. "Recent Trends in Military Expenditure," 2007, www.sipri.org/contents/milap/milex/mex_trends.html.

Sturgis, Russell. "Sculpture." *Forum,* October 1902, 248–69.

Sturken, Marita. *Tangled Memories: The Vietnam War, the AIDS Epidemic, and the Politics of Remembering*. Berkeley and Los Angeles: University of California Press, 1997.

———. "The Wall, the Screen, and the Image: The Vietnam Veterans Memorial." *Representations*, no. 35 (1991): 118–42.

Summers, David. *Real Spaces: World Art History and the Rise of Western Modernism*. London: Phaidon, 2003.

Taft, Lorado. "Required Reading for the Chautauqua Literary and Scientific Circle." *The Chautauquan: A Weekly Newsmagazine*, January 1896, 387–96.

Taft, Willam Howard. "Washington: Its Beginning, Its Growth, and Its Future." *National Geographic Magazine*, March 1915, 221–92.

Tarpy, Cliff. "The Battle for America's Front Yard." *National Geographic*, June 2004, 60–71.

Thomas, Christopher A. *The Lincoln Memorial and American Life*. Princeton, N.J.: Princeton University Press, 2002.

Thucydides. *History of the Peloponnesian War*. Translated by Charles Forster Smith. 4 vols. Cambridge, Mass.: Harvard University Press, 1928.

Tobin, William Anthony. "In the Shadow of the Capitol: The Transformation of Washington, D.C., and the Elaboration of the Modern U.S. Nation-State." PhD dissertation, Stanford University, 1994.

Torres, Louis. *"To the Immortal Name and Memory of George Washington": The United States Army Corps of Engineers and the Construction of the Washington Monument*. Washington, D.C.: Government Printing Office, 1985.

Townsend, George Alfred. "'Gath' at Lincoln's Tomb." *Washington Post*, March 9, 1891, 7.

———. "The New Washington." *Harper's New Monthly*, February 1875, 306–22.

Transactions of the Fifty-Second Session of the American Institute of Homeopathy. Philadelphia: Sherman and Co., 1896.

Traugott, Mark. "Barricades as Repertoire: Continuities and Discontinuities in the History of French Contention." *Social Science History* 17, no. 2 (1993): 309–23.

Treib, Marc. "Moving the Eye." In *Sites Unseen: Landscape and Vision*, ed. Diane Harris and D. Fairchild Ruggles, 61–88. Pittsburgh: University of Pittsburgh Press, 2007.

Turner, Frederick. "Washington as a Pilgrimage Site." In *The National Mall: Rethinking Washington's Monumental Core*, ed. Nathan Glazer and Cynthia R. Field, 79–92. Baltimore: Johns Hopkins University Press, 2008.

Upton, Dell. *Another City: Urban Life and Urban Spaces in the New American Republic*. New Haven, Conn.: Yale University Press, 2008.

U.S. Congress. House. Committee on Public Buildings and Grounds. *Hearings before the Committee on Public Buildings and Grounds, on H. Res. 221 and 222*. 74th Cong., 1st sess., 1935.

U.S. Congress. House. Committee on the Library. *Concerning the Location of the Grant Memorial in the Botanic Garden in the City of Washington*. 60th Cong., 1st sess., 1908, H. Rep. 1302.

U.S. Congress. Joint Committee on the Library. *Establishment of a National Botanical Garden: Hearing before a Joint Committee on the Library*. 66th Cong., 2nd sess., May 21, 1920.

U.S. Congress. Senate. Committee on the District of Columbia. *The Improvement of the Park System of the District of Columbia*, ed. Charles Moore. 57th Cong., 1st sess., 1902. S. Rep. 166.

———. *The Mall Parkway: Hearing before the Committee on the District of Columbia of the United States Senate*. 58th Cong., 1st sess., March 12, 1904.

Valentine, Paul W. "Viet Victory Backers to Rally Here April 4." *Washington Post*, March 21, 1970, B5.

Van Brunt, Henry. *Architecture and Society: Selected Essays of Henry Van Brunt*, ed. William A. Coles. Cambridge, Mass.: Harvard University Press, 1969.

———. "Grant's Memorial: What Shall It Be?" *North American Review*, September 1885, 282–87.

———. "The Washington Monument." Part 1: *American Art Review* 1 (1879): 7–12; part 2: *American Art Review* 1 (1879): 63–65.

———. "The Washington Monument." In *American Art and American Art Collections*, ed. Walter Montgomery, 1:353–68. Boston: E. W. Walker, 1889.

Van Horne, John C., and Lee W. Formwalt, eds. *The Correspondence and Miscellaneous Papers of Benjamin Henry Latrobe*, vol. 1. New Haven, Conn.: Yale University Press, 1984.

Varnum, Joseph B., Jr. "Monumental Structures." *New York Observer and Chronicle*, June 15, 1854, 189.

———. "The National Washington Monument and Other Kindred Subjects." *Literary World*, November 30, 1850, 425–27.

———. "The Seat of Government of the United States." *Merchant's Magazine and Commercial Review*, February 1848, 142–52.

———. "The Seat of Government of the United States." *Merchant's Magazine and Commercial Review*, April 1848, 367–75.

Vidler, Anthony. *Warped Space: Art, Architecture, and Anxiety in Modern Culture*. Cambridge, Mass.: MIT Press, 2000.

Vischer, Robert. *Empathy, Form, and Space: Problems in German Aesthetics, 1873–1893*. Translated by Harry Francis Mallgrave and Eleftherios Ikonomou. Santa Monica, Calif.: Getty Center for the History of Art and the Humanities, 1994.

Von Hoffman, Nicholas. "Television Blackout." *Washington Post*, November 17, 1969, D1, D6.

Ward, Susan Hayes. "Fine Arts." *The Independent* (New York), August 13, 1891, 8.

Waring, George E., Jr. "Public Squares and Public Spaces." *Scribner's Monthly*, July 1877, 403–4.

Washburn, Wilcomb E. "Planning Washington." In *The Federal City: Plans and Realities*, ed. Frederick Gutheim, 78–99. Washington, D.C.: Smithsonian Institution Press, 1976.

———. "Vision of Life for the Mall." *AIA Journal* 47, no. 3 (1967): 52–59.

Washington National Monument Society. *Memorial of the Committee of the National Monument Association Relative to the Completion of the Washington Monument*. 46th Cong., 2nd sess., April 29, 1880. H. Doc. 37.

Wecter, Dixon. *The Hero in America: A Chronicle of Hero-Worship*. New York: Scribner's, 1941.

Weinberg, Albert Katz. *Manifest Destiny: A Study of Nationalist Expansionism in American History*. Baltimore: Johns Hopkins University Press, 1935.

Wharton, Anne Hollingsworth. *Social Life in the Early Republic*. Philadelphia: J. B. Lippincott Company, 1902.

Whitman, Walt. *Democratic Vistas and Other Papers*. London: Walter Scott, 1888.

———. *Leaves of Grass*. Philadelphia: David McKay, 1900.

Wigoder, Meir. "The 'Solar Eye' of Vision: Emergence of the Skyscraper-Viewer in the Discourse on Heights in New York City, 1890–1920." *Journal of the Society of Architectural Historians* 61, no. 2 (2002): 152–69.

Williams, Raymond. *The Country and the City*. New York: Oxford University Press, 1973.

Wills, Garry. *Lincoln at Gettysburg: The Words That Remade America*. New York: Simon and Schuster, 1992.

Wrenn, Tony P. "The American Institute of Architects Convention of 1900: Its Influence on the Senate Park Commission Plan." In *Designing the Nation's Capital: The 1901 Plan for Washington, D.C.*, ed. Sue Kohler and Pamela Scott, 49–73. Washington, D.C.: U.S. Commission of Fine Arts, 2006.

Wright, Nathalia. *Horatio Greenough: The First American Sculptor*. Philadelphia: University of Pennsylvania Press, 1963.

Wrigley, Richard, and Matthew Craske, eds. *Pantheons: Transformations of a Monumental Idea*. Aldershot, U.K.: Ashgate, 2004.

Yates, Frances A. *The Art of Memory*. London: Routledge and Kegan Paul, 1966.

Young, James E. *The Texture of Memory: Holocaust Memorials and Meaning*. New Haven, Conn.: Yale University Press, 1993.

Zevi, Bruno. *Architecture as Space: How to Look at Architecture*. Translated by Milton Gendel. New York: Horizon Press, 1957.

Illustrations

Index

Italicized page numbers refer to illustrations.

Designer: Janet Wood
Text: 10/16 Scala
Display: Akzidenz Grotesk, Egiziano Black
Compositor: Integrated Composition Systems
Illustrator: Bill Nelson
Printer and binder: Thomson-Shore, Inc.